John Hedgecoe's
COMPLETE
PHOTOGRAPHY
COURSE

John Hedgecoe's
COMPLETE PHOTOGRAPHY COURSE

A Fireside Book
Published by Simon & Schuster Inc.
New York London Toronto Sydney Tokyo

Project Manager and Designer
Mel Petersen

Executive Editor
Jack Tresidder

Editor
Chris Cooper

Assistant Editor
Gilead Cooper

Design Assistants
Mike Strickland
Michaela David

Technical Consultants
Allan Shriver
Clifford Stokes

The Complete Photography Course
was edited and designed by
Mitchell Beazley International Limited
14-15 Manette Street
London W1V 5LB

A Fireside Book
Published by Simon & Schuster Inc.
Simon & Schuster Building
Rockefeller Center
1230 Avenue of the Americas
New York, New York 10020

FIRESIDE and colophon are registered trademarks of
Simon & Schuster Inc.
20 19 18 17 16 15 14 13 12 11 10 9

Library of Congress Cataloging in Publication Data
London Ed. Published under title: John Hedgecoe's Introductory
Photography Course.
Includes index.
I Photography. I. Title. II Title: Complete Photography Course.
TR146.H42 1979 770'28 79-15124

ISBN 0-671-47501-0 (Paperback)

Printed in Portugal by Printer Portuguesa Lda
D.L.B. 37236-1980

Contents

INTRODUCTION

Good photographs are all around us. The secret is to be able to see them and to have enough technical skill to be able to concentrate on taking the photographs without worrying about how to handle the camera. Advances in the manufacture of both films and cameras have made it possible for people to produce excellent photographs without a vast amount of technical knowledge. My aim in this book has been to pick out the essential information and convey it in a logical sequence that will rapidly take you to an advanced level of photography.

The emphasis is on learning by going and taking pictures yourself. To acquire the freedom of knowing that most of your photographs will turn out satisfactorily, you need to practice such basic skills as focusing and setting aperture and shutter speed until these become almost automatic. While you are mastering this, the craft side of photography, you should also be developing the more important visual side—your awareness of why you are taking the picture at all. Without this sense of purpose the results are liable to be dull, no matter how technically correct.

Selection and interpretation play a major part in any good picture and I have tried to show how to develop these perceptual skills in a series of projects you can undertake yourself, more or less as a student would do on a formal photographic course. These structured exercises should enable you to make faster progress than if you took photographs at random. My purpose both here and in the section on composition is to make you aware of the range of possibilities any scene can offer and to appreciate the enormous improvements you can make in your photographs by exercising conscious and careful choice over the elements you include, the emphasis you give them and the vital moment at which to press the shutter.

Nearly all the photographs in this book were taken with equipment that is easily available to the amateur. For most of them I used a medium-priced single-lens reflex camera with three interchangeable lenses; for studio pictures and some outdoor shots I used a second-hand "view" camera (one that incorporates a bellows and gives pictures on large-format film); and I sometimes used a portable flash unit, a sturdy tripod and a selection of the filters referred to in the text. With such equipment you can handle 90 percent of the work that a professional might undertake. Extra items of equipment, such as zoom lenses and close-up attachments, are also described in the text with examples of what they can do, but they should not distract the beginner who finds more satisfaction in good photographs than in impressive equipment.

I have explained some simple studio set-ups and a variety of lighting arrangements for portraits and still life studies. Studio work gives you a degree of control over your subject that transforms your photography. For a similar reason I have given plenty of space to processing film and making your own prints. This is a much simpler business than most camera owners realize, and it enables you to get the very best from what you have captured on film.

The most powerful photographs are the ones that have an element of surprise in them—that do not give up their secret at the first glance, but reveal it slowly after the initial response. This book cannot teach you how to take such pictures, but I hope it will lead you some of the way toward them. And in the course of the hard work and exploration that go into learning to *see* pictures and not merely hoping they will happen, you will find yourself having fun and developing a distinctive personal style.

HOW TO USE A CAMERA

The first stage of photography is getting to know your camera. In this section of the book the workings of the camera, the varieties of film, and the basic principles of exposure and lighting are explained with practical examples.

Understanding the camera

All cameras are essentially lighttight boxes in which a film or plate sensitive to the action of light can be kept in darkness until the moment when a shutter is opened and light from the outside world is admitted to form an image. The chemical action of the light leaves an invisible trace on the film, called a "latent" image, which can later be chemically processed to form a visible picture.

In an ordinary camera the image is formed by a lens, but an image can be formed in a much simpler way—by a pinhole. The homemade camera shown below consists of a lightproof box with a pinhole in one end, which casts an image onto the inside of the box. A piece of film is mounted, in darkness, inside the box opposite the pinhole. The pinhole is uncovered for a period of, say, a minute while the camera is facing a bright scene. The film can then be developed at home or by a commercial processing laboratory. A piece of black and white film becomes a "negative"—a transparent image with dark areas representing light areas of the subject and vice versa. This in turn can be used to make a positive print. Color film, after processing, becomes a transparency or a color negative, depending on the type of film.

The camera lens

An ordinary camera can let in quite a lot of light, while still producing a sharp image, by using a converging lens—a disk of glass or transparent plastic with one or both faces convex. After passing through it a beam of parallel light rays will be brought to a point. That is, the lens will *focus* it. Rays that are spreading when they reach the lens will either converge after passing through it or be made to diverge less strongly. Magnifying glasses are converging lenses and so are the spectacles of long-sighted people.

Such a lens will project an image of a bright object, such as a lamp, onto a piece of card. The lens has this effect because light rays are bent whenever they enter or leave a transparent medium such as glass, as the diagrams here show. A convex lens forms an image by bringing rays from each point of the subject to a corresponding image point.

The lens image is brighter than a pinhole image simply because the lens is larger and gathers more light. However, sharp images are formed at different distances beyond it, depending on the distance of the subject. The lens must be moved closer to the card to focus distant objects.

The quality of the image formed by a single convex lens deteriorates away from the lens's centerline, becoming distorted and fringed with color. But near the center of the image the lens can form much sharper images than a pinhole.

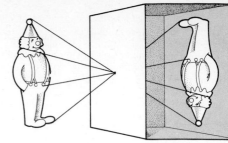

A pinhole forms an image by allowing one cone of rays from each subject point to pass. The prism (center top) bends light. Two prisms base to base converge light and a stack of prisms (bottom) can roughly focus rays, acting like a convex lens.

Making a pinhole camera. Cut a hole in a cardboard box. Blacken the inside. Tape aluminum foil over the opening, make the pinhole and cover it with opaque tape. In darkness, mount film opposite the pinhole. Expose film and keep it in dark until developed.

How a pinhole forms an image

We see objects by the light that comes from them to our eyes. While the light rays are traveling through air—not meeting, say, water or glass—they travel in straight lines. A pinhole restricts the light rays coming from a subject; thus in the diagram at top right, only a narrow cone of rays from the nose of the clown passes through the pinhole, forming a small patch of light on the far side of the box. Another cone of rays from the feet of the clown passes through the pinhole to form a corresponding spot at a different place. From all these patches of light an image is formed, inverted from top to bottom and from left to right.

A photograph taken with a pinhole camera looks "soft" because each point of the subject forms a small patch, rather than a point, in the image.

Fundamentals of the camera

The simplest cameras may have a single convex lens made of glass or plastic. But better photographic lenses are much more complex than this. A standard lens for a typical camera may consist of six *elements*, or individual lenses. Such a "compound" lens can form an image that is much superior to that formed by a single lens.

In some cameras the lens is fixed in position; in others the lens can be focused by rotating its *focusing ring*. This moves the lens backward or forward, altering its distance from the film.

The amount of light that enters the camera is controlled by the shutter speed (the length of time for which the shutter is open) and by the lens's *aperture*. The aperture is the diameter of an opening in a diaphragm built into the lens, through which the light passes to reach the film.

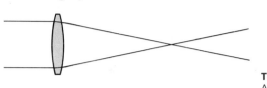

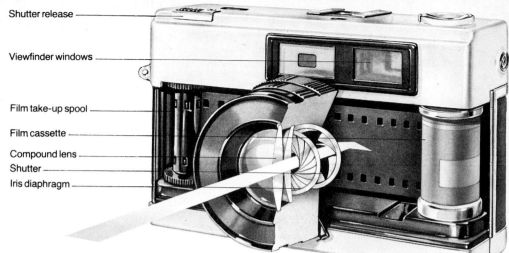

Shutter release
Viewfinder windows
Film take-up spool
Film cassette
Compound lens
Shutter
Iris diaphragm

The basic camera
All portable (nonstudio) cameras have similar basic features. The film is wound past the lens onto a takeup spool, one frame at a time. The amount of light entering during each exposure is controlled by the variable size of the diaphragm aperture and the length of time for which the shutter is kept open.

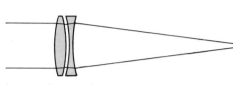

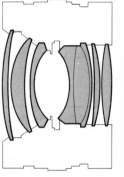

A convex lens, such as a magnifying glass, focuses light rays (top). A concave lens disperses rays, so the "doublet" (above) focuses less strongly than the convex lens would alone. But it can form a better image than the single lens can. A typical modern camera lens (right) may consist of six or more elements, both concave and convex.

Photographic film

Film is supplied in a variety of sizes and containers. Most amateur photographers use cameras that will accept either a cartridge or a cassette (but not both). A cartridge is simply clipped into the camera. As pictures are taken the film is wound, one frame at a time, across the camera behind the lens. When the film is finished the cartridge is unclipped and sent to a laboratory for processing.

Cassette film is loaded in a slightly more complicated way. A tongue of film protruding from the cassette is threaded onto a takeup spool in the camera. When finished the film must be rewound into the cassette.

Professional photographers and serious amateurs may use cameras that take *rollfilm*, which is supplied wound onto a spool and protected by lightproof backing paper. These films are broader than cassette or cartridge films and so there is room for a larger image, which means that the final picture can be of higher quality. Cameras that take rollfilm will not take cartridges or cassettes.

Finally, film may be provided in sheets, for "technical" cameras, such as those used in studios. The sheets come in a variety of sizes, ranging up to a usual maximum of 10×8 in (25.4×20.3 cm).

A photograph taken with a pinhole (opposite) has a soft quality. The pinhole diameter was $\frac{1}{64}$ in and a full minute was needed for the exposure. The photograph taken with a camera lens (right) needed only a 1 sec exposure because of its wider aperture, and the lens elements render the scene much more sharply.

How to use a camera
The simple camera

In the most basic camera, designed for easy use and for taking the simplest sort of snapshot, there is no means of varying the focus of the lens or controlling the amount of light that reaches the film. The lens forms a tolerably sharp image of subjects from infinity down to a few feet away, but not closer. No shutter speed or aperture controls are provided. Adequate pictures can be taken only on fairly bright days, although slight variations in brightness can be corrected in laboratory processing.

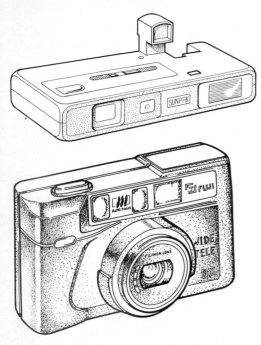

Other simple cameras give more control while still being very easy to operate. Increasing numbers offer variation in exposure by means of automatically controlled aperture settings or shutter speeds. Compared with more advanced cameras, the range of shutter speeds is limited, however. Very fast or slow speeds are not available and because the controls are usually fully automatic, your ability to take the pictures you want is restricted.

It is essential that the camera's viewfinder should show as accurately as possible just what is going to appear in the final picture. Most simple cameras are of the direct-view type, in which the scene is viewed through a small lens separate from the main, or "taking", lens.

In autofocus cameras, a small rectangle in the centre of the viewfinder shows which part of the subject the camera will focus on. To take a picture, you just position this mark over the most important part of the subject, and press the shutter release. The camera makes sure the photo is sharp.

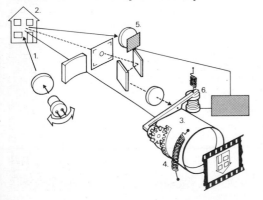

Clear sun and cloudy sun symbols mark exposure settings on some simple cameras.

Typical lens-focusing symbols: landscape, group (about 9 ft) and portrait (about 4 feet).

Pocket cameras take cartridges of 110 film, giving 13 × 17 mm pictures. Easy to use, most have automatic exposure control within a limited range of shutter speeds or apertures and either fixed focus or zone focusing.

The compact camera takes cassette film on sprockets, giving pictures 24 × 36 mm in size. It has a non-interchangeable lens, which is focused on a fixed distance in the cheaper models; the better compact cameras have automatic focusing. Virtually all cameras of this type set the exposure automatically, and have pop-up flash units.

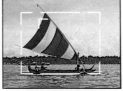

The full bright-line frame is used for far or medium-range subjects *(top)*. For nearer subjects *(above)* a smaller part of the frame must be employed.

Autofocus compact cameras work by scanning a beam of harmless infrared radiation (1) across the subject (2). As the beam swings across, the lens (3) moves closer to the film under spring or motor power (4). An infrared detector (5) notes when the beam strikes the subject; then a magnet (6) locks the lens in sharp focus.

Ideas into practice 1
First steps in using a camera

Sharp pictures of high-speed action, of dimly lit areas, of very close or distant subjects and of tall buildings are all hard to achieve with simple cameras. But limitations of lenses or focusing and shutter speeds can often be turned to advantage. The seabirds (right) have been blurred by the slow shutter of a Beirette, for example, but the fluttering impression this creates is effective and evocative of the birds' movement.

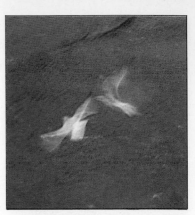

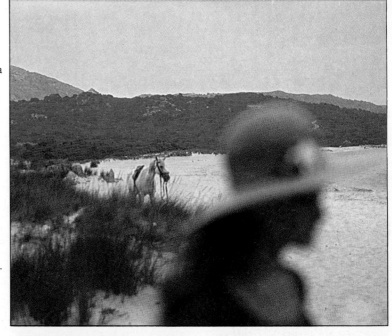

In the picture of a horse and girl on a beach I used an Instamatic's limited depth of field to leave the foreground figure out of focus while achieving an intriguing image. The photograph of horse-jumping fences shows the importance of keeping the camera level with some subjects, even if you have to crouch or stand on something to get the right viewpoint. True verticals were necessary to the strong pattern of this photograph, and an ordinary lens tends to make verticals converge if the camera is tilted. This can sometimes be dramatic, as in the picture of the cathedral at Jerez, Spain, where the positioning of the sun added to the impact of the shot. Slightly converging lines of a temple in Bangkok (bottom) are hardly noticeable because the eye is drawn to the figure of the girl and the elegant symmetry of the three arches within the picture's frame. A more striking example of the way in which the restriction of a lens can be overcome is the picture of the Blackpool Tower reflected in a pool. You can often exploit an unconventional angle of view to fit the whole subject into the frame.

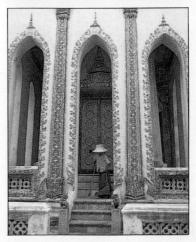

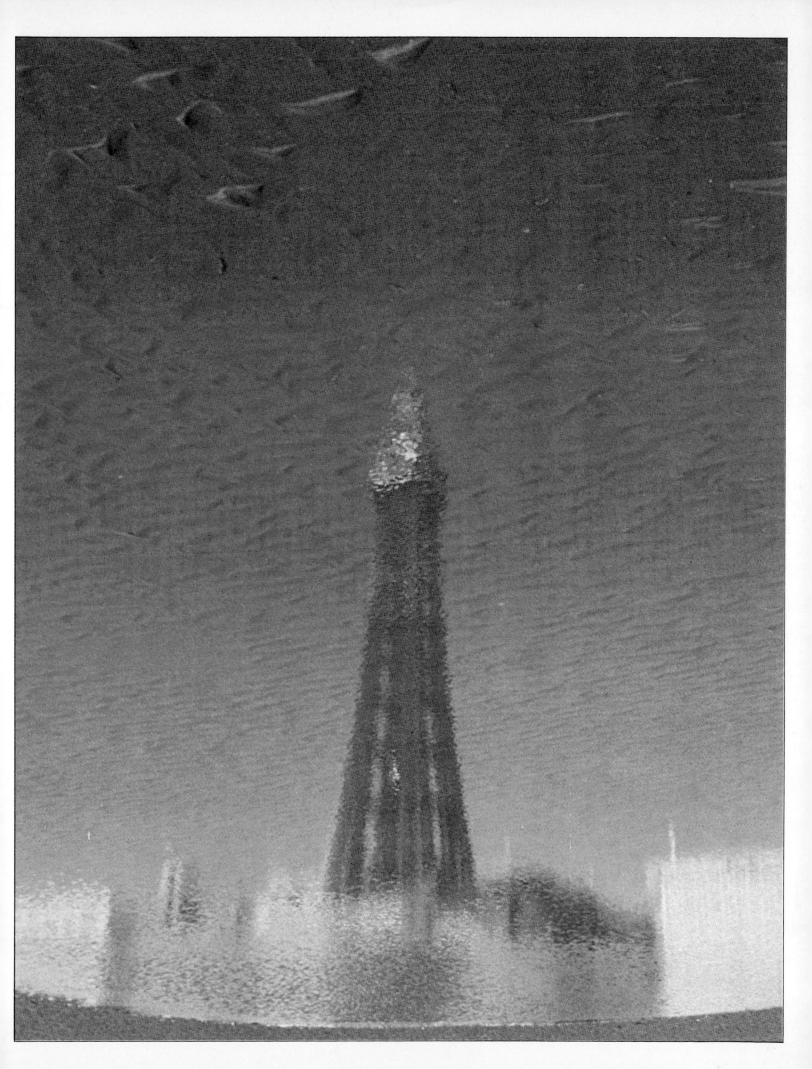

The advanced camera

For serious photography you require a camera that offers you full control over aperture, focusing and shutter speeds, and preferably a camera to which you can fit a number of different lenses. Most amateurs and many professionals work in the 35 mm format, in which the choice of cameras and accessories is unrivaled.

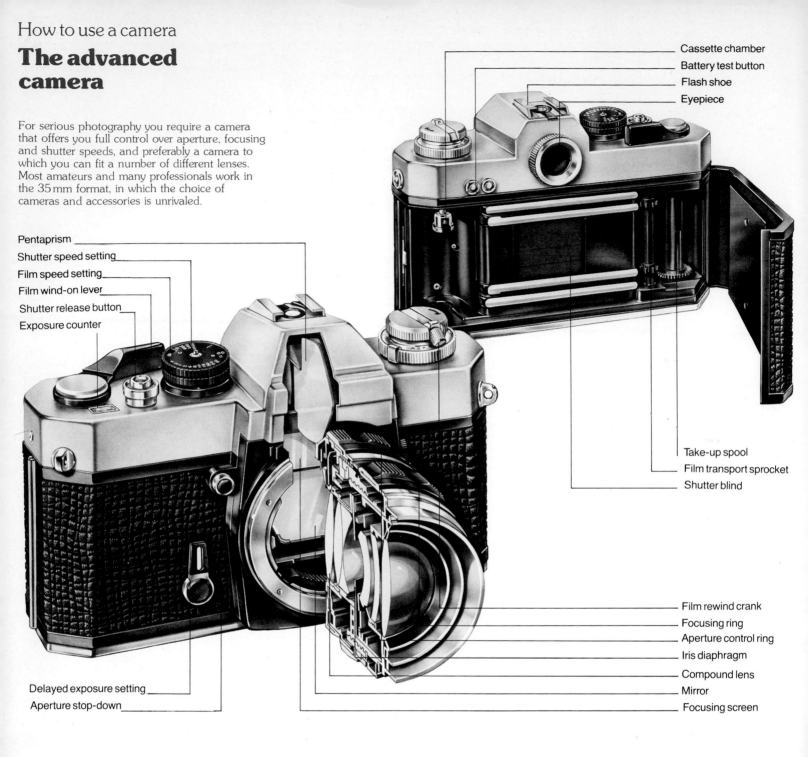

Pentaprism
Shutter speed setting
Film speed setting
Film wind-on lever
Shutter release button
Exposure counter

Delayed exposure setting
Aperture stop-down

Cassette chamber
Battery test button
Flash shoe
Eyepiece

Take-up spool
Film transport sprocket
Shutter blind

Film rewind crank
Focusing ring
Aperture control ring
Iris diaphragm
Compound lens
Mirror
Focusing screen

The single-lens reflex camera

By far the most widely sold type of 35 mm camera is the single-lens reflex (SLR) camera. In this type the light coming through the taking lens is reflected to an eye level viewfinder by a mirror and a prism, so that you see exactly what the film will register.

While you are viewing the scene before taking the picture, light passes freely through the lens. Its path toward the film is intercepted by a mirror that reflects the light upward to a ground glass focusing screen at the top of the camera body. This screen is 24 × 36 mm, the size of the picture frame as it will appear on the film. The distance from the lens to the screen via the mirror is exactly the same as the distance from the lens to the film. Looking into the eyepiece, you view the image on the screen through a pentaprism, a block of glass shaped to present the image upright and the correct way round. As you vary the focusing and framing of the image, you can see it changing in the viewfinder.

Virtually all SLRs have a built-in exposure meter

coupled to the shutter speed and aperture. A display in the viewfinder indicates when exposure is correct as you change these controls or else the camera adjusts the shutter and aperture settings by itself.

In some SLRs the diaphragm, which is built into the lens, is closed down to the value set on the aperture control during viewfinding. In an increasing number of cameras, however, the diaphragm stays fully open during viewfinding, so that the image is seen at maximum brightness, and closes down to the set aperture only when the button is pressed.

Until the moment when the button is pressed, the film is protected by the shutter blinds (either metal or cloth) in front of the film.

When you press the shutter release button on an SLR, a complex sequence of events is started. The modern SLR has evolved into a delicate and elaborate instrument that carries out this sequence as smoothly and silently as possible. The mirror swings up out of the light path, blocking off any light that may enter the camera through the eyepiece

and the image vanishes from the viewfinder. At the same time the diaphragm closes down to the aperture that has been set.

Then the exposure begins. The shutter blinds move in such a way that a gap traverses the film, allowing light to fall on the film (see page 18). When this has happened and the film is again covered by the light-tight shutter, the mirror springs back into place, the image reappears in the viewfinder and the film can be wound on for the next shot.

The image in an SLR viewfinder is large and bright and its framing is exactly that which will appear on the film. Not only the focusing of the subject but its depth of field—the range of distances over which objects are in focus—can be seen and precisely controlled. Most important of all, if a different lens is used on the camera body the viewfinder will continue to present exactly what the film "sees." You can also see directly the effect of filters attached in front of the lens. The SLR has proved itself to be the most versatile type of camera.

The nonreflex camera

Despite the attractions of the SLR, some photographers prefer nonreflex cameras. Some SLRs are bulky and heavy, and even the best of them cannot be as smooth and quiet in operation as comparable nonreflex cameras. There is a danger of camera shake caused by the mirror movement. The complexity of the mechanism means that there is more to go wrong mechanically. And some users are bothered by the loss of image when they take the shot, even though this is usually momentary.

A nonreflex camera is intrinsically simpler than an SLR and hence more reliable and quieter. It can be very compact—the smallest in the 35 mm format being smaller than the palm of the hand. The viewfinder can be very sophisticated, incorporating a rangefinder coupled to the focusing control and an exposure meter that views the scene through the taking lens, like the exposure meter on an SLR.

But the great disadvantage of the nonreflex camera is that, in all but the most expensive models, there is a fixed lens—it cannot be changed because that would need a corresponding change of viewfinder. Also the effects of lens filters cannot be directly viewed. Nevertheless, the compact and convenient viewfinder camera has its devotees.

There are sophisticated nonreflex cameras with interchangeable lenses for which the viewfinder framing alters automatically when a new lens is put on. The exposure meter's light-sensitive cell is usually mounted behind the lens and springs aside when the picture is taken. A built-in shutter protects the film while the lens is changed.

This tiny 35 mm camera shows the compactness that the non-reflex camera can achieve. The Minox 35 GT is just under 4 inches long, 2½ inches high, and weighs only 7 ounces. When the protective flap is closed to retract and cover the lens, the camera is little more than an inch thick. There is a built-in exposure meter, and the camera sets the correct shutter speed once the aperture has been set on a ring around the lens.

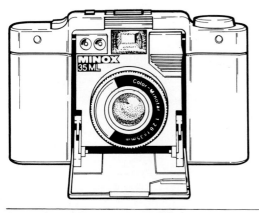

The rollfilm SLR

Some single-lens reflex cameras are designed for 120 rollfilm, which offers a choice of frame sizes considerably larger than the 24 × 36mm of 35mm cassette film. Some of these cameras have interchangeable backs, one for each format. Frame sizes range from 45 × 60 mm through 60 × 60 and 60 × 70 to 60 × 90 mm. Normally the camera is held at waist level. The ground glass focusing screen is viewed through a magnifier that can be folded down when the camera is being carried. The image is upright but reversed from left to right. Pentaprism attachments are available for most models so that the camera can be used at eye level.

The twin-lens reflex camera

Most of the advantages of the SLR are offered by the mechanically simpler and more reliable twin-lens reflex (TLR) camera. In this design you view the image not through the taking lens but through a second lens mounted above it. This lens can be simpler than the main lens. Its image, reversed from left to right, is formed on a focusing screen at the top of the camera body and is viewed through a magnifier. The two lenses move together as the image is focused. The image in the viewfinder is not exactly identical to that seen by the taking lens, because of the difference in the positions of the two lenses. But it is only for very close subjects that this difference becomes important, and the viewing screen carries markings that indicate the true image area for close subjects. Lenses are not interchangeable on most models of TLR, since both the lenses would have to be changed together.

The technical camera

The greatest degree of control that a photographer can achieve is provided by the so-called technical camera, although only with a loss of operating speed and convenience. As used in the studio, the technical camera consists of a front and a back panel, carrying the lens and a filmholder respectively, joined by lightproof folding bellows. The panels move independently along a steel "monorail" mounted on a tripod. During the setting up of a shot the back panel carries a ground glass focusing screen on which the image appears upside down and reversed from left to right. When the shot is about to be taken the screen is slid out and replaced with a filmholder containing an individual sheet of film. Any lens can be used in the front panel. Not only can the panels be slid backward and forward, they can be raised and lowered or twisted for various special purposes (see page 179).

Portable versions of the technical camera have the front panel sliding on a baseboard that folds out from the back panel. There is a ground glass focusing screen, but normally a supplementary viewfinder with a coupled rangefinder is used. The baseboard camera can take flat film or rollfilm.

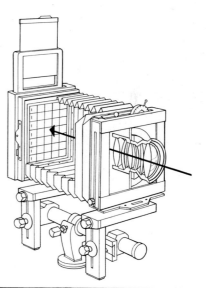

Comparison of the main camera types

Viewfinder camera
The scene is viewed through a viewfinder with its own small lens, separate from the main lens. Very close focusing may not be possible. The simplest and cheapest cameras are of this type.

Autofocus camera
This is essentially a viewfinder camera with the addition of automatic focusing. There is also usually an automatic exposure meter. These cameras are compact and virtually foolproof.

SLR camera
The image is viewed through the taking lens by means of a mirror and a prism. This is the most versatile camera type, with a vast range of lenses and accessories available for it.

Rollfilm SLR
Not only the lens but, often, the camera back can be interchanged to provide various formats on 120 rollfilm. Although bulky, this type includes some of the finest portable cameras.

Twin-lens reflex camera
The viewfinder image is formed by a secondary lens that moves with the taking lens. This sturdy and reliable general-purpose camera has been overtaken in popularity by the SLR.

The technical camera
The lens and film can be moved independently on a monorail or baseboard. This camera type excels for the professional photographer concerned with static subjects such as architecture.

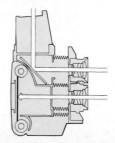

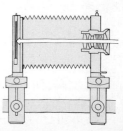

Which color film?

Film is sold in a variety of standard sizes and is normally packaged in one of four ways: in cartridges or cassettes, as rollfilm or as sheet film, depending on the type of camera it is intended for. When you buy film you should specify which of these you want, and also mention how many exposures you want, since the film may be sold in more than one length.

The format of the picture given by a camera—its shape and size—is determined primarily by the width of the film it uses: thus cassette film is 35 mm wide and the pictures produced are 24 × 36 mm. Most cameras are able to produce pictures in only one format.

Having established the size of film that fits your camera, you now have to select the kind of film you want. Whether you wish to use color or black and white, you will need to choose a film with a suitable "speed," or degree of sensitivity to light. Fast film is highly sensitive, able to record pictures in poor light, while slow film requires more exposure. However, slow film can achieve greater detail and finer quality when the lighting conditions allow.

There are several systems of measuring film speed. The most common is ISO (International Standards Organization) which is numerically equal to the older ASA system. In Europe, the German DIN (Deutsche Industri Norm) system is still used, though the ISO system is gradually replacing it.

The ISO system is arithmetic. In other words, a film rated at, for example, ISO 200 is twice as fast as one rated at ISO 100 and therefore requires half as much exposure; and it is half as fast and requires twice as much exposure as an ISO 400 film.

The DIN system, on the other hand, is logarith-mic, instead of expressing the fact that one film is twice as fast as another by doubling the number, the DIN scale expresses this by *adding* 3. Thus 24 DIN (ISO 200) is twice as fast as 21 DIN and half as fast as 27 DIN.

For general purposes choose a medium speed film which can cope with most normal conditions. For snapshots an ISO 200 film is about right—a typical exposure with an ISO 200 film on a sunny day is 1/500 at an average aperture. A faster film, such as ISO 400 or 1000 will make your camera more versatile, allowing you to take action-stopping pictures in dull weather, to use flash less often indoors and, when you do use flash, to take pictures of more distant subjects. There is a price to be paid for versatility, though: pictures on fast film are less sharp and may have a gritty texture, and the hues are usually duller. This trade-off is explained in greater detail on the pages that follow, but as a rule, the slower the film speed, the better the picture quality.

Color film

There are essentially two kinds of color film, and your choice between them will depend mainly on whether you want prints or slides. *Negative* film is intended solely for making prints; *reversal* film, on the other hand, gives color transparencies, which are normally mounted in plastic or cardboard holders and viewed as slides. It is not difficult, however, to make prints from the slides and it is possible (though less convenient) to make slides from color negatives.

When color negative film has been developed, the resulting image is "negative" in two respects. Where the original scene was bright, the photographic image is dark, and where the original was dark, the image is light; in addition, each color of the scene appears as its opposite, or "complementary," color. For example, a yellow object would be recorded as blue on the film, a green object as magenta, and so on. The film is merely a halfway stage on the way toward a full-color print, just as it is in the black and white process. Making a print from a color negative involves, essentially, photographing the negative again—this time on sensitive paper. In the new picture, all the colors and densities are again reversed, giving a "positive." The advantage of this apparently laborious procedure over the more direct reversal process is that it allows the photographer considerable control over the color balance of the picture at the printing stage (see pages 102–104).

In a reversal film, processing produces a transparent positive image in the film itself. The image is formed by transparent dyes that subtract appropriate colors from light passing through them.

Each type of reversal film is "balanced" for a particular kind of light, either natural or artificial, and will give natural-looking results only when used under the right conditions. The two types are known as "daylight balanced film" for natural light and flash, and "tungsten balanced film" for electric bulbs. They are needed because tungsten lighting is yellowish compared with daylight. Film that is balanced for daylight will exaggerate this color and give a reddish cast to scenes illuminated by electric lighting, unless a color correction filter is used (see page 196). As daylight film can be used with most types of flash lighting, you will rarely require artificial light film. Most color negative film can be used either in daylight or artificial light, because it is possible to control the color balance of the final picture at the printing stage.

The final decision you will have to make when buying film is the brand. There may be a surprising difference in the color renderings of various brands of film, as shown in the comparative photographs here. Because no brand of film renders color "perfectly" in an objective sense, your choice is governed only by your taste and preferences.

The negative's colors are the complementaries of those in the final print—blue for yellow, and so on. For technical reasons the negative also has an orange cast.

Color reversal films

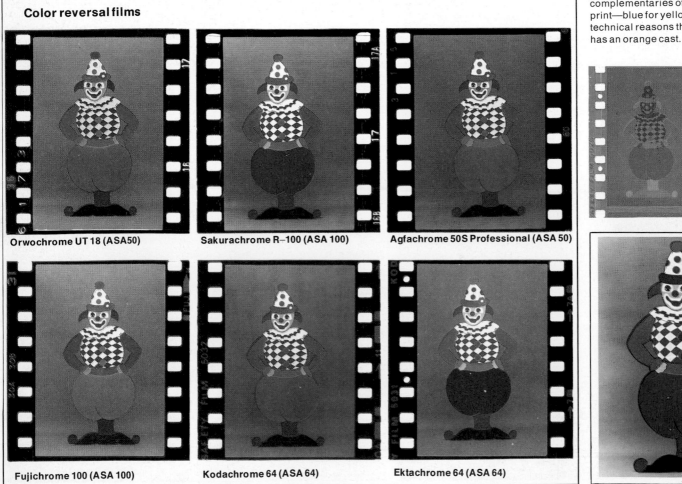

Orwochrome UT 18 (ASA 50)

Sakurachrome R–100 (ASA 100)

Agfachrome 50S Professional (ASA 50)

Fujichrome 100 (ASA 100)

Kodachrome 64 (ASA 64)

Ektachrome 64 (ASA 64)

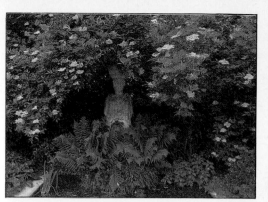

Film is packaged as sheets or rolls, or in plastic cassettes and cartridges designed to make loading the film into cameras as easy as possible. 35 mm film is normally bought in cassettes, but it can be bought in bulk and loaded into cassettes by the photographer. Rollfilm is used to give 6 × 6 cm, 6 × 4.5 cm or 6 × 7 cm negatives. Several sizes of sheet film are available for large studio and technical cameras; they include 5 × 4 in and 10 × 8 in sizes.

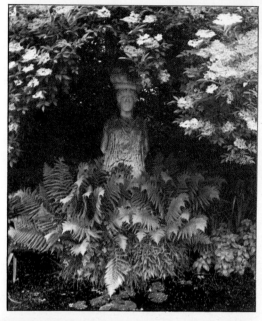

Infrared-sensitive film shows the ordinary world in striking, surreal colors (right). The foliage looks red (although it is green in the normal picture above) because vegetation rich in chlorophyll strongly reflects the infrared part of sunlight.

Artificial light film makes daylight scenes look bluish and "cold," as in the picture on the right below. The neighboring photograph, taken with daylight film, renders the doll's face and the flames in "warmer" colors.

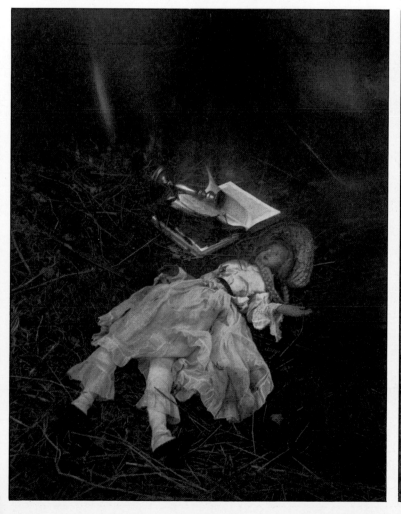

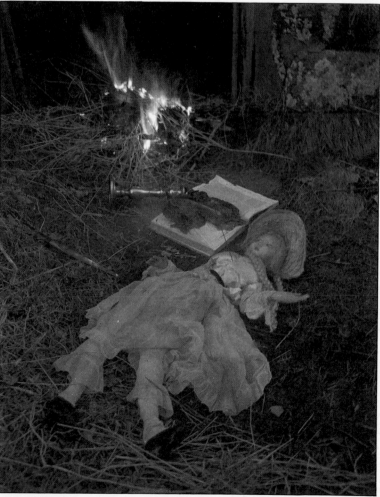

Which black and white film?

Because black and white photographic materials are easier to handle at the processing stage than color materials, many serious amateurs prefer to work in black and white when doing their own developing and printing. Being considerably cheaper than color, black and white also offers greater freedom for experimentation in the darkroom. It is certainly a mistake to think of black and white as an inferior version of color; it offers its own creative possibilities.

Because it renders all colors as gradations of black, gray and white, it offers great scope for subtleties of tone and contrast, from which color can be a distraction. Likewise, black and white can be used to emphasize the formal aspects of composition; as a more "austere" medium than color, its use can help to develop accuracy of perception and technique. In fact, the relationship between black and white and color photography is somewhat analogous to that between line drawing and painting in oils—both have their distinctive possibilities and uses.

Grain

Film speed was explained from a practical point of view on the previous page. The difference in speed between one film and another is actually the result of a difference in the size of the light-sensitive grains present in the two films. These grains form the basis of all photographic materials: they are the part of the film (or paper) that actually records the image. They consist of a certain group of compounds of silver, called silver halides. Some of these grains are converted into metallic silver, which is black, by the action of a developer; and these grains constitute the visible image on a negative or print.

Large halide grains are more sensitive than small ones, and so the greater the proportion of large grains, the faster the film will be. Since speed is thus connected with grain size, it is also connected with quality: the coarse texture of fast, large-grained films

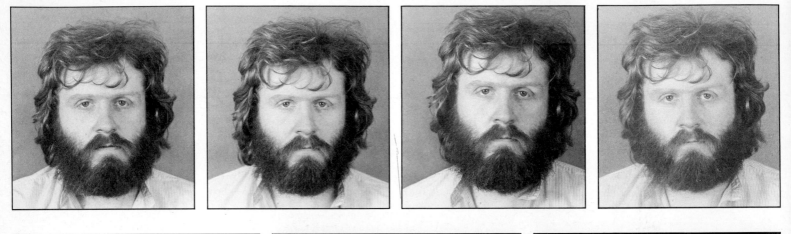

The sequence of four portraits above was taken under constant lighting conditions on four films of increasing sensitivity. The first, taken on ISO 50 film, sharply records textures in the hair and face. Contrast is high, and there is not trace of grain. Subsequent pictures were taken on films with speeds of ISO 125, 400 and 1250. Definition lessens, and grain is just discernible in the last picture.

Still life and architectural photographs like those above and to the left benefit by being taken on slow film. Such pictures are frequently intended for exhibition and film of about ISO 64 gives crisp detail that will survive enlargement. Long exposure times may be necessary because of the film's slowness, but with static subjects this presents no problem.

Portraits and many outdoor shots call for moderately fast films. There is some chance of movement, so fairly fast shutter speeds are needed. But when there is plenty of light available, as in the pictures on the right, a medium-speed film of about ISO 125 can be used and will provide ample detail.

will be unable to record as much detail or offer the same degree of sharpness as slow, small-grained films. Thus slow films are said to give better "definition" than fast ones. Contrast is also related to speed and grain size: slower films give slightly higher contrast than faster ones.

Color sensitivity

Ordinary black and white film is *panchromatic*—that is to say, it is sensitive to all the visible colors. However, panchromatic film does not respond to the various colors in exactly the same way as the human eye: it is particularly sensitive to blue, so that blue objects tend to appear rather light on the photograph. Most problems that arise as a result of such discrepancies can be dealt with by using colored filters (*see page 176*).

Several other kinds of black and white film may be briefly mentioned. Orthochromatic materials are insensitive to red light—that is, red objects appear black on the photograph. Except in the case of some special-purpose films, "ortho" film has been entirely replaced by panchromatic films.

Finally, for work requiring exceptionally good definition, such as line reproduction and copying, there are films that are blue-sensitive only.

How film works

Black and white film consists of several layers. A thin layer of light-sensitive chemicals called the emulsion is coated onto a transparent base; in films this consists of flexible acetate, though plates using glass for the base are still made. The base acts merely as a support for the emulsion; a film usually has additional layers whose function is simply to protect the emulsion.

The emulsion is made up of silver "halides" suspended in gelatin. These are compounds consisting of silver combined with the elements chlorine, bromine or iodine, and are the light-sensitive part of the film. When the shutter of the camera is opened light travels through the lens to the film, and those crystals of silver halide that are struck by the light are affected, though as yet no visible change takes place. Instead, a *latent image* is formed. A chemical agent or "developer" must then be employed in order to convert the latent image into a visible one.

The developer breaks down the silver halide, producing grains of black metallic silver. But crystals affected by the light are much quicker to react to the developer and turn into silver than those that were not. This means that all the bright areas of the original scene quickly begin to appear as black areas on the developing film, while the dark areas of the scene are represented by areas of silver halide which remain almost unchanged.

If the process of development were allowed to continue, all the silver halides, including those in the subject's dark areas, would eventually be converted into black metallic silver. Before this can happen, however, the development is stopped, leaving a negative image on the film—"negative" because it is the light areas of the scene which are now darkened by numerous particles of silver.

The remaining undeveloped silver halides (which are, of course, still sensitive to light) are then removed by a second chemical process, "fixing" the image permanently. The chemical fixer converts the halides into water-soluble compounds, which are then dissolved out of the emulsion when the film is washed, leaving only the black silver particles in the clear gelatin, which are in varying densities, giving gradations of black and gray.

When the film is dry it can be used to make prints. Essentially, the negative is photographed, this time using light-sensitive paper, which consists of emulsion coated onto an opaque white base. A development process like that already described forms an image that reverses the light and dark areas of the negative and hence is a positive.

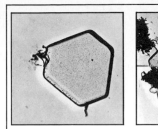 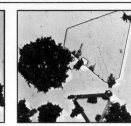

Development of a photographic emulsion begins with filamentary growth of metallic silver from silver halide crystals. More crystals are "reduced" to silver (being destroyed in the process) in areas that received more light during the exposure. But if the development is not interrupted, all the crystals will turn into silver (final picture), blackening the negative. These pictures are magnified 3000 times.

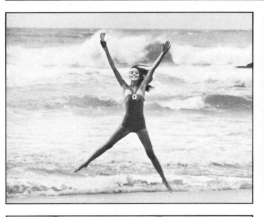 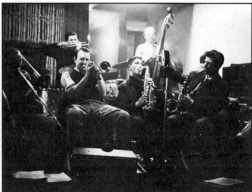

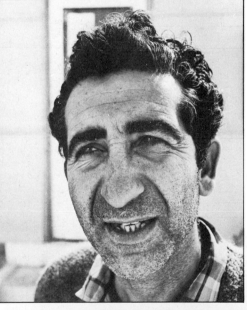

A beach scene, a jazz club and a portrait in open shade all called for a fast film, but for different reasons. I wanted to use a shutter speed of 1/1000 to "stop" the movement of the girl and the surf. I also wanted as small an aperture as possible, for this gives the greatest picture sharpness. So, although the light was bright, I used a film of ISO 400. In order to photograph the musicians, on the other hand, I needed to use a fast film because the available light in the jazz club was poor. To emphasize the roughness of the weatherbeaten and unshaven face of the man on the left, the coarse, grainy texture of fast film was ideal.

The gloom of a tunnel being constructed to extend London's underground railway system demanded an ultrafast film—one with a speed of ISO 1000 or more. There was no question of interrupting the work to set up my own lighting, so I had to depend on the dim light from the lamps in the tunnel. The film I actually used was rated at ISO 2000, but even so, I had to use a long exposure that has blurred some moving figures. The lamps and other highlights are burnt out in the picture, but this serves to emphasize the darkness of the rest of the scene, while the grain of the film suggests the dust-laden atmosphere.

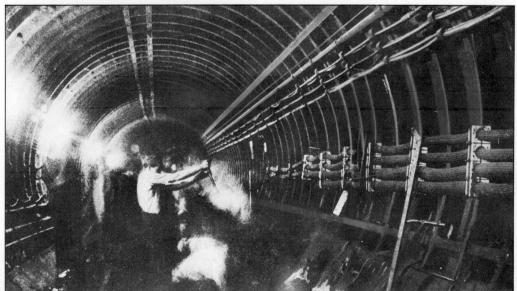

Shutter speed

The photographic materials used in the early days of photography required long exposures, so that only static scenes could be recorded. Even posed portraits were difficult, since the sitters had to remain still for uncomfortably long times. These problems have been overcome by modern film, and some cameras now offer exposure times as fast as 1/2000 or 1/4000 of a second. But it is still necessary to pay careful attention to avoiding camera shake. For sharp pictures, the slowest shutter speed that can safely be used on handheld shots is 1/60 second. (For a telephoto lens, which because of its weight magnifies the effects of shake, 1/125 is the slowest safe speed.) When you take any shot, press the camera against your cheek if possible, make sure

your stance is firm and stop breathing momentarily while you press the button. Unsuspected tremor can be caused by the buffeting of a strong wind, or even engine vibration while you are standing on a boat deck. In such circumstances use faster shutter speeds if possible.

As short exposures are not always preferable to longer ones, a camera with a wide range of shutter speeds offers you much greater control of the picture than an automatic camera that has only two or three speeds from which you are not free to select. A typical modern camera will offer automatically set exposure times as slow as one second or longer, as well as the option of longer exposures that you time yourself.

Shutter types

There are two main types of shutter. The *leaf shutter* is built into the lens. It consists of a number of metal blades that form a lightproof disk when the shutter is closed. When the button is pressed the blades swing

out to form an opening that increases to a maximum size and then closes down. If you could see the image on the film during the exposure, you would see it grow brighter and then dim again. Leaf shutters are quiet, smooth-working and free of several mechanical problems that beset focal-plane shutters, the other main type. But lenses that incorporate them are more expensive than those that do not and usually they are not interchangeable.

A focal-plane shutter is built into the camera body. It consists of two blinds directly in front of the film. They form a slit of variable width that moves across the film during the exposure. The exposure time that each point of the film receives is the time taken for the slit to pass over the point and therefore is determined by the width of the slit. Focal-plane shutters are mainly used in single-lens reflex cameras, for between exposures they protect the film while permitting light to pass through the lens to be reflected to the pentaprism viewfinder.

Focal-plane shutter

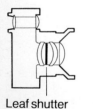

Leaf shutter

The shutter speed control indicates speeds that here range from 1/1000 to 4 seconds. If the B setting is used, the shutter will stay open for as long as the button is kept depressed. The X setting is used with electronic flash and ensures that the flash fires when the shutter is fully open.

The focal-plane shutter is built into the camera (left). It consists of two blinds that travel across the film. The primary blind, containing a rectangular opening slightly larger than the picture frame, starts to travel first (above right). The secondary blind starts moving a little later and the two blinds form a slit that moves across the film. If a shorter exposure time is set, a narrower slit is formed.

A leaf shutter is built into the camera lens (below left) and consists of metal blades that form a light-tight barrier when the shutter is closed. When the shutter button is pressed the blades rotate to form an opening and then swing shut.

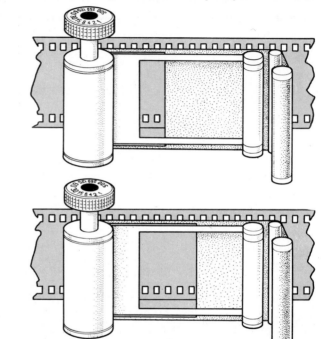

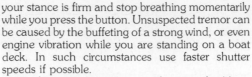

For a normal shot press the camera against your cheek and keep your elbows well tucked in. Learn to set the focus and aperture while looking through the viewfinder. Stand with one foot slightly advanced and press the button with a smooth action.

A low camera angle suits many subjects—pets and small children, for example. Since these are lively subjects you have to be ready to shift position at any moment. For stability, crouch on one knee and rest the upper part of the other arm—not the elbow—on the other knee. Support the camera with the lower hand and squeeze the button gently.

Long lenses are very difficult to use without camera shake. Not only are they heavy, their small field of view exaggerates any tremor. Use the fastest possible shutter speed and try this stance, which will improve your steadiness enormously. Rest the lens on your left forearm, curl your left hand round your right forearm and grip it tightly.

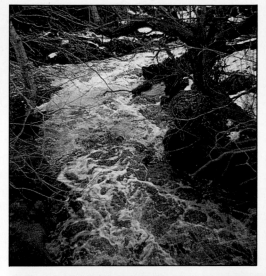

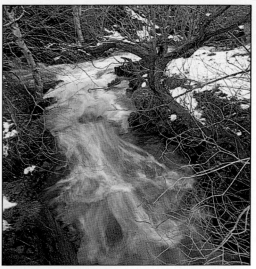

Few people can hold a camera still during an exposure for longer than 1/60second; for such shots it is best to use a tripod. You should acquire a tripod that is reasonably portable, though firm. Small lightweight models are virtually useless in the open. The best all-purpose tripod is made of aluminum alloy and has extending legs and a column on which the camera is mounted. This can be raised and lowered without any adjustment to the legs. The camera mount may be of the ball-and-socket type or the more expensive, but more precise, pan-and-tilt type. With a tripod, you normally use a cable release rather than press the button directly.

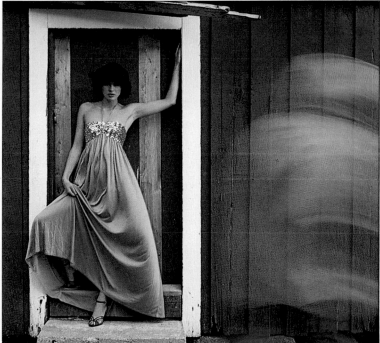

Motion can be arrested or allowed to appear as a blur, according to the choice of shutter speed. In the photograph on the left above, a speed of 1/250 was used and the movement of the stream has been "frozen." Only the pattern of foam on its surface conveys the tumbling motion of the water. In the companion picture, a shutter speed of 1/25 was used, slow enough to reveal the movement of the water, which has now been blurred to resemble layered tufts of softly curling hair.

A ghostly presence was created by using a shutter speed of 1/8. This blurred the yellow jacket of a man walking between the girl and the tripod-mounted camera.

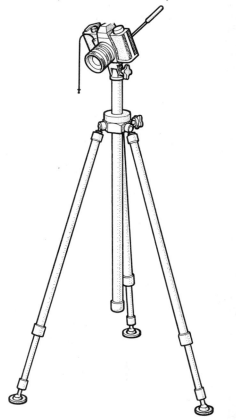

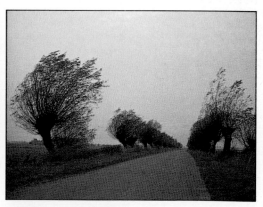

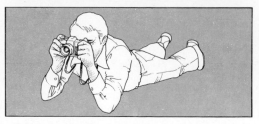

For a really low-angle shot of a subject that is not changing too rapidly, so that your own mobility is not very important, you can lie prone to take the picture. Rest flat on your stomach and splay your legs. Keep your elbows apart for greater stability.

Slow shutter speeds are often required—in situations where there is little light available, where you wish to create blur in a moving subject or where you want to use a small aperture to create a larger depth of field. If there is a suitably placed wall nearby you can reduce camera shake by pressing the base of the camera flat against it.

Bracing yourself against another person can be a useful expedient when there is no other support available. This could prove helpful for a picture like the one above, for example. It was taken in a strong wind that threatened to cause severe camera shake, and there happened to be no nearby walls or posts that I could lean against.

Exploring shutter speed

You can increase your mastery of the camera by studying the effects of a wide range of shutter speeds on many different kinds of subjects. This will teach you what speeds are needed to "freeze" people or objects in motion, how blurring can express movement and when to choose which method. As the pictures below indicate, choice of shutter speed is governed by whether the subject is moving horizontally, diagonally or straight toward the camera and on its distance as well as its speed.

Try taking a sequence of photographs of a moving subject, using different shutter speeds. Keep a note of them and compare the results. To prevent camera shake at slower speeds, you will need a tripod. (If you do not have a tripod, you can make similar experiments with faster-moving subjects such as racing cars or runners.)

The first picture in each row below "stops" the subject's movement. While 1/125 is sufficient to stop the girl when she is walking across the scene, 1/250 is needed when she is riding the bicycle in the same direction.

On the other hand, when the girl is walking toward the camera, in the second row, a shutter speed of 1/30 is sufficient to record her sharply, although motion across the picture would cause

blurring at this shutter speed. In the first picture of the bottom row, where the bicycle is moving at an oblique angle toward the camera, 1/125 is sufficient to stop it.

The effects of the blur introduced in the later pictures of each sequence are worth studying. In the second picture of the top row the blurring of the girl has made her barely recognizable, and the emphasis of the picture is firmly on her surroundings. In the third picture she is more radically blurred—one foot alone retains its solidity. This degree of blurring can be useful in architectural pictures, whether exterior or interior. Blurred figures give scale to their surroundings, and a sense of a living environment, while not distracting attention from the buildings, as human figures tend to do when rendered in detail.

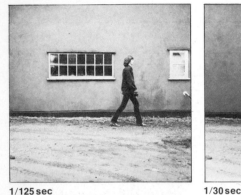
1/125 sec

1/30 sec

1/8 sec

2 sec

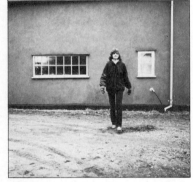
1/30 sec

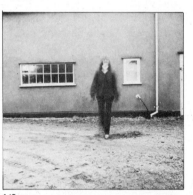
1/15 sec

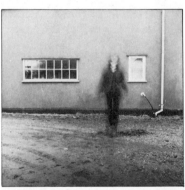
1/8 sec

1/2 sec

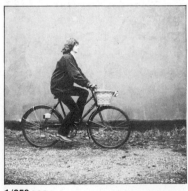
1/250 sec

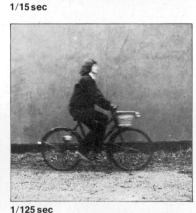
1/125 sec

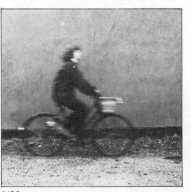
1/30 sec

1/8 sec

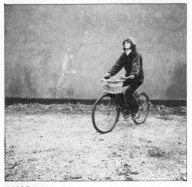
1/125 sec

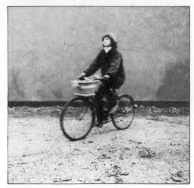
1/60 sec

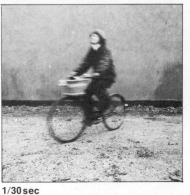
1/30 sec

1/4 sec

If you wish, you can go farther and eliminate human figures altogether. The final picture of the top row was taken with an exposure of two seconds, while the girl walked across the scene. This time there is no trace of her.

The later exposures in the second row produce a curious result: the walker's bobbing movement appears in the blurred image, but there is little sense of her motion toward the camera. The result is intriguing, but less expressive of her movement than the pictures above.

The pictures of the cyclist make clear the degree of control available to the photographer in portraying her speed. She was in fact riding fairly slowly, but she seems to be speeding in most of the pictures.

An interesting effect is apparent when she is moving diagonally toward the camera: the front of the cycle is blurred more strongly than the rear, because it is closer to the camera. This illustrates the fact that the distance of the subject affects the shutter speed you require: the closer the subject, the faster the shutter speed. A table on page 198 gives rough guidance on the shutter speeds you will require in order to obtain sharp pictures of various subjects.

Experience gained from experimenting with a variety of moving subjects will help you to establish in your own mind an idea of the shutter speeds needed to freeze different actions. Then you will be able occasionally to introduce blur in a controlled way, as in the pictures on this page, which have been strengthened by the use of a slow shutter speed.

The ringing of a handbell announces closing time in a public park. I used a shutter speed of 1/30 so that the bell and the keeper's hand would be blurred.

Spray flung aside by the car below is slightly blurred despite the fast shutter speed of 1/500. The car's movement is "frozen," but is clearly expressed by the pattern of movement in the water.

The blurring of the road and trees creates the sense of speed in the bottom picture. I took the photograph at 1/60 from another car, traveling at 50mph (80km/h). At that moment my car went over a slight bump, shaking the camera and causing each detail in the image to double—a frequent hazard that here helps to convey the feeling of the car's headlong rush.

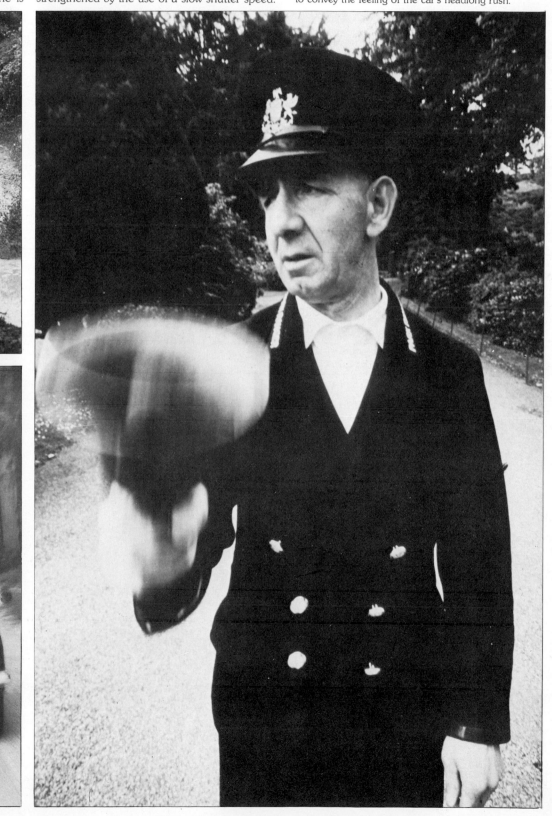

Focal length

Every photographer finds that there are some interesting subjects that he cannot photograph satifactorily, either because he cannot get close enough to show the detail that interests him or because he cannot stand far enough back to include the whole of the scene. The chances of getting the shot you want are much greater if you have a choice of lenses of different *focal lengths*—that is, focusing powers—for they provide different angles of view and image sizes.

The distance from a lens to a sharply focused image depends on the distance of the subject from the camera; the images of nearby subjects are farther behind the lens than those of more distant subjects. The focal length of a simple lens, such as a magnifying glass, is simply the distance from the lens to the sharpest image that it forms of some very distant object.

A camera lens is usually compound (having several elements) and hence has an appreciable thickness. For most compound lens designs the focal length is the distance from the film to a point *inside* the lens, when the lens is focused on infinity—that is, when the lens is closest to the film.

A standard lens for a 35 mm camera (remember that this dimension is the breadth of the film) has a focal length of about 50 mm (two inches). A "long focus" lens for the same film format could have a focal length of, say, 100 mm—that is, it needs a longer lens–film distance in order to form a sharp image, even for distant subjects.

When a long-focus lens is used, not only does the lens–film distance have to be increased to focus the image of a given object; the image of that object is larger than the image that the standard lens would form. In fact the size of the image is proportional to the focal length: the image formed by the 100 mm lens is twice the size of the corresponding image formed by a 50 mm lens. So a long-focus lens gives a close-up effect.

Since the image formed by the 100 mm lens is twice as large, less of it can fit into the film frame. That is, its angle of view (how much of the scene appears in the picture) is reduced.

On the other hand, a lens of, say, 28 mm focal length (just over an inch) will form an image of an object that is about half the size of that formed by the standard lens. The frame includes a great deal more of the object's surroundings.

A zoom lens is simply a lens of variable focal length. It is made up of elements that move relative to each other as well as relative to the film in order to change the focal length while keeping a subject in focus. With many zoom lenses you focus by twisting a focusing ring in the usual way and zoom in and out by a backward and forward sliding motion. The focal length typically ranges from 80 mm to 200 mm.

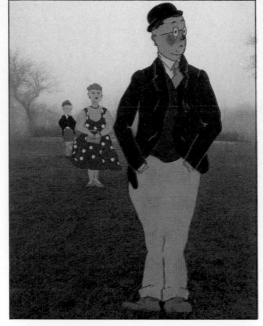

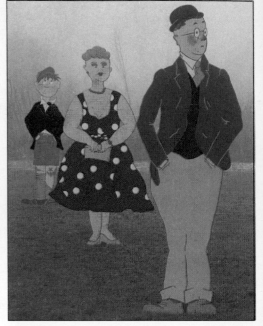

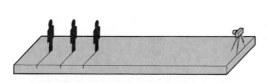

Perspective can be controlled by changes in focal length. The shot above was taken from six feet (two meters) with a 28 mm wide-angle lens. The figures are about the same height in reality, but the man looms large because he is so close. A picture taken with a 100 mm lens from about 20 feet (six meters) shows the man just as big because the increased focal length compensates for his increased distance (top right). But the woman and the boy now seem larger in relation to him. The three figures also seem closer together. Viewing from a distance with a long-focus lens "closes up" perspective; getting close with a wide-angle lens "stretches" it.

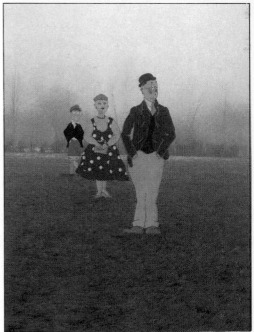

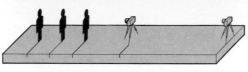

A changing angle of view in the three pictures on the right is provided by lenses of three focal lengths: a 100 mm long-focus lens at the top, a 50 mm standard in the center and a 28 mm wide-angle at the bottom. Although the effect is as if the camera moved back for successive shots, its distance from the subjects was in fact constant—20 feet (six metres) in all cases.

The focal length is the photographer's most important guide to the characteristics of a lens. For subjects that are very distant the lens must be at its closest to the film to form a sharp image on it (below). This closest point establishes the lens's focal length. The image of a nearer object may be acceptably sharp at this lens setting, provided it is not too near; but to form the sharpest possible image the lens has to be moved forward in order to increase the distance between the lens and the film (left).

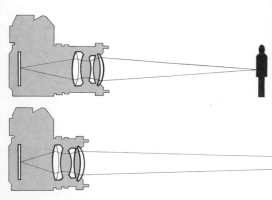

Long-focus lenses in the 35 mm film format have focal lengths of 80 mm and more. Although the term "telephoto" is often applied to almost any long-focus lens, it strictly describes one kind of specially compact construction; a typical example is shown above. The photograph at the left was taken with a 100 mm lens. The camera was 25 feet (7.5 meters) from the figures, which nearly fill the height of the frame. A long-focus lens has only a limited angle of view—24° from corner to corner with a 100 mm lens.

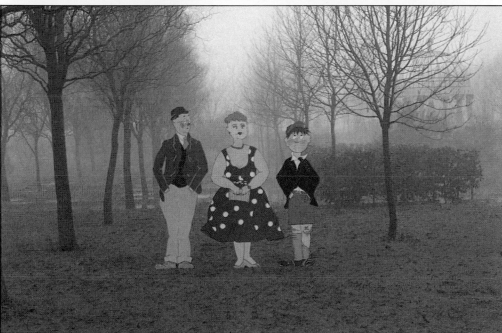

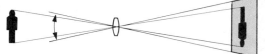

Standard lenses for the 35 mm film format have focal lengths of about 50 mm. Since the image of a distant object is closer to the lens than it would be if formed by the 100 mm lens above, the image is smaller—half the size, in fact. Hence the standard lens can take in more of the subject than the long-focus lens—its angle of view is just over 45° from corner to corner of the picture frame. (See the diagram below.) Although the photograph at the left was taken from the same position as that above, the figures now occupy only about half the frame height.

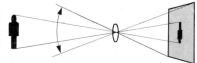

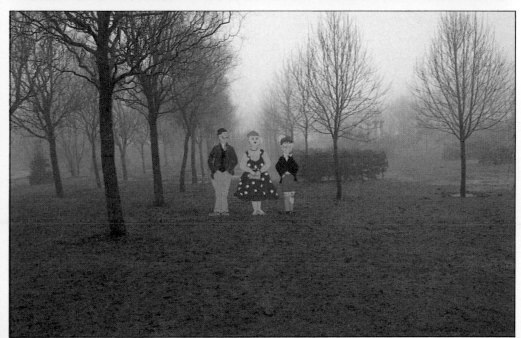

Wide-angled lenses have focal lengths shorter than that of the standard lens. Above is a typical 28 mm lens, which has an angle of view of 75° in the 35 mm film format. A lens of this type was used to take the picture at the left, in which the figures have shrunk to just over a quarter of their size in the top picture. In its corners the picture shows very slight traces of darkening and distortion, which can become more serious in lenses with still wider angles of view.

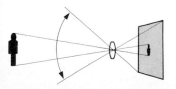

Aperture and depth of field

Unless a camera is fully automatic, the aperture of its lens—the size of the opening through which light passes—is controlled by a ring on the lens mount. By twisting it, you increase or reduce the aperture to brighten or darken the image. In conjunction with the shutter speed, this determines the amount of light the film receives during an exposure. The iris is the most common type of diaphragm. It consists of a number of metal blades that overlap, leaving a polygonal opening. Closing down the diaphragm dims the image.

Apertures are described in terms of f-stops, which are marked on the aperture control ring. These represent fractions of the lens's focal length. An aperture of f8 means that the ratio between the aperture opening and the focal length of the lens is an eighth. At f16 the opening is smaller and the ratio is a sixteenth. The marked aperture stops are arranged in a standard sequence beginning at f2 (or wider on some lenses) and running 2.8, 4, 5.6, 8, 11, 16, 22 (or narrower still). Each stop setting allows through half as much light as the previous one. Many cameras have click settings for half-stops.

The reason why the f-number series is so important is that each change in aperture by one stop can be compensated for by a one-stop change in shutter speed that will keep the exposure constant. If an exposure setting of 1/125 at f8 is correct, an exposure of 1/60 at f11 will also be correct—for it involves exposing the film to an image of *half* the brightness for *twice* the time, so that the film receives the same amount of light. Similarly, 1/250 at f5.6 can be used. In this case, the film is being exposed to an image of twice the brightness for half the time.

The f-number specification of apertures compensates for variations in focal length between different lenses. At a given shutter speed, f8 will give the same exposure with any lens. Some lenses, however, have wider aperture settings than others. With apertures of f1.8, or even wider, they allow faster shutter speeds in poor light and are therefore called "fast lenses."

Varying the aperture has other effects apart from brightening or darkening the image. In particular, it changes the depth of field. This is the area within which objects are acceptably sharp behind and in front of the point you focus on. The depth of field is greater behind than in front of the point of focus. If a standard 50 mm lens is focused on, say, 7 ft and the aperture is f8, everything in the scene from about 5½ ft to 10 ft will be reasonably sharp.

Widening the aperture causes the depth of field to decrease. At f2.8 the same lens will give a depth of field of only 11 in behind and 9 in in front of a subject 7ft away. Conversely, narrowing the aperture increases the depth of field. Learning how to control depth of field by varying the aperture is an important part of photographic technique. If you want a large depth of field it is safest to use a small aperture. But to get enough light this may force you to use a slow shutter speed. For action shots needing a fast shutter, you often have to open the aperture to compensate and keep a careful eye on the depth of field available. Many SLRs enable you to preview the depth of field in the viewfinder by closing down the diaphragm (normally wide open for maximum brightness in viewing the scene) to the selected aperture. Otherwise you must rely on experience or consult the depth of field scale.

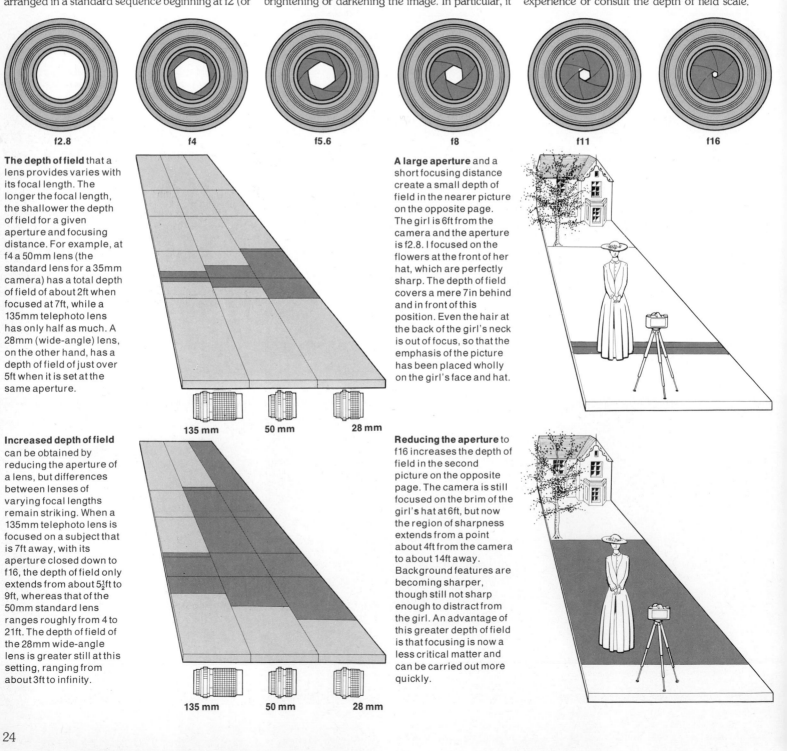

f2.8 f4 f5.6 f8 f11 f16

The depth of field that a lens provides varies with its focal length. The longer the focal length, the shallower the depth of field for a given aperture and focusing distance. For example, at f4 a 50mm lens (the standard lens for a 35mm camera) has a total depth of field of about 2ft when focused at 7ft, while a 135mm telephoto lens has only half as much. A 28mm (wide-angle) lens, on the other hand, has a depth of field of just over 5ft when it is set at the same aperture.

135 mm 50 mm 28 mm

A large aperture and a short focusing distance create a small depth of field in the nearer picture on the opposite page. The girl is 6ft from the camera and the aperture is f2.8. I focused on the flowers at the front of her hat, which are perfectly sharp. The depth of field covers a mere 7in behind and in front of this position. Even the hair at the back of the girl's neck is out of focus, so that the emphasis of the picture has been placed wholly on the girl's face and hat.

Increased depth of field can be obtained by reducing the aperture of a lens, but differences between lenses of varying focal lengths remain striking. When a 135mm telephoto lens is focused on a subject that is 7ft away, with its aperture closed down to f16, the depth of field only extends from about 5½ft to 9ft, whereas that of the 50mm standard lens ranges roughly from 4 to 21ft. The depth of field of the 28mm wide-angle lens is greater still at this setting, ranging from about 3ft to infinity.

135 mm 50 mm 28 mm

Reducing the aperture to f16 increases the depth of field in the second picture on the opposite page. The camera is still focused on the brim of the girl's hat at 6ft, but now the region of sharpness extends from a point about 4ft from the camera to about 14ft away. Background features are becoming sharper, though still not sharp enough to distract from the girl. An advantage of this greater depth of field is that focusing is now a less critical matter and can be carried out more quickly.

The depth of field scale on the lens mount shows that subject distance greatly affects depth of field. Suppose you have focused the camera at 2.5ft (the middle scale on the left), and set an aperture of f8 (the bottom scale). The divisions marked 8 on the depth of field (top) scale indicate the minimum and maximum distances of sharp focus. They show that for this close focusing the depth of field is very small, running from about 2.3ft to 2.7ft—less than 3in behind and in front of the main subject. So focusing must be precise for close-up shots, although the scale also shows that smaller apertures will give a greater depth of field. If the aperture setting is kept at f8, while the lens is refocused at 20ft (below), the scale shows how the depth of field increases. It now ranges from about 11ft to infinity—everything beyond 10ft is sharp. The camera can safely be left on this focus setting if you are shooting at f8 and you are reasonably sure that subjects you encounter will not be closer to the camera than 10ft.

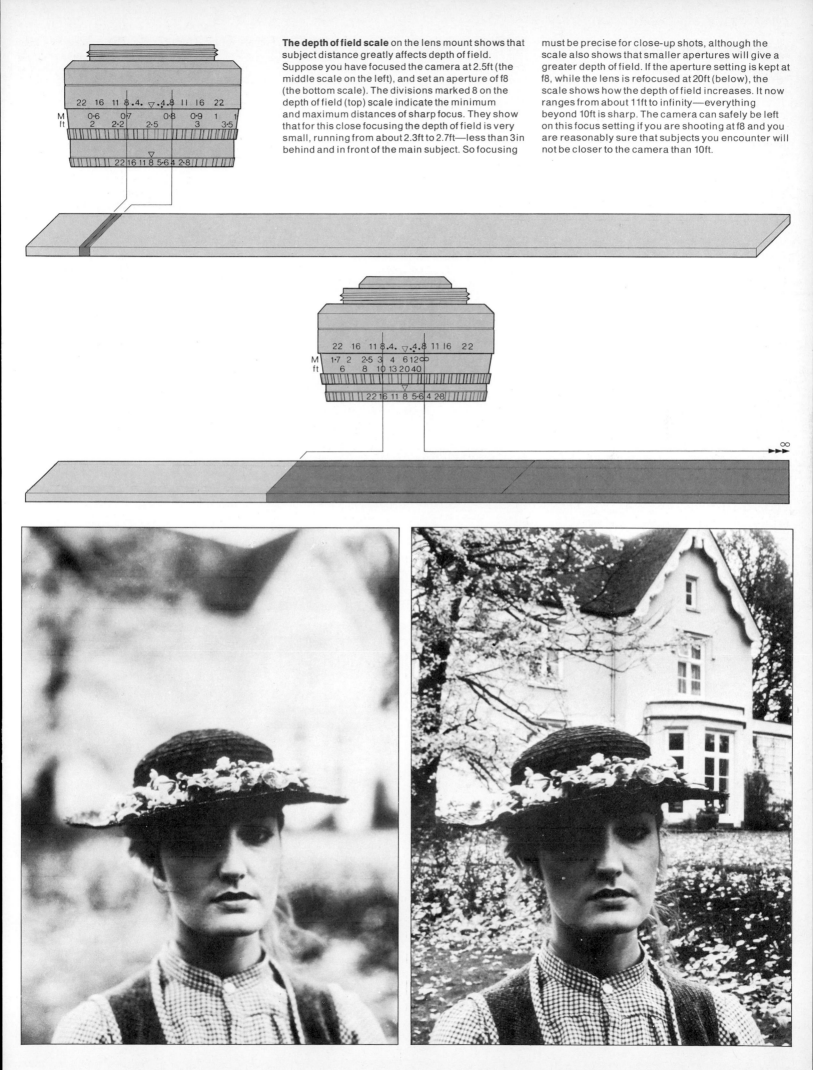

Controlling depth of field

Cultivate the habit of making a conscious decision, before you take any picture, about how sharp you want everything in the viewfinder to be. If the lens, the selected aperture or the subject distance give a limited range of sharpness, you can use any latitude the depth of field allows to focus somewhat farther or nearer than the main subject so that the range of sharpness covers the parts of the scene that most interest you. If the foreground is important, for instance, focus slightly in front of the main subject. On the other hand, you can often effectively isolate a subject from its surroundings by deliberately restricting the depth of field through choice of lens or aperture.

Pillars and a statue, though half-hidden, are the center of interest in the garden picture because foreground and background are blurred by the limited depth of field of a telephoto lens wide open at f4. The effect is of a tangled, mysterious garden.

The avenue of lime trees opposite needed overall sharpness, which I provided with a 28 mm wide-angle lens stopped down to f22. I used a tripod and 2 sec exposure.

The girl in the hammock stands out clearly since background detail has been subdued by blurring. I focused on the girl's eyes—always advisable in a portrait. Since she was only 6ft away and the aperture, f2.8, was large, the depth of field was barely a foot behind her and less in front.

A field of daffodils seems limitless in the first of the views below because the flowers, although sharp nearby and well into the distance, fade ultimately into indistinctness. I used a standard 50 mm lens at f8 and focused on a point about 12 ft away.

A single bloom is isolated in the final picture below. Again using a 50 mm lens at f8, I focused on the outer petals, 2 ft from the camera. The resulting depth of field is so limited that even the top of the flower's "trumpet" is softened.

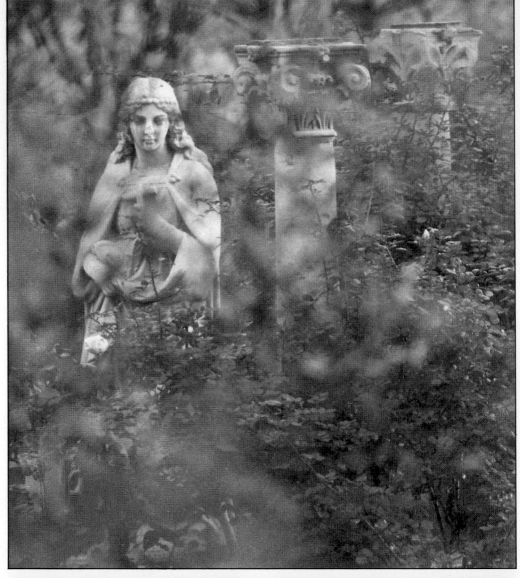

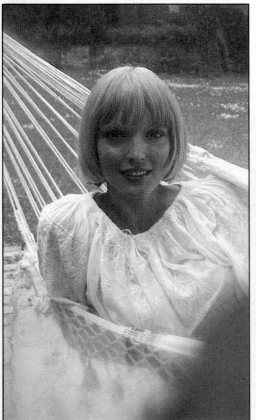

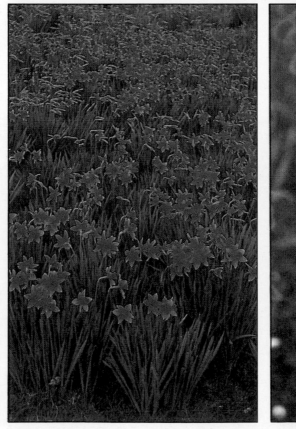

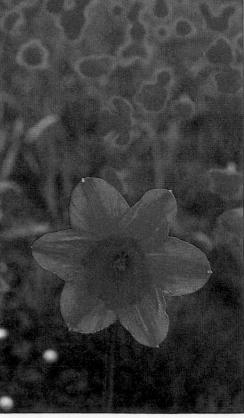

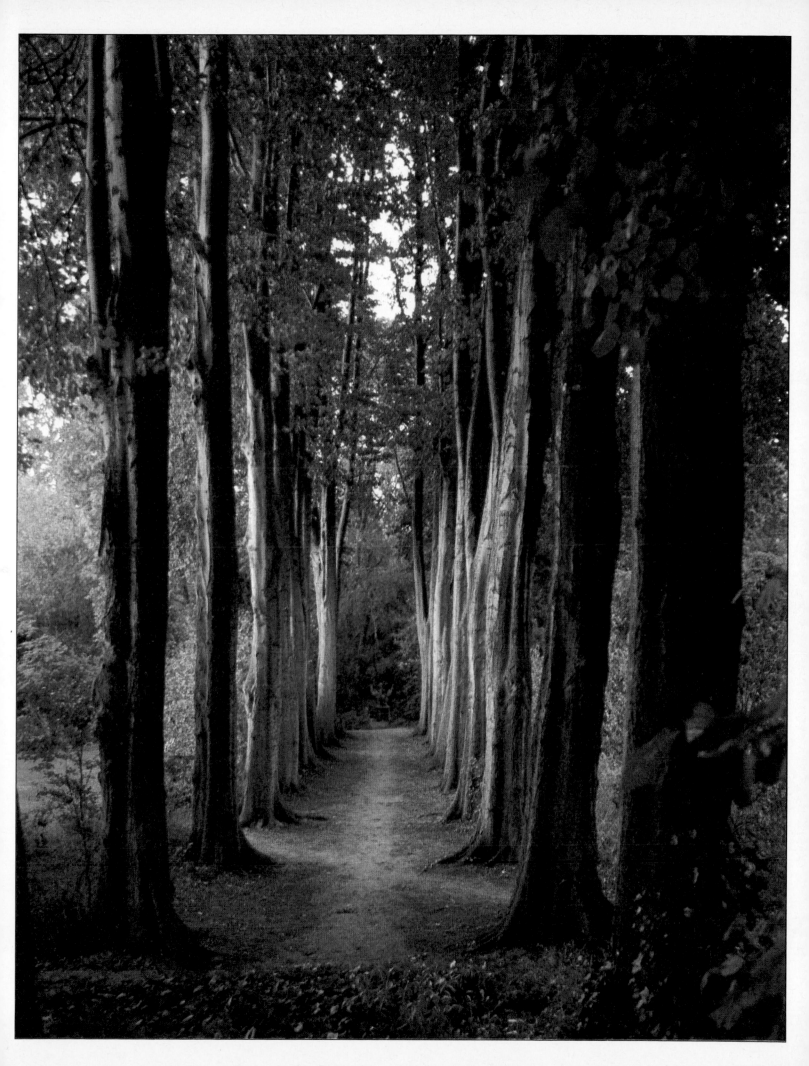

Exposure and light meters

The choice of a correct combination of aperture and shutter speed is crucial, for it determines the amount of light that falls on the film. The photographer's term "exposure" is therefore expressed as a combination of the two factors—f8 at 1/125, for instance. Incorrect exposure is the most common fault in photography, despite advances in automatic exposure control. A camera with a built-in light meter will indicate or select the correct exposure when the lighting is fairly even over the whole area of your subject. But because many scenes are not so straightforward, there is no substitute for judgment and experience in calculating the exposure that will give you the result you want. This is especially so since, as pictures here and on the following pages show, alternative exposures can give acceptable results, depending on which features of a scene you want to emphasize.

Black and white film is forgiving of mistakes in exposure, as you can change the setting by two stops—aperture or shutter speed—in either direction and still get a negative good enough to print from, correcting any deficiencies due to the exposure in the printing process. Color negative film permits much less error, though some correction can be made in printing. Reversal film offers almost no latitude—perhaps half a stop of underexposure in some cases, but no more unless you are seeking a special effect. Because exposure is so critical, therefore, it is essential to know how exposure meters work and how to use them.

Light meters

A light meter is either handheld or built into the camera. It incorporates a light-sensitive cell which may be either of two types. A *selenium* cell generates an electric current, the strength of which depends on the brightness of the light falling on it. A *cadmium sulfide* (CdS) cell is photoresistive: the light changes the electrical resistance of a wire and thus changes the strength of an electric current provided by a battery.

As the CdS meter is more sensitive than the selenium meter for a given size, it is the type preferred for cameras. But it can show appreciable delay in responding to changes in brightness and it requires a battery to enable it to function.

Usually a light reading is taken by pointing the meter at the subject and measuring the brightness of the reflected light. The meter then indicates an exposure that tends to compensate for the natural darkness or lightness of the subject. If you point it at a black, a gray and a white cat in turn, for example, it will indicate successively lower exposures, and separate pictures of the black and white cats taken at those exposures will show them closer to the gray than they really are.

The tendency of light meters to make all subjects of a medium brightness doesn't usually matter since you often *want* to brighten up dark subjects and tone down bright ones. But it is the reason why some photographers prefer to measure the brightness of the incident light—the light falling on the subject. A measurement of the light falling on the hypothetical black, gray and white cats would give the same exposure reading in all three cases, and lead to the pictures showing the cats in their correct shades of lightness and darkness. But this method of metering involves taking the measurement at the subject's position, which is impossible when the subject is inaccessible and is not very practicable with a meter built into the camera.

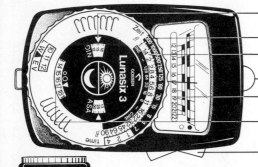

Film speed
Exposure time scale
Aperture scale
Diffuser
Indicator scale
Transfer scale
Brightness range selector

A light meter reading is indicated by a needle (showing 17 above). The transfer scale is rotated to this value and suitable f-number and shutter speed combinations are shown. The diffuser dome is slid over the window for incident light readings.

Reflected light metering is the usual and most convenient way of finding a suitable exposure. The light meter is pointed at the subject and measures the brightness of the light reflected from it. There is a danger of the background or irrelevant light or dark areas being included in the reading. If the meter can be brought up close to the subject a reading can be taken from the exact area that is of main interest. In doing this, be careful not to let the shadow of the meter or your hand fall on the area being measured. If you cannot get close to the subject, measure the highlights and the shadows and take an average.

Incident light metering is in principle the most accurate way of finding the correct exposure. The meter is used close to the subject. A diffuser attachment is positioned over the meter window so that the meter measures light falling on the subject from all directions. The meter has to be pointed toward the camera (here at the right of the subject). This method of taking a reading discounts the reflectivity of the subject. Light and dark parts of the subject are represented correctly in the photograph.

A gray card held in front of the meter can act as a substitute for the subject when you make an exposure measurement by reflected light. Commercially made cards are available. The reading can be made close to the subject, as shown. If that is not feasible, you can make the measurement at the camera position, provided the card is receiving roughly the same light as the subject. You can also take readings from your own hand when the skin tones of people in the scene are the main subject of interest. These methods are useful whenever you want to set your exposure in advance.

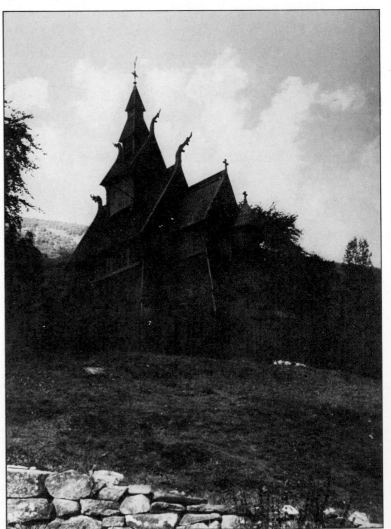

Exposing for the brightest part of the scene plunges the building into gloom in this high-contrast picture. I knew I would not be able to render straightforwardly both this medieval Norwegian church and the bright sky. So for this shot I tilted the camera, which had a built-in meter, to include a large area of sky (roughly the angle indicated on the left). The meter gave a reading of 1/500 at f11 for the film that I was using. The result is successful—a dramatic silhouette. But pictures seeking detail rather than just shape are often ruined by failure to allow for the effect on the meter of a bright background.

Cameras with built-in light meters

Meters built into modern cameras are nearly always coupled to the aperture and shutter speed controls. If the camera is manual, you turn the aperture and shutter speed controls to center a needle displayed in the viewfinder. The exposure is then "correct" for the general area within the viewfinder. An automatic camera will adjust these settings without your intervention, but in advanced models it is always possible to override the automatic setting—and this often may be necessary when you are shooting against the light or if you want to shoot a subject that is out of the ordinary.

An automatic camera can be of the *shutter-priority* type, on which you set the shutter speed and the camera sets the aperture; or the *aperture-priority* type, on which you set the aperture and the camera sets the shutter speed. (Some models can be used either way.) Usually information about the selected exposure is displayed in the viewfinder.

Often built-in meters have a bias toward the center or lower center of the scene. This means that the meter can give incorrect indications for a main subject that is off-center. The meter can also be misleading by taking in light from a field of view larger than that of the taking lens.

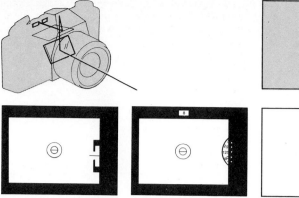

An SLR's built-in meter gives exposure information in the viewfinder. On a manual camera, aperture and shutter speed can be varied until a needle is centered (above left). On one type of automatic camera (above right) you set the aperture according to the depth of field you want; the camera automatically sets the shutter speed for a correct exposure. On other types you set the shutter speed to freeze or blur the subject, and the camera sets the aperture. Programmed cameras set both.

Camera meters don't all measure the brightness of the same parts of the subject. Cameras such as compact 35 mm models have simple meters which measure the light reflected from virtually all of the scene (top left). The main disadvantage of this metering is that when you photograph bright subjects that don't fill the frame, your pictures may be underexposed. To get round this problem, "semi-spot" meters take a reading from the central area only (middle left). The meters of some SLRs are of this type. Most cameras offer the compromise method of central weighting (bottom left).

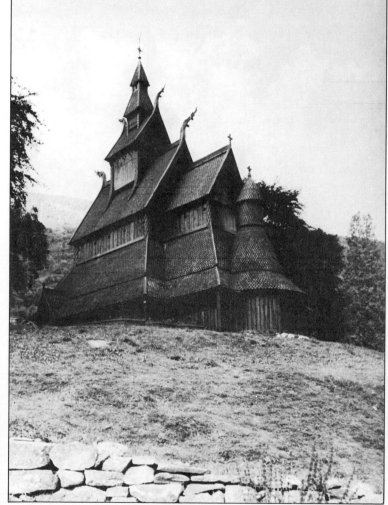

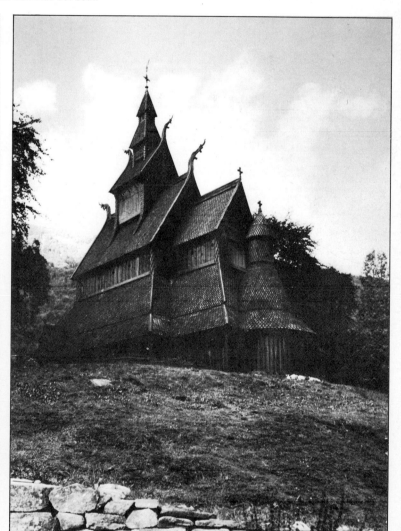

Exposing for the darkest part of the scene causes the rest of the picture to be overexposed when the contrast is high. In this shot my exposure is correct for the church. I had already taken a meter reading from a position where the church filled the viewfinder (diagram) and obtained a reading of 1/125 at f8. The exposure brings out the detail of the roof tiles and the dark, tarred walls, but at the cost of slight overexposure of the grass and more severe overexposure of the stone wall and the sky, where the loss of detail is noticeable. The picture is informative about the church, but it is not balanced.

An intermediate exposure provides the best rendering of the church and its setting. It is necessary to expose the foreground grass accurately in a scene such as this, whereas slightly overexposed sky is acceptable. I took a foreground reading and as a result reduced the exposure from the previous setting by one shutter speed stop, to 1/250. The grass now has a deeper tone and the detail in the stone wall is well brought out. The church is suitably rendered as slightly dark. A setting midway between the highest and the lowest readings is generally best for a high-contrast scene.

Getting the exposure right

By far the greatest problem encountered in judging exposure is presented by high contrast. Be on the lookout for it: a bright sky behind a subject that is in shade; a sunlit subject surrounded by shadows. Often you will simply want to reduce the contrast by changing your viewpoint or moving your subjects.

But when you do photograph a high-contrast scene, first *select the area of main interest* and aim to expose for that. If it is a face, bring your meter (handheld or built into your camera) close to get a direct reading if you can. If you can't, take a reading from your own hand, making sure it is in the same light as the relevant part of the subject. If, for instance, you are photographing a building, outlined against the sky, tilt the meter down by 30° to eliminate the sky while taking your reading.

Usually there is a range of brightness within your main area of interest; *take readings for the highlights and shadows* and use a medium setting.

Finally, remember that a meter tends to compensate for the darkness or lightness of a subject; so if you want to make a dark subject look dark, you will have to reduce the exposure by a stop from that indicated by a meter held close up; and to make snow, say, look bright you will have to increase the exposure by one or two stops from that indicated.

Sunlight and shade can set traps for the photographer. You may place a subject in the shade so that her face is relaxed, as I did (top). If you then expose for the average illumination as registered by a meter, you will overexpose the background and underexpose the subject. I took separate readings of the background and the girl's face for the two shots. (Left: 1/250, f8; right: 1/500, f16; I used Ektachrome 64 reversal film for these and the other pictures here.)

The pale sky before dawn had to appear bright in the picture above. I tilted the camera down by 30° so that the sky would not reduce the reading of its meter (f11, 1/250). In the sunset picture to its right I wanted the sun to burn out slightly, so I increased the exposure by one stop from the direct reading to 1/500 at f22.

Colors are made vivid by the bright sunlight in the left-hand picture of dancers in Singapore. An overall reading would have been falsified by the bright sky behind; so I took a close-up reading of the skin tones in sunlight and took the picture at 1/250 and f16. In the second picture, taken under a canopy, the suffused low-contrast light shows the dancers' faces clearly. The exposure, based on the skin tones, was 1/60 at f8.

Varying exposures affect the richness of color in the sequence below, taken by flash. Underexposure by one stop produces rich colors, while one stop overexposure (f5.6) makes them more delicate.

| f22 | f16 | f11 | f8 |

The faces of a family group were the points of main interest in this contrasty scene of sunshine and shadow, so I took a straightforward close-up reading of skin tones in sunlight and shot at 1/500 and f16.

A blind accordion player in the shade on a sunny evening in Norway makes a scene of low contrast. I wanted to exclude the sunlit patches on the wall from my reading and in fact made an incident light measurement from the subject's position. (1/125, f8.)

An Alpine scene after sunset is almost shadowless, lit uniformly by sky and snow. Since the lights in the windows were too feeble to complicate the exposure, I was able to take a direct meter reading. (1/125, f8.)

Snow scene exposures are always difficult to judge correctly. For the picture above I used the camera's automatic control, which set 1/500 at f16. There is no difficulty in "reading" the picture, but it lacks the brightness of snow. The meter has selected an exposure that renders the dominant tone, the white of the snow, as a medium gray, making the scene look as if it were taken at dusk. I overrode the automatic control to take the picture on the left, increasing the exposure by one stop, to 1/250 at f16. The brightness of the snow, the misty background and the colorful clothing of the skiers are now all truer to the impression that the scene made at the time, and the pervasive mistiness of the day can now be seen against the background of the hut and the trees. No meter could replace human judgment here.

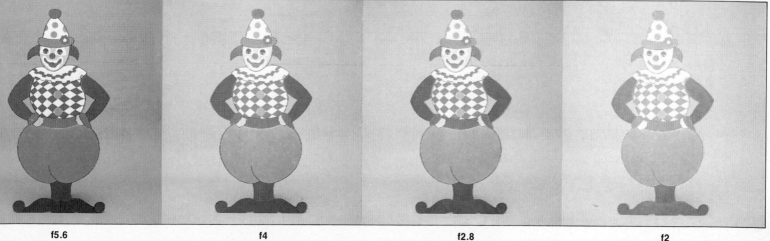

f5.6 f4 f2.8 f2

Exposing for backlit scenes

A scene is harder to photograph when the light is coming from behind the subject than when it is falling on it from the front, for the contrast is then likely to be higher. But such backlighting can often enhance a subject. It can create a halo of light around a figure or a face, and make dramatic contrasts of light and dark.

In backlit portraits it is usually necessary to have reflected light to fill in the shadowed part of the figure that is toward the camera. This makes the contrast more manageable for the film. The simplest kind of reflector to direct light back at the subject is a piece of white cardboard angled at the figure.

You then have the choice of exposing for the darker or the lighter part of the subject. The second and third shots in the top row of the sequence below are close to the metered exposure for the girl's face. The hair becomes a shining halo ("overexposed" seems an inappropriate word, even if technically correct). The darkest shot, on the other hand, though one stop lower in exposure than its neighbor, is effective because it emphasizes the girl's backlit hair and makes it the subject of the picture.

The progressively lighter shots in the sequence demonstrate that relatively overexposed pictures can still be worth while when they suit the subject.

A range of exposures creates striking portraits of a backlit girl and shows that there is no one "right" exposure. (First two pictures: f16, f11 at 1/500; next two: f11, f8 at 1/250; last two: f8, f5.6 at 1/125.) The lowest exposure turns the light on the girl's hair into a feature, while the last of the sequence (like the photograph opposite) makes a high-key picture that is especially flattering to her light complexion.

A translucent shirt diffuses sunlight, helping to provide fill-in light for the girl's face (bottom right). I slightly underexposed her hands and face, at 1/250 and f16, in order to keep them shadowy.

Mingled dust and steam lit up by the sun backlight these horses and riders at a German riding school. I exposed at 1/125 and f8 for the shadowed skin tones.

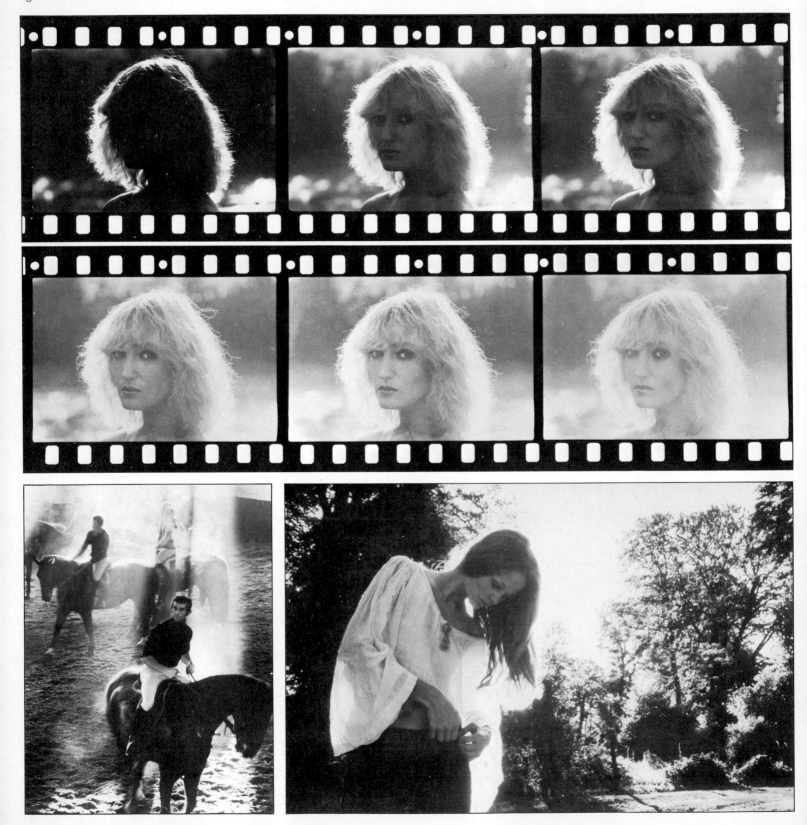

Using under- and overexposure

Color film faithfully records any departure from the textbook exposure for any particular area in a picture. But there is no reason why such variations from the norm cannot be used for the photographer's own purposes. Even "straight" photographs exploit this, by necessity, since film cannot render extreme contrasts as the eye sees them. The flare of the sun in an otherwise correctly exposed sunset, the gloom of shadows in a contrasty street scene—these are instances of "incorrectly" exposed areas of a picture that in fact work to the picture's advantage.

The picture on the opposite page is a full two stops below the exposure indicated by a meter directed at the overall scene. The effect is low-key. But somberness is exactly what I was trying to achieve in the picture, to create a sensuous atmosphere around the reclining girl. The colors of underexposed photographs are more acceptable to the eye than those of overexposed photographs. They in fact become more vivid ("saturated") than in a normal exposure. Very dark tones in the subject will merge into a continuous black, but you can sometimes exploit this effect if much of the background area is dark anyway. The dark hair of the girl in the picture on the opposite page is indistinguishable from the black background, and her face is thus isolated and emphasized.

Whereas the effect of underexposure is generally to produce a picture that is accepted by the eye as a naturalistic rendering of a dark scene, a picture that overall is overexposed is likely to look "unnatural"— yet often highly effective. Overexposure (right) of the girl seen in the normal photograph below makes it look as if she is wearing the white makeup of a clown or mime artist. Notice the contribution made by the dark eyes and mouth in this picture. It is important to include such contrasting "anchor points" to provide relief from the overall tone of an unorthodox exposure.

Underexposure creates the impression of subdued lighting in the picture on the opposite page. Yet it emphasizes the whiteness of the dress and makes the skin colors richer. (f16, 1/125 on Ektachrome 64.)

The masklike appearance of the overexposed face was produced by an exposure of 1/250 at f2.8 (on Ektachrome 64)—four stops more than that used below.

Artificial lighting

Fast films and fast lenses make it possible to take photographs even in very poor light without using any additional equipment. However, to record an adequate image on the film, slow shutter speeds and wide apertures are necessary, and these factors restrict the photographer's control over the final image. Such limitations can be overcome by using some form of extra lighting such as flash or tungsten lamps, which allow greater freedom to work in unfavorable conditions. Small flash attachments are light and easily portable, while with larger, more powerful units you can create almost any lighting arrangement you want. Drawbacks to the bulkier units, however, are that they are inevitably obtrusive, especially if the lighting arrangement is complicated, and they also take time to set up. In addition, there is a danger that in creating "ideal" lighting conditions you will sacrifice much of the atmosphere of the original scene. For certain kinds of photography, therefore, such as reportage, it may be preferable to accept the disadvantages of depending on available light alone.

Nevertheless, on many occasions the advantages of special artificial lighting outweigh any other considerations. The most popular, and also the most versatile, kind of lighting equipment is flash, either in the form of flashbulbs or as electronic flash units. Your choice between the two will depend principally on how often you intend to use such equipment, but in the long run I would recommend electronic flash as being the more economical and the more efficient. Each flashbulb can be used only once, whereas an electronic flash unit can be recharged and will give a virtually unlimited number of flashes.

It is important that the flash is correctly synchronized with the shutter of the camera, so that the flash is triggered when the shutter is fully open. This is because the length of the exposure depends not on the shutter speed but on the duration of the flash. The necessary synchronization is achieved through a special contact on the camera, either in the form of a socket into which is plugged a lead from the flash, or as part of the accessory shoe which holds the flashgun. Some cameras have several synchronization settings for use with different types of flash: "X" indicates a contact socket for use with electronic flash, while "M" is for use with expendable flashbulbs. The reason for these alternatives is that electronic flash is very much briefer than bulb flash (upwards of 1/1000 compared with 1/25 or 1/50).

Some flashguns have their own automatic exposure control: a sensor measures the light reflected from the subject and cuts off the current when sufficient light has been emitted. With less sophisticated equipment, however, exposure has to be calculated from a "guide number" related to the power of the flash unit and a given speed of film. The exposure then depends on two variables: the lens aperture and the distance from the flash to the subject. To calculate the correct aperture, the guide number is divided by the distance from the flash to the subject, and the result is the f-number. Most flashguns have a dial at the back which makes the calculation simpler. For more complicated lighting arrangements, however, possibly involving several flash units, a special flash meter is needed to determine the correct exposure.

Several flashes can be synchronized to fire together. One method is to connect all the units by a series of electrical cables. But most professional photographers mount a photosensitive cell called a slave unit on each flash, which triggers the flash when it detects light from a flashgun that is connected directly to the camera.

A wide range of sophisticated lighting equipment is available to cater for the varied needs of the professional photographer. But as a general rule for the amateur, it is the simplest lighting arrangement that gives the best result. The guiding aim should be to create an effect that seems like natural daylight.

Tungsten lighting

Powerful, mains-operated flash equipment designed for studio work is likely to be too expensive for many amateurs, while a portable flash is not always powerful enough. A cheaper alternative is to use photoflood lamps, which are essentially more powerful versions of the ordinary domestic lightbulb, based on a tungsten filament. Photofloods normally have a life span of only a few hours, and tend to deteriorate with time; tungsten-halogen lamps, on the other hand, are modified filament bulbs which last longer and give more consistent output. Tungsten light is redder in color than daylight or flash, which means that unnatural effects will appear in color pictures if it is combined with the other forms of lighting. Color reversal film has to be specially balanced for tungsten light.

Flash makes photography in dim light simple and convenient. Some cameras have a flash facility built in: on compact cameras, for example, there is usually a pop-up electronic flash. Older cameras, and the cheapest of today's snapshot cameras take expendable flash bulbs in the form of a flash bar or flash cube. Each bulb gives only one flash: you discard the array of bulbs once all have been used. Few SLRs have built-in flash—you have to buy an accessory unit like one of those shown here. The smaller units fit into the camera's accessory shoe, but more powerful flash guns are too heavy for this, and must be mounted on a bracket alongside the camera. To avoid harsh shadows, some units tilt and swivel, so that the light can be bounced.

A simple lighting set-up consists of two flash units on stands. The main unit is controlled by a light-sensitive cell. This is triggered by the fill-in light from the secondary unit, connected to the camera by a sync lead. The fill-in light is softened by being bounced off an angled white card.

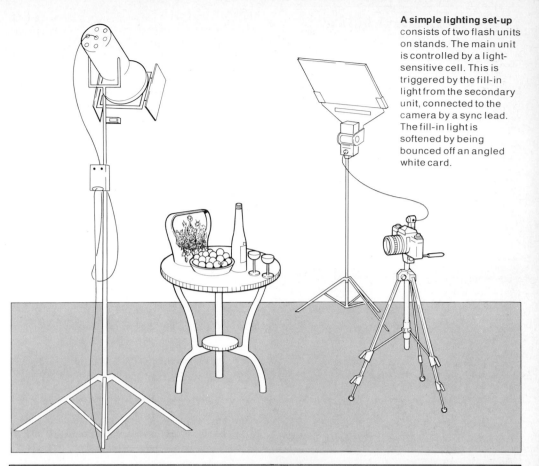

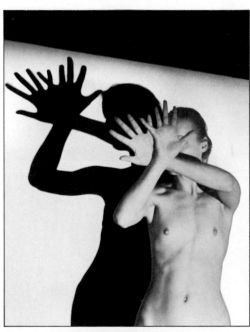

The dramatic pose of the girl produces a harsh shadow with a sharp outline caused by a point source of light from a slide projector; the projector lenses focus the light into a concentrated spotlight that can be used to create theatrical effects.

The portrait of a girl was obtained with a diffused flash above her head to the right, and with reflectors to fill in the shadows. The photograph demonstrates how a single light source can be used to give the effect of full modeling.

The bleak hospital corridor was lit by a single bulb, which provided sufficient light for this photograph. I preset the exposure and prefocused the lens to avoid attracting the attention of the woman offering comfort and protection to her child. The somber mood of this scene has been enhanced by the use of nothing more than dim available light.

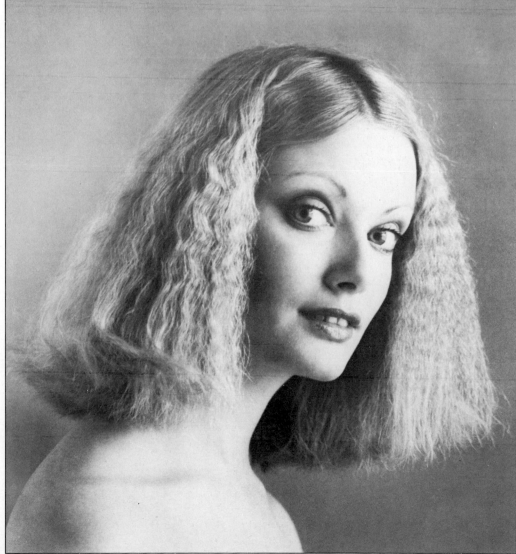

Using flash lighting

Flash has a wide variety of applications, not only indoors but outside as well, so it is worth learning to use it well. Cameras are usually constructed so that when a flashgun is attached to the accessory shoe, the flash points directly toward the subject along the main axis of the lens. But this is generally the worst position for flash, creating harsh, flat lighting in the foreground and leaving the background in complete darkness, because the flash is not powerful enough to reach it. Furthermore, light from a flash at close proximity to the lens axis is reflected back from the eyes of people in the photograph, producing an unnatural-looking effect known as "red-eye." The retina at the back of the eye is rich in blood vessels, which give the reflection its red appearance. Provided the direction of the flash is not fixed, as it is on some pocket cameras, "red-eye" can easily be eliminated by aiming the flash at a reflector or bouncing the light off a ceiling or wall so that it reaches the subject indirectly. At the same time, this technique of bouncing flash diffuses the light so that it is no longer harsh, and does not produce the same stark contrast between shadow and highlights. When you calculate the exposure for bounced flash, remember that the total distance traveled by the light from the flash to the subject will have increased and that you will have to widen the aperture to compensate. Depending on the distance and the reflectiveness of the surface used, an exposure increase of at least a stop will be needed.

Most difficulties with flash arise because you cannot easily judge what the fall of light and shade will be on the subject, except by experience. Large studio flash units sometimes have additional modeling lights, to show the approximate effect in advance. Alternatively, professionals use instant picture cameras with flash to check the lighting before taking the final picture. But if unsure or inexperienced, experiment with different lighting angles and bracketing exposures one stop on either side of the aperture you consider correct.

Flash is especially useful as a means of supplementing daylight. The two combine well even on color film because electronic flash is the same color temperature as normal daylight, and therefore does not introduce unwanted color casts. By using flash to fill in shadow areas in the main subject, you can prevent them becoming too dark. Fill-in flash enables you to avoid the effect of a silhouette in shots taken against the light. To calculate the correct exposure for a picture combining flash and daylight

A vivid example of "red-eye" gives the horse on the left an almost supernatural appearance: like many photographic "faults," red-eye can occasionally be used to good effect. Similarly, this picture turns to advantage the short range of a simple flash aimed directly at the subject: the confusion of the background has been simplified by being left in shadow.

Shooting against the light has produced a silhouette effect in the picture of a girl jumping in the air. To bring out more detail in the shadows, I used a fill-in flash for the second picture. The same technique was used in the photograph of a boy riding a bicycle, taken early in the morning. In both these pictures, movement was frozen by the high speed of the flash rather than by using a fast shutter speed.

A room lit by chandeliers, seen on the opposite page, was photographed using flash, on color film balanced for daylight. The first picture, in which the room appears in almost total darkness, was taken at an aperture of f16, as calculated from the guide number of the flash and its distance from the girl. The shutter speed of 1/60 has picked up little other light. For the next picture, I took a light reading from the chandelier, which indicated a shutter speed of 1/15 as giving the correct exposure at f16. For the final shot, I slowed down the shutter to 1/4 sec, retained the same aperture and used a second flash, aimed at the back of the room, to illuminate the background.

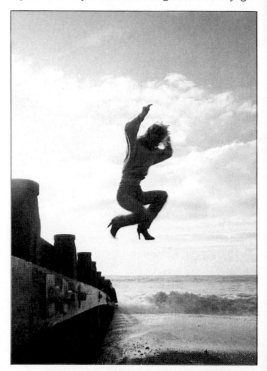

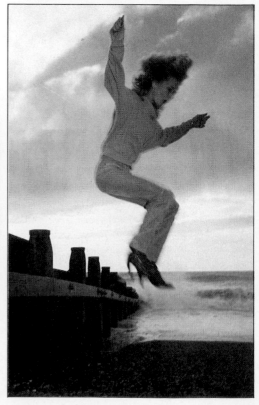

estimate the distance from the flash to the main subject and work out the appropriate aperture as if you were using flash alone; but reduce the aperture by half a stop or more to allow for the ambient light, and avoid making the areas covered by the flash too bright in relation to the rest of the picture. With the aperture fixed, select the appropriate shutter speed by taking a reading of the background. This gives the correct exposure for the whole picture.

A similar technique can be used indoors when the problem is not that there are shadows on the subject, but that the background is too dark. The procedure is essentially the same as before, except that only a small allowance need be made for ambient light. By selecting a relatively long exposure time, based on a light reading from the room, it is possible to combine flash with the weaker light from the ordinary lighting and create an effect that looks more natural than flash alone.

Light intensity decreases with distance from the source, as the photograph illustrates. The brightness decreases according to the inverse square law: if the distance from the source is doubled, then an area four times the size of the original area will have to share the same amount of light. It will therefore be only a quarter as bright and will require four times as much exposure.

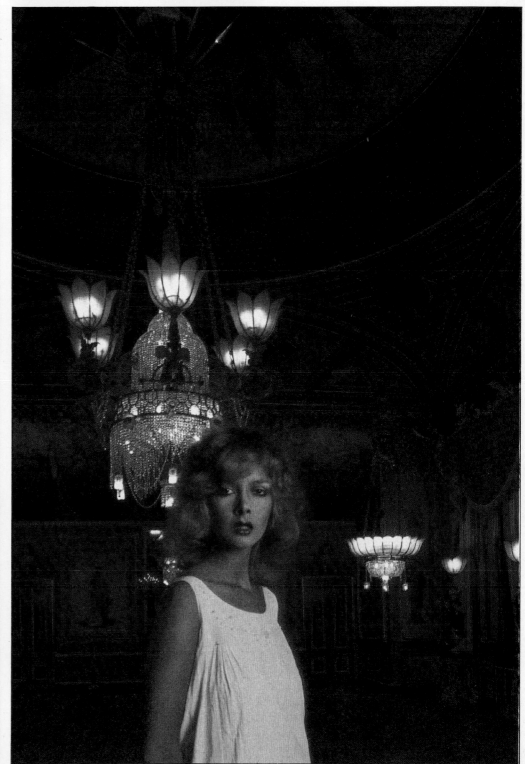

Exploring lighting arrangements

Lighting arrangements for portraiture are the same in principle as for any other kind of subject. It is an important basic rule for all artificial lighting that individual features or objects in the pictures should appear to receive their main illumination from a single direction—in other words, the shadows should not give contradictory information about the relative position of the main source of light. This does not mean that you have to restrict yourself to a single light source, but that any additional lights must be subordinated to the main one. This is a general principle that holds good in portraits no less than in, say, still life photographs; if it is ignored, the results will look perplexing and unnatural, as though several different pictures have been cut up and the pieces reassembled.

Nearly all the portraits shown on this page were taken using a single lamp and a reflector; good results in portrait lighting can be obtained without elaborate equipment, and as this sequence of pictures demonstrates, one lamp is quite sufficient for most portraits. A second light would be useful only if you felt it necessary to provide extra fill-in or background light.

Hard and soft lighting

The first decision you need to make when setting up your lights is whether the subject requires hard or soft illumination. Hard lighting produces a greater contrast between the highlights and shadows, giving sharper outlines and coarser textures. Soft light, on the other hand, is generally more suitable when you want to create a gentler appearance, with delicate modeling and smooth textures. For example, when you want to emphasize the dramatic or forceful element of a sitter's personality, the stronger image produced by using hard light will probably be better suited to the overall feeling of the photograph. By comparison, the delicate skin of a child would usually be rendered better in a soft reflected light. However, be prepared to experiment: there are no fixed rules about hard and soft light, and in any case the effect you want will not depend wholly on the lighting.

To produce hard light, simply point the lamp or flash directly at the subject; to produce soft light you can use one of several methods to diffuse or scatter the light, depending on exactly what effect you want. One method is to cover the front of the lamp with some diffusing material, such as tracing paper or fine white cloth; another is to bounce the light off walls or specially positioned screens. If you are working in color, make sure that the reflective surface you use, is not strongly colored, or it will

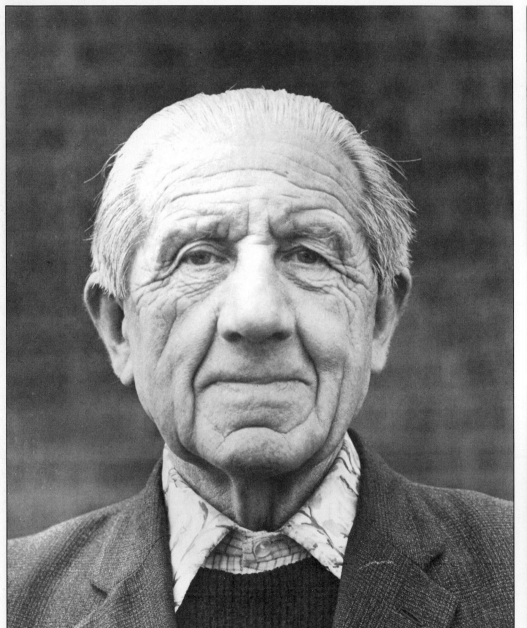

The basic lighting positions useful in portrait photography are covered in this sequence of nine pictures, mostly using a single light source. Starting with frontal light, I moved the light round the subject in a semicircle. For the first arrangement, the effects of hard and soft light are shown. The portraits show how a subject can be presented simply or dramatically, and demonstrate the importance of background and lighting in conveying atmosphere.

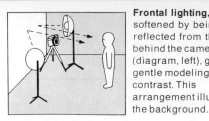

Frontal lighting, softened by being reflected from the wall behind the camera (diagram, left), gives gentle modeling with low contrast. This arrangement illuminates the background.

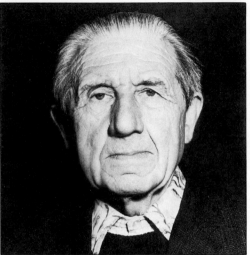

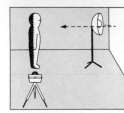

Hard frontal light from a spotlight aimed directly at the subject makes a more contrasty image than before, but with greater impact. The light emphasizes the shape of the face and the texture of the skin.

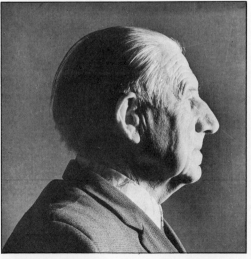

Facing into softened light reflected from the wall on one side of the camera, the subject's features are easy to "read." The head is now more gently modeled and emerges from a dark background.

introduce an unwanted color cast. Alternatively, you can use lamps with shallow reflectors and shielded bulbs, which cast the light over a wide area instead of concentrating it into a strongly directional beam. For flash lighting, the most usual version of this diffusion reflector is a white umbrella with a white or silvered inner surface (or a combination of both), which acts as a dish; the flash is directed into the concave side of the umbrella and is reflected back at the subject. The resulting light is much softer than that given by pointing flash directly at the subject. However, these umbrellas usually form part of a rather expensive lighting system, employing powerful mains-operated flash units, which are likely to be beyond the price range of most amateur photographers.

Reflecting screens, which are generally either plain white or covered with metal foil, are extremely useful studio accessories. They can be easily moved to provide surfaces from which to bounce light, particularly when you want to fill in the shadows

without introducing additional lights. Reflectors specially designed for this purpose are available commercially, or they can readily be improvised from sheets of white card or ordinary aluminum foil.

When setting up the lights, do not forget to consider the comfort of your sitter. One of the many advantages of flash over tungsten is that it does not generate heat, which can make people uncomfortable if they have to sit under the lights for any length of time. Never crowd your subject with equipment so that he feels cramped. Partly for the same reason it is better to use a lens of slightly longer focal length than normal when you are doing portrait work, since a long lens will enable you to work at a reasonable distance. More importantly, a wide-angle or standard lens will give some distortion in close-up frontal portraits, making the nose look bigger and causing the forehead and chin to recede, as if the face were reflected in the back of a spoon. Longer-than-normal lenses tend to give more flattering results.

The shape of the reflector helps to determine the quality of the light. A shallow dish, such as that seen at the top, gives a soft diffused light suitable for filling in shadows; the cap shields direct light from the bulb. A spot reflector, shown at the bottom, focuses the light into a narrower, more concentrated beam, to provide hard lighting. For general purposes the reflector shown in the center gives a directional light with softer illumination than from a spotlight.

A lamp placed 45° off-center and slightly above the subject's head has created shadow on one side of the face, partly filled in by reflected light providing good modeling and skin texture.

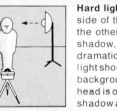

Hard lighting from one side of the face leaves the other side in shadow, creating a dramatic image. Some light should reach the background so that the head is outlined in the shadow area.

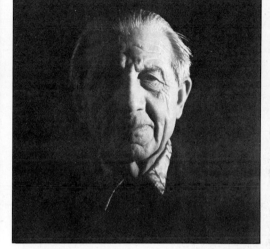

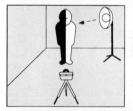

A single source just behind the subject lights one side of his face, while the other is faintly illuminated by reflected light. The sitter's shoulders merge with the background drawing attention to the face.

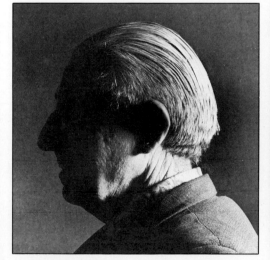

Lit from behind, the head becomes enigmatic. The light is bounced from the wall, and some of it spills onto the background, making the profile into a silhouette with shape providing the interest.

Facing a hard, direct light from the camera's right, with no fill-in light on the back of the head, the subject's features and profile stand out starkly against the complete darkness of the background.

Rim lighting outlines the profile in light. The light source is placed beyond the subject; the near side of the head could be left in deep shadow, but reflectors were used here to provide some shadow detail.

Freezing movement with flash

Electronic flash has an extremely short duration, usually lasting less than two milliseconds. Bulb flash, by comparison, takes time to reach its maximum level of brightness and then dies away gradually. As a result of its almost instantaneous peak of brightness and equally sudden falloff, electronic flash provides a means of freezing extremely rapid movement on film.

Because it is the speed of the flash that determines the exposure, you do not need a camera with fast shutter speeds to take photographs like those on this page. It is necessary simply to have a shutter that can be synchronized with electronic flash, which is possible on most present-day cameras. When photographed at ultrahigh speeds, many ordinary things acquire an unfamiliar appearance—the puttylike substance in these photographs is milk, slightly colored with milkshake powder to help it stand out. I took the pictures using the arrangement shown in the diagram. The main flash was directed at a white screen behind the bowl in order to silhouette the shape, and a second flash was bounced onto the bowl from a reflector at the front. At a given signal, an assistant dropped the balls (colored ping-pong balls) into the milk to create the splash.

What makes this kind of photography so interesting is that it enables you to see perfectly familiar events with a clarity and detail that are never apparent to the naked eye. Liquids, deprived of their movement in midair, are particularly intriguing subjects, frozen into unpredictable shapes and deceptive textures. You can extend the range of a fairly simple camera by using it to explore high-speed action of all kinds from splintering wood to whirling machinery.

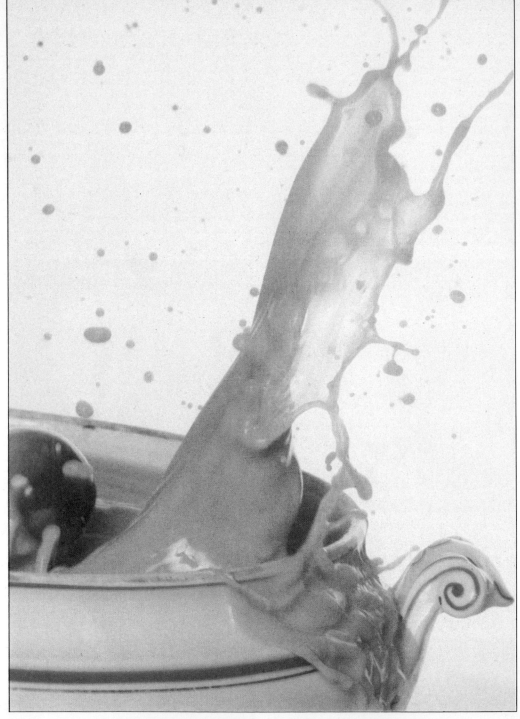

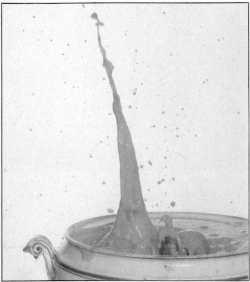

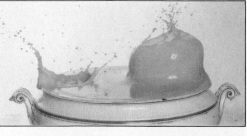

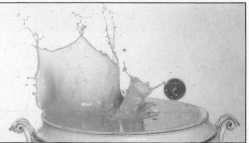

BUILDING
THE PICTURE

The examples and comparisons on the following pages will
help you to compose pictures with a trained eye. Being aware
of scale and perspective, shape and form, tone and color,
pattern and texture, enables you to *see* better photographs.

Building the picture
The range of choice

Learning to operate the controls of a camera involves only the mechanical side of taking pictures and tells us nothing about what to take. In turning to the more creative aspects of photography, the first thing to remember is that the selection of a subject is only a starting point. It leaves open a whole range of choices that will affect the picture's final impact.

Look at the picture above, for instance: a family group in Norwegian national dress, lined up outside their house in the way that most group photographs are arranged. On the page opposite is a series of photographs taken at the same time and within a few steps of the house. Scores of other arrangements would have been possible, without introducing any new elements into what is essentially a straightforward record of the family and their costumes. Even the simplest scene offers you limitless opportunities to organize the picture in the viewfinder, either by arranging the subject or by moving the camera to see the subject from a different angle. How, then, do you decide on the most effective way to set up the picture?

It is much easier to compose an effective picture if you have a dominant reason for taking it. Your aim can then be to organize the elements in the scene in such a way that everything supports this main theme—or at least does not conflict with it. A good photograph does not attempt to make too many statements at one time.

So you should begin by asking yourself what the picture is trying to convey. In a landscape, for example, is there a single feature you wa t to emphasize or is it the overall view that counts? Is the predominant mood one of grandeur, bleakness or sheltered security? Are you attracted mainly by the pattern in a scene, by the textures of things or by their shapes and colors?

In many descriptive pictures, of course, the center of interest is obvious. Yet even in photographing a group such as the Norwegian family there are different approaches to consider. Is it their faces that interest you or the detail of their clothing, their mood or their environment, their individual expressions or their family relationships? The limitation of the picture above is that it takes no particular approach to the group and hence lacks the impact that brings a picture alive. The following pages discuss the ways in which viewpoint and composition of the subject can give this kind of strength.

Organization

The reason for trying to organize a picture so that it makes a single statement will become clearer if you think about the differences between the human eye and the camera. When we look at any scene we tend to concentrate on what interests us and ignore the detail that does not seem relevant. The stronger the point of interest the less we are aware of what surrounds it, so that if we are walking through a crowd toward a friend the faces of other people may pass quite unnoticed. The camera, however, records the entire scene quite indiscriminately. This is why beginners are often surprised to find unwanted detail intruding into their pictures—power lines bisecting a landscape or a disembodied arm in the foreground of a picture of a group of their friends. They had not noticed these elements of the scene at the time because they were concentrating on the main point of interest.

The single-mindedness of the eye is something the photographer must deliberately impose on the picture by selective focusing or by shifting the camera's viewpoint so that extraneous detail is excluded, blurred, masked or subordinated to the overall design. To be able to do this, you must learn to see as the camera does.

In taking a picture of a group of friends, for instance, it is not enough simply to look at them and make sure they are all in the frame and that nobody's eyes are shut. Having arranged the group in roughly the right position, look through the viewfinder at the whole picture area, ignoring your friends for the moment and examining their surroundings. Remember particularly that the three-dimensional scene will be reproduced in only two dimensions on the film and that a post or tree some distance behind the group may therefore appear, in the picture, to be joined onto one of your friends like an extra limb. Try to look at other objects in the scene in terms of shapes, patterns, textures, tones or colors to see whether they harmonize with the subject or conflict with it. A strongly patterned or colored wall behind a group is unlikely to help the picture, for instance. If your aim is to take a descriptive shot rather than one that tells a story it is better to look for a sympathetic background, fairly neutral in tone and color. Once you have got the setting right, either by shifting your camera position or repositioning your friends, you can concentrate on their expressions while keeping a watchful eye on the background.

Order and rhythm
Your aim should be a picture that combines *order* and *rhythm*. Most people have a natural sense of order and can see when colors, shapes or tones are distributed so that strength in one area of the picture is balanced in another. Rhythm is the more subtle quality of a picture that draws in the eye and links up the various elements harmoniously.

A picture's formal strength often derives from the relation of its elements to the frame's *thirds*—the imaginary lines dividing it horizontally and vertically into three equal parts. Pictures that have a clearly discernible foreground, middle distance and background are often especially effective if these areas form thirds. An intersection between vertical and horizontal thirds is a good position for the main point of interest. From here the eye can be taken on through the picture area by leading lines and curves or by subsidiary points of interest. The pictures opposite show how rhythm can be introduced even into a rather formal group portrait. Although these combine many compositional elements, a particular aspect is singled out for analysis in each case.

The girl's eyes have been made the point of interest in the picture above by their positioning on an intersection of thirds and by the strong leading lines of the mother's cap and the top of the rock. The girl's head rising above the rock avoids too rigid a division of the picture and the strong red of the boy's jacket is balanced by being reduced in scale and offset by the green of the tree. A neutral-colored background links the three figures, suggests the ruggedness of their environment and also provides plenty of depth as the eye is carried back with the fading blues in the distant mountains (an effect called aerial perspective). The muted color is also well suited to displaying the group's costumes.

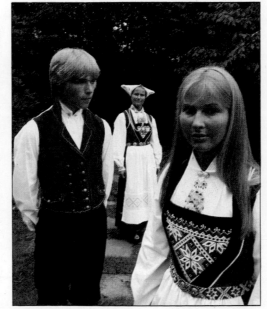

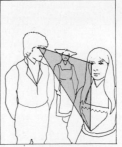

A triangular composition, repeating the many triangles in the costumes, is used here to join mother, son and daughter in a picture that helps to suggest their family relationships. Centrally placed and looking at the camera, the mother is dominant, but the angle of her head and cap links the boy's gaze with his sister's face. Attention then falls to the girl's costume and returns to the boy's vivid jacket. I stood on a step so that the girl, closest to the camera, would not fill too much of the frame. The foliage, light at the sides of the picture and receding to darker hues at the center, helps to accentuate the depth of the grouping. The picture gains from the tightness of the grouping in the frame.

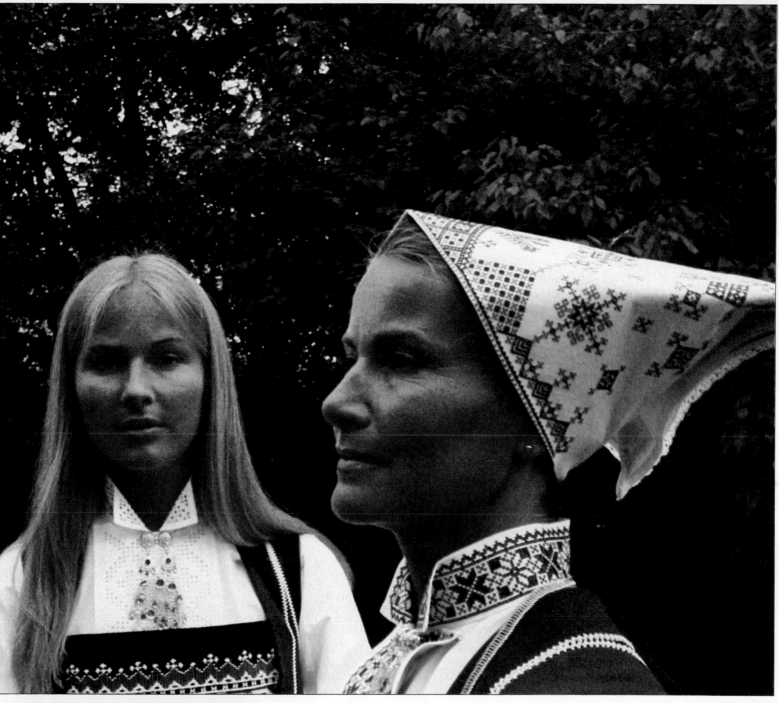

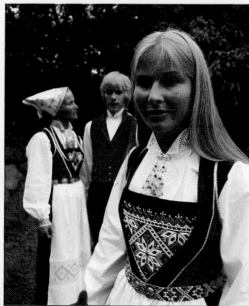

Overlapping forms and diminishing scale are two ways of giving depth to a picture and there is no reason why they should not be used in a group portrait. Many photographers feel they must show everyone at the same scale and include the whole of each figure. The angle of view of the icture on the left enables the pattern and texture of the girl's costume to be seen in sharp detail. Yet the central red and the mother's strong profile provide a balance, and the top of the girl's bodice leads the eye to the smaller figures. I focused on the girl's eyes, but there is acceptable depth of field, since I used an aperture setting of f8.

Order and rhythm are well balanced in this picture. The line of movement travels from the boy's eyes to his mother's in a strong diagonal and then on to the girl, who carries it directly forward to the camera. There is no one dominant point of interest and the expressions are placid, so that it is only the strength of the composition that balances the rich decoration of the clothes. Elaborate costumes like these could easily overpower the whole picture. But as it is, the link between the eyes is the strongest element. The group is very conscious of the camera, but it is an undisguised awareness. They are clearly proud of their national dress, immaculately presented. Now look back at the picture on a previous page of the group lined up outside their house to see how much interest has been added by simple changes of position and the alternation of frontal and profile views, as well as the use of elements of the landscape as background.

Concentrating the interest

The more complicated your subject, the more vital it becomes to select a viewpoint and an angle of view that will clarify the picture and convey the impression you want to give. Whenever you take a photograph, you should ask yourself what point you are trying to make, and try to analyze your intentions consciously rather than leaving such matters to chance or intuition. You can often strengthen a picture by moving in closer to the subject or by using a lens of longer focal length. Although you could achieve much the same effect by cropping the image later, it is preferable to eliminate unnecessary details from the start. An untidy background can often be avoided completely by aiming the camera downward from a high viewpoint, while a slight upward tilt can cut out an uninteresting foreground. The majority of photographs are taken at eye level, not because this is the best position but because with most cameras it is the easiest to adopt. Vary the angle from which you take your photographs as much as possible so that you acquire a feel for the less conventional alternatives. Cameras with waist-level viewfinders, such as twin-lens reflexes and large-format single-lens reflexes, have an advantage in this respect, since they can comfortably be held anywhere between ground level and at arms' length above your head.

Because the camera tends to exaggerate the proportions of the part of the subject closest to the lens, the foreshortening produced by photographing from an unusual angle may appear distorted, particularly when you are using a wide-angle lens. In some circumstances, this distortion is undesirable, but often it can be exploited deliberately.

It is easy to forget how important certain details can be in giving a photograph its scale and context, and you should therefore concentrate on the image as it appears in your viewfinder to make sure that you do not leave out anything crucial. Do not assume, for example, that the size of the subject will be evident unless you have deliberately included in the picture something with which it can be compared. For instance, you can often indicate scale by including some figures in the picture. You may, of course, choose to change the whole emphasis and meaning of a scene by selecting only specific details.

Massed deckchairs, ornate ironwork and glass, and a glimpse of the distant Blackpool Tower make a picture lacking a focal point, below. But I had only to turn and lower my angle of view slightly to take the picture on the right. This not only excludes conflicting detail but now shows a strong pattern consisting of the parallels formed by the receding lines of chairs, balanced by the eye-catching newspaper in the foreground. While the picture below shows many holiday-makers absorbed in their reading, the second gains interest by concentrating on just one of them and showing us what is occupying his thoughts.

A swimming pool setting and an escort of lifeguards make these portraits of a holiday camp beauty queen entertaining and striking. But though the eye is immediately caught by the tight foreground grouping in the picture below, taken from the pool's side, it soon wanders to the background detail. By climbing up to a diving board I got a high-angle view of the figures that enabled me to exclude all background except the relatively featureless water. I moved the men back a few yards to fill the increased picture depth now available and to give the girl more prominence. The resulting picture, seen on the right, is a far more forceful portrait.

The modern bungalow spoiled the view of this country church as seen from the road where I stopped my car. The road itself provided a relatively large expanse of uninteresting foreground and, like the bungalow, distracts from the principal theme of the church in its rural setting. However, by moving a short distance away from the main road, I was able to frame the church through some trees, which conveniently masked the unwanted part of the background, and provided a much more suitable setting for the kind of photograph I wanted to take. On some occasions, however, you may wish to avoid emphasizing the picturesque elements of a scene like this, and instead of concealing the modern building, you might take the juxtaposition of contrasting styles of architecture as the subject of your photograph.

The curved porch of a house in Ironbridge, Shropshire, England, prompted me to take the photograph shown below. Then, chatting to the owner, I learned that he was a coracle maker. For the photograph on the right, I moved in closer and placed the man, a coracle on his back, where he would hide the distracting window lintel and make a striking portrait. The curved lines of the coracle are echoed in the semicircular arch of the doorway, and the shape is repeated in the grass roller, seen in the background. From this angle, no clue is provided as to the scale of the house, and because the door is rather large in proportion to the rest of the building, this picture gives the impression that the house is bigger than it actually is. It was pure luck that when the cat walked into the scene, it decided to sit in the doorway, thereby taking up the ideal position in the composition.

Changing the viewpoint

When you notice something that appeals to you, your instinctive reaction should be to photograph it on the spot, from the best camera position you can establish quickly: if the light changes, or the subject moves away, you may lose the opportunity altogether. However, the first shot is unlikely to be right in every detail, and your next step should therefore be to analyze your initial reaction and try to identify the particular quality that made the subject interesting. Decide whether there are any irrelevant or distracting elements that could be excluded or made less prominent by taking up an altogether different camera position. By experimenting with various viewpoints you may find you can bring out the essence of the subject more vividly. Thinking critically about what you see is a vital part of this exploratory process.

The photographs on this page were taken within a few hundred yards of each other. Though this required rather more tramping around than most casual visitors with a camera would bother to undertake, it was worthwhile for the number of different aspects I was able to show of the mills and their purpose—which was not to grind corn but to pump water.

Three squat Dutch windmills are studied from a variety of viewpoints here. The pictures at the top and bottom center of this page show the powerful yet graceful bulk of the buildings in a straightforward way. But the other pictures say more about the function and surroundings of these mills, which were built as working machines, not mere tourist attractions. The low-lying, waterlogged countryside is indicated by the pictures at the foot of the page showing a channel and millpond. I wanted to express in my pictures the fact that, to the people who live among them, windmills are a part of everyday life rather than picturesque objects. The viewpoint and camera angle in the shot of the men playing darts therefore show the mills as incidental elements in the scene. Perhaps the most satisfying picture is the one on the facing page, which has both strength and simplicity; the mills form a balanced composition with the receding curve of the boats, their shape, scale and setting are clearly defined and the pervasive haze of mist perfectly conveys the mood of this corner of the Netherlands.

Building the picture
Conveying depth

Creating an illusion of depth on a flat surface is a traditional challenge for painters and draftsmen. Their most familiar method, linear perspective, uses principles of geometry to achieve the right proportions among objects as they diminish in apparent size with increasing distance, and to make lines that are parallel in reality appear to converge as they recede. These effects are produced automatically by the camera, so that a sense of depth is inherent in most photographs.

In addition to linear perspective, a sense of depth can be achieved through "aerial perspective": because of atmospheric haze distant objects tend to appear less vividly colored and less sharply defined than those in the foreground. Haze can therefore contribute to the illusion of distance and space in a photograph.

In photography, selective focusing is another important technique for distinguishing between close and distant objects. A large aperture will produce a small depth of field, throwing out of focus all the objects that lie behind and in front of the center of interest.

Composition of the subjects in the picture can play a part. The spatial relationship between forms is clarified when they overlap, for instance, and it is often possible to frame a scene with a nearby object so that the distance of other objects is emphasized.

Depth is implied by the relative sizes of the figures in the foreground and background of this picture of Buddhist monks in Sri Lanka (left). I used the technique of half-framing to help offset the flat lighting, which tends to destroy the feeling of depth in a photograph. The overlapping forms, the selective focus and the shadowed foreground all further strengthen the perspective in this scene.

The ruined Fountains Abbey in Yorkshire (below) is given a sense of drama by the lighting conditions of a misty day. In this photograph the viewpoint emphasizes the linear perspective of the ruined columns and arches leading into the distance, while the aerial perspective created by the mist also draws the eye into the frame. In the background the pale silhouettes of trees carry the eye to the space that lies beyond them.

Choice of viewpoint is important to the perspective in this view of Windsor Castle (above). The length of the drive helps to strengthen the imposing appearance of the castle. I felt that a figure also needed to be included in the picture to ensure a sense of scale. The man with his dogs in the middle distance is quite small and therefore establishes the drive's length. The edges of the drive and the parallel tracks of mown grass appear to converge, contributing to the feeling of a continuous recession leading toward the castle. This effect is heightened by the alternating patches of light and shade on the grass; although the trees are in fact equally spaced, the gaps between the shadows appear to become narrower at greater distances. From a position off the drive, some of these effects might have been lost and the sense of depth weakened.

Parallel lines leading directly away from the camera will appear to converge and, if continued indefinitely, would eventually meet at the "vanishing point." This effect, discussed in more detail on the following page, can be seen in the picture of King's College, Cambridge (left). I chose a low viewpoint and tilted the camera very slightly upward in order to exaggerate the convergence. The linear perspective is made particularly apparent by the regular classical façade on the right. As the evenly spaced windows recede they appear to diminish according to a constant progression. Similarly, the various groups of choirboys, also diminishing with distance, help to provide clues about both the depth and scale of the area. Such indications of distance strengthen a picture even when, as here, a sense of depth is not directly relevant to its theme.

Mont St Michel (below), lying just off the coast of Normandy, is completely cut off from the mainland at high tide. Without any clues as to distances in this photograph it would have been difficult to judge the scale of the islet. So I included some foreground detail and, in the middle distance, the fisherman in his boat. The tufts of grass rising from the water form receding planes that lead the eye into the picture. The boatman provides a figure whose approximate size we know and this enables us to judge his distance and the relative size of the church and island. So with a minimum of detail added to the flat, empty expanse of the bay, a sense of distance is conveyed. The flatness that threatens all landscape and seascape photographs and makes so many of them disappointing has been avoided in this case by these few distance "cues".

Using perspective

The power of linear perspective to suggest distance can sometimes be increased by changing your camera angle. In the picture below, the length of the plowed field is indicated by the scale of the trees at the end of it. But by aiming slightly lower in the main picture, I have deliberately eliminated everything except the linear perspective of the furrows. As a result, the field looks even bigger—an effect helped by the fact that the main "vanishing point" (where the parallels appear to meet) is located outside the frame (as shown in the diagram). The picture now has a strong, almost abstract design. Its tension and drama arise from the second set of parallels in the foreground, sweeping across the central line of view and drawing the eye off toward another vanishing point far to the left. I ensured an extensive depth of field, so as to give equal prominence to the foreground and background furrows, by using a wide-angle lens (28 mm) and a small aperture (f16). The effect of aerial perspective, caused by the early morning haze, can also be seen particularly clearly in this color shot: there is not only an overall softening of definition in the distance, but also a weakening of colors generally and a gradual shift towards blue. Both these features contribute to the photograph's illusion of depth.

Vanishing point

Thinking in black and white

Black and white photography can reveal the essential shapes, forms, lines or patterns of a subject by translating the complex play of light into simple tones of black and white and gray. To a printer, a "perfect" picture is one that can be printed on a normal grade of paper and will show sharp detail and the fullest possible range of tones extending from the purest whites of the paper to deepest black, together with all the intervening shades of gray. But in practice, a subject may call for a treatment quite different from this theoretical ideal. A misty morning may call for a soft harmony of tone, while an interesting pattern of rooftops may need a dramatic contrast of blacks and whites.

Experience will enable you to look at subjects in terms of their tonal balance—and in terms of the mood you want to create. A somber theme, for example, may call for a predominance of dark tones, while a delicate texture may require low contrast between darks and lights. These effects can be heightened by various techniques of exposure or printing. But in learning to achieve the effects appropriate to each subject you should start by choosing one that includes a full tonal range.

A still life such as the one above is a useful exercise in tone quality, because it is easy for you to control the selection of items and include a variety of contrasting shapes and textures, as well as to control the lighting. In this photograph I aimed to demonstrate what is meant by a "technically perfect" print, balancing the lighting so as to retain detail both in the highlights (particularly on the eggs) and in the shadows, yet at the same time trying to obtain good contrast and a full range of intervening gray tones.

This detail of a sculpture by Henry Moore required a more interpretative treatment than the still life. However, it is possible to compare the two subjects insofar as the white Carrara marble presents a problem in lighting and exposure that is quite similar to the difficulties involved in photographing the eggs in the still life. Smooth reflective surfaces, unless carefully handled, can produce a loss of detail and form, especially in the highlights. Wishing to capture the subtlety of the modeling, I used diffused directional lighting to limit the contrast. Printed on normal paper, the picture restricts the tonal range to the lighter grays, but the result is entirely in keeping with the quality and spirit of the work.

The old man's face has a rough texture paralleled by the strawberries of the still life in the same way that the marble sculpture is paralleled by the eggs. Heightened contrast, achieved through the choice of printing paper (harder than normal) emphasizes this textural quality, which I felt to be the most interesting feature of the subject, best able to bring out his character.

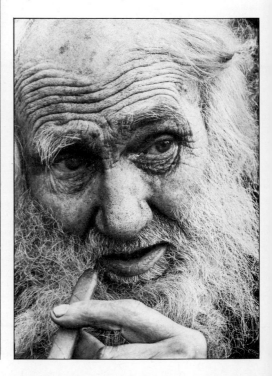

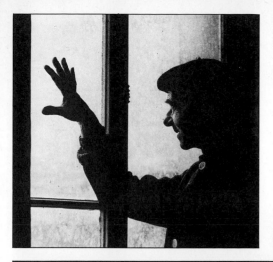

Shooting against the light but retaining detail in the window has here produced a high-contrast picture which did not rely on printing technique. The figure is almost silhouetted against the light, except for the edge of his face and hands, where a few details imply solidity: the effect might be compared with that of the black jar on the left-hand side of the still life on the opposite page, where a similar use is made of limited highlights.

Another Henry Moore sculpture makes an interesting contrast with the first. The dramatic element of the mask is brought out partly by the use of a low viewpoint, but mainly through the minimal, strongly directional lighting, which at the same time captures the texture of the stone and a few important details. Harsh lighting and high-contrast printing combine to give an effect known as "low key"; but as in the picture of the man at the window, there is an adequate area of gray to balance the black areas.

This picture of two sisters contains an unusually large proportion of white areas. This helps to convey a feeling of delicacy and softness, particularly in skin tones, and is often used in portraits when the intention is to give a flattering impression of the sitter. In the example shown here, the deep black of the shadows has been retained without destroying the main effect.

A "high-key" photograph is one in which all the tones are at the white end of the scale. The first Henry Moore sculpture shown on these two pages is rather a subtle example; a more extreme use of "high key" is shown at the bottom of this column. The negative was overexposed half a stop to emphasize the aerial haze surrounding the camel, obscuring much of the detail and suggesting fierce desert heat; and the high-key effect was further brought out by printing lightly on normal grade paper. With its neck strangely twisted round, the animal resembles the forms seen in some primitive cave paintings.

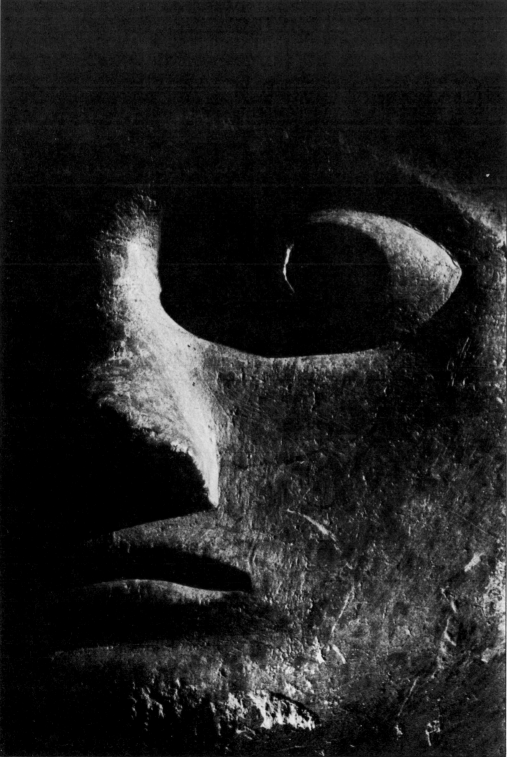

Building the picture
Thinking in color

Of all the compositional elements in photography, color has the most direct impact. A good color photograph is one that evokes an emotional response in keeping with the theme of the picture and knowing how to achieve this is more a matter of taste and judgment than precept. Nevertheless, certain fundamental characteristics of color can be analyzed to explain its different effects.

Some combinations of color are generally felt to be gentle and harmonious, others vibrant, dramatic and even discordant. The *color wheel* sets out in a circle the main colors of the spectrum in the order in which they merge indistinguishably into each other—red, orange, yellow, green, blue and purple. Colors facing each other across the center of the circle, such as red and blue-green, or yellow and blue, are called "complementary" colors and will tend to form strong contrasts with each other, giving an impression of vitality, while adjacent colors, such as red, orange and yellow, will harmonize, creating a more placid mood.

Colors can be of the same hue but have a different degree of purity, or *saturation*. Thus the primary hue red includes pink, cerise and crimson, but these colors are less saturated than a pure red because they contain more admixture of white. Colors often look more saturated or deeper in hue in overcast conditions when they are not reflecting strong sunlight and some of the best color photographs are taken in these subdued lighting conditions. Colors also differ in their brightness—essentially, their ability to reflect or absorb light, pale yellows being brighter, for instance, than pale blues. In color photographs, these brighter tints appear to advance ahead of darker shades.

The effect of each color is dramatically influenced by the context of other colors surrounding it. A pure color will tend to appear especially vivid when seen against neutral, unsaturated colors; conversely, the prominence of a saturated color will be diminished if it is surrounded by too many other strong colors.

Color can be controlled in ways less obvious than the choice of the subject itself. Because the color of objects changes according to the angle at which light strikes them you can often subdue or emphasize certain colors simply by changing the viewpoint or timing the shot according to the play of light.

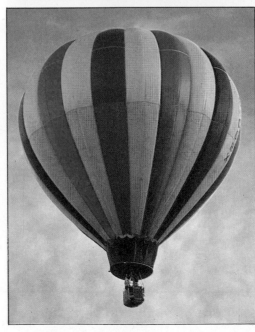

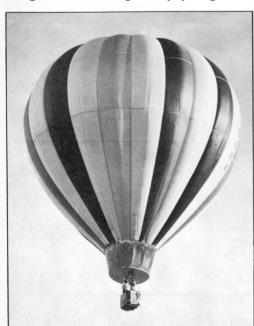

Costumed children and stylized models of characters from Indian drama illustrate the distinction between colors that clash and those that form attractive contrasts. The Indian group is painted in colors which, although contrasting in hue, have been softened to predominantly pastel shades. The picture is further harmonized by being taken in diffused light. The same complementary colors, red and green, appear in the picture of the children, but this time the effect is jarring. The deep, saturated red of the boys' costumes is placed next to a very light, desaturated green background and the bright sunlight adds to the conflict of colors to produce a picture that is much less comfortable to look at than the Indian group.

Entertainments for children—here a traditional Punch and Judy show—are always occasions of noisy bustle and lively disorder, and these are the qualities I have tried to convey in this picture. The jumble of contrasting, highly saturated colors expresses the confusion visually, while the low sun produces strong contrasts between light and shade. I used a 28 mm wide-angle lens, which made it possible to include a wide area of the scene, and thus to pack the photograph with plenty of color and movement.

Farm buildings, photographed in late afternoon light, show the strength of contrasting colors and the need to balance them carefully for an effective picture. Low sunlight striking the barns has strengthened the reds, making them almost leap out from the background of complementary green. A single color of such vividness might have unbalanced the composition but here the two barns are played off against each other and the bluish-green house between them acts as a link. Strongly contrasting colors, or single colors contrasting strongly in tone, are the most attractive color combinations. But it is usually desirable to limit their range, as in this photograph, rather than having too many competing colors jostling for attention and flattening the picture into a mere color pattern.

Contrasts of hue and brightness in the multicolored stripes of a hot-air balloon make a striking color picture. In the black and white picture the huge differences of color, light and shade are reduced to a single variable: tone, the degree of lightness or darkness at each point. It is testimony to the amazing powers of the eye and brain that the difference in illumination on the two sides of the balloon can be "read" and distinguished from the variations in color; thus the varying tone of the neck of the balloon is interpreted as being one color, partly illuminated by sunlight, partly in shade, rather than as different hues. But by itself tone cannot do justice to many scenes. Pictures that are dramatic or expressive in color often become dull in black and white. It is not only the obvious variation in hue that is lacking in the black and white picture of the balloon—the difference in saturation between the bronze and the vivid, deep blue cannot be rendered. Modern color film, on the other hand, is highly successful at capturing the nuances of color in almost any scene.

Blue paintwork and yellow flowers make a strongly contrasting combination. But they are linked by the green, which is intermediate on the color wheel, as the diagram on the opposite page shows. The total effect of the photograph is thus made more harmonious.

Harmonious colors are adjacent on the color wheel, while complementaries are opposite each other. Each of the hues can be desaturated, or made less pure, by being mixed with white or black, giving tints or shades that are lighter or darker, and less vivid, than these.

Brilliant yellow flowers dominate the first picture at the top of the page because the yellow hue is highly saturated and because yellow is the brightest of all the colors. As green and yellow are close on the color wheel, the effect is harmonious.

A green field with a gentle slope shows how a single hue can vary with the angle of the light. The tones of green convey the contours of the land.

Some colors have deep emotional associations. The ripe gold of a field in autumn, for instance, makes an image of reassuring warmth and mellowness.

The strong blue-green of the sea and the pale blue of the sky harmonize coolly and demonstrate how a very vivid color can be balanced and to some extent subdued by a weaker color that is close to it in hue.

Exploring tone

The replacement of color by black, white and gray tones not only helps to simplify a photograph but also forces the photographer to be constantly alert to the subtleties of tone and contrast in the scene he is taking. It needs a certain amount of practice to be able to visualize how a black and white picture will turn out, and when its final result is to depend on tonal balance for its effect, it is critical that all the variables that will influence tone—exposure, development, lighting and printing—are controlled as accurately as possible.

The cobbled street demonstrates how a subject that is not spectacular in itself can become a strikingly unusual image in a black and white photograph, simply as a result of the careful handling of tones. Pointing the camera down into the bright sunlight reflected from the road, I exposed the film for the highlight areas alone and then printed the picture on hard paper to exaggerate the pattern of the cars and cobbles as well as the violent diagonal design. I used a 135mm lens, which flattens the perspective and makes the motorcyclist look as if he is climbing a steep ramp. A shutter speed of 1/60 rendered him slightly blurred in a setting of oppressive stillness.

A London dock on an overcast day (opposite) is the kind of subject that is particularly successful in black and white, provided that the tonal values are judged correctly. The danger with a high-key subject such as this, in which the white steam against a light gray sky is vital to the atmosphere, is that the negative will be overexposed and the details in the highlights will be lost. For this picture, therefore, I deliberately underexposed by half a stop and increased the normal development time by a quarter to compensate for the resulting loss of contrast.

In a steelworks interior, the dramatic contrast suggests the extremes of noise and heat close to the furnace and the molten steel. With the glowing metal providing light for the photograph, I took the meter reading from the floor (an average gray area), compromising between the extremes of light and dark.

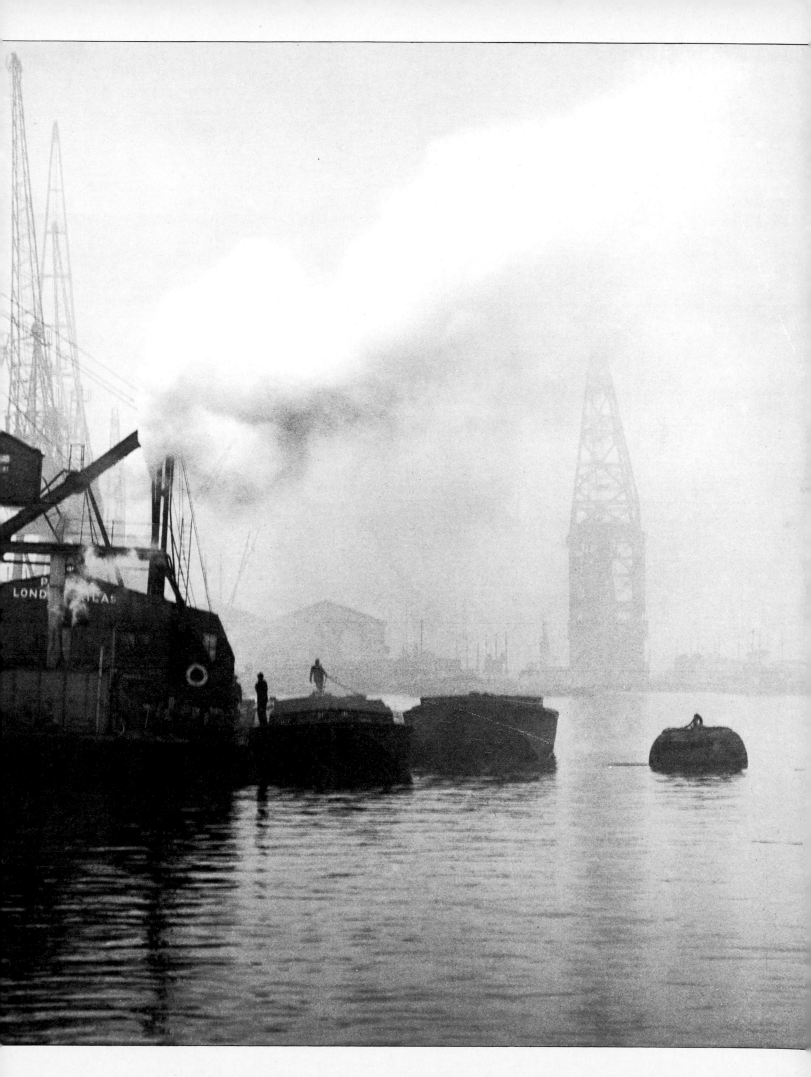

Restricting color range

In trying to extend your awareness of color as a photographic subject in its own right, it is useful to begin by restricting the number of colors in the frame. By doing so you will be able to experiment with the emotional and aesthetic effects of balancing one or two colors against each other. The idea that some colors do not go together is a fallacy. Used in

the right proportion, any combination of colors will work. What is true, however, is that a very bright hue may need to be balanced against a large area of subdued color. Limited and carefully placed color accents are often more effective than extravagant displays containing every conceivable hue: the more economically you use strong color, the greater its impact will be.

By playing off one or two colors you will also find that the impact of the picture does not depend on the brightness of the colors. Used in the right combinations, colors can seem brilliant even though they are in reality quite subtle and muted.

A picture of poppies in a field uses a very small proportion of color to great effect. In this instance the accent is a bright primary hue, contrasting with the complementary green. The red is so vivid that it seems to have been dabbed on with the swift and free impressionist brush of a Monet.

The bricked-up window is a rather surrealistic image, a visual joke implying that windows can be used to keep light out rather than let it in. But it is mainly the balance between two subtle hues that gives this picture its charm. The pale blue of the wooden window frame's peeling paintwork picks up the bluish tint in the brickwork, giving a unity of color to the composition.

Building the picture
Studying shape

Shape, form, texture and color are all different aspects of an object's physical character. When they are all present in a photograph they tell you everything about the object—what it looks like, what it feels like, and what it is made of. The picture may also contain pattern, which is not necessarily an intrinsic quality of a single object but rather a repetition of similar shapes, or forms, or textures within the picture area. Although it is normally the collective effect of these essential elements that is important, you can exercise considerable flexibility in the emphasis you give to any one element. Understanding how each of them works enables you to control your photographs by stressing the qualities that are the most characteristic or graphically striking.

Shape is the most economical and in a way the most fundamental of all these descriptive elements: the simple outline of an object is often enough to enable you to recognize it. People, for example, can be identified from silhouette portraits in which nothing is visible but the profile. Details such as the texture of the skin, the form of the features or the color of the hair clearly play a less important part in recognition than the basic shape of the face. Similarly, the difference between, say, an oak and an elm can be seen from a distance simply from the shape of the tree outlined against the sky.

You can experiment with shapes in photography following the procedure shown at the top of the page, using backlighting from a window to produce the effect of a silhouette. The inability of the film to cope with the extremes of light intensity ensures that no detail is recorded in the shadows. Since you can easily strengthen the contrast by printing on hard paper, the quality of the film is not very important for this kind of work—even old film that has deteriorated too much for other purposes would be suitable. As subject matter, even the most ordinary household items, such as coffee pots, saucepans and vases, can produce unexpectedly striking results when photographed in this way, and simple pictures like these make ideal ingredients when you are assembling collages or decorative murals.

Objects to be silhouetted can be out on a shelf or table in front of a window. Making sure no extraneous light or object is spoiling the outline, mount the camera on a tripod and expose for the highlight area of the window. Then overdevelop the negative by about 25 percent. All the detail in the highlights will be lost, giving silhouettes like these.

The profile of Queen Elizabeth II is used on British and Commonwealth postage stamps. I took the photograph on the opposite page in the same way as those below, using a brightly lit window to provide the necessary lighting for the silhouette.

Discovering shape

There are not many occasions on which it is appropriate to isolate the element of shape to such an extent that all other pictorial elements are eliminated. On the previous page the silhouetted shapes of simple household objects were explored as an introduction to the subject of shape; the next step is to combine shape effectively with form, texture and color.

Each of the photographs shown here sets out to emphasize the dominant shape of the subject, but they use only partial silhouettes. By selecting your exposure carefully and choosing a suitable viewpoint, it is not difficult to produce a photograph in which dark areas and clear outlines are combined with full modeling in other areas of the picture. Alternatively, a plain area of a single color can serve to bring out a striking shape. Whether the shape is a delicate structure, such as the branches of a tree, or a bold one, such as a mountain or cliff, it can be an effective means of enhancing the picture's dramatic qualities.

A partially silhouetted tree retains sufficient modeling on the main branches and foliage to avoid the appearance of a cardboard cutout, but it is still the shape that dominates the picture. When I had chosen a viewpoint that I thought showed the tree most effectively, I waited until the tree surgeon approached the position where he would be the natural center of interest. Suspended midway between two layers of foliage, he seems to be precariously balanced on the delicate structure of the branches; both the limbs of the tree and the rope on which he depends appear more slender as a result of the picture's use of silhouette.

The sheer rock face is impressive in its own right, calling for a romantic treatment that conveys its natural grandeur. I eliminated the detail in the shadows by using the exposure meter reading for the sky to produce a simple but appealing blend of sea, sky and cliff. The use of silhouette also serves to draw attention to the unusual facelike formation in the outline of the rock. Revealed against the brightest part of the sky can be seen a few trees, which lend a vital sense of scale.

Ice serves as a plain background to the shape of a man engaged in the sport of curling. The contrast in colors between the light blue ice and the man's bright red sweater strengthens the bold outline, which is distorted by my use of a 28 mm wide-angle lens. The swing in the man's arm and the effort he puts into wielding the curling stone are also conveyed more emphatically by this dramatic use of shape.

Ancient buildings and formal academic costume, two characteristic features of Cambridge University, are aptly framed like a diptych in an arched double window. The outline of a door or window can often be effectively used to frame the main image in a picture. Our ability to recognize things from their shapes alone is clearly shown by this photograph: the mortarboard, spectacles, pocket watch and waistcoat sported by the don are easily identifiable from their silhouettes, and imagination can supply the details.

A restaurant interior has a relaxed, leisurely atmosphere in the large photograph opposite. The idea of framing an image has here been given a new twist by making the "frame" the actual subject of the picture. The exposure in this photograph was critical, for it had to be balanced between overexposure for the tree outside the window and underexposure for the figures at the table. The warm colors of the room are the result of using color film balanced for daylight, which enhances the reddish quality of electric light.

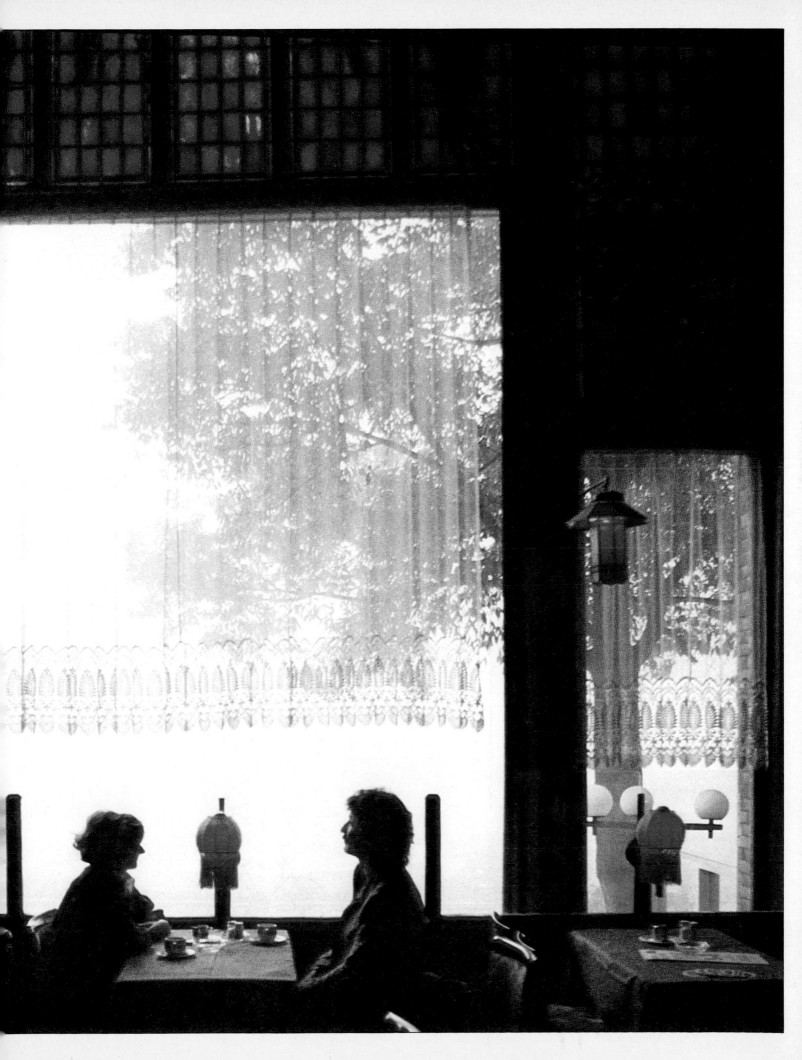

Building the picture
Awareness of pattern

Pattern is a vital ingredient of nearly every picture, contributing to the visual harmony of the picture as a whole. On these two pages, however, I have sought to isolate the element of pattern so as to concentrate on its most distinctive qualities and suggest how you might use them. Patterns are to be found in all surroundings and in every size. Natural forms are particularly rich sources, often containing simple regular geometrical patterns built up into larger, more complex shapes, which are themselves repeated on a larger scale. Natural growth is revealed as a process of continuous repetition of patterns, creating endless combinations of order and symmetry. Similarly, many industrial processes depend on repetitive copying; things made by machines often form their own kind of patterns, offering further scope to the photographer.

The most suitable viewpoint for taking pictures of patterns is usually a flat, frontal position, with the lens well stopped down for good depth of field.

The most elementary patterns are repetitions of one basic shape (top left); more complex patterns may contain several shapes repeated in an orderly sequence (next picture). The simplest shapes are geometrical, but any shape that is recognizably distinct (such as, for example, the hands) can be built up into a pattern. The Javanese decorative paintwork uses highly complicated shapes and symmetries to give an ornate and sophisticated pattern. One of the principal characteristics of pattern in photography is its tendency to create an appearance of flatness, destroying the natural illusion of depth. The patterns made by the play of light and shade on steps, for example, or by the symmetry of the yacht's mast and rigging, have the effect of reducing or eliminating the normal appearance of solidity or volume in three-dimensional objects. This phenomenon may, however, be offset by other features: in the picture of a row of houses (above), where the regularity of the roofs introduces an element of pattern into an otherwise unremarkable view, the diminishing size of the shapes gives depth to the image (see page 52 on perspective). But the zigzag pattern has at the same time a tendency to look flat, and there is a slight tension between these two opposite impulses. If the picture were made more abstract, by the use of close-cropping or ultrahigh-contrast printing, then the pattern and its tendency to flatten perspective would be strengthened. Another type of pattern consists of a random arrangement of regular or near regular objects, as opposed to the orderly arrangements of neatly stacked items. Here, a pile of empty motor-oil cans provides an example of this kind of subject, and, in a similar way, so do the enormous links of metal chain. Finally, I have chosen some examples of pattern in natural objects, which interestingly combine regularity with asymmetry, pattern with disorder. When, as in a number of the examples on these pages, the pattern is brought out only by coming in close to the subject with the camera, some form of close-up equipment such as a macrolens will be needed to achieve the best results.

Controlling pattern

Subjects containing very strong patterns need to be photographed with caution, since the pattern can easily dominate all the other elements. On the other hand, many subjects are more exciting visually when photographed in such a way that you can forget what they are, and think of them simply as abstract designs—pattern is essentially a decorative feature. The photographs on this page enable you to compare the effects of lighting and symmetry on pattern and its relative importance in the final picture: perfect symmetry or flat lighting tend to strengthen pattern.

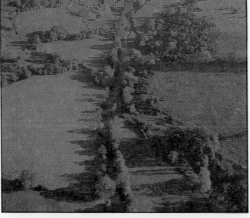

The fire-breathing Balinese demon is clearly decorated to be as startling and ferocious in appearance as possible. Its bright colors and the violent patterns of its paintwork provide an example of how flat an object will appear in a photograph if there is a strong element of pattern and the picture is taken in soft, shadowless light; here I was using a flashgun positioned close to the camera. I diffused its light by bouncing it off a reflector.

Landscape photographed from an airplane contains patterns made up of fields, hedges and roads, which take on an unfamiliar appearance when seen from directly above. The picture on the right was taken when the sun was behind cloud, and the absence of shadows on the ground makes the image look very flat; by comparison, the smaller landscape photograph above it, taken in oblique light, is far less abstract, principally because shadows reveal the forms of the trees and hedges and even the texture of the grass.

The hot-air balloon shown on the far right was decorated with bands of color that offered an opportunity for taking an unusual pattern photograph. The symmetry of the balloon when seen from directly below has eliminated any sense of form. The smaller picture of the same balloon, in contrast, was taken with a slight change in the angle of the camera. You can see how this immediately reveals the rotundity of the subject, making it more easily recognizable as a three-dimensional, rather than flat, subject. Also, the change in camera angle markedly lessens the symmetry of the pattern.

Building the picture
Recording texture

The texture of a surface can be recorded by a camera so accurately that it is easy to imagine exactly what the surface would feel like if you touched it. Indeed, in portraiture the tendency of the camera to searchingly reveal every detail of a subject's skin can be unflattering. But by varying the lighting you can greatly modify the way texture is recorded and exercise considerable control over the appearance of the final picture.

The natural textures of a leaf and a tree root are excellent subjects for a photographic study. The pictures on this page clearly show how the rendering of the texture is affected by the lighting.

Direct sunlight from a window was used for the first photograph, above. The arrangement of the camera and tripod is shown in the diagram. The oblique light has dramatically brought out the more pronounced texture of the large ribs of the leaf, but the deep shadows have obscured the finer texture of the tiny veins that cover the surface.

Greater detail is revealed by the softened and diffuse light of the second photograph. As the diagram beside it shows, I taped a piece of tissue paper over the window before taking this picture.

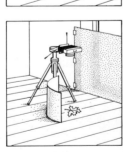

The maximum detail, bringing out the very finest texture, is shown in the third photograph. To set up this picture I placed a polished reflector behind the leaf, facing the window. The reflector helped to fill in the shadows and soften the lighting; but at the same time the contrast is much lower than in the first picture. Although this arrangement allowed me to capture more delicate textures, it also subdued the overall impact that the picture makes.

The highly intricate texture of an old tree root is shown on the opposite page. The light fell on the root obliquely and I used a reflector to fill in the shadows and give a certain amount of modeling, which lends body and depth to the object. However, the deeper hollows of the wood remain in shadow.

Seeking texture

Sand on a beach is molded into a network of changing patterns by the water washing over them. Low early-morning sun picked out highlights on the crests of the ridges to give depth to the pattern and create an unexpected textural impression of oiled smoothness.

A knot provides textural range in this photograph of a wooden fence. Such mundane objects, left to weather over a long period, often reveal a surprising richness of color and texture to the observant eye. Their subtleties show up best in weak directional light.

When raking light brings out their texture, apparently uninteresting surfaces are sometimes transformed into highly decorative photographic subjects. One way of exploring new aspects of familiar things is to photograph them simply as textures, searching out the kind of details that might normally be overlooked. Examples of the richly varied and almost abstract designs that can be found in ordinary surroundings are the ribbed patterns within the wooden fence shown here and the glistening texture of sand eroded by a retreating tide.

Landscapes often look best in the morning or evening, when oblique light reveals the different textures of rocks or vegetation. Photography in direct overhead sunlight or the even, diffused light of an overcast day, on the other hand, gives a flatter image with less emphasis on the contours or irregularities of the land.

The rugged face of a Norwegian mountainside needed appropriate lighting to reveal its strength. Not satisfied with the first photograph because the light was too flat for textural interest, I took a second three hours later in slanting evening sunlight: the change is dramatic.

Building the picture
Revealing form

An object in a photograph appears to be solid largely because the modeling of its surface is revealed by the interplay of light and shadow. The shape of the outline is, as we have seen, quite sufficient to identify the object, but the information the outline supplies tells nothing about the "roundness" of the object, nor about the texture of its surface. These two physical characteristics, form and texture, are closely related to one another, in that together they suggest how the object would feel to the touch.

Photography can render the qualities of form and texture extremely vividly, perhaps more vividly than any other medium, because of its ability to reproduce accurately the subtle gradations of light and shade that reveal form, and the exact detail of the texture. The quality and direction of the light play a vital part in bringing out the modeling by shadow and texture, and it is principally by modifying the light that you can exercise control.

Forms can also be emphasized by juxtaposition: rigid and supple, curved and angular, or bulky and compact forms, for example, acquire a dramatic relationship when they appear together.

The simple yet subtle contours of eggs filling a glass beaker are brought out by their mutual shading. The light is diffuse and nondirectional, but in the recesses between the eggs the shadows reveal the curves of their surfaces. The relationships among the overlapping volumes also provide the eye with ample evidence for their three-dimensional forms.

Shape is revealed at the expense of form in the study of eggs in a china bowl. The deep sides of the bowl allow the soft light of a cloudy day to fall on the eggs only from above. Although there is some highlighting on each egg to suggest its solidity, this is principally a flat design using the elliptical shapes of the eggs and the enclosing circle of the bowl; clues to form are not provided by the flat lighting or by the side-by-side positioning of the eggs.

Highlights are emphasized on the lumpy, bulbous forms of a bronze sculpture by Picasso. I used a strong flash bounced from a reflector, together with an additional reflector on the opposite side of the sculpture to help fill in the shadows.

Though piled at all angles, both the forms and shapes of plastic cups are brought out here. I used a spotlight, with a silvered reflector to fill in shadows.

The roundness of the cigarette and the strong knuckles of the fist are modeled by a light at the rear and to one side.

The weatherbeaten hand and the eggs that it cradles are strongly contrasted in texture. Soft sunlight with deep shadows emphasizes the eggs' roundness.

Combining the elements

All the elements we have been discussing on the last few pages—shape, color, pattern, texture and form—are brought together in these pictures, which illustrate the crucial importance of lighting and its ability to transform the appearance of surfaces. A jagged and twisted sheet of corrugated iron could hardly be more different than the breasts of a girl. And my aim in photographing the corrugations for their abstract and formal qualities was also different from the erotic impact I sought in photographing the girl. Yet you will notice that the subdued light on the corrugated iron has made its undulations gentle rather than harsh and given this picture almost as much tactile form as the other, while still conveying the energy and violence of the impact that originally formed the strong radial patterns.

Bright sunlight falling obliquely on the body of a girl gives depth and weight to the form of her breasts, further emphasized by the knotted scarf tucked between them. The moisture beading her skin draws attention to its texture and heightens the picture's tactile quality.

Taken in diffused light, the corrugated iron seems soft enough to have been crumpled with a thumb. The delicate coloring and modeling and the interest of the fanlike pattern show how much richness can be found in an ordinary piece of scrap metal.

HOW TO PROCESS AND PRINT PHOTOGRAPHS

Processing your own pictures will give you final control over the effect you want to achieve. In this section, all the essentials of processing are outlined, from setting up your own darkroom at home to making color prints.

Setting up a darkroom

Setting up a darkroom at home

A spare room fitted with purpose-built work benches and shelves and permanently blacked out is the ideal starting point for good darkroom procedure. Here your equipment can remain undisturbed between processing sessions. For many, though, a more makeshift arrangement is necessary, making temporary use of a bathroom or kitchen. Surfaces and materials may have to be removed at the end of each session, and equipment that can be stored easily is therefore an advantage.

The essential requirements

To be suitable as a darkroom, a room must fulfill three essential requirements. Firstly, it must be able to be easily and effectively blacked out. Even a small amount of light creeping around the door frame could be enough to spoil unprocessed film and paper. Secondly, mains electricity is needed to power the enlarger and safelight. A permanent darkroom may also need power to run other items, such as a print dryer or light box. Ventilation to clear fumes from processing chemicals is the third requirement if many hours of work are anticipated, as lightproofing can block the free flow of air.

A factor that is convenient but not essential is a supply of running water so that films and prints can be washed and chemicals mixed without leaving the room. If this is not possible, films and prints can be placed in a bucket of water after processing and washed later.

The dry area

Whether permanent or temporary, your darkroom should be divided into two distinct areas of activity. A dry area should be reserved for all activities that do not involve the use of water or chemicals, such as selecting negatives or exposing paper in the enlarger or contact printer. The dry bench must be firm so that the enlarger does not vibrate during exposure.

You should group near the enlarger: a print easel; a seconds timer for timing exposures; dodgers and burners (for controlling local print density—see pages 90–91); negative files, printing papers, scissors and scalpel. An added help is a focus magnifier (to examine the image under the enlarger) and a print trimmer.

A print dryer should be separated from both the dry and wet areas; as you are handling wet prints, they must be kept away from negatives and other materials. At the same time, the dryer itself should be protected from chemical contamination.

The wet area

In this area of your darkroom chemicals are mixed and processed. Black and white processing involves three steps: developing the latent image, stopping the action of the developer and fixing the image (making the paper insensitive to further exposure to white light). The three dishes necessary for this process should be arranged so that the fixer dish (for the last step) is next to the sink. The safelight should be positioned above the developer dish.

Dry area

1 Enlarger
2 Exposure timer
3 Print easel
4 Focus magnifier
5 Dodgers
6 Burners
7 Safelight
8 Negative files
9 Print trimmer
10 Scissors
11 Scalpel
12 Boxes of printing paper
13 Storage area
14 Ruler
15 Blower brush
16 Magnifier

Wet area

17 Developing tank
18 Spirals
19 Color print drum
20 Measuring cylinder
21 Measuring jug
22 Chemical concentrates
23 Funnels
24 Paper towel dispenser
25 Developer dish
26 Stop bath
27 Fixer dish
28 Print washer
29 Rubber hose and water filter
30 Two sets of print tongs
31 Thermometer
32 Safelight
33 Timer
34 Differently sized print dishes
35 Film clips
36 Squeegee
37 Bucket
38 Extractor fan

Processing negatives

You can process your own films at home without a photographic darkroom. The only essential items of equipment (apart from the appropriate chemicals) are a thermometer and a daylight developing tank, which consists of a lightproof container with a lid specially designed so that liquids can be poured in and out of the tank without letting in any light. Inside the tank is a spiral reel, which holds the film and allows the developer to circulate freely over the entire film. The spiral can be adjusted to accommodate different sizes of film. The film must be loaded onto the spiral in total darkness, either in a room or cupboard that has been blacked out or in a special lighttight changing bag, but once the tank has been closed the processing can be carried out in ordinary light. Practice with waste film until you are confident of being able to carry out the whole operation smoothly in the dark.

If you intend to process only black and white film, your thermometer should be accurate to $\pm\frac{1}{2}°C$; for color processing it will need to be accurate to $\pm\frac{1}{4}°C$. A few additional items will be needed, though you may be able to improvise substitutes; a timer, measuring cylinders, warm water, filter paper or a clean handkerchief, a funnel and a tray are the most important. Other useful accessories are illustrated on the opposite page.

Preparing the equipment

Although you cannot watch the process of development as it takes place, you can control it by measuring time and temperature: the rate of chemical activity is determined by the temperature of the solution, so it is simple to ensure the correct amount of development by timing the process. Black and white films are normally developed at 20 °C (68 °F) and the manufacturer's instructions will give you the appropriate development times for the film you are using. (For color processing, see pages 100–101.) Development normally takes five to ten minutes. It is possible to work at slightly higher or lower temperatures, but the time will have to be adjusted accordingly.

Chemicals are normally supplied in the form of a concentrated solution, or as powdered crystals. The first step in processing, therefore, is to mix or dilute the concentrates to their normal working strengths. Next, load the film in total darkness into the developing tank, as shown in the illustrations below. I always soak the film in water at the development temperature and pour it away before adding the developer. This pre-wash assists even development, brings the film to the correct temperature and helps remove air bubbles. Bring the chemicals up to the required temperature by standing the cylinders or measuring jugs in a bath of warm water. Only the temperature of the developer is critical; the other two solutions, the stop bath and the fixer, should be at more or less the same temperature to avoid sudden changes, which can damage the film.

1 In total darkness, open the cassette using a can punch and take out the film. Avoid touching the film surface with your fingers.

2 Cut off the tapered film leader with a pair of scissors, taking care to cut between the sprocket holes, since this facilitates loading.

3 Wind the entire length of the film onto the spiral and place it in the developing tank. Close the lid of the tank and turn on the light.

4 Bring the developer to the correct temperature, within the required limits of accuracy. Pour it through the tank's lighttight lid and start the clock.

6 At the end of the development period, quickly pour the developer through a filter back into the bottle using a funnel.

7 Without opening the tank, pour in the stop bath to halt development. After a minute or two, empty the tank. The stop bath can be reused.

8 Pour in the fixer. After the film has been in contact with the fixer for a few minutes, it will be safe to open the tank in the light.

9 Complete the fixing process according to the directions and finally wash the film in running water for at least 30 minutes.

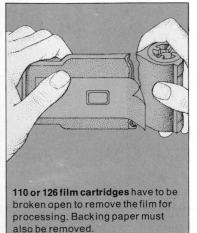

110 or 126 film cartridges have to be broken open to remove the film for processing. Backing paper must also be removed.

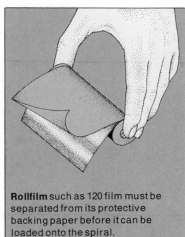

Rollfilm such as 120 film must be separated from its protective backing paper before it can be loaded onto the spiral.

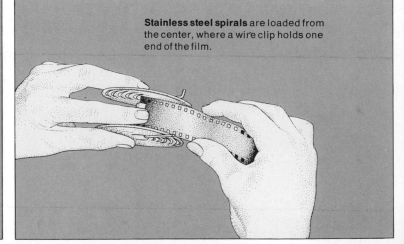

Stainless steel spirals are loaded from the center, where a wire clip holds one end of the film.

Developing the film

Following the sequence shown in the accompanying pictures, pour the developer into the tank as quickly as you can and start the timer. Tap the tank gently to release any air bubbles on the surface of the emulsion. Pay careful attention to the manufacturer's instructions regarding agitation, which is needed to bring fresh chemical regularly into contact with every area of the emulsion, thus ensuring even development. Some developing tanks are agitated by inverting the whole tank; others have a rod, which can be inserted in the center and twisted to rotate the spiral inside the tank. It is usually necessary to agitate the tank once every minute throughout the development.

The next solution, the stop bath, is essentially a weakly acidic solution, which neutralizes the alkaline developer and thus halts any further development. At the same time it serves to prevent the developer contaminating the fixer, which is acidic. Some types of stop bath contain an "indicator," which causes the solution to change color when it becomes exhausted. However, it is possible—though not recommended—to rinse the film in water at this stage, instead of using commercial stop bath.

The third and final chemical stage of the processing fixes the image and stabilizes the film, so that it can safely be exposed to light. Fixing normally takes five to ten minutes, depending on the type of fixer you are using. Approximately half-way through the fixing stage, the film loses its "milky" appearance and becomes clear; once this has happened, you can open the tank and examine the film. Do not, however, unwind the film from the spiral as it is difficult to reload it while wet.

The film must then be washed for at least half an hour in running water to remove the unused silver compounds; film that has not been properly washed will deteriorate in time. It is best to use a short length of special hose (with a filter) attached to the tap and inserted into the center of the reel in order to ensure a continuous circulation of fresh water during the washing of the film.

When the film has been washed it must be hung up to dry. A few drops of wetting agent added to the final rinse will help the film to drain evenly. Wipe off the excess water with a squeegee or with your fingers, taking great care that no spots of dust or grit scratch the film as you wipe it: the emulsion is most vulnerable when it is swollen with water. Hang the film to dry in a dust-free area—special drying cabinets are available for this purpose. Weighted clips or clothes pegs attached to the bottom of the film will prevent it curling as it dries.

Black and white film can be processed to give positive transparencies instead of negatives, by a similar process involving a few more steps. Special film and chemicals designed for reversal should be used. After the film has been developed in the normal way, but before it has been fixed, the negative image is bleached out and the film is deliberately fogged, either chemically or by exposing it to white light. A second developer is then used to convert the remaining silver halides to form a positive image, before the film is finally fixed and washed normally.

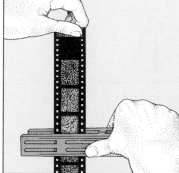

5 Lightly tap the tank on the workbench to remove air bubbles. During development agitate the tank as recommended by the maker.

10 Drain off the water and unwind the film from the spiral. Remove excess water with a squeegee and hang the film to dry.

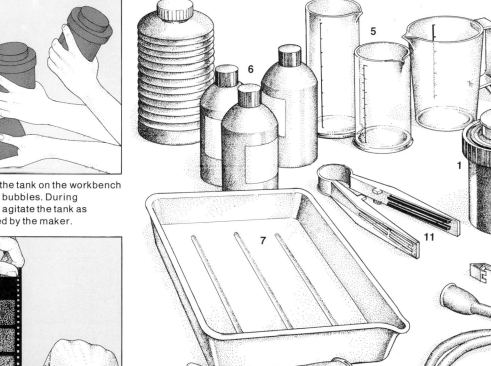

Equipment for processing black and white film:
1 Developing tank
2 Spiral
3 Thermometer
4 Timer
5 Measuring cylinders
6 Bottles for storing chemicals
7 Dish for warming chemical solutions
8 Funnel
9 Rubber gloves
10 Hose with filter
11 Squeegee
12 Film clips

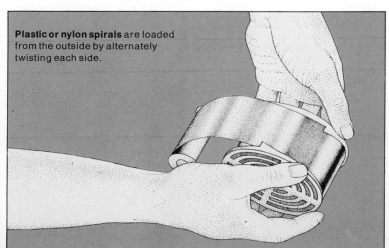

Plastic or nylon spirals are loaded from the outside by alternately twisting each side.

Sheet film is sometimes processed in dishes in the same way as photographic paper. However, it is more convenient for each sheet to be clipped onto a hanger as illustrated, and immersed in a deep tank full of the solution, maintained at the right temperature. A separate tank is used for each solution. In this way, several sheets can be processed together, suspended on a cage, but the whole processing sequence must be carried out in total darkness.

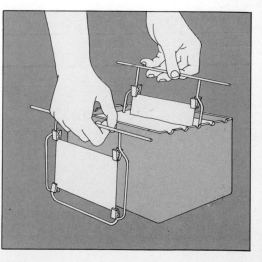

Assessing negatives

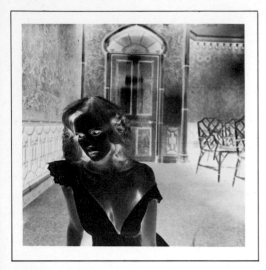

A good negative shows a range of tones from the clear areas (subject shadows) to the dark ones (subject highlights). In the final print both shadow and highlight areas should show recognizable detail. Note the good range of half-tones that also appears. The sharpness of the negative is crucial to the success of the final picture. To achieve sharpness in a portrait, focus accurately on the subject's eyes.

Different grades of printing paper form prints of varying contrast from a single negative. When the contrast is very low the picture is lifeless; when it is very high, the highlights are "burned out" and the shadows are inky, so that significant detail is lost.

When you have processed a roll of film and produced a set of negatives, you should look critically at the results and decide whether anything has gone wrong and what can be done to correct any faults. Although your negatives should be as good as possible, acceptable prints can often be made from negatives that are far from perfect.

Inspect the negatives you have processed carefully and you will probably see that some of them show excessive contrast, with featureless clear areas (corresponding to the shadows of the final print) and dense blacks without detail (the highlights) with very few half-tones (shades of gray) in between. Other images may have a muddy look, with indistinct clear areas and an overall gray appearance with no strong blacks—all signs of low contrast. Others will fall between these two extremes, with images having rich blacks, pure whites and an extensive range of half-tones—the perfect negatives to print. You will find it easier to judge the qualities of negatives when you have had experience of the kinds of print that they produce.

If the film was correctly exposed, a low-contrast negative could be the result of underdevelopment. This occurs when the development time is insufficient, when the temperature of the developer falls below that recommended by the manufacturer, or there is too little agitation during development. On the other hand, negatives showing excessive contrast could be the result of overdevelopment—too much development time, too high a solution temperature, or too much agitation during the development process.

Such problems can be overcome quite simply by taking more care in the critical stages of processing films. You can also manipulate the contrast of the final print to some degree by your choice of printing paper. Printing paper is graded according to its ability to reproduce shades of gray. Contrast grades start at grade 0 and progress in equal steps to grade 5 (sometimes grade 6, depending on the manufacturer). Grade 0 is the "softest" or lowest in contrast and has the ability to reproduce the most extensive range of tones; grade 5 is the "hardest" or most contrasty and reproduces virtually no half-tones. Grade 2 is designed for negatives with a normal contrast range.

If, for instance, you have produced a low-contrast, underdeveloped negative you can improve it by printing on a hard grade of paper (perhaps grade 3 or 4). If, on the other hand, the negative shows signs of overdevelopment (excessive contrast), printing on paper grades 0 or 1 would probably be the best way to correct it.

To avoid the inconvenience and expense of buying several grades of paper, you can instead use variable contrast paper such as Ilford Multigrade. This is coated with two emulsions, one hard and one soft, each sensitive to a different hue of light. Changing paper grades is simply a matter of slipping a new filter into a small drawer on the enlarger.

Because negative density is bound to vary, it is advisable to keep a selection of different grades of printing paper in the darkroom. You can also buy variable contrast photographic papers; these will produce a picture whose contrast depends on the color of the light used for the printing. A range of colored filters is provided for use with the enlarger, so that the equivalent of a full range of contrast grades can be achieved.

Negatives in 35 mm and smaller formats are sometimes hard to assess because of their relatively small size. Even when looking at detail on a contact print (see page 86) it is not always easy to see if shadow and highlight detail is as it should be. A magnifying glass giving about eight times magnification, and a light box, which uses fluorescent tubes to give an even distribution of light, should give you enough information to decide which grade of paper is best suited to a particular negative.

Grade 0

Grade 1

Grade 2

Grade 3

Grade 4

Grade 5

An underexposed negative is thin, since relatively little silver appears in the dark (highlight) areas. Thus in this negative the girl's dress and the highlights reflected in the door are gray rather than black. The clear areas, which represent the dark areas of the subject, such as the shadows behind the chairs, lack detail and have low contrast, whereas the contrast in the darker areas of the negative is normal. Because of this discrepancy, the final picture can only be a compromise.

Underdeveloped negatives, such as this one, have a thin and grayish appearance and the overall contrast is low. The development process was not continued for long enough, or was at too low a temperature, and silver has not been built up in the highlight areas. Since the original exposure was correct, however, there is considerable detail in both shadow and highlight areas. A good print may be obtained from such a negative, if it is printed on a grade of paper that is harder than normal, which will heighten the contrast.

A dark picture, with gray highlights, results from printing the underexposed negative seen above it. Nevertheless, a darkish print is probably the best you can achieve with a seriously underdeveloped negative; a lighter print with brighter highlights would have dark areas of a low-contrast gray.

A print made from the underdeveloped negative has the correct overall lightness because the exposure time used in printing was reduced. But the contrast is low, with a consequent lifeless quality about the picture, because it was made on paper of a normal grade.

An overexposed negative is dense, with deep black areas representing the subject highlights and strongly marked detail in the light (shadow) areas. The contrast is correct in the lighter parts of the negative, such as the patterned lower part of the wall, and the shadows in the girl's hair, but it is somewhat low in the highlight areas, such as the girl's dress and face. A relatively long exposure time is needed in enlarging from such a negative to get a dark enough tone overall.

Overdeveloped negatives such as this are dense, but can be distinguished from overexposed negatives by their greater contrast and by the fact that, provided they are not grossly overdeveloped, detail is retained in both the shadow and the highlight areas, as the texture of the girl's hair in this negative shows. It is not difficult to correct errors in the development procedure, and a reasonably balanced picture could be obtained from this negative by printing on soft paper to reduce the contrast.

A print made from the overexposed negative seen above is of the right overall brightness, but is flat and lacking in contrast in the highlights. A better result might have been obtained on a higher grade of paper, which would have increased the contrast, though making some of the shadow areas very dark.

A high-contrast positive is produced by printing the overdeveloped negative seen above on a normal grade of paper. A lower grade would have given an acceptable picture. A moderate error in the amount of development that a picture receives is more easily corrected than an error in exposure.

Making a contact print

It is useful to make *contact prints* (which are the same size as the negatives) of every roll of film you shoot. A roll of 36 exposures, cut into six sections, can be printed on one sheet of 8 × 10 in (20 × 25 cm) photographic paper. Once this is done, you have positive images of all your photographs, which can be filed alongside their corresponding negatives to provide easy reference for later enlargement of individual frames. Seeing the images side by side allows you to make fine comparisons between similar pictures, which would be more difficult if looking at the negatives alone. The best can then be selected for enlargement.

A commercially made contact printer is little more than a sheet of glass hinged to a baseboard on which the sensitized printing paper is placed. Many commercial varieties of contact printer are made, but you can make your own contact prints without

one. All you need is a piece of clean unscratched glass and a firm surface (the baseboard of an enlarger is ideal if it is large enough).

It is not even necessary to use the enlarger as the light source. The darkroom's ordinary lighting can be switched on for the exposure. Or the negatives can be laid on a light box, normally used for viewing transparencies, and the sensitized paper laid on top of them. The correct exposure time must be found by experience—try 10 seconds to begin with.

Whatever method is used, it is important that the emulsion sides of the film and paper should be in contact. The emulsion side of film is matt; it is on the concave side of the film's natural curl. The emulsion side of the paper is shiny.

A medium-contrast grade of paper is best—grade 2 or 3. This should give you enough information to judge the tonal range of individual frames and will indicate which contrast grade of printing paper will be most suitable for a particular enlargement. The newer resin-coated papers are much more convenient than conventional ones because they need only about five minutes' washing; a traditional paper needs at least half an hour.

A contact printer comprises a baseboard, a sheet of glass and metal strips that hold the negatives.

Position the negatives under the strips in the contact printer's lid, emulsion side down. Ensure the frame numbers are visible for easy identification later.

With the safelight on, place a piece of printing paper, emulsion side up, on the baseboard of the contact printer. Then close the lid and secure it.

With the negatives and paper now in contact, place the contact printer on the enlarger baseboard. Set the lens of the enlarger at f8 for average exposure.

Turn on the enlarger light to expose the paper. The exposure time depends on the density of the negatives. Most negatives require 10 to 20 sec.

Developing the contact print
In the wet area of your darkroom you need three mixing beakers and three plastic trays for the chemicals—developer, stop and fixer.

Preparation
1 Dilute the chemicals to the correct strength.
2 Bring them to the recommended temperature (usually 68°F/20°C) by standing the beakers in warm water.
3 Pour the solutions into their trays. Economize on chemicals by using trays only slightly bigger than the paper being used.
4 After making the exposure, follow the step-by-step sequence below.

Equipment list
Contact printer or sheet of clean unscratched glass
Enlarger, light box or domestic light
Three developing trays
Processing chemicals
Measuring beakers
Thermometer
Printing paper
Print tongs (two sets)
Timer
Print washer
Squeegee or photographic blotting paper

Tilt the developer tray, and quickly slide in the print while laying the tray down, bringing developer into contact with the whole print at once.

When the print is fully developed, lift it out of the solution with a pair of tongs, letting the excess fluid drain back, and transfer it to the stop bath.

After 20 sec use the second set of tongs to transfer the print to the fixer. Leave the print for the recommended time; agitate the fixer for the first 20 sec.

Wash the print in running water. Wipe off excess water with a squeegee or photographic (not ordinary) blotting paper. Dry the print in a warm place.

Making an enlargement

The key to a good print is a good negative—one that has medium contrast, a range of tones and some detail in both shadow areas and highlights. The satisfying thing about doing your own enlarging is that it gives you the chance to bring out the best features of your negative. You can dictate both the size and the shape of the print and exercise considerable control over its tonal quality.

An enlarger is basically a simple device to project light from behind the negative and focus it onto a sheet of sensitized printing paper held in an "easel" on the baseboard. Enlargers vary in their versatility—and in their cost. The only essential requirements are solidity, a lens that will produce a sharp image and a column height that will allow you to make prints up to the sizes you will want. A tenfold enlargement is usually as much as you will require from a 35 mm negative and most enlargers provide this capacity. If you can afford it, choose a head that can be adjusted for other negative sizes and has a filter drawer for color printing. An exposure timer is also useful, although a wristwatch is adequate.

As with film processing, a methodical approach is necessary to avoid printing errors. You should begin by assembling near the enlarger your sheet of contact prints, negatives, scissors, blower brush or soft watercolor brush, pencil and notebook and a box of printing paper. (Start with a semiglossy number 2 grade.) Prepare the wet area with the materials specified for contact printing on the previous pages. Then note the number of the negative you have chosen to enlarge and follow this printing sequence.

1 Remove the negative carrier, open it and, holding the film by its edges, position the negative you want over the carrier window with the emulsion side (matt side) facing down. If you find the frame is not centered when you close the carrier, reopen it, as you could damage the film by tugging it with the carrier closed.
2 Fully open the lens aperture.
3 Remove the red filter from the enlarger lens, switch on and turn off the darkroom light.
4 Hold the carrier under the beam and inspect the negative. Remove dust gently with a brush.
5 Insert the carrier into the head, turn on the safelight and adjust the head until the image is projected at the size you want. Frame the image with the easel blades. Setting the easel may be made easier if you insert a sheet of ordinary paper with the desired paper size marked on it.
6 Focus the lens until you can see the grain, checking with a focus magnifier if necessary.
7 Stop the enlarger lens down by at least two stops, to about f8. This will give better depth of focus and a safety margin if the negative is not quite flat.
8 Turn off the beam and, by safelight only, take a sheet of printing paper from the box and cut off a test strip at least 1 in (2.5 cm) wide. Close and secure the box lid with masking tape.
9 Expose and process the strip as illustrated.
10 Use the test strip to gauge not only the best exposure time but also whether you need a different grade of paper. (If you choose a different grade it may be necessary to expose a new test strip of that grade.) At f8 a reasonable exposure time is about 10 to 20 seconds. If the test strip suggests a longer or shorter exposure it may be better to change the aperture and expose another test strip.
11 With only the safelight on, take a sheet of paper from the box, secure the lid and position the paper, shiny side up, under the easel blades. Turn on the enlarger light, remove the red filter, expose the paper for the required time and process it.

The basic enlarger
Simple enlargers of compact design can be taken apart and stored if you have only a small or temporary darkroom.

The enlarger head carries the light source—often an opal lamp with a mirror that absorbs heat and reflects light through two condenser lenses to the negative. The lamp can be moved to maintain even illumination over the printing area. Diffusion enlargers give a softer and less contrasty light, but the condenser type is more usual, giving sharp, lively prints. Head height is adjusted by a winding knob or by a clamp. Many heads also tilt to give giant enlargements on the darkroom wall, or simply to make image verticals parallel.

The negative carrier is designed for only one size of negative. Open carriers are preferable to glassed ones as there are fewer surfaces to clean. But if the enlarger has automatic focusing a glass carrier is needed.

The lens has no shutter, but the aperture (usually f4.5 at maximum) is stopped down in a series of click settings, each halving the brightness relative to the previous one. A red filter placed below or above the lens provides a safelight for viewing the image without exposing sensitive material.

The easel is a flat white board with a hinged frame that holds the paper flat. The image may be cropped by adjusting the metal blades. Two blades are usually adequate, but some easels have four.

Developing the print

The method of processing the final print is essentially the same as that already described for contact prints, but a meticulous approach is now even more important. The print will display a full range of tones only if kept in the developer for the recommended time. Errors should be corrected by changing the exposure of the print, not its development time. The sequence at the right shows the effect of stopping development at different stages. The fifth and sixth examples display the qualities of a fully developed print, while the last two are beginning to look a little muddy. After development the final print is put through a stop bath and fixer, as the contact prints were.

15 seconds **30 seconds** **45 seconds** **60 seconds**

1 min 15 seconds **1 min 30 seconds** **1 min 45 seconds** **2 minutes**

Printing papers

Black and white printing paper can be chosen from six contrast grades: grades 0 and 1 give a soft image and are suitable for making prints from excessively contrasty negatives. Grade 2 is best for negatives of average contrast. Grades 3 and 4 produce a hard image and are suitable for soft negatives displaying little contrast. Grade 5 eliminates most halftones, and is generally used only for special effects. There is a choice of paper thickness—single weight and double weight are the most popular. Finishes range from glossy, which gives the deepest blacks, to matt, which helps to hide grain.

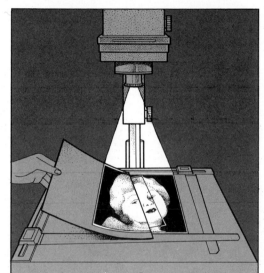

Exposing the test strip should show you how the whole print will respond to different exposure times. With the red filter over the enlarger beam, carefully position the strip of printing paper across the projected image. The strip should cover a representative range of tones. If the picture includes skin tones, as does the one on the right, these are the best tones to test with the strip. If skin tones are well reproduced, the picture as a whole will seem right, even if other tonal values are not so accurate. Cover three-quarters of the width of the strip with a card and remove the filter to start the exposure. After 20 seconds, move the card across the strip a little way; move it again after intervals of 10 and 5 seconds successively and then remove the card completely for a further 5 seconds. The result will be four bands on the strip representing exposure times of 40, 20, 10 and 5 seconds respectively. Give the strip a full development; after an initial 30 seconds in the fixer it can be viewed by white light.

Instead of using one strip you can use four, laying each in turn over the chosen part of the image and giving it an exposure double that of the previous one.

A good print has a well-defined tonal range, with solid blacks and clear whites. There should be a continuous range of tones, sharp definition and little grain apparent. In the print on the right there is plenty of detail both in the light tones on the left of the woman's face and in the shadow areas. Compare these characteristics with those of the same areas in the first four underdeveloped prints above, and with the last two, which show the signs of overdevelopment.

Burning in and dodging

When you are assessing a negative, choosing a suitable grade of paper, and determining the right exposure by making a test strip, you will naturally work on the basis of the density and contrast range of the negative as a whole. You may find that to produce an acceptable-looking print you have to ignore areas of the negative which represent extremes of brightness or shadow: a highlight in the original scene may have been so bright that it appears only as an area of pure white in the print. In order to bring out detail where the negative is too light or too dark to be accommodated by the contrast range of the printing paper, it is necessary to give some areas of the print more or less exposure than others. Thus the enlargement may require a basic exposure of, say, 15 seconds, but need 25 seconds in the highlights, or only 10 seconds in the shadows. You can either estimate the corrections from the basic exposure, or make separate tests.

The highlights are too light in this photograph of a girl, which has been given a uniform exposure in printing: detail and texture are completely lost. A longer overall exposure would have filled in the highlight detail but made the shadow areas too dark, losing detail there. To produce the print on the opposite page, made from the same negative, I used a card with a specially shaped hole to burn in the highlights. The whole print was exposed for 20 seconds, and then the highlight areas were given an extra 12 seconds using the mask, as shown in the diagram. The best way of determining the exposure times is to make separate test strips for the different areas of the picture. In some photographs it may be necessary to give one area two or three times the basic exposure.

Balancing the contrast

The technique used to give a briefer exposure to a selected area of an enlargement is known as "dodging" or "shading". The idea is simply to mask the appropriate portion of the image during part of the exposure time, so that it receives less than the full exposure and is therefore lighter than it would otherwise be. Burning in works in exactly the opposite way; instead of holding back part of the image, you give additional exposure to a highlight area (masking the rest) after the normal exposure of the print has been completed.

For both dodging and burning in, it is essential to keep the shading device moving slightly, in order to avoid a hard edge around the area you are masking. For the same reason, the best place to hold the mask is about half-way between the lens of the enlarger and the printing paper, so that the edges of the shadow it casts are slightly blurred. You should not, of course, be able to detect where a print has been dodged or burned in.

When the shapes are simple and great precision is not essential, you can use your hands to dodge or burn in the print, or else you can work with ready-made masks like those shown in the illustration above; for more complicated shapes you should make a mask specially for the particular photograph as follows. First, project the negative onto the easel of the enlarger and trace the outline of the shape you need on a sheet of stiff card. Cut out the shape, making it slightly smaller than the original outline, and attach it to a piece of rigid wire. (Masks for burning in will probably not need wire handles since they can more easily be held by the edges.) To avoid reflections from the masking device, it is best to use black card and to cover any wire with black tape. Make sure that the wire is long enough to enable you to keep your hand out of the light path of the enlarger during exposure.

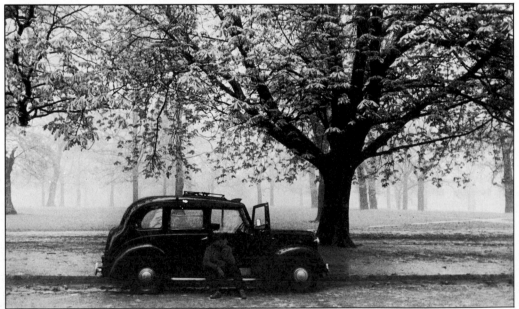

The image of a London taxi is underexposed in relation to the rest of the print above (taken against the light). The driver, seen relaxing with a cigarette, is barely visible against the car, while the trees in the background are correctly printed. The exposure time for this print was 20 seconds. I made a second print, shown on the right, using the same exposure for the background, but this time I used a simple circular mask to shade the area of the taxi after the first 10 seconds of exposure, as shown in the diagram. This time was indicated by a separate test strip exposure. Dodging this section of the picture has prevented it becoming completely black, and highlights and detail in the car and the man are now visible. Often dodging is the only solution to the problems of high contrast in a negative.

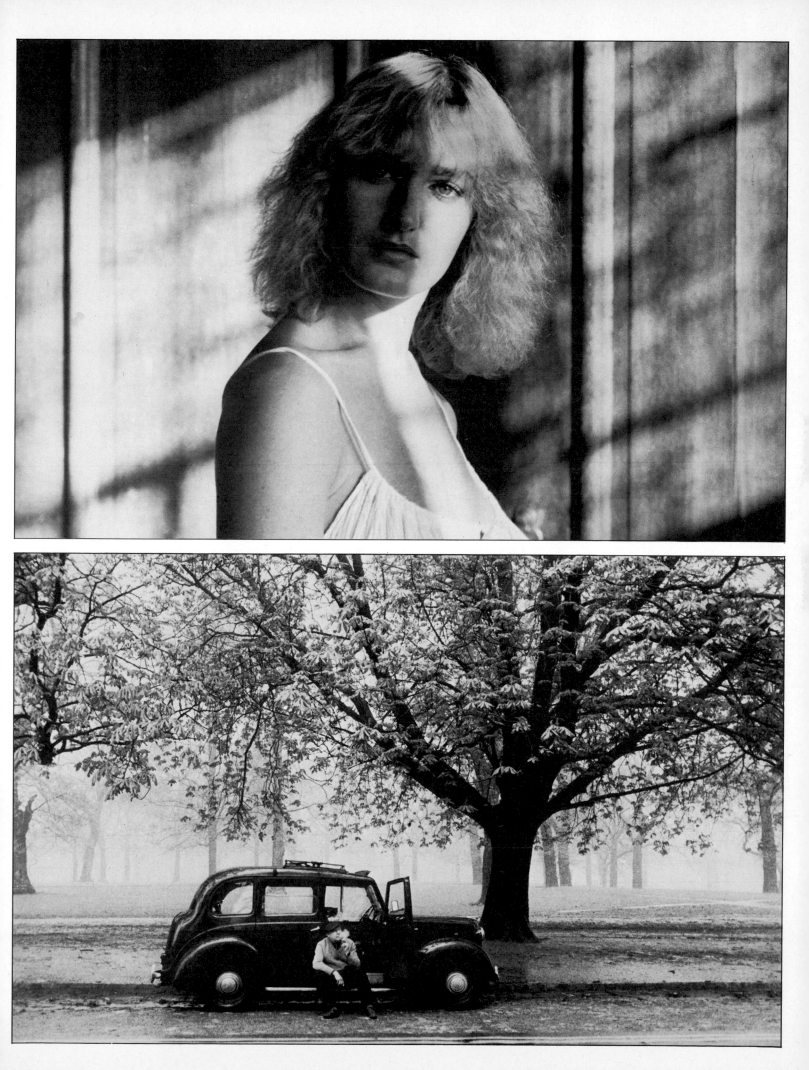

Controlling the print

Apart from the satisfaction of making your own prints (and saving money by doing so), the principal attraction of home processing is the degree of control you can exercise over the quality of your photographs, and the style of presentation. The basic control techniques, such as choosing the appropriate grade of paper, dodging, and burning in, have been described on previous pages, and similar methods can be used for creative purposes: vignetting, for example, is essentially an extension of dodging and burning in.

Vignetting
A vignetted photograph is printed in such a way that the subject fades into either a black or a white surround, giving the picture a rather old-fashioned air, well suited to certain types of photograph, particularly portraits.

A vignette is made by using a circular or oval mask. For a white surround, use a mask with a hole in the center and hold it in place between the enlarger lens and the photographic paper throughout the exposure. For a black surround, begin by exposing the printing paper in the normal way. Then turn off the enlarger and remove the negative. Holding a piece of card mounted on a short length of wire so that the shadow falls over the central area of the print image, turn on the enlarger for a further 15 or 20 seconds to fog the border. If you want the boundary of the vignetted image to be very diffuse, keep the mask moving during the exposure; otherwise hold it still. For a completely sharp edge, use a suitably large mask and place it flat on the printing paper during exposure.

Controlling perspective
It is also possible to modify the perspective of an image at the enlarging stage by tilting the printing frame so that the negative is projected obliquely across the paper. This enables you to partly correct the converging verticals that occur when the camera is tilted upward. However, tilting the printing paper under the enlarger will also have the effect of throwing parts of the image out of focus. The best way of correcting the focus is by tilting the enlarger head and the negative carrier as well, adjusting them in such a way that the planes of the negative and the paper intersect in the plane of the lens. Not all enlargers can be adjusted in this way, so instead you may have to stop down the lens as far as possible to achieve the maximum depth of focus. Closing down the aperture will, however, emphasize blemishes on the negative and defects in the enlarger system.

Grain
Grain is normally regarded as marring the image since it degrades definition and tends to distract the eye, but you may find that some subjects are positively improved by a strong, grainy texture. The photograph on this page, for example, is enhanced by the deliberate use of coarse grain. Exaggerating grain in this way simply involves reversing all the normal rules intended to keep grain to a minimum: in other words, using the fastest possible film, uprating it to a higher speed than that recommended by the manufacturer by using a speed-increasing film developer such as Acuspeed FX-20, and printing on hard, glossy paper. A safer, though less dramatic, method of accentuating grain is to make very big enlargements or enlarge only a small portion of the negative. Some enlargers can be tilted at right angles to project the image onto a wall; others may have to be turned back to front, so that the image is projected onto the floor.

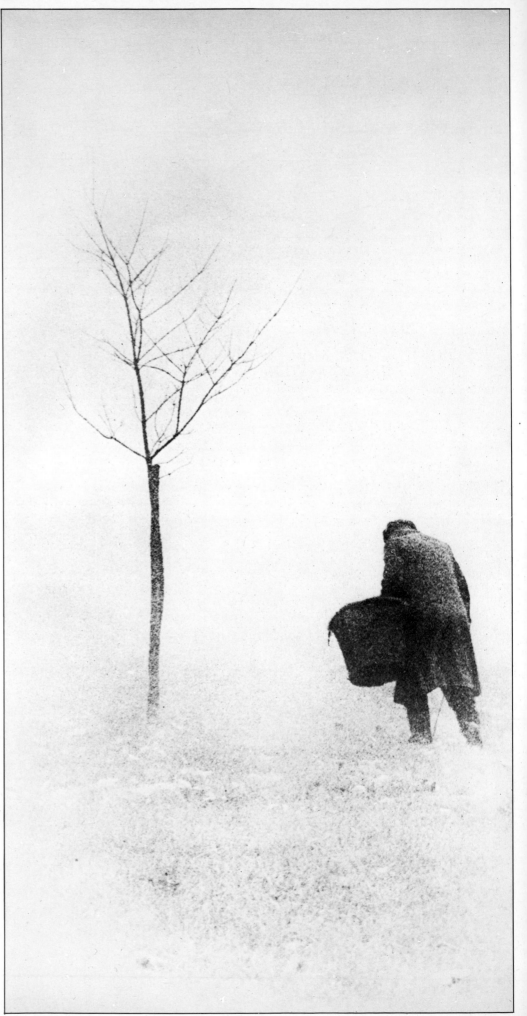

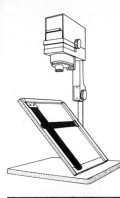

Converging verticals in the photograph below give the building the appearance of leaning over backwards. To produce the corrected print on the right, I tilted the masking frame as shown in the diagram, and stopped down the lens to give as much depth of focus as possible and thus ensure sharp focusing over the whole print.

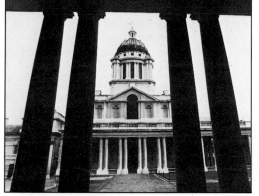

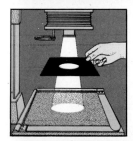

This riverside house was printed as a vignette with a white border by exposing the paper through a mask with a circular hole, as illustrated in the diagram on the left.

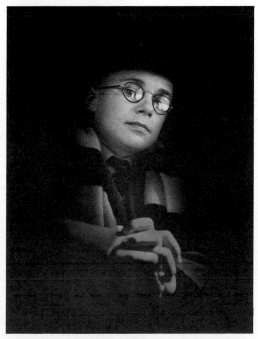

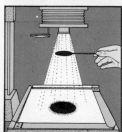

The vignetted portrait of a boy was first printed in the normal way; the area surrounding the face and hands of the subject was then fogged by exposing the print to white light, while shielding the main image with an oval mask, as shown in the diagram on the left.

Special effects

None of the techniques described here demands a great deal of darkroom expertise or experience. In fact, the first procedure, used for making photograms, is the simplest and most direct way of producing a photographic image. A photogram is a picture made without using a camera; it records not the image of an object produced by a lens but the shadow cast by the object itself. To make a photogram like the one below, place a sheet of photographic paper on the baseboard of the enlarger, and arrange an assortment of items on top of it. Expose the paper with white light from the enlarger with the lens closed down two stops, giving it about 10 or 15 seconds, and process as usual. The resulting photogram will have a solid black background with the shapes of the objects in white. Less exposure will give various grades of gray. You can also make photograms on sheets of film and then contact-print or enlarge the result to produce a positive image. Interesting effects can be achieved by making photograms of semitransparent and translucent objects, or objects that do not lie flat on the paper.

Further variations can be obtained by combining photograms with images produced in the conventional way. For example, I used the technique of the photogram to make a border providing a sympathetic background for the old picture taken on a boat. This print was made in two stages. First, the central image was exposed, while a broad border was masked. Next, with the negative still in position and the safety filter over the lens of the enlarger, an opaque sheet of card was placed over the main picture area to prevent it being fogged, and the lace trimming was arranged in position. For the second exposure, the negative was removed from the enlarger, and the photogram border was fogged with white light.

Another special effect that can easily be achieved at the printing stage is tone elimination, in which the image is reduced to areas of pure black or white, without any intermediate gray tones. In order to eliminate gray tones entirely it is first necessary to print the negative onto special high-contrast film (called "lith" film), but you can produce a very similar result simply by printing directly onto very high-contrast paper. Use grade 4, 5 or 6, depending on exactly how much you want to increase the contrast. Hard grades of paper are normally used to improve the picture when the negative is too thin from underexposure or underdevelopment. But, as here, they can be used to enhance negatives that are already of good quality.

It is also possible to use darkroom techniques to create photographs that appear to be objective records of an actual scene, although in fact the events portrayed need never have occurred and may indeed be an impossible fantasy. Various methods can be employed to combine elements from several different negatives: you could, for example, paste together sections carefully cut out from several pictures and photograph the result. More simply, if there are only two or three negatives to be combined you can expose a single print in several stages, using the method explained in the caption on the right to ensure that the images are correctly aligned with each other.

A miscellany of everyday items was taken as the subject of this photogram, which was made without the use of camera, lens, or film. The arrangement was composed on the photographic paper while the enlarger safelight was on. Most of the objects are easily recognizable, with the possible exception of the floodlight bulb and the cut-glass ashtray. The picture of a scene aboard a sailboat was made using a combination of normal printing and photogram techniques to create the decorative border around it.

The brittle delicacy of this tree was emphasized by printing the negative on hard (grade 4) photographic paper. This has given the picture a very harsh contrast between dark and light areas, without entirely eliminating all of the gray tones.

A handful of pebbles and a girl walking on the shore were photographed on separate negatives, and the two images were combined into the single print seen here. Combining the images without a visible join was in this instance made easier by the absence of detail in the sky. First of all, I exposed the lower part of the print, at the same time masking the top half. Then, with the safety filter over the lens, I traced the skyline onto a sheet of paper, taking care not to move either the negative or the original photographic paper. When I had replaced the first negative by the second, I was able to position the image of the hand correctly in relation to the tracing of the skyline. During the second exposure I covered the portion of the paper that had already been exposed. Finally, I processed the print in the normal way. If you use resin-coated printing paper you may prefer to use an alternative method of multiple image printing, in which you develop the print after the first exposure, without fixing it: you can then dry it and, using the safelight, align the second image with the first. You then expose the second image and develop the print a second time. This process may be repeated any number of times before you finally fix and wash the print.

Finishing and storing

The amount of care you take in finishing, mounting and storing your final enlargements and transparencies should reflect the effort that you put into producing them. Slides, negatives and reference prints will spend long periods in storage and must be well protected and convenient to find.

Storing negatives

If you have large numbers of negatives, the ideal storage system is a loose-leaf ring binder. Acid-free paper sleeves for rollfilm and 35 mm film are available from photographic supply shops. A 35 mm sleeve will take several strips, each consisting of six negatives. One complete film of 36 negatives can be filed on one page, with a little extra space available in case you have managed to take a few extra shots on a roll. The contact sheets belonging to each roll of film can be filed alongside, so that visual reference is available for all your negatives.

Storing slides

Slides are normally mounted in cardboard or plastic frames by the processing laboratory, but it is possible to have them returned to you in the form of strips of film, so that you can mount selected pictures in the kind of frame you prefer. Plastic frames are hard-wearing and are the least vulnerable to damage by projectors or from rough handling.

Ordinary mounts do not protect the surface of the film from damage. Transparencies that are likely to be frequently projected can be mounted between two cover glasses, which are then bound together to make the slide. The best glasses are of the "anti-Newton" type, which prevent the formation of the interference patterns called Newton's rings.

Slide storage systems are numerous. The cheapest method is to keep slides in the plastic box in which film processors return mounted slides to you. If you do not have too many slides, a spare magazine for your slide projector makes a handy storage system; you can keep the pictures in the correct viewing order, ready for immediate projection. This method of storage is relatively expensive, however, and the slide magazines take up more space than other storage containers.

Slides can also be kept in transparent plastic sheets with pockets. A rod runs along the top of each sheet so that it can be hung in a filing cabinet drawer. Photographers who frequently offer pictures for publication find such sheets useful for transporting large numbers of slides and displaying them alongside each other on a light box. The system is not so suitable if your slides are mainly intended for home projection.

Mounting prints

Before being displayed a print needs to be mounted. The best mounting material is heavy-duty card. Fixing materials are varied and rubber-based glue, double-sided tape and spray fixative can all be used. The method preferred by most professional photographers, however, is to use special mounting tissues, impregnated with a resin that becomes adhesive when it is heated. This method of mounting is explained on the opposite page.

All negatives, slides and prints need to be stored in an environment that is free from dust and moisture and in which the temperature is fairly constant. A humid atmosphere will encourage the growth of destructive funguses on emulsion surfaces, so it is wise to place packets of silica gel in drawers to absorb excess moisture. You will need to dry these crystals periodically by baking them in an oven at a low heat.

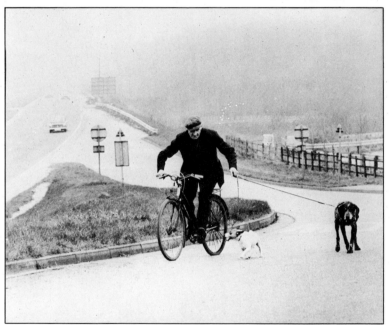

Mounting a print behind glass
1 Cut a piece of hardboard to the required size.
2 Attach the print with double-sided tape.
3 If you wish, add a colored facing card with an aperture just large enough to show the print.
4 Add a piece of glass the same size as the hardboard and facing, to complete the assembly.
5 Attach a clip at each corner to hold all the components together securely.

Prints may be marred by a variety of blemishes. Here a number of tiny spots on the negative have appeared as white dots on the print. With use, a negative or transparency is likely to acquire inconspicuous scratches or other marks that will become prominent on an enlargement. If cleaning the film does not remove such marks, the print will have to be retouched as shown below.

Spots on a print can be retouched with special photographic dyes, or with designers' gouache, applied with a fine sable-hair spotting brush. A fixative spray may be applied afterwards. If large areas are to be retouched, it is necessary to spray on the dye or gouache with a device called an airbrush. Dyes are obtainable for retouching color prints. The color is built up in layers.

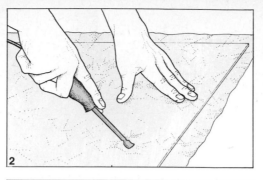

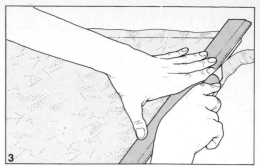

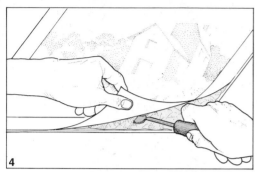

Mounting a print on card

1 Cut the mounting board to the required size, which can be larger than the print.
2 Place a piece of mounting tissue (at least as large as the print) on the reverse side of the print and secure it at the center, using a tacking iron.
3 Turn the print over and trim off excess tissue.
4 Position the print on the mounting board. Lift each corner and use the tacking iron to secure each corner of the tissue to the board.
5 Cover the print with clean paper and run over it with an ordinary household iron, so that the whole print adheres to the board.

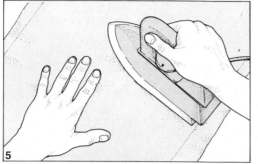

Acid-free envelopes are available for storing all sizes of film, including $2\frac{1}{4} \times 2\frac{1}{4}$ in, 35 mm and 5×4 in. A loose-leaf ring binder is convenient for storing negatives with their contact prints, positioned on opposite pages for quick and easy reference.

Slides should be labeled with identifying information as soon as they are mounted. A spot placed in, say, the top left-hand corner saves time in arranging them for viewing. The slides can be stored in the box in which they are returned by the processing laboratory, in a spare projector magazine or in transparent display sheets kept in a filing cabinet.

Understanding color film

A color photograph has a complex structure. A transparency or negative has three colored layers, each containing its own dye formed or added during processing, and several transparent protective layers, all coated onto a base layer. In a color print a similar structure is coated onto white paper. Only the three layers in which colors appear concern us.

Before exposure, each of these layers consists of a light-sensitive material, essentially like ordinary black and white film. But the top layer is sensitive only to the blue part of the light from the scene, while the other layers are sensitive to the green and the red parts of the light respectively. Blue, green and red are the primary colors to which the human eye responds and which, mixed together, make up every other color.

A color print or transparency represents a range of different colors, with varying hues, saturations and brightnesses, by means of only three dyes, yellow, cyan and magenta. Each dye subtracts one primary color from white light. Thus yellow absorbs blue light (blue is called the *complementary* of yellow). Cyan absorbs its own complementary, red; and magenta absorbs its complementary, green. During development, an image is formed in each layer consisting partly of clear areas and partly of dye areas—yellow dye in the blue-sensitive layer, magenta in the green-sensitive layer, cyan in the red-sensitive layer. When these images are super-imposed they yield the colors of the original scene, as explained in the diagrams on this page. On the opposite page the essentials of the actual processing are explained for the benefit of anyone wishing to do his own color processing.

Color transparencies are made up of many layers of gelatin, including three dye layers. In the picture of the flag, the dye layers, shown separated here, contain images colored yellow, magenta or cyan. Superimposed, these layers make up the correctly colored picture.

Each layer of a color transparency subtracts one color from white light passing through. The yellow dye absorbs blue in areas where blue must be absent from the final image, such as the green part of the flag. The magenta dye absorbs green light in areas where green is absent, such as the red areas, and the cyan layer absorbs red light in appropriate areas.

Yellow, cyan or magenta dye is formed in each layer of a color transparency in those areas where light of the complementary color was not present in the corresponding area of the subject. When the transparency is viewed, these dyes in combination subtract the unwanted colors in the appropriate areas of the image. Since each dye subtracts one component of the light passing through the transparency when it is viewed, yellow, cyan and magenta are called the subtractive primaries. Study the effects of combining these colors as shown on the right. Then see in the diagram above how the color of each area of the picture is formed by the superimposition of the corresponding dyed areas of the separate layers. The illustrations are simplified so that in each layer the dye is shown either absent or present in full density.

Light of three primary colors, red, green and blue, can be combined in appropriate proportions to form any desired color. Thus a mixture of red and green light will look yellow, a mixture of red and blue light will look purple (magenta), and a mixture of blue and green light will look an intermediate greenish blue (cyan). A suitable mixture of all three primary colors looks white. Furthermore, any intermediate color can be formed by varying the proportions of the primaries. Thus to make a correctly colored picture of a scene it is sufficient to ensure that it reflects or transmits appropriate proportions of red, green and blue light.

Any scene can be analyzed into red, green and blue components. Here a flag is viewed through three colored filters in turn. The red filter absorbs blue and green light, so that it makes areas of these colors look dark, while the red part of the flag continues to look red. But the white and yellow parts of the flag also look red, showing that red light is present in the light reflected from these areas. The other two filters show that blue and green light are present in the light from the white area, while green light, but no blue, is present in the light from the yellow area.

A yellow and a magenta filter look red where they overlap: the yellow absorbs blue light and the magenta absorbs green.

Magenta and cyan filters absorb the green and red parts of light respectively, so where they overlap only blue light can pass.

Cyan and yellow filters, absorbing red and blue light respectively, allow only green light to pass where they overlap.

No light can pass where cyan, yellow and magenta filters overlap, since the red, green and blue parts of the light are absorbed.

Reversal film processing

All film types are similar: the top layer records the blue component of the light, the middle records the green, the bottom layer records the red. Transparency processing proceeds thus:

1 A black silver image is developed in each layer wherever the relevant color was present in the subject (compare the diagrams at the top of the facing page). Then the film is fogged, chemically or by exposing it to light.

2 The remainder of the silver can then be developed. But special chemicals now cause the dyes to be formed with the new silver. Thus yellow dye, for example, appears wherever blue did *not* appear in the subject.

3 The silver is bleached out, leaving the transparent dyed layers making up the final picture.

Negative film processing

Color negative processing leads to an image in colors complementary to those of the subject.

1 Color development takes place first: thus silver and yellow dye appear wherever blue appears in the subject.

2 Silver and the undeveloped silver compounds are removed, leaving the dye images in place. Since the dyed and clear areas are the reverse of those in a transparency, all colors in the image are reversed. The negative can be used to make an unlimited number of prints by being photographed onto sensitive paper, which is then processed in a similar way to reverse the colors again, forming a positive image.

Red-sensitive layer
Green-sensitive layer
Blue-sensitive layer

Dye destruction printing

In prints made from slides with dye destruction papers, the dyes are present in the unexposed paper (below). The transparency to be copied is projected onto the paper with an enlarger.

1 Silver images are developed in each of the layers.

2 The silver is bleached out while the dyes are destroyed in the same areas, forming the final positive picture.

Printing from a color negative

Ordinary photographic paper is coated with three sensitive layers of emulsion like those of a film, but in a different order. The processing is much like that of the negative itself and results in the reversing of the colors of the negative to produce the colors of the subject. First the negative is projected onto the paper using an enlarger; latent images are formed in the three sensitive layers in those areas where the corresponding color is present in the negative (and therefore absent in the subject).

1 The silver is developed in the exposed areas and dyes are formed with it.

2 The silver is bleached out, leaving three dye images making up a positive image by subtractive combination.

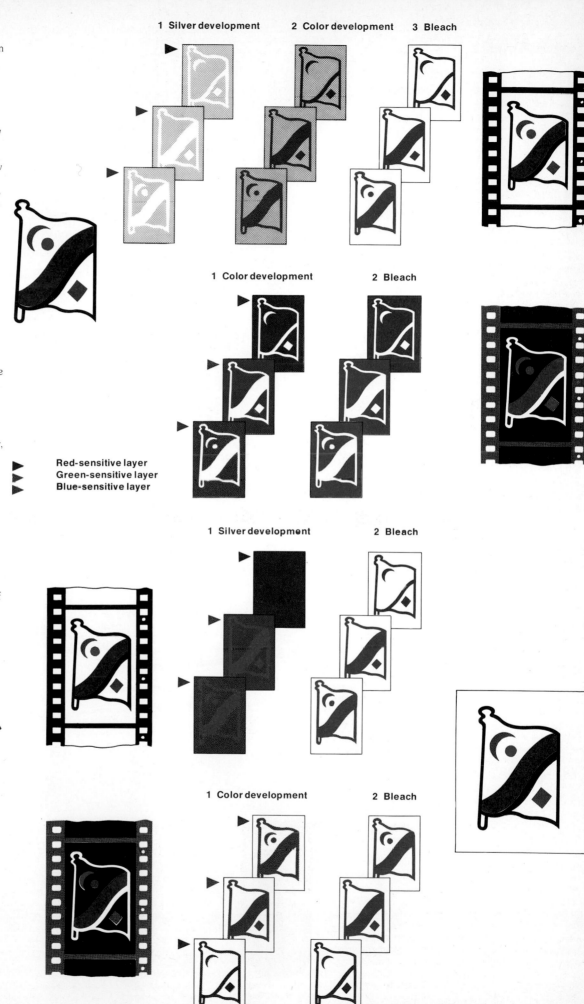

99

The color darkroom

Darkroom equipment for processing color materials differs only slightly from the standard equipment used for black and white processing. A simple enlarger can be adapted for color work if it is equipped with a drawer for the filters needed to produce the correct color balance. You will need to purchase a set of yellow, magenta and cyan filters: sets usually contain about seven filters of each color, covering a range of densities. In addition, an ultraviolet filter should be used with the pack (already incorporated in color enlarger heads), and the enlarger must be fitted with an infrared heat filter above the filter drawer.

The alternative is to buy an enlarger with a special color head. These are more expensive than ordinary enlargers intended primarily for printing black and white photographs, but they are more convenient to use, and worth the extra expense if you intend to do a great deal of color printing. Color enlargers have continuously variable filters built into the lamp housing; the percentage of each color in the filtration is controlled by three external dials.

Two further items of equipment will make color enlarging easier. A voltage stabilizer evens out fluctuations in the supply from the mains. An electronic color analyzer determines the correct exposure and color filtration, thus eliminating the need for a series of test strips. The procedure for determining exposure and filtration by means of test strips is explained on page 104.

Apart from the different requirements in the enlarger, the only major additions needed in your darkroom equipment are an accurate high-temperature thermometer and a print processing drum. The drum is not strictly essential since you could, if necessary, process the prints in dishes in the same way that you process black and white prints; but processing drums are used almost universally for home processing and can virtually be guaranteed to give consistent results. Their use is explained in detail on the following page.

Temperature must be controlled much more accurately in color processing than in black and white processing and the temperatures used in color processes are higher, often by 10°C or more. You will need a thermometer capable of giving readings accurate to a quarter of a degree centigrade on a scale between 20°C and 40°C.

If you have difficulty in maintaining temperatures with sufficient accuracy, you might consider buying one of the aids intended to overcome this problem. At the more expensive end of the scale you can buy thermostatically controlled baths that monitor temperatures and compensate for any changes.

A simpler aid is a calculator, resembling a circular slide rule, for the presoak technique. The paper is placed in the drum and soaked in warm water for a minute before the developer, which is at room temperature, is poured in. The correct temperature for the presoak water is indicated by the calculator when you have dialed in the process temperature and room temperature. During processing, the temperature of the developer rises as it absorbs heat from the drum. Such calculators are made by certain manufacturers, such as Durst, for use with their own equipment, and give very accurate results.

Extra care must be taken in color processing to prevent chemicals contaminating each other, preferably by using a separate measuring cylinder for each solution. Finally, since the chemicals involved are considerably more harmful than those used for black and white processing, always wear rubber gloves when handling them and take care to keep them out of the reach of children.

The basic equipment needed to process and print color materials at home is illustrated below. Most of the essential items will already be part of a darkroom equipped for black and white processing.

1 Inexpensive enlarger with filter drawer
2 Set of yellow, magenta and cyan printing filters
3 Color enlarger with built-in filters
4 Print processing drum
5 Measuring cylinders
6 Rubber gloves
7 Accurate high-temperature thermometer
8 Film developing tank
9 Chemicals for processing color
10 Timer

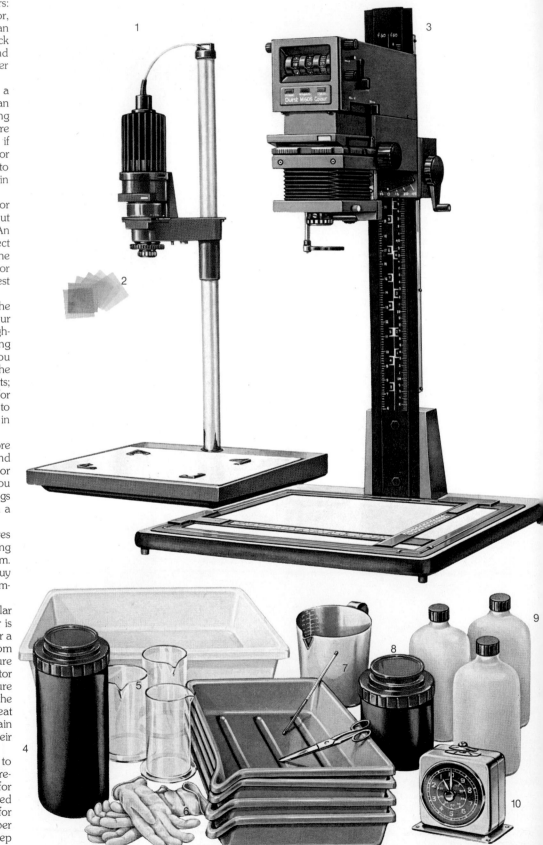

Processing color film

Color films can be processed in the same daylight developing tanks used for black and white films. Nearly all color films, both negative and reversal, are suitable for home processing, though there are one or two exceptions (such as Kodachrome) which must be sent back to the manufacturer to be processed in a laboratory. Unlike black and white materials, however, the chemicals made by different manufacturers are not interchangeable, so make sure you have the right chemicals for your film.

Provided you follow the manufacturer's instructions carefully and maintain a high standard of accuracy and consistency, you should find color films no more difficult to process than black and white films. The step-by-step guide given below is a generalized account of the important stages common to all makes: no two systems are exactly alike, but as far as the user is concerned the only differences are the number of solutions that are involved and the actual times and working temperatures required for each stage of processing.

There is, moreover, very little difference between processing color negative films and color reversal films (which give positive transparencies), except that reversal films require a step missing from negative processes: the film must be fogged at the appropriate moment. In one or two systems, this fogging is produced chemically, but in the majority you have to take the spiral out of the tank after the first development and expose it to bright light before continuing with the processing. This stage of the process is illustrated in the sixth picture of the step-by-step sequence shown below.

1 Begin by preparing the chemicals, diluting them to their working strengths as recommended by the manufacturer. Take great care to avoid the slightest contamination. Stand the solutions in a dish of warm water to bring them to the correct temperature.

2 In total darkness, load the film onto the spiral in exactly the same way as for a black and white film, first making sure your hands are completely dry and handling the film by the edges to avoid touching the emulsion surface. Close the tank.

3 Turn on the lights and stand the loaded developing tank in warm water, together with the chemicals. Having adjusted the temperature of the first solution to the value required, within the recommended limits (usually $\pm \frac{1}{4}°C$), pour it into the tank.

4 Tap the tank gently against the workbench to dislodge air bubbles and start the timer. Agitate the tank as advised in the instructions. While it is not being agitated, the tank should be kept in the warm water bath to maintain its temperature.

5 At the end of the first stage pour out the developer. In some processes the chemicals can be stored and reused; in others they are thrown away after a single use. (Sometimes the chemicals must be neutralized before you can pour them away.)

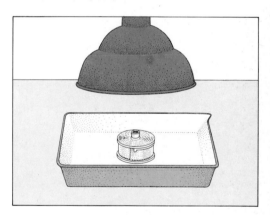

6 Continue with the solutions in the correct sequence. If you are developing a reversal film, the instructions may tell you to expose the film to light after the first or second chemical has been emptied; other reversal films are fogged chemically.

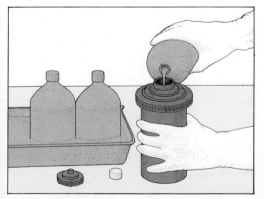

7 Reversal films will require a second developer after they have been fogged. Both color negative and reversal films have a bleaching stage in which the black and white silver image is removed before the film is finally fixed and washed.

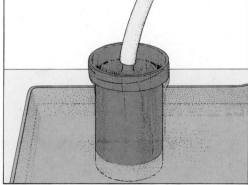

8 Wash the film by pouring in several changes of fresh water or by using a hose attached to the tap, as shown here. Color films normally require a final stabilizer bath after the wash; after the stabilization the image is permanent.

9 Finally, hang the film up to dry in a dust-free atmosphere, preferably in a special drying cabinet. Correctly processed negative film should have an overall orange cast, which compensates for certain deficiencies in the colors of the film dyes.

Making color prints

Although it is possible to process color prints in shallow dishes like those used for black and white prints, a much more convenient method is to use a print processing drum. Since color printing paper is sensitive to all colors of the spectrum, you cannot handle it under an ordinary safelight, so processing in dishes has to be carried out either in total darkness or using a sodium safelight, which is expensive and gives hardly enough illumination to be helpful for a beginner. Print processing drums, on the other hand, allow most of the process to be carried out in normal room lighting, and are similar in principle to the daylight developing tanks used to process film. Immediately after the paper has been exposed, it is placed inside the cylindrical drum, curled so that its emulsion surface faces inwards; the natural springiness of the paper holds it against the walls of the drum. Some models are large enough to allow several sheets of paper to be processed simultaneously. The lid of the drum has a light trap; immediately below the lid is a cuplike container, which stores any liquid poured in until the drum is turned on its side. You can save on chemicals by processing your color prints in a drum because a relatively small quantity of each solution is needed —no more than will fill the cup below the lid. The processing drum is agitated continuously by being rolled backwards and forwards on the surface of the table or workbench; more sophisticated models are rotated in a thermostatically controlled water bath by an electric motor.

Mention should also be made of the fully automated color print processors designed for high speed or bulk processing in the home darkroom. The exposed paper is fed into rollers at one end and is returned processed at the other.

1 Place the negative or transparency in the negative carrier of the enlarger, emulsion side facing downward. If you are printing from a slide, you will first have to remove the film from the mount. Clean the film carefully with a soft brush or cloth to remove any specks of dust. Preferably wear a pair of cotton gloves to avoid leaving fingerprints.

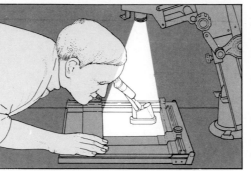

2 With the negative carrier in position, focus the image. Set the lens at full aperture when focusing. Some enlargers have sophisticated autofocusing mechanisms; however, a simple and reliable method is to use a microfocusing device, also called a focus magnifier, as illustrated above, to focus on the grain of the image.

3 In total darkness, open the packet of color printing paper. Cut one sheet of paper into strips that can be used for making test exposures. Place a strip in position on the baseboard so that a representative part of the image falls on it. Put the rest of the paper back in the lightproof packet and make sure it is properly sealed before beginning the exposure.

4 You can make a number of test-exposures on several strips of paper, bracketing the time you think is likely to be required. Or you can make several exposures on one test strip by using a piece of card to mask it. First cover all but a quarter of the strip. Then uncover further bands in succession, so that the strip records a series of known exposures.

5 Switch off the enlarger and load the exposed test strip into the print processing drum, making sure the emulsion side of the paper faces inwards. Once you have closed the drum, you can turn on the lights, but it is as well to make a final check that no paper has been left lying around. Make sure your hands are completely dry when handling the paper.

6 Stand the chemical solutions in a dish of warm water to bring them to the correct working temperature. Follow the manufacturer's instructions and take care that the temperatures are within the specified limits. The temperature of the developer is particularly critical. Always wear rubber gloves when handling color processing chemicals.

7 For some processes, the makers recommend soaking the paper in water before the first chemical is added. One method of achieving exactly the right temperature for the developer, explained on page 100, depends on warming the drum with a presoak at a high temperature calculated exactly on a special calculator dial.

8 After the presoak water has been drained off, pour in the required amount of developer, holding the drum upright, as illustrated above. The solution is stored in the lid of the drum, and will not come into contact with the paper until the drum is turned on its side. Replace the watertight cap on the drum and preset the timer.

9 Turn the processing drum on its side and simultaneously start the timer. Roll the drum backward and forward as illustrated to agitate the solution. Agitation should normally be continuous. (Some models may employ a different mode of agitation, but the essential principle is that you should be consistent in the method you use.)

Printing paper

You can make color prints from color negatives or positive transparencies, using the appropriate type of paper for each. Prints from transparencies are slightly easier to produce, but you can exercise more control in printing from negatives. There is a specific set of chemicals for each brand of paper. Most systems employ dye couplers, chemicals that form the appropriate colors in the papers during development. However, some of the reversal papers designed for printing from transparencies use a dye destruction process, in which dyes already present in the emulsion are eliminated in areas where they are not required (see page 99). Various texture surfaces are available. As all color printing papers are resin-coated, the paper fibers do not absorb the chemical solutions, so prints dry quickly. The papers should not be overheated or the coating will melt.

Slight variations occur in the manufacture of paper, so each batch is tested by the manufacturer under standard conditions, and recommended filter values are printed on the label. Once you know from tests the filtration needed by a given negative for one batch of paper, you can use the information given by the manufacturer to calculate the filtration needed for the same result on a different batch. The normal method of making test strips to determine the correct filtration is described on the following page.

Storage

Unopened packets of color printing paper should be stored on their sides in a cool, dry place. If the paper is not going to be used for some time, it is usually best kept in a refrigerator, at a temperature between 2 C and 10 C. However, to avoid condensation when the packet is opened, allow it to stand for about two hours at room temperature before use. Once opened, the packet should be used up as quickly as possible; do not put it back in the refrigerator, since condensation may occur as it cools. Before closing the packet, squeeze out the air, fold the end and keep the packet in a plastic bag to prevent moisture from getting in.

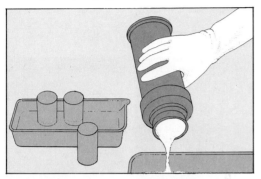

10 At the end of the development time, pour out the solution as quickly as possible. You may find it helpful to allow 10 seconds for draining time. Developer is normally discarded after a single use, but you should check the instructions to see whether any of the chemicals have to be neutralized before they are poured down the drain.

11 Continue with the remaining chemicals in the recommended sequence. The quickest processing systems take about 12 minutes from start to finish, using only three baths: developer, bleach and fixer. Most, however, involve intermediate stop baths and rinses. When the processing has been completed, take the test strip out of the drum.

12 Wash the test strip in fast running water so as to remove residual traces of chemicals. The water should not be too cold. Stabilize the print if necessary and allow it to drain. Finally dry it in warm air. Do not attempt to assess the colors of the strip while the print is still wet, since they appear to change as the paper dries.

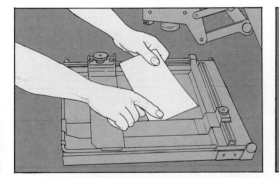

13 From your first test strip you should be able to assess the correct exposure time, but it is unlikely that you will be able to judge the right filtration: you should expect to make several filtration tests before the final print. In the long run you will not save money by trying to make a lucky guess. Process each test strip in exactly the same way.

14 Remember that when you increase the filter values you will also have to increase the exposure time, since the stronger the filters are, the more light they will absorb. Once again, calculator dials are available to determine how much compensation is needed. You should never use filters of more than two colors at the same time.

15 When you are satisfied that you have the right filter values, expose the final print and process it in exactly the same way. Be sure, however, to wash and dry the processing drum thoroughly each time, before beginning a fresh print. Keep a record of the filtration and exposure time used in case you want to make new copies at a later date.

Printing from slides

The Ilford Cibachrome process is an ideal one to use if you are new to color printing. It is a direct positive process for printing from color transparencies, which simplifies the trickiest aspect of color printing: assessing the filtration; the color of the cast is subtracted. Moreover, the Cibachrome process involves only three stages, and has a much greater tolerance to variations in temperature than most color processes: accuracy to ± 1.75°C is acceptable. The chemicals are supplied in kit form, containing six basic components: two liquids that are mixed to form the developer; a powder and a liquid concentrate for the bleach; the fixer; and a powdered neutralizer. The neutralizer should be mixed with the bleach (which is particularly acidic) after use to make it harmless enough to pour down the sink. The Cibachrome chemicals are intended only for Cibachrome color printing paper.

Cibachrome employs a dye destruction process: dyes incorporated into the paper emulsion are selectively removed during the processing. The resulting prints are particularly stable and their color reproduction is good.

Kodak also manufactures a reversal printing system, Ektachrome 14RC, which employs a dye-coupling process, based on the same principle as ordinary color reversal film. Assessing exposure and filtration is nevertheless the same as for Cibachrome: a test strip is first made to determine the correct exposure, and then further tests are made with a series of filter values to get the color balance correct. There is a certain loss of saturation in reversal printing, and it is not suitable for use with slides that are at all thin and overexposed.

Assessing color prints

The aspect of color printing that requires most skill is the assessment of the filtration needed to achieve the best color balance. There are two methods of printing from negatives: additive and subtractive. The additive method is rarely used, being slightly cheaper but slower and more troublesome. It involves making three separate exposures for each negative—once through a red filter, once through a green filter, and once through a blue filter; the colors are balanced by selecting a suitable exposure time for each of the exposures.

The subtractive method is the one described here. The filters that you require are in the subtractive primary colors, yellow, magenta and cyan (see page 98), each in a range of different strengths. Combinations of these filters are used to give a color cast to the enlarger's light—a cast that will exactly compensate for any overall color cast present in the original negative.

When your test print exhibits too much of a particular color, you *reduce* that color by *increasing* the amount of the same color in the filtration: for example, a magenta cast is removed by using a stronger magenta filter. However, the cast is unlikely to require a correction by a change in the magenta filtration alone: you are more likely to need a combination of, say, a large amount of magenta and a small amount of yellow to remove a shade between magenta and red. Experience will make it easier to decide how much of each filter is necessary to cancel a given cast. Color should be assessed only in properly exposed areas of the test strips and against a neutral background. Skin tones provide a good reference point in judging color accuracy.

It is never desirable or necessary to use more than two filter colors at the same time. A third filter will simply reduce the effect of the other two, at the same time lowering the brightness of the image. And adding any of the filters is equivalent to reducing the other two. Suppose, for example, that you want to remove a cyan cast. You could do this by *adding* a cyan filter—say, a 30C—to your filtration. But if your filtration already includes both yellow and magenta, do not do this. Instead, *reduce* the filtration by the complementary of cyan, namely red; do this by reducing the filter combination by 30Y and 30M. This information is summarized at the foot of this column.

Finally, remember to correct the exposure time whenever you change the filter values: the stronger the filters, the less bright the image, and thus the longer the necessary exposure. When you have determined a correct exposure time with your first test, the information provided with the filter pack (or the color enlarger) will enable you to calculate the corresponding exposure for each filtration test.

The ring-around color chart is a useful guide for assessing a color cast and judging how much extra filtration is needed to compensate. At the center is a correctly exposed, correctly balanced print. Along each arm of the chart the print shows an increasing color cast of a particular hue. The numbers below each print refer to the strength of the cast, in terms of the density of the filters needed to correct the cast. These depend on the make of filter you are using—the numbers quoted here refer to Kodak filters. Remember the following corrections:

Yellow cast:	increase Y or decrease M and C
Magenta cast:	increase M or decrease Y and C
Cyan cast:	increase C or decrease Y and M
Red cast:	decrease C or increase Y and M
Green cast:	decrease M or increase Y and C
Blue cast:	decrease Y or increase M and C

The first test is intended to determine the correct exposure, using a basic filtration that experience with your own enlarger has shown you will be about right. Assess your first test as you would a black and white test strip: in the example on the left, for example, the exposure times for the test were 5, 7, 9 and 13 seconds, and the third section is correctly exposed. It has, however, a cyan cast. For the second test, therefore, the amount of cyan in the enlarger beam was increased by reducing the yellow and magenta filtration in the following separate steps: $77\frac{1}{2}Y + 50M$; $75Y + 48\frac{1}{2}M$; $68Y + 44M$; and $62\frac{1}{2}Y + 41\frac{1}{2}M$. At the same time, the exposure was steadily decreased to compensate for the decreasing filter densities: the first strip received 8 seconds, the second 7.7, the third 7, and the fourth 6.3 seconds. The third strip showed the correct balance, so the final print, which appears at the center of the "ring-around" chart below, was made at the filtration and exposure values used for this strip.

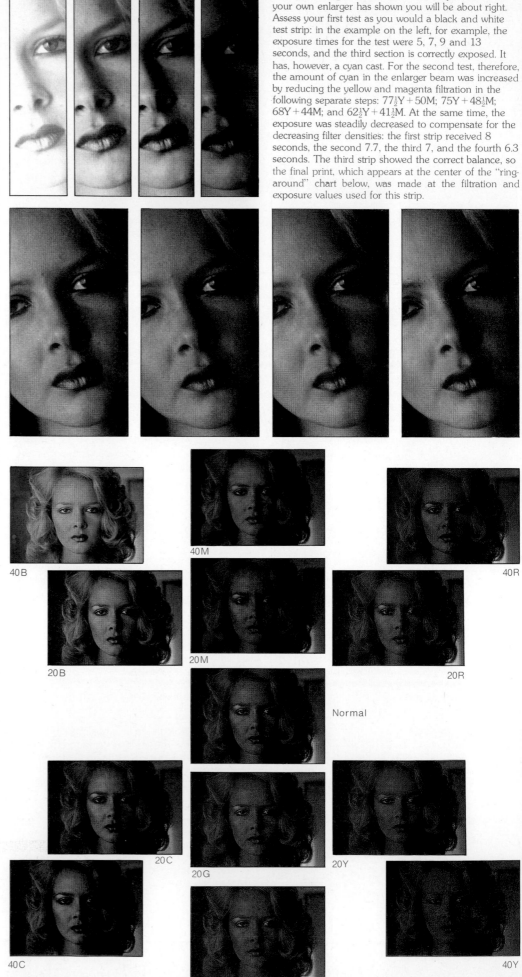

40B

40M

40R

20B

20M

20R

Normal

20C

20G

20Y

40C

40G

40Y

PROJECTS

The principles discussed throughout this book are now put to work in a range of diverse situations. By setting yourself similar projects you can extend both your technical skills and your imagination.

Project 1

Using natural light

Look at any display of scenic postcards and ask yourself why the pictures have a sameness about them. In almost all the views the sky is blue, the water is calm and the landscape is curiously static. It looks as if nothing is going to happen.

This lifelessness is largely a matter of lighting—not very different from the effect of flat, frontal lighting in a portrait. It may seem that landscape photography gives you little opportunity to control the lighting—you have to take what is there. What is there, however, is infinitely variable. The quality and direction of the light change constantly with wind, weather and time of day, producing a shifting play of color and tonal patterns.

Next time you find yourself in scenic surroundings, take one shot in sunny

"postcard" conditions and use the rest of the film to see how many different aspects of the same scene you can capture simply by waiting for the lighting to change. Make sure you get some shots at dawn and at dusk, when the light changes most swiftly and dramatically. If clouds are moving across the sun you can often wait for a shaft of light to illuminate a particular area. Take any opportunity to photograph the scene in mist, rain or storm light.

The pictures here are all of the same fishing village in the Lofoten Islands of Norway. They were taken with only slight changes of view, using two lenses. The first is essentially a postcard shot; although given some interest by the play of light and shade on the mountain it presents an idyllic view of a setting that was actually awesome in its bleakness. Using the same exposure (1/250, f8), but switching from a 35 mm to a 100 mm lens, I waited for late afternoon light to outline the delicate structures against the ominous peaks. The same view at night, with a five-second exposure at f5.6, brings out the warmth and comfort of the lighted houses. Finally, after getting up at six in the morning, I was able to capture a momentary shaft of light through rain clouds, which gave an impression startlingly different from the picture I began with, but much truer to the atmosphere of the location.

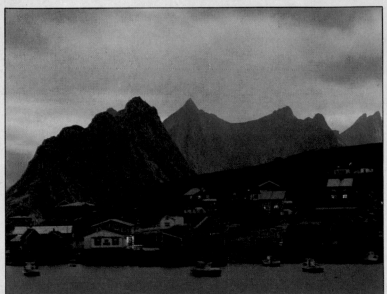

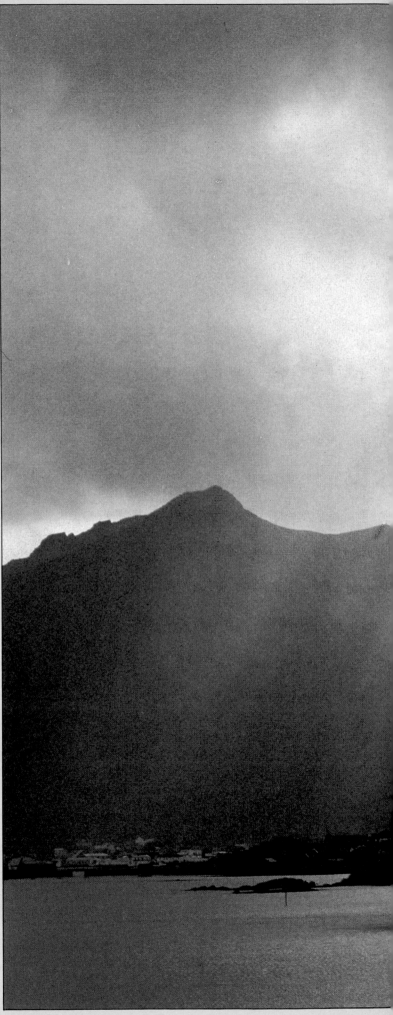

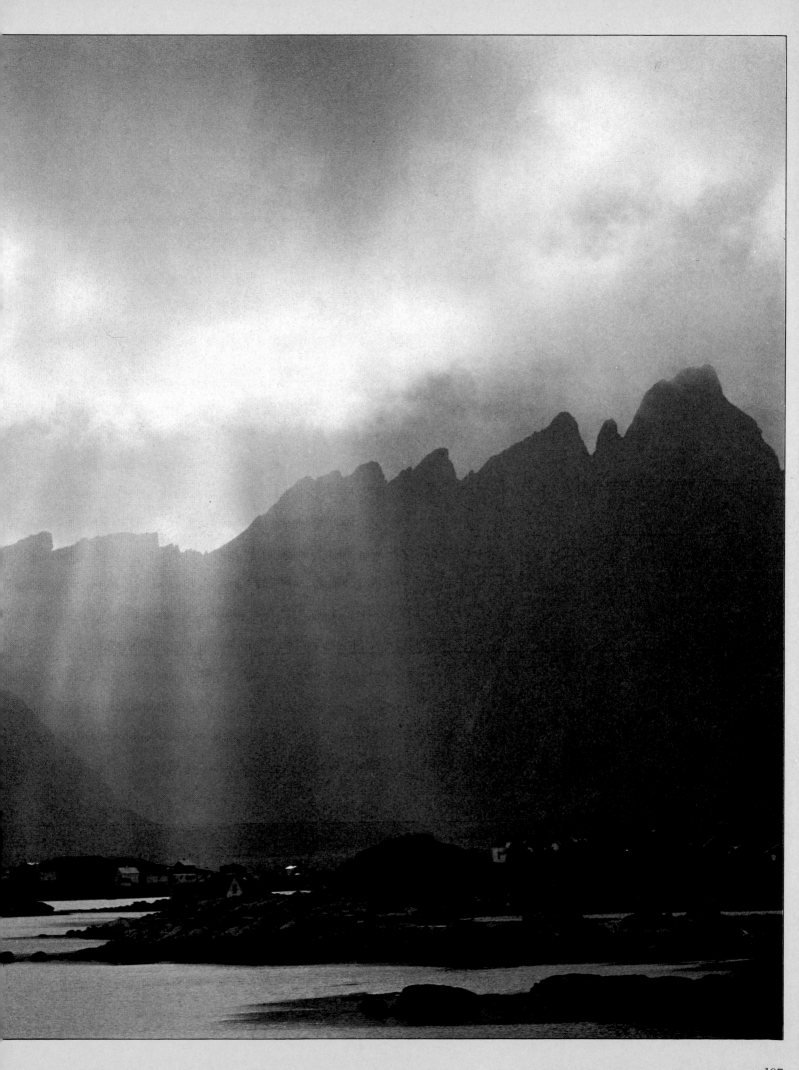

Project 2
Exploiting background

Photographing a subject that is interesting in itself may seem to need little effort on your part. But by using a little imagination you should be able to extend the impact of the picture by introducing into it elements of your own choice. A simple way of testing your ability to do this is to find a fixed background with some inherent appeal and then see what connections you can make between it and the foreground.

The street mural shown here made a colorful subject on its own and I began simply by recording the artist's work in a straightforward way. The even lighting of an overcast day was well suited to bringing out the qualities of the painting. On a brighter day, with slanting sunlight on the wall, the brick surface might have been thrown into relief that could have conflicted with the painting.

The close-up of a butterfly dwarfing a flower was among several details I selected, still to show the artist's work. I underexposed the Ektachrome in my Pentax by half a stop—which helps to produce rich, saturated colors when you are working with reversal film.

Then I began to add something of my own to the subject by relating the wall to its transient surroundings. A common mistake in urban photography is to regard obstructions or passersby as nuisances. In fact they can often be incorporated, either to reinforce the subject or to provide ironic contrasts with it—as in this case, where the gaiety and exuberance of the mural reflected the nostalgia that city dwellers feel for the colorful prodigality of nature.

The parked taxi is taken from an angle that makes it seem to have embedded itself in the wall, causing some alarm to the open-mouthed woman above it, as well as the teetering cyclists.

To establish another link between the comic book world of the mural and the sober world of the city, I used a slow shutter speed (1/30) to photograph an elderly passerby. Blurred in this way, he seems absentmindedly about to reach out and pat the head of a dog, as if bewildered by the odd creatures and exotic plants that surround him.

Fantasy meets fantasy in the final picture, of an eccentric vehicle parked in front of the same section of mural. The motorcycle's windshield, mysteriously packaged in a tarpaulin, neatly frames an equally eccentric bird, which seems about to be dislodged by the windshield wiper from its perch on the rail of the cart.

The capacity of photographs to bring together in a permanent image subjects that may be linked only accidentally and momentarily can be used to comic effect, or, alternatively, to make a serious social point. This is particularly true because photographs, in the absence of strong perspective, always tend to represent everything in the scene on the same plane. Anyone who is alert to the possibilities of juxtaposition is well on his way to being a creative photographer.

Finding a theme

Any theme can be used to bring together a group of pictures—usually the simplest themes are the most effective. Individual photographs will often benefit from being grouped together, gaining interest from the context supplied by the other photographs. The idea of seeking out pictures with a common motif lends itself very well to project work. No special equipment is required, nor are any particular technical difficulties involved. Once you have chosen a subject you can continue to develop it over a long period of time, even working on other things in the meantime.

If you are normally inclined to take pictures of anything that catches your attention, you may find that you already have a number of photographs with a recurrent motif, of which possibly you have not been aware. It would obviously be logical to develop such a theme deliberately and to take advantage of what you have already been doing in a haphazard way.

An example of a suitable project motif is the use of windows in all the photographs on these pages. With this providing the general theme, the pictures have been grouped into smaller units of two or three that have something further in common. For example, two simple pictures show windows decorated with lace curtains; two others show the designs on the glass of a bar and a restaurant. Some of the other pictures are linked by the way they use windows as convenient frames for human action, so that the flat surface of the glass is extended by the various miniature dramas that are reflected in it or seen through it. The blurred shape of a woman in front of a door, for example, suggests that she is rushing past the musician who appears to leer at her from the poster. In another pair of pictures the resemblance between the rows of shelves emphasizes the contrast between the objects that are neatly arrayed on them— on the one hand, cold, metallic containers, and on the other, freshly baked bread and cakes.

Sometimes bizarre objects create the interest of the picture, as in the case of the unusual scarecrow by the window propped open with a tin can. Or the window may frame an evocative collection of objects, such as the sausages or the hairdresser's display. The picture of the jewelry shop, its window broken as if a burglary has been attempted, exploits the pattern made by the glass.

Social interest is one of the potentials of any photographic subject (though one never knows what the historians of the future will find interesting) and the two figures outside the "stewed eels" shop clearly fit into the style of the surroundings, completing the picture as a social period piece. In a contrasting example, three figures can be seen reflected in a modern window; the bright wall around the window adds an element of color to a very simple design.

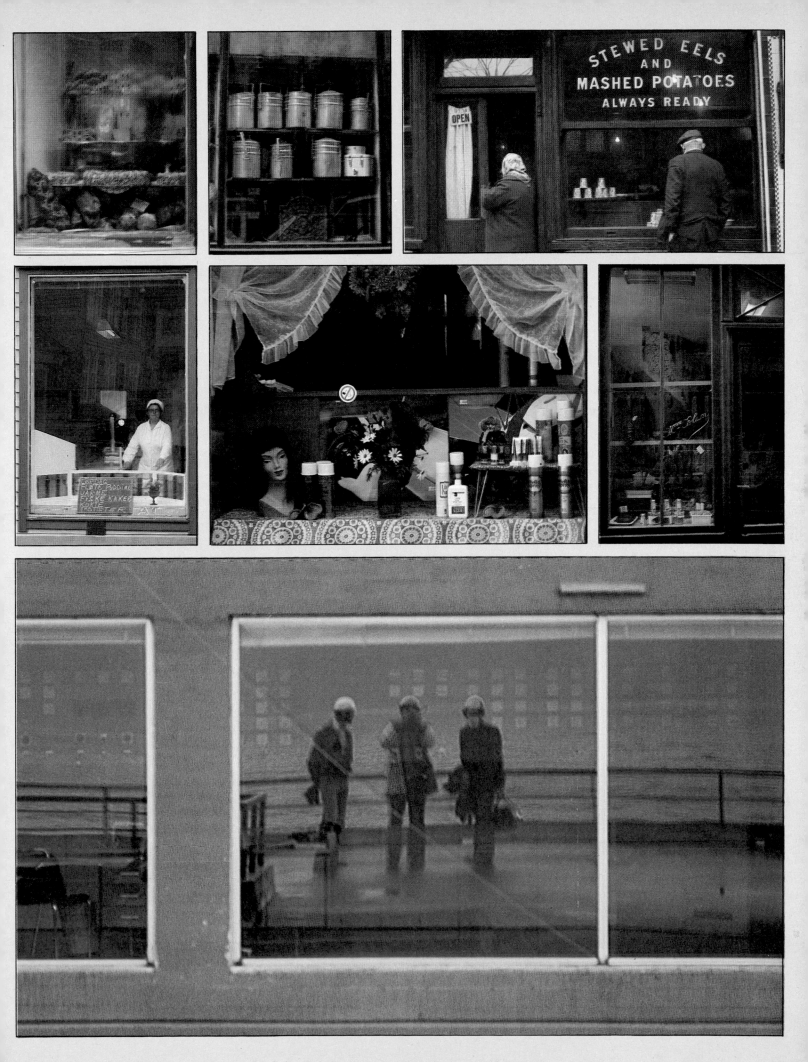

Project 4
Colored lights

The multicolored lights of a resort or a city center can make a spectacular project sequence as long as you keep a careful eye on exposure. The most common fault is underexposure, so that only a few points of light appear,

surrounded by darkness. For these pictures of the summer illuminations at Blackpool, I used exposures of around a minute at f16, using ISO 64 film. You should experiment with a range of exposure times, using a tripod or firm resting-place for your camera. Interesting results of a different kind can be obtained by deliberately moving the camera during the exposure.

In calculating exposure, use your light meter carefully. Don't point it directly at

the brightest parts of the scene; I aimed my viewfinder just above the lights seen here so that the built-in meter took in some of the sky. In most of the pictures the sky is fairly bright and silhouettes the buildings. The lights are somewhat overexposed, but this adds to the sense of their brilliance. For the large picture on the opposite page I reduced the exposure: the sky is dark and most of the light are clearly defined. The impact of pictures such as these is heightened if

large reflecting areas, such as puddles, store windows or the sea, are included. In the large picture below I filled the dark foreground with a cascade of color by exposing the picture for about 45 seconds and then slowly tilting the camera upward during another 30 seconds. Special filters can be used to create striking abstract patterns. The photographs at the foot of the page were taken through a "starburst" filter (left) and a prismatic filter.

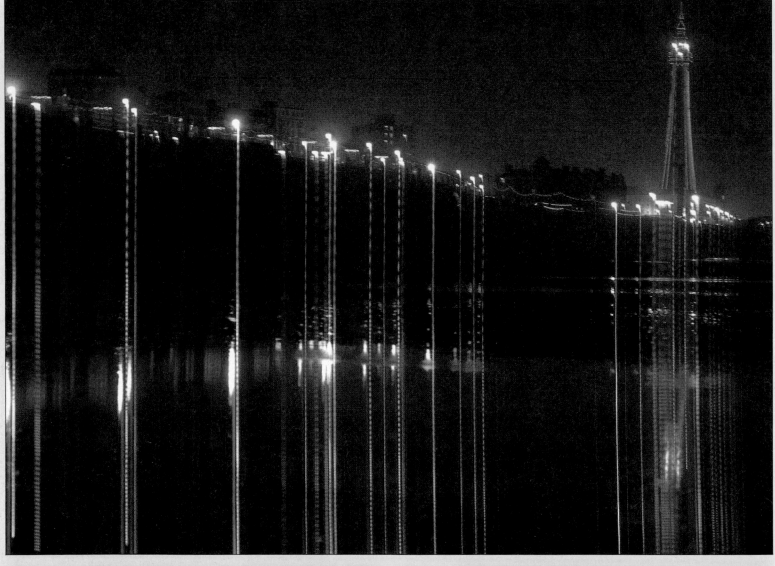

Project 5
Still life: found objects

A still life is a picture in which inanimate objects are photographed for their own sake. You can approach still life photography either as a formal exercise in composition, lighting and handling of materials, or as an opportunity for self-expression in which the objects are selected and arranged to create a special mood or express an idea. The best still life photographs are both technically skillful and imaginative.

Ideas for building up a still life group are discussed on the following pages. But you should begin by looking for chance arrangements that are pleasing in themselves, such as those shown here, and which can be photographed with any cheap camera. In fact the purpose of much painstaking effort in setting up groups is often to give the impression of an arrangement found by chance. In a found still life the relationship and position of objects usually reflect their function, giving the arrangement a purposeful strength.

These pictures were taken in a kitchen illuminated by shadowless overall light, superb for bringing out the details of its diverse contents. The diagram shows the camera position in relation to an overhead skylight and a window. Kitchen utensils are a useful starting point for a still life offering an assortment of interesting shapes and textures. Their very familiarity makes it challenging to find fresh ways of looking at them. The decorative yet functional display of pots and pans here suggests an old-fashioned orderliness, with home-made jams neatly stacked and labeled by an owner who seems to have an eye for balance and variety of forms.

To fill the frame with a small group such as the telephone and key on the opposite page you will need a camera capable of focusing down to distances of only a few feet. This particular group is both balanced and casual in its composition. The forms of the old-fashioned telephone and hotel key are revealed by the shallow recess as if in bas-relief, and the coiling line of the cord carries the eye out of the frame, suggesting a connection with the outside world. As in all good pictures, this simplest of groups triggers off the imagination because both the key and the phone are so rich in associations.

115

Project 6
Still life: arrangements

Still life is of vital importance in developing photographic skills because it allows you to exercise complete control over your subject. Although soft directional light is usually best, it is instructive to explore the effect on a still life of changing lighting angles.

The project on the previous page showed the possibilities of recording chance arrangements; the next step is to build up a composition piece by piece. This takes imagination as well as patience. A still life needs a unifying idea or sympathetic shapes, forms or textures, and it may take some time to gather suitable objects. It is essential to check your arrangement constantly through the viewfinder as you build it up. Although special equipment is not necessary, a

large-format camera (perhaps a cheap second-hand model) is ideal as time is less important than print quality and control over the image.

To record fine detail and ensure overall sharpness in the pictures shown here I exposed fine-grain film at a very small aperture. The quality of glass is clearly revealed by the reflected highlights formed on the surface in the diffused light of a weak sun. To make the bottle and glass shine I gave them a hot wash and cold rinse and then photographed them through a hole in a curved foil reflector as shown in the diagram. The contrasting texture of wooden boards brings out the glowing transparency of the glass.

Contrasts of tone and texture also help to give the still life of eggs on a plate its strong tactile quality. The different forms and surface qualities of pewter, glass and candle wax, the smooth eggs and the dark, polished table are all clearly identified through their juxtaposition, while the recurring ovals and farmhouse associations provide a unifying theme.

Project 7
Still life: lighting

Using still life creatively depends above all on having a clear conception of what you are trying to achieve; there must be a purpose behind your selection of props and of the final arrangement. For this project, choose a theme for the still life so as to make a definite point. For the first arrangement, for example, I selected items that were linked by a humanitarian idea: an old photograph of my grandfather, a war victim, together with his war medal showing an engraved horse, and a china equestrian statuette, produced as a war memento. The juxtaposition of these objects is a way of making a comment on the way society looks at war and on the nostalgia industry: the ornamental china officer, more like a chocolate soldier than a real one, is a trivialized emblem of battle, contrasting with a reminder of a less glamorous reality.

The light source for the small picture was a desk lamp placed so that hard shadows were cast on the wall by a rack taken from a refrigerator and supported by books. I moved the horse slightly to prevent the shadow from the photograph touching the head of the figure. The larger photograph of this group was taken in normal room light from a 100 watt bulb in the ceiling.

The photograph of a plate of snails with a glass of wine makes a gently ironic comment on the conventional idea of a "gourmet" picture. At the same time it illustrates the kind of practical difficulties that may confront you: the snail was more active than expected, and tended to crawl off the plate. Eventually I slowed it down by pouring a few drops of water into the dish, making the sides more slippery.

The style, based on simple, clear shapes such as the oval that is echoed repeatedly in the picture, suggests taste, elegance and restraint. The live snail, however, adds an undisciplined touch as it innocently explores the plate.

The nude /1

The human body is one of the most evocative of subjects as well as one of the most difficult to photograph well. At its most challenging level, nude photography can become a means of expressing mood and emotion. But I suggest that you start by learning to observe and capture the changing forms of a woman's body from a more abstract viewpoint, as in the two main pictures here. It is important that you should establish a good working relationship with your model so that she does not feel embarrassed or vulnerable. Choose a secluded area where other people will not disturb the photographic session. Background music and constant reassurances will help put the model at ease. Do not be in too much of a hurry; if her poses are awkward leave it for a while: she may be more self-confident later. Make sure the room is warm, and remember it is tiring to remain in the same position for a long time.

Lighting need not be elaborate. These photographs were taken in soft directional light from a window as the only source of illumination; for the picture on the opposite page, a fill-in reflector was used.

You might also want to experiment with working out of doors, but take care to select a sympathetic setting. The photograph at the bottom of this column makes use of the space and rhythm of the background and is intimate without being too provocative. The model's facial expression plays a vital part in the mood of a picture; by excluding the head in the other examples, I could treat the body more impersonally.

Project 9
The nude /2

Once you have become accustomed to the practicalities of nude photography, you should begin to look for ways of developing its possibilities. Start with a simple idea: here I have combined the interplay of shadows cast by sunlight shining through venetian blinds with the curved form of the model. The way the lines fall on her body helps to describe the subtleties of shape: in the picture of the girl resting her head on her knees, the outline of her back against the wall is indicated not so much by a change of tone as by the slight dislocations in the patterns that the shadows make.

In these two photographs, the patterns of light and shade have become a major part of the subject. The shadows conceal the figure as well as reveal it and the sense of organic form is heightened by the contrast between curves and analytic lines. When trying out such effects, take care that the play of light does not completely overpower the form, and avoid overelaborate poses.

As an alternative to natural light, you can use an ordinary slide projector to create similar patterned effects, although the results will generally be harder and more emphatic. For straightforward soft, directional light, on the other hand, it is easy to improvise a natural-looking effect by using four 500-watt bulbs behind a white bed-sheet to act as a diffuser.

Environment and mood

Many photographs of urban scenery fall into one of two categories: those that portray the conditions of city life as grim, depressing and squalid—particularly in heavily industrial areas—and those that express the photographer's nostalgia for ways of life that are disappearing. Each type of picture is a form of social comment, since the quality of people's surroundings reflects the quality of their lives. Some photographs arouse indignation; others idealize and romanticize, soothing the conscience or encouraging pleasant memories.

As a basic exercise in giving prominence to what is most beautiful or what is most ugly you should begin by trying to select the viewpoint or weather conditions that suit your interpretation. Then experiment with the ways in which you can emphasize the mood of the scene at the printing stage. The pictures on these two pages show some of the techniques that can give a critical view of urban life, while the following pages deal with more romantic interpretations.

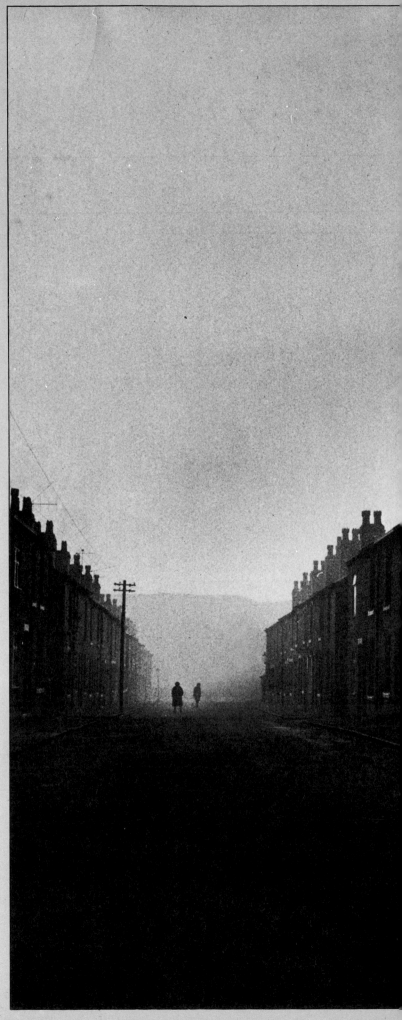

Political and industrial forces sometimes seem to overshadow ordinary people, controlling and restricting their lives. In the large photograph of a street (since demolished) in Castleford, Yorkshire, low-key tones, a foggy atmosphere and the linear perspective along the regular rows of houses present a picture of an unhealthy, monotonous existence dominated by factories. Even the figures in the distance seem to be moving sluggishly, without energy or enthusiasm. A heavy print helps this mood. As shown overleaf, the same street could have been made to look cheerful or comforting by using a different technique.

The Berlin Wall has a complex political significance, but I have treated it from a purely human angle, emphasizing the stark shape of the wall and barbed wire against the bleak sky. The downcast figures, smudged and anonymous, seem to make their own comment on the wall's oppressive effect.

An isolated farmhouse on Canvey Island in Essex, standing on the very edge of its remaining land, looks threatened by the industrial monstrosity that has sprung up behind it—a gigantic oil refinery. Dozens of chimneys, resembling the stalks of unhealthy plants, contrast with the wheat in the foreground, so that here the juxtaposition of images itself makes the point, underlining the conflict between agriculture and large-scale industry.

Project 11
Idealizing the environment

There are no fixed rules for making cheerful photographs of areas that might otherwise appear to be depressing. A high-key print may sometimes help to lighten the mood. But if you are trying to convey a buoyant or nostalgic feeling you will probably find that it is more a matter of selecting the right viewpoint or of using people in the scene to emphasize its optimistic aspects.

The first photograph here makes an interesting comparison with the gloomy urban scene on the previous page. A similar misty street, this time in Sheffield, is photographed from much the same angle, but the mood of the picture is utterly different. Instead of suggesting that a squalid past should be swept away the feeling this time is that something worth preserving is in danger of disappearing. The workman cleaning the antique street lamp so carefully is the key to this mood. The high-key tone, together with slight vignetting, suggests the quaintness of an old-fashioned picture album, and the houses vanishing softly into the mist also seem survivors of a past in which pride in work and a close, friendly community were more important than modern comforts.

The view of an oil refinery at night again takes a subject that on the previous page seemed hostile and turns it into a romantic image of the kind used in industrial posters to stress the power and promise of technology. To take this photograph I used a plate camera, which enabled me to double-expose one half of the negative while giving the other half only one exposure. The jet of flame is seen through a tube of rolled-up metal foil held in front of one side of the lens. The first exposure thus recorded both the refinery and the flame. During the second exposure, I slid the sheath across half the frame to cover the jet and gently tapped the tripod so that its vibrations produced a double-exposed image of the refinery that seems to quiver with power.

The butcher's shop front has quite a self-important air about it, imitating the façade of a Greek temple. I exploited and exaggerated this feeling by a viewpoint that allows the shop to fill the frame and stresses the symmetry even of the hanging meat. As a result the picture becomes a kind of monument to a small shop proud of its personal service and defying supermarket competition.

People and environment /1

People express their characters through the way they furnish and decorate their homes as much as through the way they look. Not only personal traits such as a concern for tidiness but also their tastes, interests and background are revealed in their arrangement of rooms and in the objects with which they surround themselves. The extent to which people impose their personalities on their environment increases with time, so that over a long period houses seem to grow to suit those who inhabit them. It is therefore natural that photographing people in the settings they have created for themselves has some advantage over taking portraits in the studio. I suggest that for an initial project in portraiture you should choose a domestic background which reveals as much as possible of the subject's character.

Portraiture of any kind requires above all sympathy with the subject, and tact is especially important if you are intruding into someone's home. With this in mind you should take care that your photographic equipment is not too obtrusive; most people feel ill at ease in front of a camera. Rather than set up cumbersome lighting equipment I often bring a photoflood bulb and fit it into the existing light socket. This has the added advantage of providing light from the most natural direction.

The possessions of the old lady in the photograph below seem to serve as tangible memories, displayed not merely as decorations but as a comforting residue of the past. In this photograph the belongings suggest a story of their own. There is evidently not enough space to accommodate them all comfortably—in fact the room was so cramped that I had to take the photograph through the window from outside. The half-framing of the lace curtain helps the feeling of seclusion and of a candid glimpse into a private world.

Cramped quarters are also evident in the photograph of an elderly couple on the right. Here the furnishing is plainer, but although there are fewer items of obvious sentimental significance, the room is equally revealing about the lives of its occupants. The array of medicines on the mantlepiece suggests that the health of one or, more likely, both of the people is declining, but the tough, determined expression on the face of the woman and the cheerful look of the man whistling to his budgerigar suggest the self-respect of people reluctant to complain. The oil heater used for cooking and the absence of any kind of luxury complete the picture of a couple who have known few comforts.

Project 13
People and environment /2

Not every portrait photograph sets out to tell a complete story or give a penetrating insight into character. Often you will find it more appropriate to reflect the public side of your subject's personality, rather than attempting, as in the previous project, to probe into the private history or social background of the person you are photographing. There are many ways of using the environment in which people live or work as a background for portraits, without necessarily turning the picture into an essay in reportage. For example, try looking for resemblances between the physical appearance of your subject and the objects that surround them daily. The elderly woman and the man shown outside the same apartment block in the opposite photograph had faces full of interest and, wishing to emphasize the unusual quality of their features, I chose as a background the equally unusual entrance to their apartment. Without making any revealing comment on the couple, the building's design is suitable because it echoes unexpectedly the forms and textures of their faces. The wrinkled forehead of the old woman, for example, is reflected in the wavy pattern of the brickwork, while the shape formed by the black bricks in the lower corners of the photograph suggests her cheekbones. The brickwork is again echoed in the picture of the man, this time in the zigzag pattern on his cap. These formal resemblances are strengthened by the symmetrical composition of both pictures.

Another way of creating interest in a portrait through your use of people's environment is to photograph them in the context of their work. This enables

you to present an important facet of their character without intruding on their privacy: you should not feel obliged to attempt to make too personal a statement about someone with whom you have only a superficial acquaintance. The three photographs at the bottom of the page are examples of portraits that show the subjects against the background of their jobs: the storekeeper and the workman are immediately identifiable, while the third picture benefits from the knowledge that the couple run a hotel in the Outer Hebrides.

Let your subjects choose their own setting and pose, rather than trying to force them into positions they may find uncomfortable. It is obvious from the expression on the face of the storekeeper in the portrait below that he feels at home behind his counter: he seems confident of being photographed as he would like to see himself, and his pose expresses his satisfaction with the display on the shelves behind him. In the same way, the hotel proprietors take an evident pride in the condition of their hotel. Because the room was small, I used a wide-angle lens in order to include as large an area of it as possible. As a result, the perspective appears rather exaggerated, but the strongly converging lines lead the eye toward the couple, who are naturally the main point of interest—it is important to compose each picture carefully so as to maintain a balance between the subject of the portrait and the interest created by the environment. If you choose a horizontal composition, remember that the person in the photograph will appear small in relation to the surroundings, and the background must therefore be interesting without being distracting. In the final picture on this page, I made the figure of the man prominent to cut out irrelevant parts of the background, as well as to emphasize the roundness of his build.

Project 14
Portraits

A formal or semi-formal portrait differs from a snapshot in that it attempts a more thorough and considered record of a person, perhaps capturing something of his character, interests and achievements as well as simply preserving a picture of his physical appearance at a particular moment. Portrait photography offers great scope for style and imagination, and you should not base your approach on preconceived ideas; a formal portrait need not be conventional. Find out as much as you can about your sitter's life and personality and, if possible, choose a setting that is representative of him or her.

In the first photograph on this page, for example, Sir Michael Tippett and Antony Hopkins are clearly identified with the world of music. A page of musical manuscript, linking the subjects' heads in the frame, is a simple yet effective way of implying the artistic collaboration between the two composers. The design of the double portrait is based on straight vertical and horizontal lines, which divide up the picture into rectangular areas of white or gray, with the composers themselves providing the only definite color accents. The portrait thus balances formal restraint with vitality. The tranquility and repose of Sir Michael's profile is similarly balanced by the concentrated expression of Hopkins. Although the composition was largely spontaneous, I repositioned the men slightly to cut out extraneous detail.

The striking design of the mantelpiece, on the other hand, was deliberately included in the portrait of the artist Patrick Proctor in his apartment. The idiosyncratic décor of the room, an exotic blend of vulgar and sophisticated styles, reveals a highly distinctive taste which is both unconventional and aesthetically fastidious. Proctor has arranged himself with care on a fur rug on the floor, casual, yet elegantly poised.

An intriguing project exercise is to place dissimilar subjects in similar poses and study the extent to which the pose itself creates an effect and the way in which this is modified by other elements such as the sitter's clothes, as well as his features and expression. An unshaven, sweating boxer, his head wrapped in a rough towel after a strenuous work-out, is shown on the opposite page next to a portrait of a model wearing a headdress of silk scarves: though the subjects could hardly be more unlike each other, there is a marked similarity about the pictures.

Above all, do not treat people as stereotypes. The subjects of the two final portraits are all scientists (on the left, Sir Lawrence Bragg, together with Professor Sir George Porter, Director of the Royal Institution; on the right, Professor Dennis Gabor, the inventor of holography). The strength of intellect revealed in all three faces shows that it is possible to allow your sitters to speak for themselves, rather than explicitly indicating the subject in which they are distinguished.

133

Project 15
Portraits: varying pose

Portrait photography does not require all the facilities of a fully equipped studio. The most important aspects of a portrait, namely the pose and expression of the subject, depend not on equipment but on your ability to bring out the most

interesting or characteristic qualities of the subject. This involves first putting people at ease by talking to them so that they relax and forget the camera. At the same time, without being too obvious, you should be closely watching their movements and mannerisms, noticing how they use their hands and particularly the direction of their gaze and the shape of their mouth when relaxed or firmly shut. Be prepared to waste film, as your subject will probably be self-conscious at

first. Then use your observations to try out different camera angles, poses and lighting schemes, as I have illustrated here.

The simplest and most basic positions for a portrait are front, profile and three-quarter profile. A portrait in profile will give an essentially formal effect, as at the end of the third row of pictures on this page. With her hair swept back to emphasize the shape of her head and the line of her neck, the girl seems to be

holding herself aloof. The picture lacks intimacy largely because she is looking away from the camera: the effect is to prevent any contact with the viewer. In the three-quarter profile next to this, the girl looks directly at the camera and at once a more intimate effect is created. Because the eyes are so important in suggesting a relationship between the subject and the viewer, it is on the eyes that you should focus the camera. The two other portraits of the same girl

illustrate a similar point with slightly more elaborate poses.

The simple expedient of varying the background enables you to control the balance of colors in the photograph. A plain background is often the most effective: choose a color that suits the clothes worn by your subject as well as the natural colors of the hair and skin. Dark, somber colors are used in the two middle rows of pictures to create a pensive, introspective mood. The blonde hair of the girl in the second row, photographed in natural light from a window, shows up well against the nearly black background. In the top row of pictures, on the other hand, I chose a metallic blue-gray background, partly to contrast with the black hair of the girl and partly to match the silvery sheen of her crushed-velvet costume. Light shades, moreover, suited the girl's vivacious and extrovert personality.

By contrast, the bottom row of pictures illustrates the idea that portrait photographs can be taken under a wide range of informal circumstances and lighting conditions. You should not feel bound by the convention that the sitter must be dressed up for a portrait. A completely casual photograph need not be unflattering.

The four larger pictures appearing on this page suggest a portrait project making use of what you have learned about combining daylight with flash. The first of the series was taken using a single direct electronic flash. The flash was not powerful enough to light up the whole room, so the background is in darkness. However, by synchronizing the flash at a slower shutter speed, you can record the natural light in the room while using flash on the main subject. In the second and third shots I used this technique with a shutter speed of 1/15. The final picture below shows the result of making the exposure with natural light alone.

Project 16
Children

Children normally like being photographed because they enjoy having attention paid to them. Yet they can become shy in front of the camera. Sometimes they will alternate between being coy and showing off. You can reveal much of a child's personality by trying to capture all these typical reactions in a single sequence, as in the shots here of a little girl in Martinique guarding the entrance to what she thought of as her own territory. At first she did not want to let me inside, and her expression was a mixture of suspicion and hostility, but she was pleased that I was interested in photographing her. Her reticence, evident in the first picture, soon gave way to her natural inclination to play up to the camera, and eventually she invited me inside. The building, originally a prison, had an interesting story behind it, to which I have alluded in the final picture of the sequence: a condemned prisoner held there survived a severe earthquake which killed all the other inhabitants of St. Pierre. Using a slow shutter speed (1/15), I swung the camera in an arc during the exposure to suggest the sensation of an earth tremor.

Children are less inhibited than adults, displaying simple, direct emotions. Pleasure or frustration can follow in quick succession, but they easily become tired or bored. The best approach is to work for only a few minutes at a time, and to enter their imaginative world by joining in their games. The boy hanging upside down, for instance, wanted to impress me with his dangerous feat, and was proud to demonstrate his skill. I crouched on the grass for the picture, to get closer to his view of the scene.

There is less scope for variety of activity or surroundings in photographing babies. Direct your efforts to creating the right conditions for an interesting picture through your choice of lighting and background: here I used natural light from a window to bring out the soft quality of the baby's skin, and arranged the towel into patterned creases.

Children will often come and watch you when you are photographing in the street. Don't regard them as a nuisance: try turning their curiosity to good account by making them the subject of the picture. The girl wearing a riding hat has a quizzical expression that I could not have captured if I had set out to pose her for a photograph. Even when taking less casual portraits, allow the child as much freedom as possible, since it is more important to capture character than to show the child looking clean and smartly dressed. The girl standing inside her wardrobe had asked me to come and help her choose her dress for a formal portrait, but I took the opportunity to photograph her in the self-assured pose she adopted in her own room. The boy sitting alongside his toys also posed for the shot, but the arrangement of the toys was his own.

Groups

This project covers a wide range of possible types of group, from formal wedding photographs to candid or documentary shots. Whichever you choose to begin with, you should bear in mind that the division between the formal and the informal, between the serious and the lighthearted, is not rigid and that you should be ready to adapt your approach as opportunities arise. For instance, when photographing an occasion that is essentially formal, such as a wedding, take a few pictures before the group is finally arranged, and save one or two extra frames for the moment when everyone relaxes. In one of the wedding photographs on the opposite page, the guests seem more concerned about preventing their hats from blowing away in the wind than about looking their best for the camera; as a result the picture is a vivid record of the occasion.

The main function of a group photograph is to portray the collective identity of the club, band or family that is being photographed—even in candid shots, the picture should convey the feeling that the people in the group have something in common. You should try to show this link visually, either through your choice of background or by using theatrical props. A family portrait, for example, will often benefit from the use of the family's home as a setting, particularly if the rooms are as fine as that shown in the large photograph on the opposite page. I used a wide-angle lens to include a large portion of the room in the frame. Other features, such as costumes, uniforms or hats can be used to link a group together.

However, you should not ignore the character of each individual. Allowing people to arrange themselves will ensure a more natural appearance than if you tell them where to stand; but it remains your responsibility to make sure everyone can be seen clearly. Depending on the size of the group, it may be best to follow the conventional principle of placing the tallest at the back and the smallest in front. If you are working in harsh sunlight, consider moving the group into the shade, where deep shadows will not obscure their faces. Sometimes it takes a while to complete all the preparations, so try to anticipate where the sun will be by the time everything is ready. Having an assistant will leave you free to concentrate on essentials, but do not lose the attention of the people being photographed by taking too long. Work out exposures beforehand.

Picture essay

The story of Anne Frank, the young
Jewish girl who, together with her family
and another Jewish family, lived for two
years in a secret annex of their house in
Amsterdam during the German
occupation of Holland, has become
known all over the world since the
publication of the diary Anne kept
throughout the period they were in
hiding. The house in which they lived
has now been opened to the public
under the auspices of the Anne Frank
Foundation, which preserves it as a
memorial to the Frank family and all the
Jews who died during World War II.

I chose this house as the subject of a
pictorial essay because of the moving
story of human suffering with which it is
associated. The problem from a
photographic point of view was to
present as full a factual record of the
house as possible, and at the same time
convey the poignant atmosphere that
makes it such a powerful reminder of
recent historical events.

This kind of photo-essay is
sometimes produced in conjunction with
a magazine story or some similar form of
documentary report, but ideally you
should try to find a way of making the
pictures independent of words. Any
environment rich in associations would
be suitable for a project essay.

Here, I have combined some
photographs that document the facts in a
very straightforward way with a few
strongly atmospheric pictures. It is
important to allow the story to speak for
itself, and items like the original diary,
the photographs of Anne at different
ages, and the map on which Mr Frank
recorded the advance of the Allied
forces, need no comment. But a more
expressive technique was needed to
capture the highly charged atmosphere
of the rooms in which the two families
lived. Using the play of light and shade
within the rooms, I set out to recreate
imaginatively how it must have felt to live
for two years in the confined space of
the annex, under continual fear of
discovery. The sinister and oppressive
effect of the shadows falling across walls
and floors could appear too
melodramatic if not carefully controlled,
but the dispassionate lens of the camera
lends authenticity to the mood.

Architecture

A challenging architectural project is to choose a building that attracts and interests you and then try to capture its essence and atmosphere. You should start by walking around the building examining it from various positions for typical features and at the same time giving some thought to the overall impression it makes. It is also a good idea to do some preliminary research so that you have an understanding of the architect's intention and the materials and building techniques.

No single picture can tell you everything about a building so you should try to build up a composite portrait by taking several shots from different positions. Ideally you should return to the building at different times of the day so that you can study its appearance in changing light or weather conditions. But it is possible to reveal a good deal in a single hour, as these pictures of a stave church at Vik, in Norway, show.

A building's surroundings often make an important contribution to its atmosphere. The first pictures on this page present the church in its setting because I wanted to bring out the contrast between the peaceful countryside and the dark, almost ominous, building. This is heightened by the backlighting of the scenes at top left and center left. The church at Vik dates from about 1200, when Christianity had not long been established and when pagan elements were mingled with Norman styles. The shot at center right was taken from a low angle to emphasize the pagodalike outline of the roof.

In the view on the opposite page, arches are juxtaposed with the traditional wall construction of upright staves, or planks, tongued and grooved to fit together. From this angle, sky light gives a sheen to the tarred planks and the roof tiles, but the untarred wood on the sheltered wall glows through warmly. I used a 100mm lens here to flatten the perspective.

I also used the 100mm lens for the close-up view of the two "dragon's head" projections from the gables. These recall the prows of Viking ships and give the building much of its sinister aspect.

The high roof, steeply sloping to shed snow, needed strong pillars connected by bracing struts inside the church. The interior shots show the elaborate structure of this timbering. To photograph the columns, and the altar with its canopy, I used a small Vivitar flashgun, giving four flashes for each picture. Since the unit needed considerable recharging times I kept the shutter open for several minutes on each shot. This also enabled me to time the flashes to avoid people who were walking around the church.

I stopped the lens down to f22 to make sure that the natural light, even though weak, did not produce overexposure or destroy the mysterious atmosphere. The flash was used from one position; moving around would have filled in shadows but retaining them brings out the structure of the timbering.

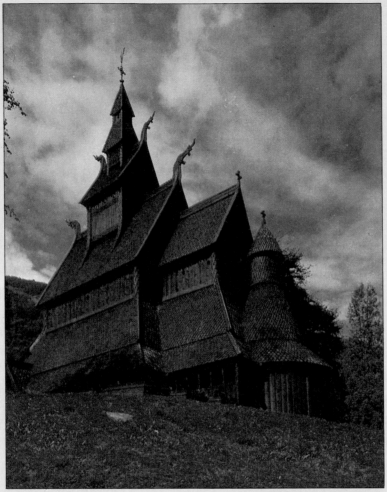

Project 20
Large interiors

Large interiors such as the auditorium and foyer of the Tuschinski Cinema in Amsterdam shown here present a special problem, illustrated by the first photograph I took of the subject (top right), for which I used no additional lighting. Since a single flash would not be sufficient to illuminate so large a room, a technique known as "painting with light" is used to fill in the shadowy areas and bring out the detail. Essentially, the method is to position the camera on a tripod and, leaving the shutter open on a "T" setting, move around the room with a flashgun, covering the entire area with a series of separate flashes.

The technique involves a certain amount of guesswork in estimating the exposure, so when you take on a project like this you should be prepared to experiment. You will require a long exposure which will allow time to move around using the flashgun, and a small aperture to record the existing lights correctly. Thus in the auditorium the exposure was about 3½ minutes at f22.

Clearly, a sturdy tripod is essential, and a cable release should be used to fire the camera. (Some releases have a special device for locking open the shutter of cameras that have only a "B" setting.) In order to ensure uniform lighting, you should divide up the subject area (mentally or in a quick sketch) and then cover each part in turn. Bearing in mind the inverse square law (see page 39) you will need to give extra flashes to areas farthest from the flashgun. Thus the guide number will tell you what the distance from the flash to the subject should be at the aperture you have chosen. If the distance is in fact twice this, then four flashes will be necessary instead of one. The auditorium required a total of 36 flashes from the various positions shown in the diagram below. The camera angle was chosen to emphasize the perspective as dramatically as possible, and a 21mm lens was used.

Photographing the staircase (right) I used a 28mm lens and deliberately chose an angle which again exaggerated the perspective to compensate for the flattening effect of the strong pattern. One flash was pointed down the stairs, another at the wall, and the third bounced off the ceiling. In the foyer (bottom) I used the 21mm lens; the foreground objects help to create a sense of depth. I moved the flashgun around the subject in an arc from left to right, passing behind the camera as I did so, and firing a total of ten flashes.

Project 21
Nature: landscape

Landscape photographs that successfully capture the scale of nature can often make the creations of man seem insignificant. But even when people and their dwellings are dwarfed by the scenery or excluded from the picture altogether, it would be a mistake to think that human interest is lacking. What gives a good landscape picture its appeal is its ability to reflect human emotions and to express ideas about the relationship between man and nature. If a view of a mountain or an area of countryside is sufficiently spectacular, you may be content simply to record it, but you are likely to be disappointed with the results unless the photograph succeeds in capturing not only what you saw but also what you felt.

It may seem at first that in landscape photography timing is not a critical factor, since you can return to a particular spot as often as you wish. However, natural light can change from moment to moment with the movements of clouds, from hour to hour with the weather and the course of the day, and from month to month with the seasons. Other transient effects, such as rain storms or rainbows, can last just a few minutes and demand quick reactions to capture them. In the autumnal scene here the shafts of sunlight breaking through the trees are a vital part of the picture. Moments later the sun might have disappeared behind clouds.

Take advantage of the opportunities that this diversity offers you: revisit favorite spots at various seasons and notice how different they appear and how you may need to adapt your viewpoint or technique to reveal their different qualities. As an initial project try photographing the same landscape at different times of day, especially at dawn or in the evening. The vivid, short-lived colors of a magnificent sunset are unpredictable, but if you are ready with your camera and with an appropriate lens selected as the sun is setting, you will be able to seize the chance of a spectacular shot if it arises.

Scenes like the burning stubble can rarely be foreseen in the same way, but alertness and an eye for color will help you to notice the contrasts and contradictions that make such pictures interesting. The orange flames and the shadowy figures of farm workers make a macabre contrast with the gentle moods of sunsets and autumn leaves.

An important thing to remember in landscape photography is that a vast landscape may look disappointingly shrunken in a photograph unless you select a foreground or viewpoint that will provide a sense of scale. Wide-angle lenses can also help. For the photograph on the right, taken within the arctic circle, I used a 28 mm lens to capture the scope and grandeur of the gorge and composed the shot so that the foreground echoes the sky and the melt water carries the eye into the distance.

Project 22

Nature: close-ups

Special equipment for close-up photography, such as macro lenses, extension tubes or bellows, is necessary only if you wish to produce on the film images that are life size or larger (see page 185) For this project, however, it is sufficient to rely on the minimum focusing distance of your normal lens, and employ close cropping of the final picture wherever necessary.

Nature is rich in subject matter too small to be photographed except at very close range, but it is advisable to begin with the easier, immobile subjects such as plant life. Take care not to forget the basic principles of composition and color balance. I recommend underexposure by half a stop to increase color saturation. Fast film and shutter speeds are a help.

The characteristic problem of close-up photography is the limited depth of field, which becomes more restricted the closer you focus; but this can also be seen as an advantage. As you can see from the photograph of the iris, the shallow depth of field causes the subject to stand out well against its background. Similarly, in the picture of a cobweb covered in dew, extremely selective focusing is helpful in isolating the delicate, almost transparent, threads from the confusion of the natural surroundings. Subjects such as these will probably be in continual motion unless you protect them from the wind: a piece of cardboard can be used as a shield and reflector, and flowers can be supported by a piece of wire.

Flash can be used to illuminate shadowed subjects, with a slow exposure to record surrounding areas.

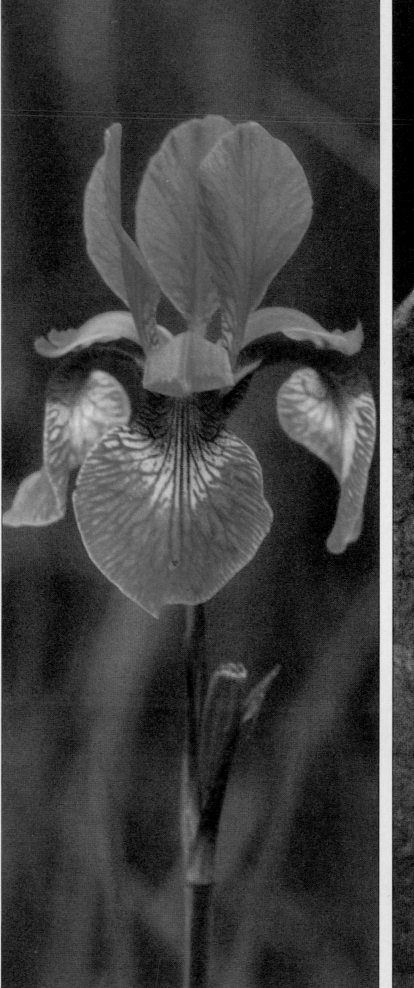

Nature: sky and water

The sky has a major importance in landscape photography as a source both of light and of variety. The appearance of the sky, as the intensity or color of the light alters or as clouds group and regroup, influences and often dominates the mood of a landscape. My favorite weather is a cloudy day with sun and wind so that the landscape is one of constant surprise. The link between the sky and the foreground can be strengthened by including in the picture an area of water. The water echoes the character of the sky, for it naturally tends to reflect the sky's colors, as well as being itself subject to the effects of the weather. It also gives unity to the photograph in terms of exposure, often providing a linking highlight.

The mirrorlike surface of the lake in the main photograph on this page reflects a mountainous landscape that seems as calm and serene as the water. With the sky misty and overcast, the light is soft and the colors muted. In contrast, the ominous turbulence of an impending storm can be seen in both the sky and the sea in the seascape. The billowing clouds are matched in color and shape by the foam of the breaking waves.

In your project on sky and water, remember that many effects can be captured at moments of sudden transition: the eerie glow of the sun lighting up the land against a background of storm clouds about to break, or the first shafts of light immediately after a storm; the interval between day and night at sunset or sunrise; or the rapid buildup or dispersion of clouds in strong winds. Water, similarly, is often most interesting from a photographic point of view just as the weather changes. In some lights you will discover a remarkable feature in a landscape that at first seemed quite ordinary: the green of the field seen here, for example, caught my eye when late light gave it an unusual intensity.

The best proportions between the area of sky and the rest of the picture depend on the mood you want to convey. The main photograph on this page is composed symmetrically around a central line, and although this equal balance can sometimes produce a static effect, it is clearly apt here. More conventional proportions based on the division of the scene into thirds are used in the seascape and in the shot of a bridge over a river.

Ideally you should have a selection of three basic lenses: a wide-angle, a standard and a long-focus. In the 35 mm format the most useful focal lengths are about 28 mm, 50 or 55 mm, and 135 mm. These will give a reasonable degree of versatility in your compositions. The wide-angle lens is particularly useful in enabling you to include large areas of foreground and sky at the same time, producing an almost panoramic effect, while the long lens can pull in distant features such as mountains.

Fog and mist

Of all atmospheric conditions, dense fog may seem the least suitable for photography. In fact, it is not only possible to take photographs when visibility is poor, but the results are often far more interesting than pictures taken under clear skies and in bright sunlight. Adverse weather can transform banal localized scenes into something dramatic and universal as drab surroundings become indistinct and enigmatic. Colors are softened and contrasts muted by the scattering of light, while people and objects lose their everyday identity. Seen through the mist, everything is reduced to simple, featureless shapes.

The picture of an Amsterdam street car, for example, would hardly have been worth photographing in fine weather. As it is, the fog has obscured the messy urban sprawl in the background, simplifying the image and giving it strong atmosphere. The overhead cables, the back of the street car and the rails appear to dissolve into the distance, and the platform looks cut off from the outside world. With its glowing headlamps, the street car might have been sent out specifically to rescue the stranded figure on the platform.

Taking photographs in such conditions presents no particular technical difficulties as long as you are prepared to put up with the discomfort. To capture all the subtleties of tone and the soft, fragile colors, however, exposure is critical. In carrying out your own project on photography in fog or mist, the best guide is to take a light reading for the highlights and, as a precaution, bracket the exposure. If you want to retain the misty effect rather than disperse it, you should err on the side of underexposure, since overexposure will have the effect of penetrating the fog.

In the photograph of an aluminum refinery on the opposite page, accurate exposure has preserved the distinction between the quality of the smoke from the stacks, the steam from the cooling sheds and the mist on the hills behind. I composed the shot so that the strong diagonal lines of the smoke rising from the chimneys were echoed by the slanting roofs and the dark line of the mountain in the background. Simple shapes looming out of the fog will heighten the drama of scenes like this. In ordinary light, the factory would have looked quite different, perhaps offering other photographic possibilities, but here, in fog and stormy weather, it is less the factory than its waste that has become the subject of the picture.

Do not be overconcerned about protecting your camera from the rain: pure water, unlike salt water, will not damage your equipment as long as you dry things carefully before putting them away. Rain on the lens while you are actually taking a picture will, of course, blur the image, so carry with you a soft cloth so that you can wipe the lens dry a moment before shooting.

Travel

When a professional photographer goes on location, he uses the opportunity to take pictures of anything that catches his attention, whether or not it falls within his original assignment. A holiday offers you a similar chance to experiment with every kind of photography: landscape, portraiture, still life, reportage, sport—anything that interests you. With so many diverse possibilities, a travel project should involve more than merely photographing your own family.

In this selection I have included some examples of pictures taken in varying light using different lenses and angles of view. These suggest ways in which you can vary the pace between close-ups and distant views, action and relaxation. Once you have judged the exposure suitable for local light conditions, you should carry the camera preset to save time in composing shots. Avoid the habit of taking every picture at eye level, with the subject placed in the middle distance.

Good travel photographs are not only about places but also about people. People will often be happy to pose for the camera, but informal or candid pictures catching them slightly off balance are more likely to provide the most accurate record of the spirit of the holiday. The large photograph shows how you can combine exotic scenery with an unposed picture of your friends in holiday mood, slight movement adding to the atmosphere: tourist photographs are too often unnecessarily solemn.

Traveling is normally accompanied by a share of inconvenience and minor hazards, and it is worthwhile taking all reasonable precautions (such as checking batteries, shutter and aperture mechanisms, and meter function) before setting out, and insuring your equipment against theft and damage. In some of the places you visit, sand, water or excessive humidity may prove troublesome, and it is a good idea to take a supply of plastic bags to use for storing film and protecting equipment. To prevent lenses from misting up when you take them from an air-conditioned hotel into hot, moist conditions outside, let the camera warm up to the outdoor temperature for 15 minutes before using it. Finally, when you go through customs, have your equipment checked as hand luggage, as there is a slight risk of fogging from X-ray security equipment.

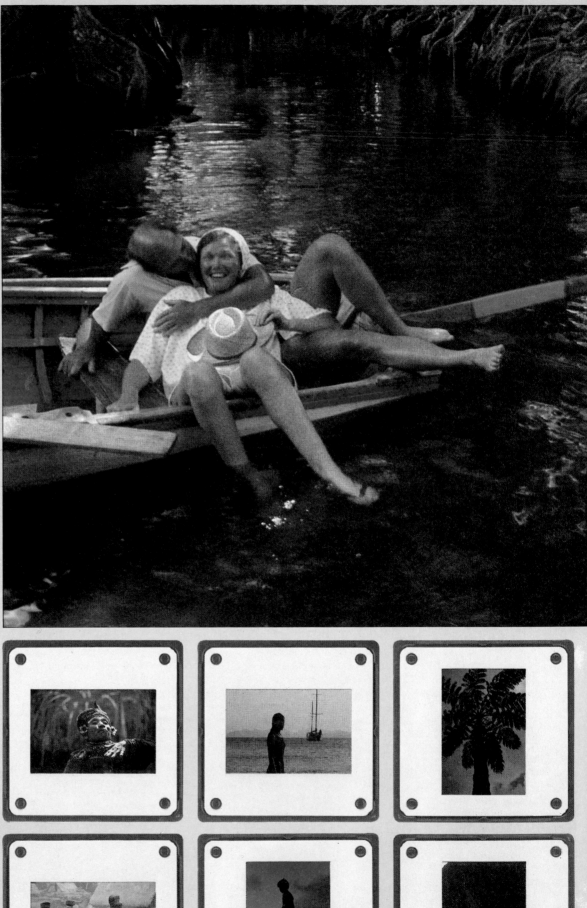

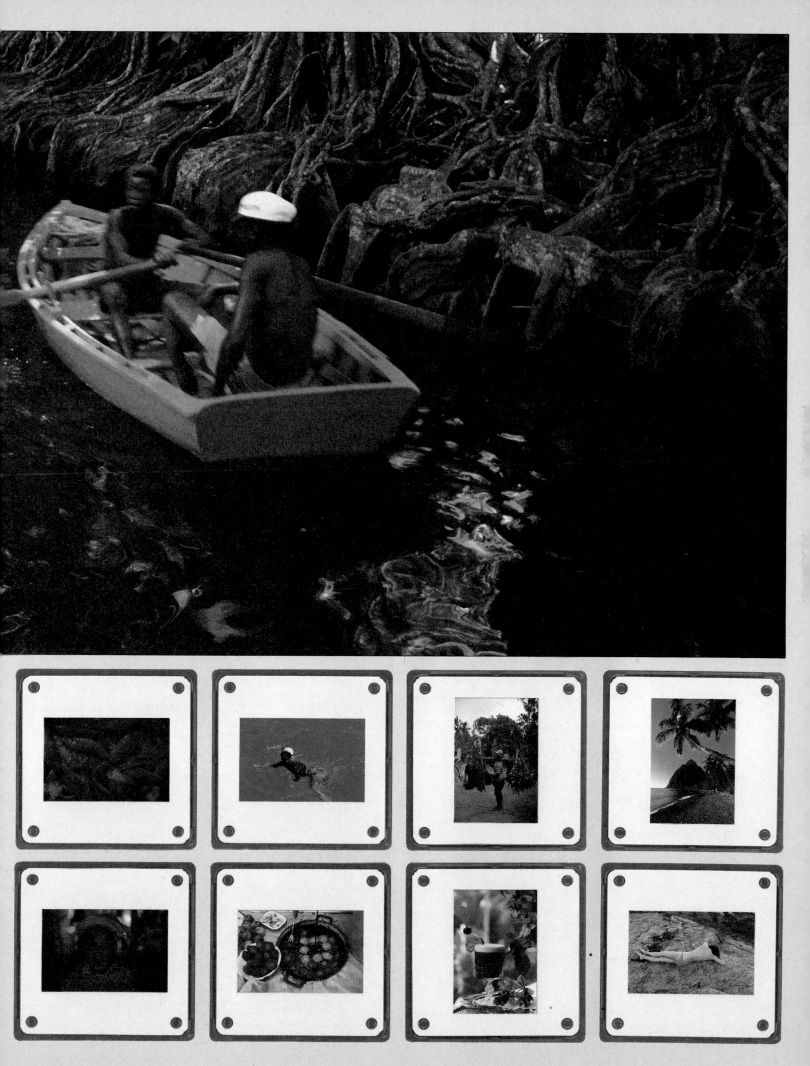

Project 26

Expressing movement

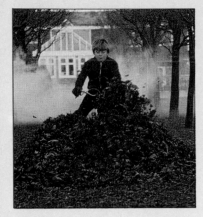

Very fast shutter speeds can capture a split second of action, but at the same time they tend to freeze it, often losing the spirit of motion. In order to evoke movement you may have to find the right balance between a shutter speed fast enough to catch the action yet slow enough to allow some suggestive blur.

You may find that the action is too far away or the camera is not fitted with the appropriate lens, with the result that the "spontaneous" movement must in fact be restaged if the picture is to be successful. This kind of manipulation of events is common among professional photographers and there is no reason

why you should avoid it. However many times an action is staged, you still have to be prepared to react freshly to the subject and adapt in order to take advantage of unexpected elements. It is too simple to contrast "arranged" pictures with "spontaneous" ones.

In the photograph on the right-hand page I tried to remain faithful to the boy's speed and exhilaration and to do so I had to set up the event repeatedly until I was satisfied. But the boy actually improved as a performer with each attempt, and his gain in confidence became part of the subject of the final picture. In the first picture (left), for which I set the shutter speed at 1/250 sec with the aperture at f5.6, he was still rather cautious about riding fast through the leaves, and this is apparent in the photograph. Moreover, the shutter speed was too fast, and nearly all movement in the pile of leaves has been frozen. For the next shot (below) I slowed down the shutter to 1/60 at f11. Here the leaves in the middle of the pile are blurred, while those at the edges remain sharp. To emphasize the moment of impact, I slowed down the shutter even further to 1/30 sec at f16, and for the third picture (right) the boy kicked up his feet as he hit the leaves, creating the effect of a splash. On the fourth attempt, he almost fell off his bicycle, and it was, in fact, because of this near-accident that on the final occasion (far right) he kicked his feet right up. By capturing this climax I have tried to preserve the impression of continuous, fluid motion.

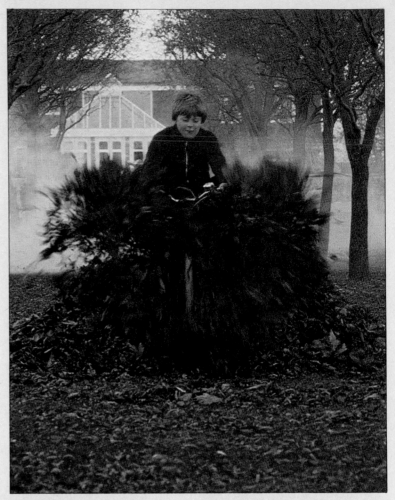

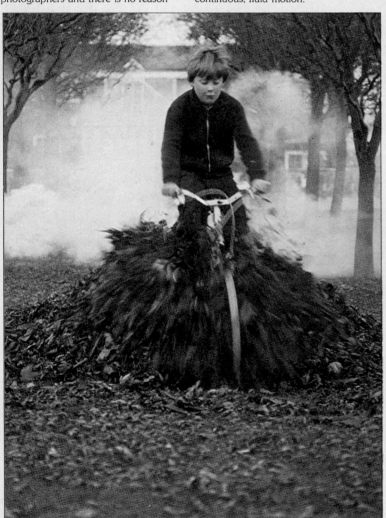

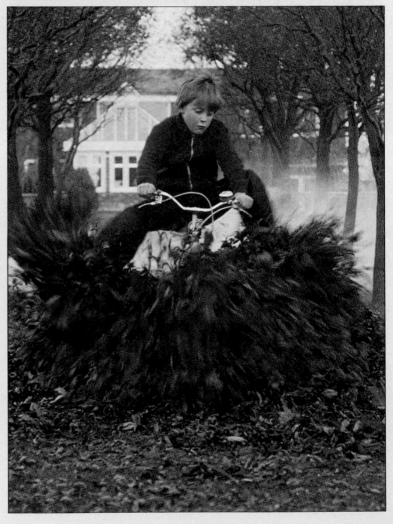

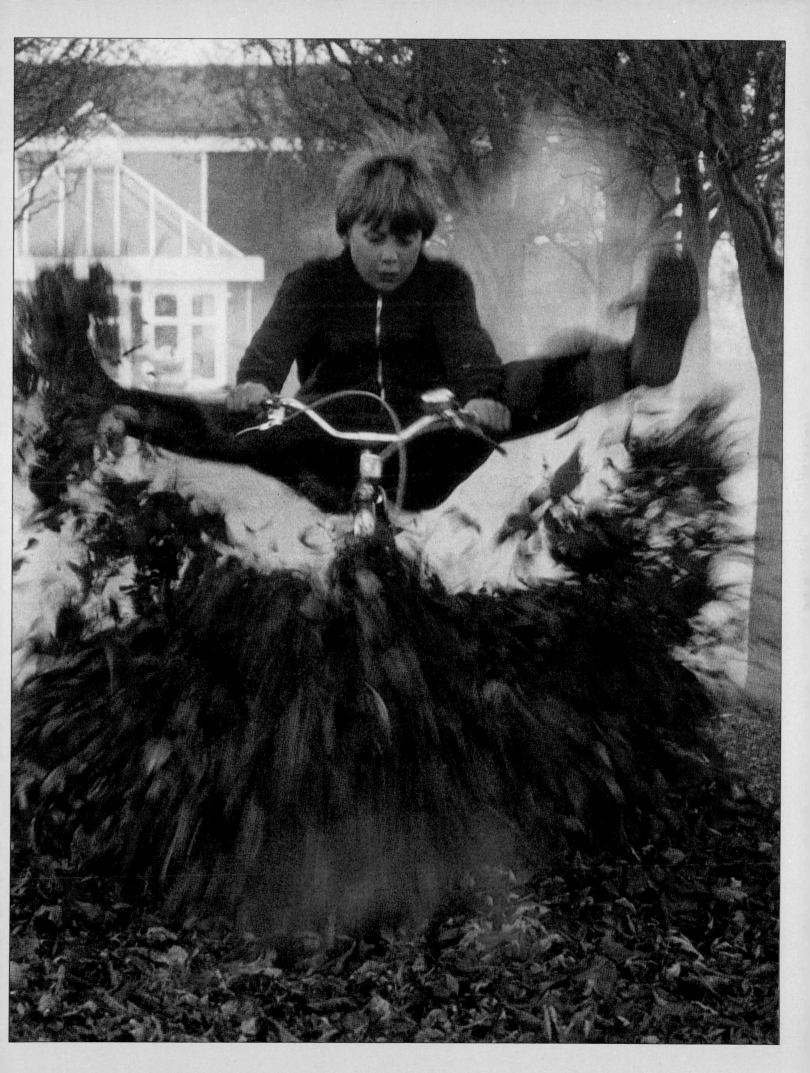

Project 27

Capturing action

Using even the simplest camera, you can develop a powerful means of expressing movement by practicing panning—that is, swinging your camera horizontally or vertically at the moment of exposure. This movement can freeze the image of a moving subject so that it is rendered sharply, at the same time blurring the background to form "speed lines."

I used panning to enhance my pictures of a group of young skateboarders in central Amsterdam. The straightforward shot on the right shows the problems that faced me. Although the stance of the foreground figure maneuvering his board has some interest,

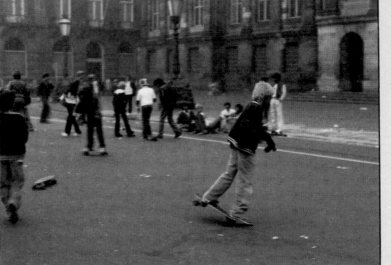

The technique of panning
In practicing this technique yourself, remember that panning needs a firm stance and a smooth swing from the waist. Begin to follow the subject before you press the shutter release and follow through afterward. This will enable you to position the subject accurately in the frame rather than to trust to luck. It is best to use as slow a shutter speed as possible, enabling you to use a smaller aperture and a greater depth of field.

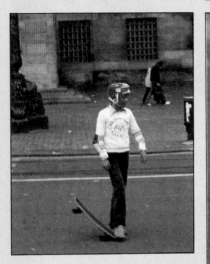

the surroundings detract from him. The street is littered with scrap paper; the other skateboarders and onlookers form no coherent group and confuse the eye; the subject seems lost against the background wall.

I achieved a better result with the solitary figure above. The light tones of his helmet and pullover overcome the distraction of the background; and his body makes a visually compelling angle with the upraised board. But he is static, whereas skateboarding is dynamic.

The other pictures here show the result of panning while using a shutter speed of 1/15. On the right, below, the same skateboarder is caught in a sharp, well-defined image as he performs a graceful feat of double-deck skateboarding. He is clearly "readable" while the background is slightly blurred, indicating his movement unmistakably.

At center right the panning has been sufficiently rapid to blur the moving figure as well as the background; this further heightens the sense of speed.

In the picture on the facing page, the blurring of the background is reinforced by another factor—the skateboarder's angle unequivocally says "movement."

Although fast-moving subjects will require faster shutter speeds, satisfactory background blur can still be achieved by rapid panning with shutter speeds up to about 1/250—a good speed to choose for close-range shots of racing cars on a fast stretch of the track, for example.

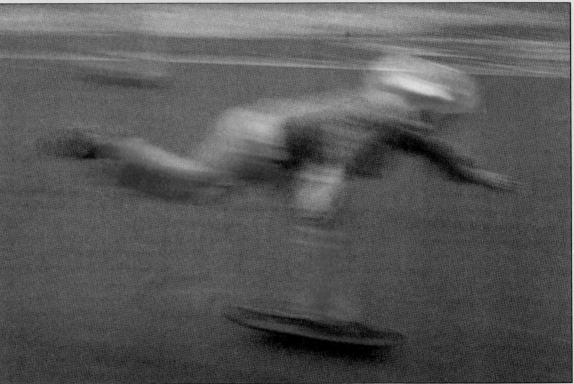

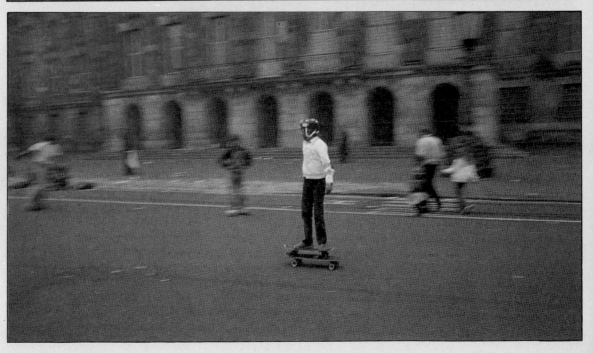

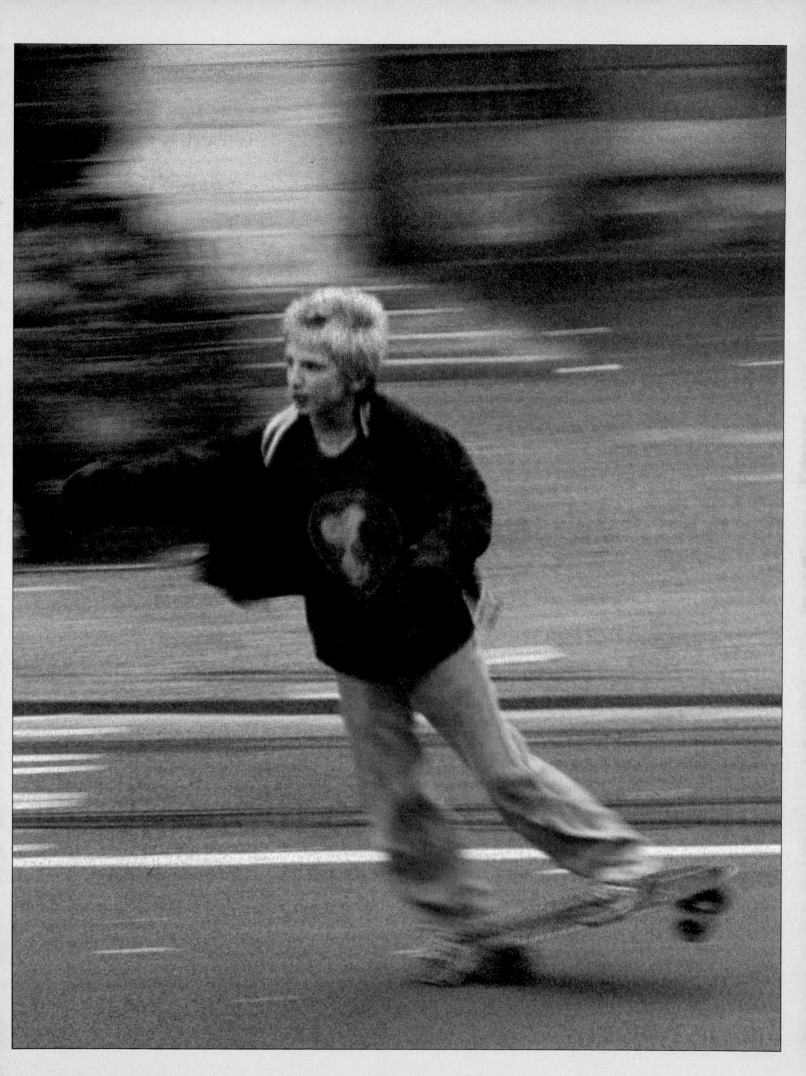

Project 28

Reflections

A reflection in a mirror, or in a pool of still water, is at least one step removed from reality. If you photograph a real object, together with its reflection, under normal lighting conditions (for example, the castle in the first picture below), the reflected image will be subordinate to the main subject. In the second photograph, taken against the light, the silhouetted

castle and its reflection merge to form a single black shape that is more dramatic and mysterious than before.

In experimenting with reflections you will find that a sense of mystery is enhanced when you photograph the reflected images alone. Their strange fascination is linked with our feeling that the insubstantial reflection mirrors an object that may in some sense be illusory itself. We know that the reflection is not where it appears to be, behind the reflecting surface, and we are therefore encouraged to doubt everything about it. The borderline between reality and

illusion becomes uncertain.

In the portrait of Sandra Blow with some of her paintings, the mirror acts as a frame, enclosing a separate world; the painter and her work are juxtaposed, yet the mirror keeps them sealed off from one another.

The fantasy conception of a world of mirror images existing behind the glass can be turned to surreal or symbolic effect. In the wedding picture on this page I used the mirror to convey a distant, dreamy, romantic atmosphere, so that the image appears timeless. You may also try using reflections to suggest

a world of past events, of events that never took place, of dreams, or of the supernatural world.

An imperfect mirror produced the bizarre image of an owl, which appears to have dissolved onto the page. Distorted or fractured reflections can be found almost anywhere, and it is well worth experimenting with them. The purely abstract design of the photograph on the left is rich in color and pattern; the surface of the water seems to have a hard, glossy texture, like paint or plastic, conjuring up sensations far removed from the mundane vessel it reflects.

Project 29
Changing emphasis

Ultimately the aims of any photographer, amateur or professional, are highly personal and as subjective as his tastes, interests and imagination. Pictures with a distinctive personal style depend on accurate technique as well as on the individual vision of the photographer, and this can only be fully developed over many years. But now that you have had some practice in applying a large range of fundamental photographic techniques in a variety of projects, you should find yourself very much better equipped to express your own, more intimate ideas. As an advanced project, then, I suggest that you choose a subject with a strong element of fantasy, which will allow you to experiment with private associations and images. There is a danger of becoming self-indulgent in such projects, but the only way of avoiding this is to be intelligently self-critical.

In this series of photographs I restricted myself to a single position for the camera and lights throughout the session. The whole sequence is really an ercise in manipulating the emotions conjured up by the pictures, simply through the changing relationship of the camera and the model. The setting is exotic in itself. The chinoiserie of its design, particularly in the lamps and decorated walls, provides suitable surroundings for strange, even occult, images. However, it is principally the model, moving closer to the camera at each stage, who provides the mounting drama of the sequence as a whole, rather like a series of "stills" from a scene in a motion picture.

The effect is intended to be slightly unsettling, like the symbolism of a recurring dream, and a dreamlike ambivalence surrounds the enigmatic girl at the center of the picture. In the first two frames, she looks threatened and vulnerable; her bare feet, flimsy white gown and submissive stance expose her as unprotected and uncertain. As she moves closer to the camera, however, her role in the picture appears to change, and she gradually becomes dominating rather than frail. Her elegant features hint at sophistication and decadence, and the closer she moves the more forcefully this contradictory impression takes over from the first. In the last frame her cold stare has finally turned into something quite menacing, disturbing the balance of the picture in every respect: in its composition, its lighting and its focusing.

Fantasy images can often be created by only slight displacements of normality. Whether the picture is a complicated surrealistic montage full of outlandish objects, or whether it is simple and restrained, the impact of the fantasy results from the use of familiar things in an unfamiliar way, violating our expectations based on "rules." In trying to create fantasy photographs of your own, either in single pictures or in sequences like the one here, you should be prepared to abandon conventional assumptions and to attempt to make bizarre connections between objects that you find in the everyday world.

Project 30
Fantasy

The objects used in these pictures seem bizarre as a result of their context rather than through any intrinsic oddity. In looking for project material you may find your image accidentally, as in the picture of a boy playing with a discarded lampshade. Or you may set up a surreal image deliberately, as in the "plastic wedding." On the one hand this can be seen as an erotic fantasy. On the other, it has satirical implications, suggesting a parallel between the conventions of a wedding and a commercial transaction: veiled by a sheet of plastic, the bride seems prewrapped for consumption.

Projects
Further suggestions

The suggestions on these and the following pages are intended to help you undertake projects similar to those described in this book and to provide additional technical tips. Countless variations are possible in the subjects and the approaches outlined here. By attempting a number of projects, making your own adaptations, you will extend your photographic skills and develop your imagination, while building up a portfolio of interesting photographs.

Using natural light
Variations in the quality and direction of natural light give a changing character to landscape. Take one or more of the following ideas as a theme:

the seasons—photograph the same scene at different times of year;
direct and diffused light: take a series of photographs of a colorful scene—a brightly painted house, perhaps—in harsh sunlight and the subdued light of an overcast day. Then compare the results;
on the river;
transient moods;
sunshine and rain;
in the forest;
sunset and sunrise.

Exploiting background
Find an interesting background and begin by making a straight record of it. Then use it to create a significant juxtaposition, perhaps humorous, perhaps providing some kind of social comment—for example, the contrast between the glamorous world of an advertising poster and the everyday world of the passers-by. Examples of striking backgrounds are:

advertising billboards;
graffiti;
store window displays;
architectural façades (such as imposing entrances);
mosaics;
outdoor art exhibitions.

Finding a theme
The pictures in a photographic collection might be linked by nothing more than a shared pattern—strongly marked parallels in the planks of a fence, in corrugated iron, or in pleated cloth, for example. Or the nature of the subjects themselves might be the common link, as in these suggestions:

doorways, flights of steps, architectural detailing;
pebbles, rocks, mineral formations;
hats, uniforms, ceremonial dress;
car styling—radiator grilles, chrome finish, tail lights, etc.
glassware—elegant bottles, drinking glasses, ornaments;
inn signs and traders' signs.

Environment and mood
Select an area in the town or country that has some oppressive aspect that you wish to bring out. It might be some part of the city that is in decay: search for such telling details as garbage in the street, graffiti and boarded-up windows. Or it might be an area that has been spoiled by new development, in which case you may want to bring out the impersonal and monotonous character of the buildings. The country, too, can seem sinister and lonely, or impoverished and abandoned: look for weird and threatening shapes in trees, for deserted and ruined buildings that tell a story. The mood you create will be more convincing the more genuinely you have responded to the aspect you are depicting.

Idealizing the environment
Imagine that you are called on to show the best aspects of a scene, as the professional photographer often has to do. It could well be the same scene that you dealt with in the previous project. You have control of the framing and viewpoint of the picture and, to a lesser extent, of the weather conditions and the objects and people appearing in the foreground. You can try to express the cosiness of your own home, the friendliness of your neighborhood, the vitality of a business area, a railroad station or an airport, and so on. The aim is not so much to enhance the subject but, as with the previous project, to express in photographic terms what you feel about some aspects of it.

People and environment/1
Take a series of photographs showing the storekeepers and traders who work in a particular area, presenting a kind of documentary survey of the neighborhood. Use the stores and workplaces as settings for each picture and try to build up an image of a complete community. Or explore the home environment of a single family—their house, garden and neighborhood. Try to convey information about how the members of the family live, individually and together. Make use of details in their surroundings that suggest stories or past incidents. As in all photography that depicts people in spontaneous activity, try to be as unobtrusive as possible, and avoid making your shots look posed.

Colored lights

The best time to photograph street or festival lights is in the early evening, when the shapes of surrounding buildings are outlined against the sky. Experiment with filters—a color-burst or a prism lens. Try moving the camera during the exposure or making a double exposure. The lights of moving traffic can be made a feature; or the lights of passing vehicles can be eliminated by covering the lens. Interesting displays of lights can be found in various places:

> fairgrounds;
> Christmas street decorations;
> riverside scenes;
> neon signs and advertising displays;
> airports, and airplanes in movement.

Still life: found objects

Take a series of "found" still life photographs, making only minor alterations to the arrangements of objects and the lighting. Look for arrangements that suggest a story—as if they have been left by someone who may return at any moment, for example. Try photographing:

> tidy and untidy rooms (try to convey the house's atmosphere, and the character of the occupants);
> the kitchen, with food and utensils;
> a dressing table;
> the playroom;
> tools in a workroom;
> family mementos;
> the contents of a drawer.

Still life: arrangements

Before you begin to set up a still life, spend time collecting items that may be useful. Concentrate first on good composition and balanced lighting (using daylight, and white or silverized reflectors). Try interpreting one of the following themes:

> historical associations (using objects closely identified with a particular historical period);
> hobbies, arts and handicrafts;
> collections;
> music;
> anniversaries and personal milestones;
> sporting achievements;
> club activities.

The nude

Begin with a session indoors, using natural light from a window together with a reflector. If possible, work in the early morning or late afternoon, when you can make use of directional light. The essential problem lies in capturing and interpreting form. Use shadows falling across the body of the model to give added interest. Later experiment with different backgrounds and settings, so that the atmosphere of the surroundings becomes a part of the picture. Introduce new elements, such as textured surfaces. The same model can be used to interpret an endless variety of conflicting themes: repose or movement, grace or vitality, spontaneity or self-consciousness.

People and environment/2

Make a study of an environment or way of life that has something unusual and distinctive about it, trying to show how it shapes the people you encounter:

> the local bar and its customers;
> theater or circus life;
> contrasts of wealth and poverty;
> people who live and work on water— houseboat dwellers, etc;
> living close to the land;
> lives apart—religious and "alternative" communities, hospital life;
> the life of an ethnic group in a city;
> changed circumstances—the bereaved or separated;
> one-parent families;
> living in a one-room apartment.

Portraits

You can choose your sitters because they have interesting faces, because they lead interesting lives, or because of some specific achievement. Find out as much as you can about your subjects and try to show links with their achievements. An inventor could be shown with one of his inventions, for example. Many people work in surroundings, or wear uniforms, that instantly identify them. There is often a mystique about their work that fascinates outsiders. Such ideal subjects could include:

> artists;
> tycoons;
> nurses, doctors and hospital workers;
> drivers of taxis, buses, or trucks;
> lawyers and judges.

Portraits: varying pose

The purpose of this project is simply to acquaint yourself with the possibilities of pose, background and lighting in portrait photography. Begin with a series of six photographs all taken from the same angle, changing the sitter's position slightly each time: show full face, profile and three-quarter profile, etc. Take another six pictures, changing the camera angle. Experiment with different lighting positions, combining artificial light and daylight, using hard and soft light, and so on. Vary the expression of the model, and include the hands in some shots. Finally, try more complicated poses in which the arms and hands are brought into play to form interesting and expressive shapes.

Children

If you have children of your own, you can find the same satisfaction as any other parents in keeping a photographic record of their growth and development over a long period of time. It can be interesting to take a picture every few days for the first year of a baby's life, one a week during the second and third years, and at least one a month thereafter. Don't forget that not only the special occasions are worth recording but also more regular activities: traveling to and from school, playing with toys, or helping in the house. When they are photographed frequently, children lose their self-consciousness. Schools and playgrounds provide opportunities for intriguing studies of children.

Projects

Further suggestions

Groups

A tight grouping is usually best, preferably with a definite point of interest. Use a high camera angle if there is difficulty in making everybody visible. Shoot some pictures while the group is off guard, just before and after the "official" picture-taking, and vary the degree of formality during shooting. Take plenty of pictures, since probably there will only be a few in which everyone is fully visible and acceptably posed.

Picture essay

Try to explore a subject in much the way that a documentary film would. Bring in related material in order to analyze the subject in terms of its past, its development and its future. Thus a picture essay on a public monument should deal with what it commemorates as well as its appearance and surroundings. An essay on a historic house could include portraits and mementos, etc., that show who lived there and what they are famous for. An essay on the life of a church could show the activities of its minister and parishioners far from the church itself. A picture story on a person can be treated by depicting one day of his or her life.

Architecture

Preliminary research greatly assists you in knowing what to look for. Aim to include significant internal and external details as well as overall views of the building. Apart from the more obvious buildings that attract sightseers, some possible architectural themes are:

domestic architecture—show the details that create character, comfort and convenience;

railroad stations, signal boxes, locomotive sheds;

industrial complexes;

buildings that are undistinguished except that they are well-adapted to their surroundings or make good use of local materials.

Nature: close-ups

A macro lens or extension tube should be seriously considered for close-up work, but these suggestions can be pursued with no special equipment. Static subjects can be simply recorded or composed into still life studies:

leaves, grasses, ferns—dried and pressed;

collections of butterflies, beetles, or other insects;

abstract patternings in mottled tree bark, lichen on rocks, foliage, frost on windows;

You will have very little depth of field but living subjects can often be guided; thus insects can be attracted by a drop of honey, and aquarium fish can be restricted with a sheet of glass.

Fog and mist

Although misty conditions can perhaps be relied on in damp areas in the early dawn, they are otherwise not easy to foresee. When you find yourself in fog, bracket your exposures, since they are difficult to get right. A powerful sense of recession and, often, of vague threat is created by parallels that are swallowed up in the mist—the edges of a road, low walls, overhead power lines, railroad tracks. The easiest theme to look for is mystery, in the veiling of figures and familiar objects, but in addition look for the elements of color and tone—mist lends a blue cast to everything during the day. The sense of space in any landscape rich in distance cues will be dramatically enhanced in misty conditions.

Travel

All the projects discussed can be reinterpreted when you are in a location that is fresh to you. You can work to themes; you can capture the feel of the area by photographing its architecture and its landscapes or by composing still life pictures using typical local products, foods or handicrafts; you can take portraits; and you can even set up fantasy pictures in these new surroundings. Remember that local sights will be diminished rather than enhanced if your fellow holidaymakers are included with no other purpose than to prove they were really there. Try making a photographic diary of the holiday to help you to get out of the rut of conventional tourist photography.

Expressing movement

Practice using the full range of shutter speeds with a variety of moving subjects, gradually acquiring a feel for the speed that will freeze a subject or give a blurred image suggestive of the movement. At the same time explore other ways of expressing action. Take repeated pictures of some sequence—the blows of a man felling a tree, a series of high jumps—trying to capture a different phase of the action each time. Note the contrast between picturing an action at its peak and the unbalancing effect of catching it at a different point (which conveys greater movement). Try applying the old rule that "the motion must be contained in the frame"—and study the effect of breaking it.

Large interiors

First gain experience in photographing interiors that have adequate natural lighting. High contrast between windows and shadows will present problems. Choose viewpoints that exclude windows where possible and use flash to fill in limited areas. Take many views of the same interior varying the amount of foreground you include. Later, try the "painting with light" technique described in the text on pages 144–5. Do not be too ambitious at first; begin with moderately sized rooms that require three or four flashes. A wide-angle lens is indispensable for interior work; remember that it will exaggerate perspective, particularly in the foreground.

Nature: landscape

If you are impressed by a landscape while traveling, but the light is unfavorable, make a "notebook" shot as a reminder for a future visit and try to decide when the light will best reveal what you want to show. For the landscape study itself, choose a viewpoint from which objects in the near and middle distance will overlap to convey scale and distance. Use filters to balance or add drama to your pictures. Figures lend scale and can create definite moods, but if they are too prominent they can detract from the landscape. Your pictures should express a mood (isolation or abundance, tranquility or wildness) or an idea—perhaps an aspect of local history or a way of life.

Nature: sky and water

Practice the control of sky and water photography by the use of filters. Polarizing filters are valuable for darkening the sky or its reflection in water. A yellow filter will darken the sky and increase cloud/sky contrast in black and white photography. A graduated neutral filter can balance the lightness of the land and sky, but frequently you can use the brightness of the sky to good effect by underexposing the land and making the horizon a dramatic silhouette. Explore the effect of high, low and symmetrically placed horizons. In photographing still water, include details that break the excessive symmetry between sky and water.

 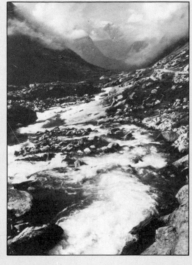 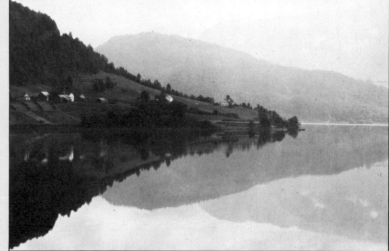

Capturing action

There are usually opportunities for several panning shots in any scene of activity you photograph. Make sure your panning movement is smooth and that you follow through after pressing the shutter button. Remember to choose backgrounds that contain some variety of color or shape so that the effect of the panning is brought out in the form of speed lines. Take into account the distance between the subject and yourself—the farther the subject, the slower you need to pan, and the slower the shutter speed that you need to achieve significant blurring. Remember that panning can be used not only for horizontal movement but for vertical movement, such as that of a high-diver.

Reflections

Look out for interesting reflections in the course of all your normal photography—in the windows of vehicles and buildings, in wet streets, and so on. Often you want to control or eliminate these reflections with a polarizing filter, but you should also feature them occasionally. The reflected image can be seen in virtual isolation, with only a frame of some kind to show that it is a reflection, or it can appear juxtaposed with real objects. Attempt some multiple portraits, with the real face in profile and the reflected face in three-quarter profile, for example. Mirrors in landscapes can also create intriguing images. If you print your own pictures you can create montages in which "impossible" reflections appear.

Changing emphasis

Produce a series of photographs in which the elements are manipulated in such a way that the atmosphere of the scene is changed for each shot. Rely on slight shifts of camera position or in the balance of the composition to achieve the effect. Two people in an almost bare room could be used in a sequence expressing harmony and discord, intimacy and distance, simply by their placing, attitudes and position relative to the camera. Whether they appear in silhouette or are clearly portrayed, and whether their actions have an intelligible relationship or appear to be mysteriously disconnected—all these can change the mood of the picture. Objects, too, can take on strange significance by mere change of position.

Fantasy

There is no limit to the possible starting points from which your imagination could take flight. You might be inspired by legend and myth, or you might wish to create photographs that illustrate incidents or ideas found in fantasy literature—from J. R. R. Tolkien to John Cleland, from sword-and-sorcery to science fiction. Or you could set up scenes that give a bizarre twist to the conventions of the western, the soap opera or the detective story. You could try to fit a composition to a title—to find an image that will give meaning to such paradoxical phrases as Stationary Travel, Never-ending Road, or Transparent Wall. Or you can create fantasy from bizarre combinations of the materials at hand.

SPECIAL SITUATIONS

Although there is no limit to the unusual conditions that can arise in photography, the tips offered here should enable you to adapt to them with more confidence. The section includes an account of the technical uses and creative possibilities of the different kinds of filters.

Special situations/1

A landscape at night can be recorded on film without much difficulty, although exposures of several minutes may be required and you will need a tripod. To record detail while capturing the atmosphere of night try photographing at dusk and including lights in the picture to provide contrast. In the photograph on the right, taken at dusk, shapes are discernible that give the picture interest and which do not appear in the picture shown above, taken only a few minutes later.

A theatrical performance presents problems to the photographer because of the lighting that is used; it is both high in contrast and low in overall intensity. Remember that a large area of dark background will tend to give a low reading on your exposure meter and you may overexpose the performers unless you compensate, as I did here, by closing down a stop. High-speed film makes many theatrical shots possible that otherwise could not be taken at all. It is a great advantage to be able to photograph a rehearsal for the freedom of movement that will then be possible. Watch out for the climaxes, which are the easiest and most dramatic moments to photograph, since the performers hold their poses briefly.

Moving vehicles often afford an unusual vantage point for a photograph. The snow scene on the right was taken from a train passing over a bridge. On any vehicle there will be vibration that you may not notice while concentrating on taking the picture. To minimize camera shake and subject blur, use the fastest shutter speed. If shooting through a window, make sure the glass is clear and does not reflect light from behind.

Special situations/2

Rain can bring to life scenes that might look dull in more comfortable weather conditions. On the right it has created a hazy, soft-focus effect, because I used a relatively slow shutter speed of 1/16. Frequently, a shutter speed of 1/60 can capture the raindrops themselves as individual streaks. But in general they will appear only when the picture is taken into the light and against a dark background. To capture the sparkling effect created by wet reflective surfaces without losing detail in the contrasting light, expose for the shadows, as in the photograph below, taken at a carthorse parade in London. The strong top lighting has bleached out the top part of the picture altogether but umbrellas shield the faces. Photographers are often deterred from venturing out in wet weather, not by the discomfort, but by the fear that their equipment will be damaged if it gets wet. In fact there is no risk from rain water, provided the camera and lenses are dried off as soon as you get home. (Salt water, on the other hand, should never be allowed to get onto a camera.) Make a habit of drying off the lens with a soft cloth immediately before taking a picture; a lens hood, normally attached to prevent flare, also helps to keep rain off the lens. But the soft-focus effect created by a few drops of water on the lens can often be turned to good account.

Artwork, photographs or pages from books can be copied reasonably accurately and without much difficulty using the arrangement shown below. An ordinary camera, loaded with slow fine-grain film, is mounted on a vertical rail perpendicular to the baseboard on which the page to be copied is laid flat. Film will show any unevenness in lighting, so two lamps are attached to the stand, symmetrically placed to provide even sidelighting that will not give highlights on glossy paper. Stands designed specially for copying work are available commercially, or you can construct your own from the baseboard and central column of an old enlarger.

TV pictures can be photographed using the exposure indicated by a built-in or hand-held meter close to the screen. Daylight color film may be used to photograph color TV. There may be a blue-green cast in the resulting pictures: try a Kodak CC40R filter or try making the TV picture a little redder by changing the color balance of the set. The TV picture is scanned 25 or 30 times per second (it varies from country to country); with a between-the-lens leaf shutter, a shutter speed of 1/30 or slower is therefore needed. But with the focal-plane shutter used by nearly all SLRs, you will need to use a speed of 1/15 or slower.

Underwater photographs can be taken using a camera designed specially for underwater work, such as the Nikonos III, illustrated above, which offers a wide range of underwater accessories, or with an ordinary camera protected by a special waterproof housing. Underwater camera housings are built to withstand pressure, and the depth at which a particular model can safely be used will be specified by the manufacturer. Most housings are designed for a particular make of camera and have watertight control knobs that enable you to adjust the camera settings underwater. At depths greater than 20 ft it is necessary to employ some form of artificial lighting, since a large proportion of daylight is reflected from the surface, and the intensity of the light usually decreases rapidly with depth as it is absorbed by the water. Flash units specially made for underwater work are available. Another complication of underwater photography is the change in the effective focal length and hence the angle of view of the lens caused by the water's high refractive index. The lens "sees" a smaller angle than it would see in air, and objects appear to be closer than they actually are. However, the apparent change in distance can be ignored in estimating the focusing for subjects more than three feet away; and the underwater housing is usually equipped with an external viewfinder frame that compensates for the change in the angle of view.

Photographing fireworks presents the problem of high contrast. Where there are large highlight areas, expose for these; when I took this picture of a child with a hand-held sparkler there was plenty of time to get an exposure reading from the face before I pressed the button. I actually used an exposure of 1/30 at f5.6, on Ilford HP5. (Of course, it is vital not to forget safety when you are photographing children playing with fireworks.) To increase the impact of your pictures, mount your camera on a tripod and take time exposures that will show successive firework patterns.

Effects filters

When discussing filters used with color film, it is convenient to distinguish between correction filters and those intended to create some more or less bizarre effect. The former variety is essentially of importance only to professional photographers who require the utmost accuracy of color rendition: to compensate for minor variations in color balance from one batch of film to another, or from one light source to another, very pale color-compensating filters are used to adjust the color temperature of the image. Of less specialized interest is the diverse assortment of special filters, a selection of which is illustrated in the picture below. These range from multiple-image prism filters to color-burst, soft-focus, color-spot and fog filters. The list could be continued, but most of these filters are of limited

value because their effects are so pronounced that they tend to dominate any photograph in which they are used. Since their main interest lies in novelty, their effects can very easily become stale through overuse. Used in moderation and with discretion, however, special filters have a place as interesting accessories that extend the photographer's control over his subject, and can be used to produce unusual images that cannot be obtained in any other way.

The main use of these filters is to add a touch of drama or the surreal to ordinary subjects. In a separate category of its own is the polarizing filter, which is useful both in color and in black and white photography. The polarizing filter has two distinct uses: to cut down reflections from polished or shiny surfaces and to deepen sky color. Because its effect looks natural rather than gimmicky, the polarizing filter finds a wide range of applications. A neutral-density filter is also useful to darken the sky without affecting color balance.

A **polarizing filter** has been used to darken the sky behind the statue in the second photograph at the top. The same filter can also be used to reduce glare from certain reflective surfaces, notably glass and water: reflections in the hood and windshield of the car are visible above, but have almost been eliminated in the

picture on the right. The filter works by blocking out light that has been polarized, while allowing other light to pass. The amount of light that is blocked varies as the filter is rotated, so when you use a polarizing filter, rotate it in front of the lens until you find the position that gives the best result.

A **triple-prism filter** creates three overlapping images of each subject. Similar filters can be obtained that produce a larger number of images. The effect, too striking to be used very often, usually gives the most satisfactory results with simple subjects.

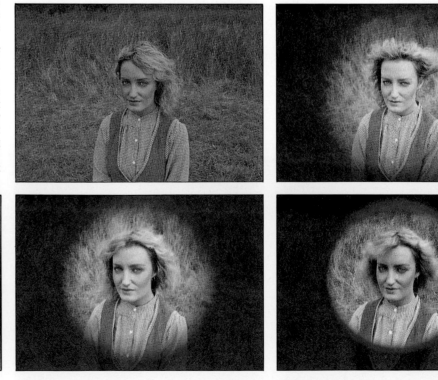

A **green "color-spot" filter** has been used to produce the photographs shown above. The first picture, taken without any filter, is included for reference. The sequence demonstrates how changes in the aperture size influence the effect of this filter: a wide aperture

(f2.8) was used in the first photograph taken with the filter, giving soft edges to the central spot, while in the final shot a small aperture (f16) caused the hole in the filter to appear more clearly defined. The aperture for the intermediate photograph was f8.

Night scenes can be given a feeling of vitality and excitement by a color-burst filter, which will transform an uninteresting string of street lamps into a dazzling array of color and light. The filter is not itself colored, but is engraved with a grid of fine lines that splits light into its component colors. The effect of the color-burst

filter is most successful in situations where a number of isolated light sources are surrounded by darkness. The filters are designed to be rotated for the best orientation: the picture above, with its horizontal floodlit area, would be less effective if the lights had been dispersed horizontally.

The unnatural red sky over the church was produced by using a graduated filter, available in various colors and useful for enlivening areas of the picture. A similar filter gave a reddish tinge to the clouds above the "Pleasureland" sign, lending the sky some of the garishness of the fairground below.

An orange and green dual-color filter gives a different color cast to each half of this picture. There are many differing color combinations, but as the effects are so strong these filters have only limited applications, except where a highly theatrical result is wanted.

A starburst filter gives a jewellike brilliance to nighttime pictures. I was careful to include the isolated lights to relieve the empty foreground. This filter works best with light from a point source such as a naked light bulb or clearly defined reflection.

A six-rayed sun was produced here without any help from filters by stopping the lens down to f22. Multiple "ghost" images are also often produced by reflections in the lens when shooting into the sun, rivaling those formed by special effects filters.

Contrast filters

Filters are frequently used in black and white photography to give a truer rendering of the tonal values of colors or to exaggerate contrast for special purposes. The filter darkens areas of complementary color (see page 98) more than other areas of the picture, which are restored to their normal tonal value by an increase in exposure. A yellow filter, for instance, darkens blue areas particularly, by absorbing some of the blue component of the light that passes through it. This is useful in skyscapes, where the filter compensates for the excessive blue-sensitivity of the film, as the accompanying pictures show. A yellow filter also penetrates haze to some extent, for the haze is predominantly blue.

A medium-density yellow filter is the most useful. For more specialized work, a light green filter can be used in garden pictures to darken red flowers in relation to the surrounding foliage. It can also be useful for portraits taken indoors, since it counteracts the redness of artificial light and prevents skin tone looking unnaturally light.

If you are considering using a colored filter for a black and white photograph, decide on the area of main interest and whether you want to lighten or darken it. A filter has least darkening effect on areas of similar color to its own, so that a red filter would be appropriate if you wanted to lighten the image of a scarlet rose in relation to its leaves. Red filters are sometimes used in architectural photography to emphasize the grain of wooden surfaces.

If your camera has a through-the-lens exposure meter it will read correctly when a filter is over the lens. Otherwise, increase exposure according to the filter manufacturer's instructions.

Blue sky seems washed out in the photograph on the right, taken without a filter. The film's excessive sensitivity to blue light has caused the sky to appear too light and reduced its contrast with the clouds. The summer sky's typical depth of color is lacking, though the tonal values in other areas are correct.

A yellow filter enhances the contrast between the sky and clouds in the left-hand picture below. The filter absorbs blue light, with a darkening effect that is much greater on the sky than on other areas. A one-stop increase in exposure compensates for the darkening of the other parts of the picture.

An orange filter makes the sky still darker in the final picture. Such filters are popular for creating dramatic skyscape pictures. They can distort the tonal values of skin, and so are not suitable when human figures are an important part of the picture. An orange filter makes it necessary to increase the exposure by $1\frac{1}{2}$ stops.

TECHNICAL GUIDE

This final section gives advice on setting up a studio, helps you to track down the reasons for faults in pictures, tabulates some useful data and provides a glossary of the technical terms of photography. It begins with a brief survey of cameras and lenses available today.

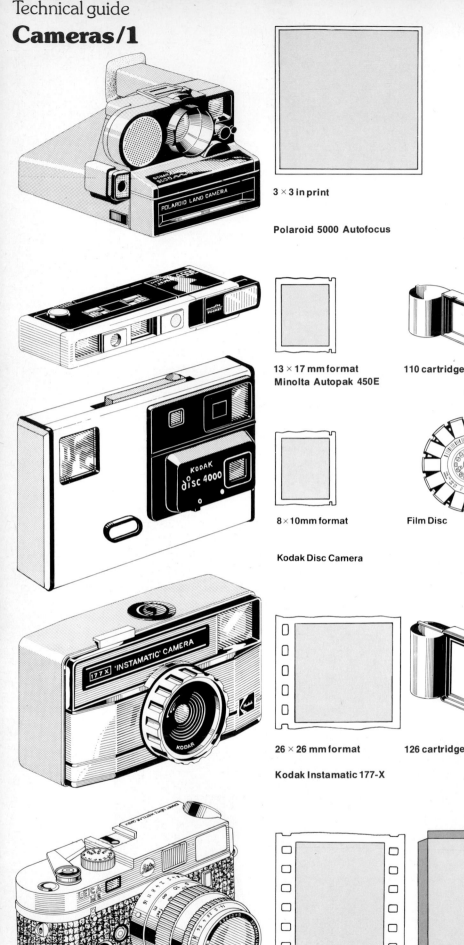

3 × 3 in print

Polaroid 5000 Autofocus

13 × 17 mm format
Minolta Autopak 450E

110 cartridge

8 × 10 mm format

Film Disc

Kodak Disc Camera

26 × 26 mm format

126 cartridge

Kodak Instamatic 177-X

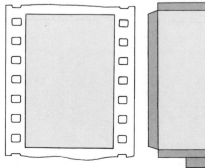

24 × 36 mm format
Leica M4P

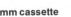

35 mm cassette

Instant-picture cameras

The advantage of a Polaroid instant-picture camera is that the developed print can be seen 30 seconds to eight minutes after taking the picture, depending on the film type used. The print size varies slightly but on average is about 3 × 3 in or 3 × 4 in. Apart from the mediocre print quality, disadvantages are that the cameras are bulky (though light), film tends to be expensive, and prints exactly like the first cannot be made unless specially copied and reprinted in the conventional way. The exception is black and white Polaroid film Type 665, which gives both an instant print and a negative. Most instant-picture cameras are "solid body", but a few can be folded for easier carrying and storage. Two models are true single-lens reflex types, giving a picture identical to the image seen in the viewfinder. Dry-process films are less messy than those that peel apart and they also leave no waste-paper tags. Most of the cameras have a simple lighten/darken control to adjust the exposure if the automatically exposed print is not acceptable. Attachments for close-up photography are available.

110 pocket cameras

Prior to the introduction of disc film, these small cameras were the most popular format for snapshooters. The cameras take 110-size cartridge films, yielding 13 × 17 mm negatives. They are still among the cheapest cameras to buy, and since 110 negatives are significantly bigger than those on disc film, these cameras are capable of producing slightly sharper results than disc cameras. Most models have a fixed focus lens and a fixed exposure system. Some have an integral electronic flash, and a supplementary telephoto lens that can be slid into position.

Disc cameras

These wafer-thin cameras barely make a bulge in the pocket, so they are the easiest of cameras to carry around. At 8 × 10 mm, the negatives are little bigger than a finger-nail, and this sets an upper limit on picture quality; nevertheless, used with care, a disc camera can produce negatives that will stand enlargement up to 8 × 5 inches. Most cameras of this type have fixed-focus lenses, but many have automatic exposure and built-in flash.

126 format cameras

The 126 format camera followed Brownie in mass popularity. It had the advantage of easy-to-load cartridge film, but has steadily lost ground to the 110 and disc cameras that superseded the 126 format. The print quality obtainable from the 26 × 26 mm film size is considerably better than that produced by the two smaller cameras, and there is a larger range of film types available. The choice of 126 cameras still being manufactured is extremely limited, and few of the currently available models have anything like the sophistication of up-to-date 35 mm compacts.

36 mm rangefinder cameras

The rangefinder camera is the ancestor of today's autofocus camera: twin windows on the camera front create a double image of the subject in the viewfinder, and to focus the photographer turns a ring on the lens until the two images coincide. Autofocus cameras carry out a similar operation eleronically. The Classic Leica M4-P is one of the few cameras of this type still manufactured, and is built to last a lifetime. Most rangefinder cameras are high-quality instruments, but usually lack the sophistication and electronic gadgetery that is the rule on 35 mm single-lens reflex cameras. Most have built-in light meters, and "parallax correction"—a system that moves the bright-line frame indicator in the viewfinder to compensate for the changing field of view as the photographer focuses closer.

Integral flash 35 mm compacts

To make 35 mm compact cameras even more popular and versatile, many have been designed with integral electronic flash. The power unit is usually two penlight-size batteries and can provide several hundred automatically correct flashes. The flash is not very strong, but is adequate for subject distances up to 10 to 18 feet, depending on the film speed and the strength of the unit. Most of these flash units are switched on as they pop up from a "parked" position when a button is pressed, though some are mounted in a fixed position. Some models also have automatic exposure control, while some have manual control of the lens aperture, enabling the user to control the depth of field.

Autofocus 35 mm compacts

These cameras are similar to other 35 mm compact cameras, but they additionally focus automatically, using a beam of infrared radiation to measure the distance to the subject. Autofocus cameras don't set the exact subject distance; instead they decide which of a series of zones the subject lies inside. The simplest models have just 3 zones—near, middle and far—but more sophisticated types have up to 11 and therefore produce sharper pictures. All auto-focus cameras set exposure automatically and have a built-in flash unit. Many also advance and rewind the film using a motor, so that loading and unloading is effectively foolproof. Focusing isn't always so certain—only central subjects come out sharp.

Baseboard cameras

Baseboard cameras are the portable versions of the so-called "technical" camera. They use sheet film, usually 4 × 5 in, held in a sliding film holder. This can be replaced with a rollfilm holder on some models. The large film frame size gives very high quality enlargements. A bellows connects the body and the interchangeable lens, which incorporates a between-the-lens shutter. The front "standard," the panel which holds the interchangeable lens, may also be tilted, swung and raised for image perspective control. The baseboard under the front standard can even be lowered, and the film-holding back may also have some or all of these movements for still further control. Certain models have a simple frame viewfinder, while others have a rangefinder coupled with the lens for increased focusing ease and accuracy. Some models may be only slightly more expensive than a high-priced 35 mm SLR camera. The great advantage of the baseboard camera is the image control it offers, but it is bulky and heavy. Frequently it is used on a sturdy tripod in a studio.

Monorail cameras

Monorail cameras are rarely used outside the studio. Their advantages include both a large negative format (as large as 8 × 10 in) and an infinitely variable combination of front and rear panel movements, such as rise and fall, swing and tilt, for the utmost control over image perspective. Both the front and rear standards may also be rotated around the single rail which holds them. By using these movements the photographer can correct converging verticals and introduce controlled distortions—making a golfball egg shaped, or an egg spherical, for example. Monorail cameras are made from aluminum and stainless steel with a bellows connection between the film-holding rear standard and the lens-holding front standard. The lens panels are interchangeable and they are equipped with between-the-lens leaf shutters. Focusing is accomplished by replacing the film holder in the rear standard by a sheet of ground glass. The image is adjusted and focused and then the focusing screen is replaced with the film. These cameras must be used on a sturdy tripod. Although monorail cameras are bulky in use, they can be folded into quite a small space to store them or pack them for traveling.

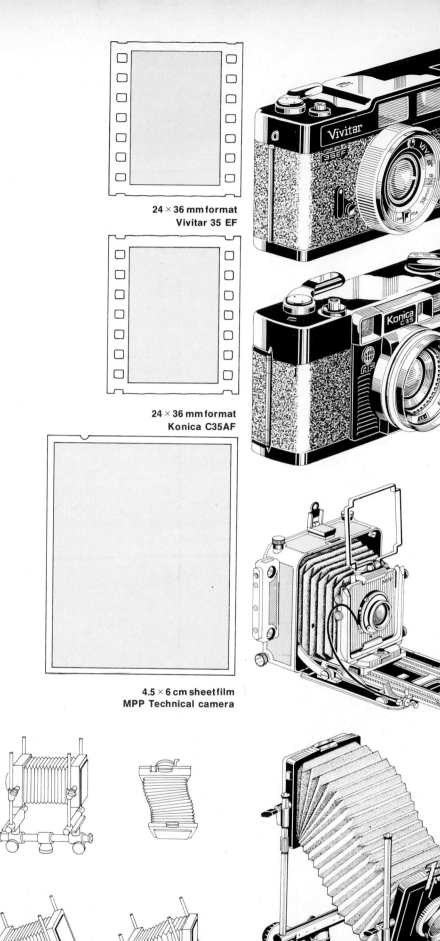

24 × 36 mm format
Vivitar 35 EF

24 × 36 mm format
Konica C35AF

4.5 × 6 cm sheet film
MPP Technical camera

Linhof Kardan Super Color

Cameras/2

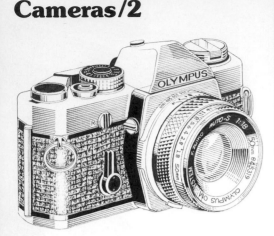

Olympus OM-1

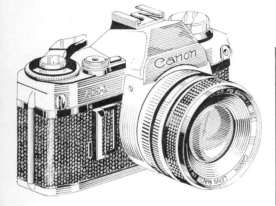

Canon AE-1

Minolta Maxxum autofocus

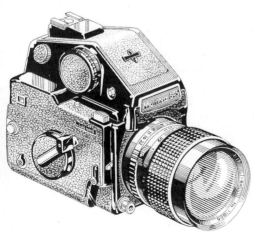

Mamiya M645 1000S

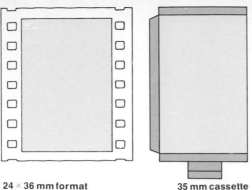

24 × 36 mm format 35 mm cassette

24 × 36 mm format

24 × 36 mm format

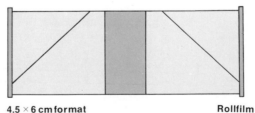

4.5 × 6 cm format Rollfilm

35 mm single-lens reflex cameras—manual

Apart from a handful of rangefinder cameras, the single-lens reflex or SLR camera is the only type of 35 mm camera that takes interchangeable lenses, which is one of its biggest advantages over other types of cameras. Another advantage is the photographer's ability to see in the viewfinder the exact image that will end up on film. Many 35 mm SLRs are called "system" cameras: for these a vast number of accessories are available to help the photographer with virtually any kind of special shot. The term "manual" refers to the camera's exposure control. The photographer must set both the lens aperture and the shutter speed in order to achieve the correct exposure—this point is indicated by lights or a swinging needle in the viewfinder. This form of exposure measurement is preferred by some photographers who feel that it gives them more control over the picture, and manual metering is available as an option on much more sophisticated cameras. However, most photographers who choose a manual SLR do so because it is the least expensive.

35 mm single-lens reflex cameras—auto/manual

Many 35 mm SLR cameras offer an automatic exposure facility as well as manual control. In an aperture-priority SLR, the photographer first sets the aperture he desires and the camera automatically chooses the shutter speed for the correct exposure. In a shutter-priority SLR, the photographer first chooses the desired shutter speed and the camera selects the correct lens aperture. In an auto/manual camera, the photographer also has the choice of manually setting both speed and aperture. Very few SLRs of this type offer a choice between automatic aperture and speed priority. Auto/manual cameras generally offer such advanced features as autowind mechanisms, able to advance the film at $1\frac{1}{2}$ or 2 frames per second.

35 mm single-lens reflex cameras—autofocus

The most sophisticated of all SLR cameras focus automatically. They do not use the infrared system that is common on compact cameras, though; instead, a series of light-sensitive cells inside the camera measures when the focused image has maximum contrast. This system is much closer to the way a photographer judges sharpness by eye. Autofocus SLRs are generally highly sophisticated in other ways besides focusing: most offer several different methods of exposure metering, and a wide choice of accessories and lenses. There's usually a choice of focusing methods, too—some cameras will even track a moving subject, keeping it constantly in focus. Autofocus is so popular that all top-quality SLRs may soon have this option.

645 single-lens reflex cameras

These medium-format cameras have all the features of the 35 mm SLRs, and the added advantage of a film frame measuring 6 × 4.5 cm (compared to 24 × 36 mm). These cameras use rollfilm: either the 120 size, giving 15 shots per roll, or the 220 size, giving 30 shots. The 6 × 4.5 cm frame size is mainly intended for studio work in commercial photography. One type is for use at waist level, the other (incorporating a pentaprism) is for use at eye level. With some of the pentaprism heads, the camera can be converted to automatic exposure control, while some merely incorporate exposure meters. While these cameras have interchangeable film inserts for 120 and 220 film, they do not have interchangeable backs, with which it would be possible to change from one film type to another midway through a roll. Compared to their 6 × 6 cm bigger brothers, 645 cameras can get 25 percent more pictures onto a roll of film (15 frames rather than 12). Apart from the model illustrated, several other cameras in this format are made by the Mamiya company.

Twin-lens reflex cameras

This type of camera has two lenses, one to provide the viewfinder image and the second to actually pass light through to the film. It yields a medium format 6 × 6 cm frame size. There is a reflex viewfinder used at waist level, in which the photographer sees an image similar to that which will appear on film; but although he sees the subject the right way up, it is reversed laterally (left to right). This makes it difficult to follow moving subjects, and so for this type of work part of the focusing hood may be unfolded in order to form a simple frame viewfinder. TLRs use both 120 and 220 rollfilms, giving 12 or 24 shots respectively. They are the cheapest type of camera for the 6 × 6 cm format, but have considerable drawbacks when compared with 6 × 6 cm single-lens reflex cameras. For example, only one model of this type has interchangeable lenses and the lens panels are understandably expensive, since each has two lenses and a shutter. The picture-taking lens has a between-the-lens mechanical shutter, which has the advantage of being able to synchronize with electronic flash at any shutter speed. However, usually it only has a speed range of one second to 1/500 second.

Parallax error becomes noticeable in close-up shots taken with a TLR. This is simply the difference in viewpoint between the upper (viewing) lens and the lower (taking) lens. Some correction must be made in order to frame the correct portion of the subject on the film. Some TLRs have a parallax correction device incorporated in the viewfinder focusing screen. Otherwise it is necessary to frame a close-up scene normally, with the camera mounted on a tripod, and then raise the camera by an amount equal to the distance between the two lenses.

6 × 6 single-lens reflex cameras

This type of camera is most widely used by commercial photographers, owing to its generous medium format frame size and the variety of interchangeable lenses and accessories available. Lenses incorporate a between-lens leaf shutter, which will synchronize with electronic flash at any speed. Various types of viewfinder are available; though most photographers prefer the waist-level type, pentaprism heads can be used. Some models, including the Bronica illustrated, will accept different film backs in order to shoot in another format—say 6 × 4.5 cm. A film-plane capping blind allows the photographer to change film types midway through a roll without exposing the film. To check the lighting arrangement and the chosen exposure, the photographer can use a special Polaroid film back to take an instant picture.

6 × 7 single-lens reflex cameras

Some photographers who wish to work in a format larger than 6 × 4.5 cm choose the 6 × 7 cm format, since they favor a rectangular picture. If they already have a technical camera, they can equip it with a suitable back. But there are also 6 × 7 cm SLRs on the market, capable of being used hand-held and similar in all respects to other SLRs. The two models made by Asahi Pentax will accept interchangeable viewfinder heads, focusing screens, and lenses. One type has a revolving back allowing shots to be taken in horizontal or vertical formats without the necessity of turning the camera. The model illustrated has a focal-plane shutter, and can accept a range of a dozen lenses. The other takes lenses with built-in leaf shutters. In this format, 10 shots can be taken on a 120 rollfilm and 21 shots on a 220 rollfilm. The Hasselblad 6 × 7 takes interchangeable film backs that provide different formats or Polaroid instant pictures. These cameras are extremely expensive, and new models are therefore out of the price range of most amateur photographers. They are naturally less convenient than 35 mm SLRs.

$2\frac{1}{4} \times 2\frac{1}{4}$ in sheet film

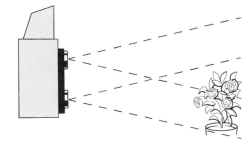

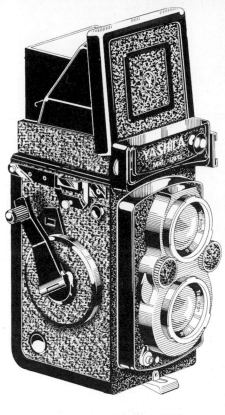

Yashica 124 G

$2\frac{1}{4} \times 2\frac{1}{4}$ in sheet film

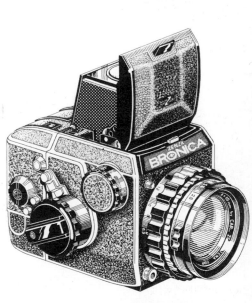

Bronica EC-II

6 × 7 cm sheet film

Asahi Pentax 6 × 7

Lenses/1

Long-focus and telephoto lenses

Any lens whose focal length is greater than the standard or "normal" lens for a given film format is commonly referred to as a "telephoto." (Strictly speaking, a telephoto is a special type of long-focus lens with an optical design that results in the lens being physically shorter than its focal length.) Long-focus lenses are particularly useful for photographing such subjects as sports, wildlife or candid shots, when it is an advantage to be able to remain at a distance. In photographs taken using long-focus lenses, distances appear to be compressed and the depth of field is very limited. Long-focus lenses also tend to be much "slower" than normal lenses, rarely having a maximum aperture much greater than f4.5. Without close-up accessories, they are not capable of focusing closer than several feet.

Canon FD 200 mm f2.8 SSC

Converters

A teleconverter is a lens attachment that fits between the camera body and the lens, increasing the effective focal length of any lens with which it is combined. Most converters have a factor of either 2 × or 3 ×: here, for example, a 2 × converter was used to convert a 200 mm lens into a 400 mm lens; similarly, it would enable a 50 mm lens to be used as a 100 mm lens. In this way, converters provide a cheap way of extending your range of lenses, though some sacrifice of image quality is inevitable. When buying a converter, make sure that it is adapted to retain the facilities your main lens has, such as full-aperture through-the-lens exposure metering. Converters are most commonly used in conjunction with standard or medium-long lenses.

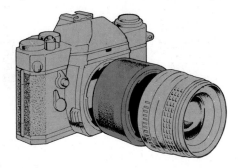

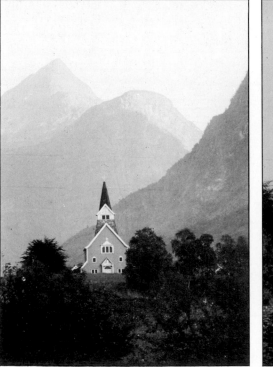

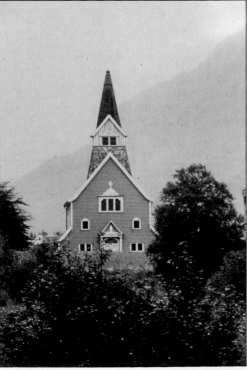

Zoom lenses

A zoom lens is a lens of variable focal length. The focal length is altered by changing the position of a group of independently movable elements inside the lens, and in nearly all models, changes in the focal length do not affect the focus. Some zoom lenses have separate control rings for focusing and zooming, while on other designs a single ring serves for both purposes (twisting the ring focuses the lens, pushing or pulling it changes the focal length). The former design is known as "helical" zoom, the latter as "rectilinear" or "one-touch." Zoom lenses are available that offer focal lengths ranging from wide-angle to normal; the majority, however, range either from normal to medium telephoto lengths, or from medium to long telephoto. Some also have a close-focusing or macro facility. Zoom lenses are useful when the subject distance is constantly changing and in framing the scene in the best way without having to change viewpoint. No zoom lens, how-ever, can give optimum image quality over the whole of its range. The pictures below that include the girl were taken from a single position, using a Vivitar TX f5 lens, which can range from 100 mm to 300 mm in focal length. The detail shot shows its close-focusing ability. The effect on the right was achieved by a slow shutter speed and zooming the lens during the exposure.

Canon FD 80–200 mm f4 SSC

Canon FD 35–70 mm f2.8–3.5 SSC

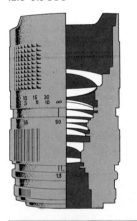
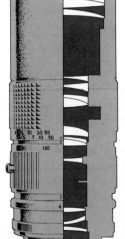

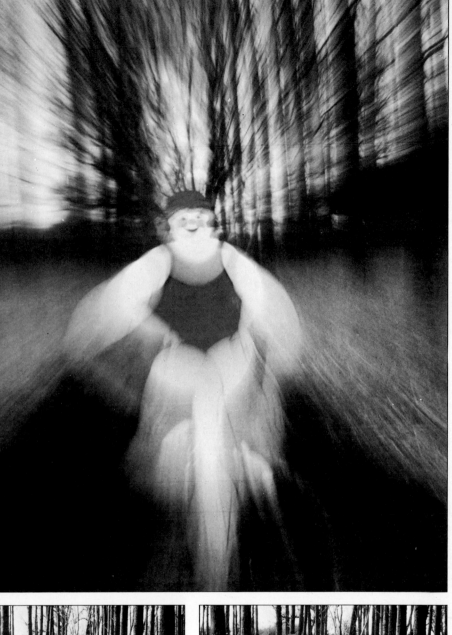

100 mm

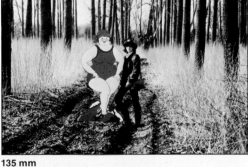

135 mm

180 mm

200 mm

300 mm

8 in from subject, macro setting

Wide-angle lenses

A wide-angle lens is one whose focal length is significantly shorter than that of a standard lens. For example, for a 35 mm format camera, the most common varieties of wide-angle lens have focal lengths of 24 mm, 28 mm and 35 mm. Short-focus lenses have a wide angle of view compared with their standard counterparts, and are thus able to "see" a larger proportion of a given scene. This ability is useful for taking shots in restricted areas, such as the narrow village street at bottom right, for photographing buildings (bottom left) and also for giving a sense of spaciousness, as in the picture of a cathedral and the aerial view of a harbor. These pictures were all taken with the same 28 mm lens.

The photograph on the right illustrates the distortion that becomes obvious in shots taken with a wide-angle when the subject is close to the lens. The distortion is not nearly so pronounced in the smaller picture of the same girl taken at a greater distance. Both photographs show the extensive depth of field typically given by wide-angle lenses. In general, the shorter the focal length of a lens, the greater the depth of field.

It is difficult to design wide-angle lenses free of aberrations—barrel distortion especially. As a result, they tend to be relatively expensive and bulky. Distortion is particularly acute in lenses that give an angle of view of about 180°, called "fish-eye" lenses. Some of these give a circular image on the film, others fill the frame in the normal way.

Canon FD 24 mm f1.4 SSC AL

Macro lenses

A true macro lens should be capable of giving a life-size image—in other words, achieving a 1:1 magnification ratio by focusing very close objects. Many lenses described as "macro", however, merely offer a closer focusing distance than normal. Macro lenses have extra-long focusing mounts, which enable the focusing ring to be turned through several complete rotations, and give their best-quality image with close-up subjects, though they can also be used for ordinary purposes. A few telephoto and zoom lenses offer a macro focusing facility: the close-up of the cat was obtained with the same 100 mm lens as the shot above it.

Canon FD 50 mm f3.5 SSC

Extension tubes

Fitted between the body of the camera and the lens, extension tubes serve to increase the distance between the back of the lens and the film, which permits closer objects to be focused. Tubes are normally supplied in sets of three, each having a different length, and they can be used singly or in combination. Simple models are relatively cheap, but do not allow automatic aperture control, so the lens has to be stopped down manually. Approximate focusing is achieved by moving the whole camera, and fine adjustment is made with the focusing ring on the lens.

Bellows

Bellows units are similar in principle to extension tubes, but have the advantage of allowing a continuous range of adjustment, giving the photographer greater ability to vary the size of the image and judge the exact scale he wants. They need to be used with a tripod, however, and are more complicated to set up. In addition to being more cumbersome, they are also more expensive than extension tubes. As the distance between the lens and film is increased, the image grows dimmer, and the f-numbers cease to be a reliable guide to exposure. A through-the-lens meter can still be used directly as the easiest means of achieving correct exposures; but to calculate an exposure, consult the guide on page 194.

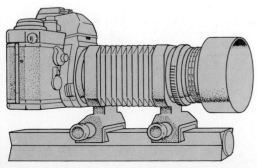

Setting up a studio

A studio can vastly increase the scope of your photography by giving you an area in which you have total control over lighting and background. It is easy, and not expensive, to improvise a studio in your home, but unless you are fortunate enough to have several spare rooms, your ability to choose the size and shape of your studio may be restricted. However, almost any reasonably spacious room will be suitable, especially if it has a large window or skylight to provide a source of natural light. The floor should be some hard and easy-to-clean material such as hardwood or tile. It should be nonreflective and should have no carpets to hold dust. Apart from being suitable for picture sessions the studio is a useful working area for preparing subjects, backgrounds and "props," for storing materials and equipment, and for displaying or projecting photographs.

1 Diffusing blind	13 Nonslip floor
2 Lightproof drapes	14 Trolley
3 Large window	15 Filters
4 Gray wall	16 Blower brush
5 Paper roll	17 Extension cable
6 Reflectors	18 Storage space
7 Auxiliary spotlight	19 Work surface
8 Photoflood	20 Storage hooks
9 Umbrella reflector	21 Spare lenses
10 Extension sockets	22 Negative files
11 Reflector	23 Reflector bowls
12 Tripod	24 Snoot

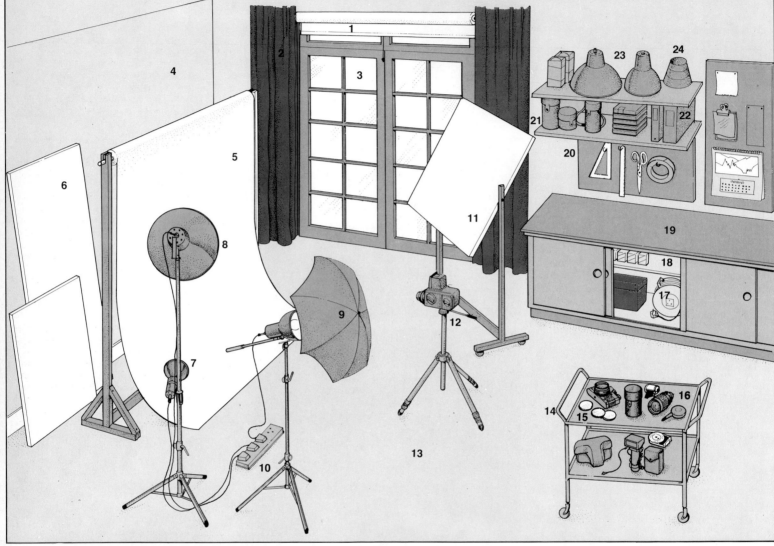

The walls and ceiling of your studio should be painted matt, preferably with at least one white wall and one dark gray or black. The white wall can be used to reflect light, in order to fill in shadows. But there are often times when you will want to provide a dark background and prevent stray light finding its way into shadows, so a dark wall is also useful. Black, dark gray or white wall and ceiling surfaces are desirable because they do not give a color cast to reflected light, which color film would exaggerate.

A hard, smooth floor is necessary to provide a firm surface for tripods and lighting stands, as well as to allow a model to stand on background paper without creating ugly crinkles.

Most of the space available should be kept clear for the set, the area in which you will actually place and photograph your subjects. It should be close to the available source of natural light, which can be regulated by an opaque blind or softened by greaseproof paper over the window. The set area should extend at least 10 feet (3 meters) in front of the background to allow a variety of lighting gear to be employed and to give you the maximum freedom of movement, so that you can shoot subjects from many different angles. Rolls of colored paper or material are useful for providing a variety of settings. They can be hung from special roller racks or pinned to the wall itself. You can also achieve exciting effects by throwing colored light onto plain walls with a slide projector to provide an inexhaustible variety of backgrounds.

If you are using a telephoto lens, which is common in portrait work, you will need more working space than when you use a standard lens. Thus, if you use a 135 mm lens with 35 mm film for a full-figure shot, the camera–subject distance will need to be about 20 feet (6.3 meters), more than twice the distance required with a standard lens. An additional space of a few feet is needed behind the subject in order to avoid unwanted light spilling onto the background.

Space must also be allowed for the preparation area. The equipment required here is straightforward. A good working surface or tabletop to lay out all the equipment you plan to use for a particular session is important for efficient work to avoid time-wasting searches for elusive items. You will probably need another firm table at a convenient height for still life photography, together with a stool and a chair for a model.

If you are doing portrait or fashion photography, then a makeup table is necessary, equipped with bright, even lighting and a large mirror in a changing room; if this cannot be arranged, a folding screen will do and, if painted white, could usefully double as a light reflector.

In the storage area it is useful to have somewhere to lock away valuable equipment and a shelf or drawers for storing background paper and any tools necessary when you are making sets. You will also need plenty of storage space for printing paper and chemicals, and possibly a clothes closet.

It helps to have plenty of electrical power points in the studio, which will give you greater flexibility when arranging lighting equipment. Points are also needed to provide light for the makeup table and for normal (nonphotographic) room lighting, and occasionally for the power tools you may need in building a set or making props.

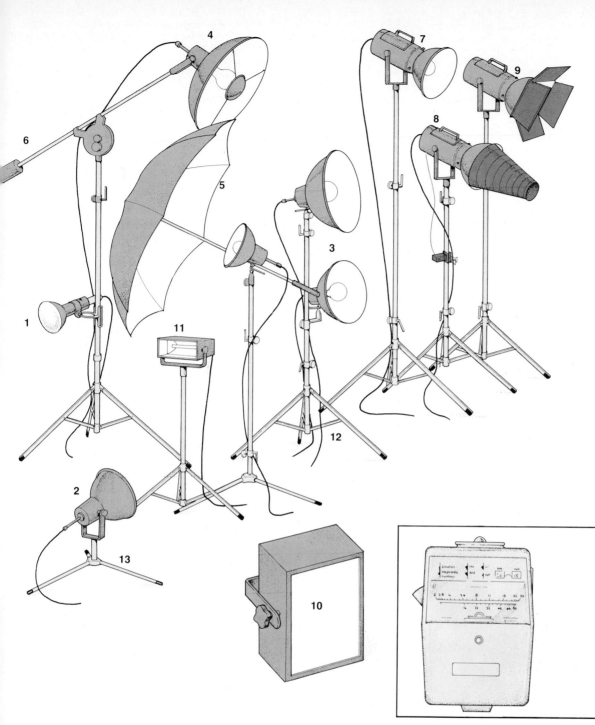

1 A simple photoflood bulb gives a hard light, although some of it will spill onto walls and act as fill-in light.
2 A small, deep reflector bowl helps to direct light, which is then more accurately aimed but still gives hard shadows.
3 Large, shallow reflector bowls provide a slightly softer lighting effect.
4 A large reflector is fitted with a small shield that blocks direct light from the bulb so that the unit gives almost shadowless illumination.
5 A brolly reflector gives bounced light with a very soft quality.
6 A boom-arm lighting stand helps in positioning a unit and in directing its light accurately.
7 A studio electronic flash unit provides more light than a tungsten bulb, and it can be used with daylight color film. It may incorporate a modeling light, used during the setting up of the shot.
8 A slave flash unit is fired by a light-sensitive cell triggered by the main flash unit. The one shown here is fitted with a "snoot" that channels the light into a narrow beam.
9 "Barn doors" can be attached to a lighting unit to limit the beam at its sides.
10 Fluorescent tubes mounted in a light box provide a diffused light, compatible with daylight color film.
11 Tungsten halogen lamps have longer lives than conventional tungsten lamps, and the color of their light is more stable, justifying the fact that they are more expensive.
12 A tripod is the most common type of stand used for lighting units. Larger studio units may have wheeled "dolly type" stands.
13 A short tripod stand, or an adapted tabletop camera tripod, can prove useful.

The flash meter is almost indispensable when more than one flash unit is used, since reliable calculations of exposure are then difficult. A reading is taken by firing the flash units once, while holding the meter close to the subject. The meter records the total amount of light falling on the subject from all sources and indicates the camera aperture that is required. A professional will use a flash meter several times all around the subject; with careful use and some practice he can measure the lighting on specific areas of the subject to create exactly the effect he requires.

Do not forget the importance of good heating and ventilation. They help to create a comfortable atmosphere for yourself and for any models who may be working with you.

Studio lighting
When you have created the basic setup for your studio, your next priority will be to light it. Natural daylight from a window or skylight plays a vital role in a studio lighting scheme, either as the main light or as fill-in light for the shadow areas of the scene. You can diffuse it by, say, a white roller blind, or by reflecting it from a white card. The window must be capable of being completely blacked out with a curtain when the need arises.

Artificial lighting may be provided by tungsten filament lamps—essentially the same as domestic light bulbs—or by electronic flash. Tungsten "photoflood" lamps are cheaper to buy than electronic flash units, but the short lamp life—a matter of hours—tends to make them more expensive in the long run. Several tungsten units can quickly heat up the studio—and the subject—but the results ob-

tained with tungsten lighting are more predictable than those obtained with flash equipment.

Each tungsten unit needs to be plugged into the mains power supply, which means that there may be five or six lamps which have mains leads trailing off into power points in the corners of the studio. This makes for a cluttered floor area and is a hazard when you are moving round the studio and concentrating on the shot. But the camera need not be connected "in sync" with the lamps.

Electronic flash units must also be connected to the mains and in addition at least one must be connected to the camera by a synchronization lead. The other units are synchronized by "slave" units, light-sensitive cells that are triggered by the main flash units, so that there is no need for a physical connection with the camera.

A fairly wide range of accessories is available for use with tungsten units. Bowl-type reflectors can vary the quality of the light and its direction, and gel filters can vary its color. Whether you use electronic units or tungsten filament lamps, clamps are very handy for fixing small units to the backs of chairs if

there are not enough stands.

Another important device in the photographer's armory is the flash meter, illustrated above. Professional photographers often double-check the accuracy of their lighting by taking a test shot on Polaroid film.

Some flash meters now on the market also act as conventional available-light meters, and may have digital read-outs accurate to one-third or one-quarter of an f-stop.

Itemized above are various lighting accessories and the effects you may expect to get with them. But avoid the temptation to invest in an excessive amount of lighting equipment when setting up a studio for the first time. If you fill the studio with lamps you will find yourself spending more time arranging the lighting and less taking pictures. Lighting effects become harder to control, exposure errors become more likely and you may create confusing multiple shadows. A great deal can be done with one or two light sources and a reflector screen to provide fill-in light. Here, as elsewhere in photography, the watchword is simplicity.

Technical guide
Accessories

Many useful and reasonably inexpensive accessories can extend the range of your photographic equipment. Once you acquire these you will need some kind of "gadget bag" or case for photographic trips.

Soft gadget bags are made in plastic or leather, which gives better protection and lasts longer. Carrying cases have rigid shells to provide maximum protection. Both bags and cases have compartments for different items, specially shaped and lined with foam rubber or velvet. You are likely to find that the compartments provided do not exactly meet your requirements, but it is easy to improvise your own with suitably shaped pieces of cardboard lined with velvet. A lining of $\frac{1}{2}$ in thick rubber on the bottom of the bag or case will give additional protection.

To keep items separate but readily available, you will need compartments that will hold your camera body, lenses, and such accessories as a cable release, filters, light meter, flashgun and bracket. Use separate areas for new and used film.

Lens hoods are vital to help cut out extraneous light and prevent flare when shooting against the light. They also protect the front element of the lens against scratches and knocks. A hood designed for a specific lens can be left in position while you are photographing. A clear ultraviolet filter, which also protects the lens, can be left over the camera lens all the time.

I keep a supply of adhesive labels in my camera case so that I can fix one to a cassette to record details of special exposure conditions, such as backlighting, or errors, such as setting the wrong film speed on the light meter. This gives the laboratory the chance to adjust the processing accordingly. I also take along a notebook, plastic bags for film rolls, and adhesive tape. I include a small clean silk scarf in a plastic bag. This is much better than lens tissues for cleaning lenses.

Portable electronic flash units are versatile aids. They divide into three main groups. There are small, low-output manual units, slightly bulkier ones giving a brighter output, and "hammer-style" units such as the Vivitar kit illustrated below. Such a unit may have an output of about 700 flashes from each charging, and can recycle quickly. It can be powered either by a number of small batteries inside the unit or, as we show here, by a separate wet cell pack which can be carried with a shoulder strap.

The smaller flash units can provide a source of fill-in light when you are shooting outside, with the sun as the major light source. Many of the medium-

1	Soft bag	5	Tabletop tripod
2	Rigid case containing:	6	Monopod
	camera body	7	Clamp
	cable release	8	Lens cases
	flash bracket	9	Pneumatic cable release
	lenses	10	Lens hoods
	light meter	11	Filters
	filters	12	Camera case
	lens hood	13	Vivitar flash unit
	flash gun	14	Handgrip
3	Small tripod	15	Flash filters
4	Large tripod	16	Lens/filter adaptor

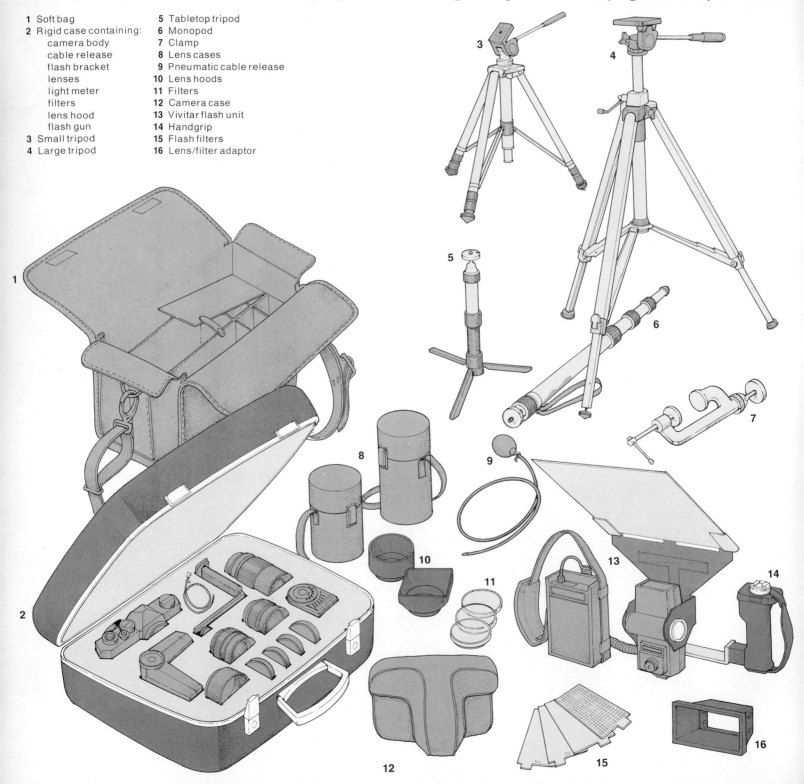

sized guns have an automatic "shut-off" facility—a light-sensitive cell quenches the flash when enough light has reached the film.

The more sophisticated units have a wide range of accessories. You can change the light's color or angle of coverage by means of filters and lenses that fix onto the flash head. Diffuser screens will soften the otherwise harsh light. A holder at the top carries a white card that has a standardized 90 per cent reflectance and gives bounce light.

Whichever type of tripod you buy, a pan-and-tilt or ball-and-socket mounting is essential. The heaviest tripods are best used for static studio work; the lightest and smallest tripods, such as the one shown here, are also useful for "tabletop" still life shots and close-up work.

Where it is impractical to use a large tripod—in taking action shots at sports meetings, for example—a monopod provides a light, maneuver-able "crutch" for steadying the camera, and allows rapid changes of camera direction.

An important part of your "accessory" range is equipment for viewing color slides. There is a wide selection of projectors and viewers, which serve varying functions. The Agfa 110 projector takes the smallest type of slide, those in the 110 format. Viewers range from the simplest, which take one slide at a time and have to be held up to the light, to more sophisticated models that hold a stack of slides and use batteries or mains power. There are also projectors designed to display $2\frac{1}{4}$ in transparencies. Most projectors need to be operated in a darkened room, but there are so-called daylight projectors that have built-in screens. They are portable, and have their own carrying cases.

Projectors are equipped with racks that may carry 40 or more slides, and which are advanced by a manual action or by a remote-control lead. It is possible to have the slides changed automatically at preprogrammed intervals. An autofocusing device is commonly built into modern projectors. While a slide is being projected it is liable to flex as it is heated by the light beam. A sensor can detect this and adjust the focus to compensate; after the initial manual focusing, the projector keeps the image sharp. The latest designs eliminate even the need for initial focusing by hand: a system similar to that used on certain types of autofocus cameras keeps the projected image at maximum sharpness by advancing or retracting the projector lens.

In general, 35 mm slide projectors take no other size of slide. But some models will accept 126 and $2\frac{1}{4}$ in square slides in addition.

Other useful viewing aids are small magnifiers for looking at detail on individual slides; soft brushes for dusting negatives; and a light box, useful for comparing transparencies.

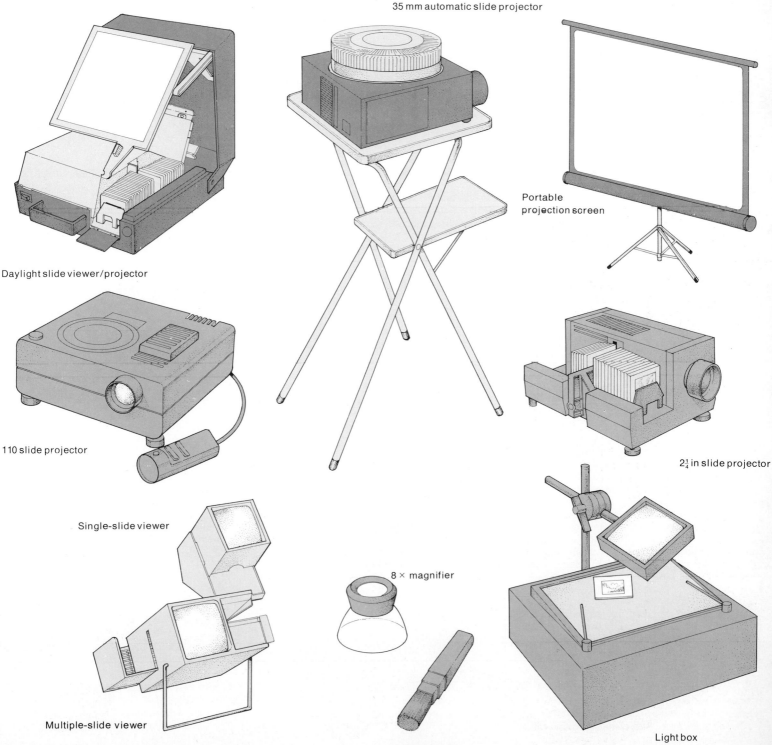

35 mm automatic slide projector

Daylight slide viewer/projector

Portable projection screen

110 slide projector

$2\frac{1}{4}$ in slide projector

Single-slide viewer

8 × magnifier

Multiple-slide viewer

Dusting brush

Light box

Faults in Picture-taking

The guide on these pages is intended to help you trace the reasons for disappointing photographs, where the fault lies in camera technique. A guide overleaf deals with faults in developing and printing that can also spoil a picture. Different errors in picture-taking or in processing can lead to similar-looking faults in the final picture, so a guide such as this can only narrow the field of possibilities.

It is especially important to avoid errors when taking the picture because it is often difficult, if not impossible, to correct these after processing. It may be easier in the long run to reshoot the picture, if that is possible, than to try to print a good picture from a bad negative. It is only rarely that the affected film itself can be improved. So for most of the faults listed here, the remedies which I have described are intended to help you to prevent similar faults from recurring in the future.

Many errors that could be simply avoided arise through unfamiliarity with your equipment. When you acquire a camera or any other new piece of photographic equipment, or when you use an unfamiliar film, shoot a test roll. Take notes on each picture (this is a good habit to keep up in all your photography). "Bracket" exposures—that is, in addition to the shot taken at the indicated exposure reading, take others with an exposure one stop greater and one stop smaller—explore the full range of shutter speed and aperture, and take pictures in extreme light conditions; record the exposure you use for each shot and indicate whether it agrees with or departs from that indicated by your exposure meter. The cost of a single roll of film may be repaid many times over by the failures that you subsequently avoid.

There are, of course, many disappointments in even the most meticulous photographer's work. But few of them can be directly attributed to inherent faults in the equipment, provided manufacturer's recommendations are followed. It is important to avoid using out-of-date film, especially color film; the expiry date is noted on each film box. Store film properly, in a dry, cool, dark place and process it as soon as possible after it is exposed. Beware of X ray damage by security checks at airports. Even lead-lined bags don't always avoid X ray damage; carry your films through as hand luggage and ask that they be checked by hand.

If your camera work is always consistent, then it will be easier to isolate and identify the cause of a fault. Sometimes, however, your pictures may gradually fall off in quality without your noticing it. It may be that your photographic equipment is slowly deteriorating with age and use.

For example, your camera's shutter speeds may slow down over a period of years, causing exposure errors that you may attribute to faulty processing. Lens aperture values may similarly change over long periods. Shutter blinds or diaphragm blades may occasionally stick, causing gross exposure errors. Have your equipment cleaned and checked for accurate performance every year or two.

Experts often recommend that photographers, both amateur and professional, should keep to equipment they are familiar with and know how to use instinctively. This is often good advice, but it pays to experiment with new equipment and materials from time to time. Never use unfamiliar equipment or materials in cases where a good result is imperative and where you will not have a chance to reshoot if you have made a mistake the first time. If you decide to adopt a new material, then stick with it. Occasional change is good, but constant change and experimentation is only confusing.

Subject blurred, other parts of the scene sharp
Cause: Incorrect focusing or movement of the subject.
Remedy: Pay careful attention to focusing before shooting, checking it in the viewfinder of an SLR or rangefinder camera, and using the focusing distance scale on the lens barrel if the light is too dim to use the viewfinder; check that the subject is not closer than the lens's minimum focusing distance (marked on the lens or in the handbook). In future, use faster shutter speeds for similar subjects and adjust the aperture for correct exposure.

Whole image blurred
Cause: Camera shake.
Remedy: Use a faster shutter speed—at least equal to the reciprocal of the lens's focal length in millimeters (1/60 for a 50 mm lens, 1/100 for a 100 mm lens, and so on); take a firm stance when shooting, hold breath at moment of taking, press shutter button smoothly.

Series of geometric shapes progressing across frame, and/or a lack of contrast
Cause: Lens flare, usually caused by direct light from sun or other source hitting the front lens element; often accentuated by dust or grease on the front or rear lens element.
Remedy: Use a lens hood; when taking a backlit shot, take care that the subject shades the lens from direct light if possible; be sure there is no dust and grease on your lens.

Streaks of light on negatives and prints
Cause: Fast film advance or rewinding has caused static electricity to fog the film locally.
Remedy: In future advance or rewind the film fairly slowly and steadily.

Negative too dense or too thin
Cause: Inaccurate exposure—dense negatives have been overexposed, thin negatives have been under-exposed—due to: metering exposure from wrong part of scene; setting camera's film speed dial incorrectly; (on automatic exposure cameras) setting backlight compensation dial incorrectly.
Remedy: Ensure film speed dial correctly set (use the camera's film memo holder if fitted, or store the end of the film box in the camera case as a reminder); remember that backlighting or large dark or bright areas behind the subject will affect the exposure meter; remember to cancel the correction factor on the backlight compensation dial after every shot.

Pictures are flat and lack contrast
Cause: Often due to frontal lighting.
Remedy: Black and white pictures can be corrected at least partially by being printed on high-contrast paper; for the future, when using flash, hold it high and to one side of the camera for better modeling; shoot landscapes in the morning or late afternoon when the low angle of the sun gives longer shadows.

Picture too hard and contrasty
Cause: Often due to harsh direct lighting.
Remedy: Black and white pictures can be corrected at least partially by being printed on low-contrast paper; for the future, when shooting in direct sunlight or with a single light source, reduce the subject contrast by filling in the shadow areas with light from a reflector or additional light source, such as a flash gun; soften the main lighting where possible by bouncing it (in the case of flash) or diffusing it.

Varying density or general color cast over most negatives from a particular roll of film
Cause: Film out of date or badly stored.
Remedy: For the future, check the film expiry date; store film in a cool, dark, dry place and process it as soon as possible.

Hazy, soft-focus image with low contrast
Cause: Grease, dust or condensation on lens.
Remedy: Clean lens thoroughly; after entering a warm, moist atmosphere from a cold one, wait for the camera to warm up and condensation to clear before using it.

Dark streaks and blotches on negatives, and/or low-contrast prints
Cause: Fogging of the film by stray light, before or after exposure and before development, possibly due to a nonlightproof join between the camera body and the film back, or a light leak in the film cassette.
Remedy: Have the camera checked by a repairer to ensure that it is lighttight; load and unload film in shade; if you load your own reusable 35 mm cassettes, you should replace them in case they are slightly bent.

Overall orange cast
Cause: Using a daylight color film in tungsten lighting (that is, from an electric bulb).
Remedy: Use an appropriate color correction filter on the camera lens for indoor shots; or use flash that is suitable for daylight film.

Overall blue cast
Cause: Using a film balanced for tungsten lighting in daylight or with "daylight" flash.
Remedy: Use a daylight film or an appropriate color correction filter.

Subjects have red eyes in flash pictures
Cause: The flash was placed too close to the lens-subject line, and light has been reflected from the blood vessels in the subjects' retinas.
Remedy: Hold the flash high and to one side of the lens axis or bounce the light from a wall, the ceiling or a reflector.

Underexposed flash picture
Cause: Incorrect synchronization; flash too weak; incorrect aperture setting; film exposed before flashgun capacitor fully recharged.
Remedy: Correct synchronization according to manufacturer's instructions; remember that the aperture calculation depends on the guide number for the film speed and the subject distance in feet or meters (check which units your guide number relates to); when you are bouncing flash from a wall, ceiling or reflector, use the distance along the lightpath in calculating aperture, not the direct flash-subject distance; add one stop if the reflecting surface is gray rather than white; note the recharging time of your flashgun and check the "ready" light before shooting—the recharging time increases slightly as batteries run down.

Color cast on certain indoor flash pictures
Cause: The flash was probably bounced off a surface with a marked color.
Remedy: Bounce flash only off neutral or very lightly tinted surfaces.

Bluish cast in landscapes
Cause: Ultraviolet light from sky.
Remedy: Fit an ultraviolet filter or a "skylight" filter (absorbing ultraviolet and also tinted very pale yellow) over the camera lens.

Bluish cast in indoor flash pictures, especially noticeable in the foreground
Cause: Smoky atmosphere.
Remedy: Take flash pictures early on at parties or other functions before there is too much smoke in the atmosphere.

Orange or red cast in outdoor shots
Cause: Picture taken very early in the morning or late in the afternoon.
Remedy: Before about 10 a.m. and after about 4 p.m., use a bluish correction filter.

Distorted images in portraits—faces seem "stretched" and noses too large
Cause: Using a standard or wide-angle lens close to the subject.
Remedy: For full-face portraits, stand farther back and either use a telephoto lens or enlarge part of the picture given by a standard lens.

Vertical lines of buildings converge
Cause: Tilting the camera upward to include the top of the building in the frame.
Remedy: Exaggerate the effect or give up trying to get the whole building in; take the photograph from farther away using a telephoto lens, so that less tilt is needed; use a special PC (perspective control) lens.

Negative completely clear or transparency completely black
Cause: Film not exposed.
Remedy: Check that lens cap is removed before shooting (with a rangefinder camera); ensure that the film is being transported through the camera by winding on the whole of the leader before closing the camera; check that the rewind crank knob turns as the film is wound on; check the camera batteries.

First few frames are grossly overexposed (negative film is black, transparency film is clear)
Cause: Fogging during loading or unloading.
Remedy: Wind the film on by two frames when you have closed the back after loading, in order to wind the fogged leader film past the shutter; rewind the film completely into the cassette after finishing the roll.

Overlapping images
Cause: Double exposure due to faulty film advance or to reuse of exposed film.
Remedy: Camera repair; rewind film fully into cassette or clearly label it "used."

Underexposure with extension tubes, bellows, teleconverter or other close-up accessory
Cause: Failure to increase the exposure setting by one or two f-stops to compensate for the increasing distance from the lens to the film.
Remedy: Consult the formulas on page 194 that give the exposure correction in terms of the magnification or extension. (A camera with a through-the-lens exposure meter will automatically indicate the correct exposure.)

Picture incorrectly exposed except for a band at one side or in the center of the frame
Cause: Using the wrong shutter speed with an electronic flash unit; or a sticking shutter. (These faults can occur only in cameras with focal-plane shutters.)
Remedy: Check camera handbook for correct X-synchronization with flash; if the problem persists, have the shutter and synchronization mechanisms checked by a technician.

Double exposure

Wide-angle distortion

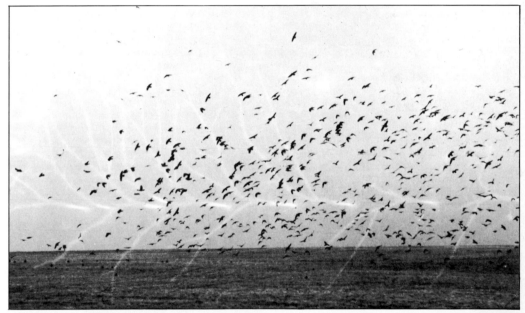
Static electricity marks

Fogging (film not completely rewound into cassette)

Fogging by stray light

Faults in processing and printing

Faults in processing
Unlike picture-taking or print-making, processing film calls not so much for judgment as for accuracy in following manufacturers' directions. Most faults can be traced to lack of care in keeping working areas clear, controlling the temperature of the processing, and washing equipment thoroughly after every process. Agitating the solutions during processing also needs to be done correctly. Accuracy is much more important in color processing than in black and white processing. As always a methodical approach should help you to achieve consistent results, so for normal work you should try to establish an unvarying routine. Some flexibility will naturally be needed if you have reason to believe there is something wrong with your exposures. If a "clip test" on a piece cut from the end of a roll shows that the film is overexposed—perhaps owing to a faulty exposure meter or incorrect film speed setting—fine-grain developer can be used to compensate. If the test clip is· underexposed, "high-energy" developer can be used. Otherwise, successful processing is a matter of being workmanlike and neat. Obviously, materials should be matched to the films for which they are intended; and films should be handled only by the edges, with clean, dry hands. The faults listed here do not include the results of ordinary carelessness—finger marks, scratches, dust marks—the nature of which is usually self-evident. Note the concentrations of solutions on their bottles and the dates of mixing, how many films can be processed, how many have so far been processed, and the processing time and temperature required.

Faults in print-making
Photographic printing requires as much care and accuracy as film processing. The freshness of solutions, their dilutions and temperatures, and the accuracy of timing are just as important. In addition, the enlarger itself can be responsible for degrading the image. The lens must be kept scrupulously clean and free of abrasions, and it must be adjusted carefully and gently during printing. However, mistakes made during printing do not result in the permanent loss of the image. Furthermore, most can be discovered and corrected when the test strips are made, so that they need not be costly in materials. The need for a systematic approach is nowhere more evident than in making test strips. Exposure times and filtrations should be noted in a book or on the backs of the test papers themselves. Not only exposure times but also enlarger lens apertures and magnifications should be recorded. The values finally chosen should be recorded (again, with the particular enlargement ratio) together with the picture's reference number, to be consulted whenever you wish to make prints in the future. Such basic faults as finger marks, scratches and dust marks are not listed here.

Defects that can appear in all types of films are listed under the "black and white" heading. Faults specific to color negative or transparency films are listed under the appropriate headings. Unless otherwise stated, faults in processed film cannot be rectified, and the remedies described refer to future processing technique.

Black and white film

Scratches along film length
Cause: Grit dragged in contact with film, when it is being either wound out of or rewound into film cassette; grit dragged along film when it is being passed through fingers or squeegeed prior to drying; possible rough spot on film pressure plate in camera (rare).
Remedy: Protect film cassettes from dust, grit and sand—don't unwrap film or open package until film is to be loaded in camera; with reloadable cassettes, check that felt light trap is clean; ensure squeegee is clean before using and/or use lighter pressure.

Isolated light or clear areas on negatives
Cause: Air bubbles have stuck to film during processing.
Remedy: Tap the developing tank after agitation to dislodge air bubbles.

Dark streaks and/or blobs of irregular shape
Cause: A light leak has locally fogged film before development.
Remedy: Prevent by checking reusable film cassettes and lighttightness of darkroom and developing tank; ensure that a gasket is used between the developing tank and its lid and that the tank has no hairline cracks.

Clear or light band along edge of film
Cause: Insufficient solution in developing tank to completely cover the film.
Remedy: Follow the tank directions to ensure that enough solution is used for the quantity and format of films being processed (check using clear water).

Negatives too dense and contrast too high
Cause: The development temperature was too high, or the developing time too long, or the agitation during development was excessive.
Remedy: Farmer's Reducer can make thick negatives somewhat thinner; for the future, check the developer directions for the correct time, temperature and agitation for the particular film being processed; control the temperature of the solution by placing it in a water bath constantly adjusted to the correct temperature or, if this is impossible, adjust the developing time to compensate for the temperature actually used.

Negatives too thin but contrast near normal
Cause: The development temperature was too low, or the development time too short, or the agitation during development was insufficient.
Remedy: Control the development process as described above.

Milky white appearance
Cause: Insufficient fixing bath time, exhausted fixer or incorrect fixer concentration.
Remedy: Try refixing in new solution; check manufacturer's recommendations concerning dilution and the amount of use; mark your reusable fixer solution bottle with date of mixing, concentration and the number of films that one batch will treat.

Faults common to all types of printing are listed with those relating to black and white printing; those specific to color printing are listed under the appropriate headings. Apart from minor blemishes that can be retouched, faults in prints cannot be corrected, and the remedies described here can be applied only in subsequent printing.

Black and white printing

Low contrast, poor black and white tones
Cause: Underdevelopment; paper fogged.
Remedy: Try a higher grade of paper; check the agitation time, temperature and dilution directions of the developer; guard against fogging the paper—don't expose it to the safelight for too long before processing, or place it too close to the safelight; ensure that the safelight is not too strong and is of the right type, and be careful not to leave the lid of the paper box off while making a print.

High contrast with compressed range of grays
Cause: Overdevelopment.
Remedy: Check the developer directions concerning agitation, time and temperature.

Image too dark
Cause: Overexposure in printing; overdevelopment; paper fogged.
Remedy: Make a second test strip to confirm the exposure time; check that the lens was stopped down to the correct aperture; check the developer directions for the recommended time, temperature, agitation and dilution; check that the paper stock hasn't been fogged—check the paper's box, the safelight directions and the darkroom's lighttightness.

White spots
Cause: Air bubbles on the print during development.
Remedy: Agitate the print constantly while it is in the developer.

White or light-toned, branched, lightning-like marks
Cause: Static electricity has marked the print or negative slightly.
Remedy: If the mark is on the negative, retouch the print.

Print completely white
Cause: Print "developed" in fixer by mistake, or paper exposed on wrong side.
Remedy: Always lay out your trays in the same order; ensure that the paper's emulsion side is upward when you expose the print.

Blue, purple or brownish stains
Cause: Developer contaminated from fixer or stop bath.
Remedy: Remix chemicals; avoid carry-over.

Dark streaks
Cause: Excessive draining time after development; or fixer solution is too weak.
Remedy: Drain print quickly after development; use fresh fixer solution.

Uneven, patchy image
Cause: Insufficient solution level in tray; or the print was taken from the developer before fully developed, in an attempt to compensate for overexposure.
Remedy: Use more solution in each tray and check that the print is always covered by the solutions; give all prints full development time.

Overall crazed pattern ("reticulation")
Cause: The "shock" of inconsistent solution temperatures—for example, warm developer and cold fixer.
Remedy: Ensure that all solutions and the water wash are at the same temperature.

Film completely clear
Cause: Film accidentally placed in fixer instead of developer.
Remedy: None for affected films.

Film completely black
Cause: Exposure to light before fixing.
Remedy: Do not be tempted to inspect the film before adequate fixing.

Reversed tone: some highlight areas show up as light areas on the negative and some shadow areas show up as dark ("solarization")
Cause: Light hitting the film before it was fully processed.
Remedy: Keep the lid tight on the developing tank until processing is complete.

Color negative film

Negatives too dense and contrasty
Cause: Overdevelopment; on Agfa film, if the orange mask is also too dense, then the likely cause is excessive bleaching.
Remedy: Follow the manufacturer's directions on time and temperature carefully; avoid excessive tank draining times.

Negatives too contrasty, density normal
Cause: Excessive bleaching.
Remedy: Check maker's directions regarding bleaching time, temperature and dilution.

Spots in which the orange mask can be seen but no image, or only a faint one
Cause: Air bubbles stuck to film during processing.
Remedy: Tap the tank after agitation.

Irregularly shaped streaks running downward from the film's sprocket holes
Cause: Developer was caught in holes during excessive draining time.
Remedy: Start to drain slightly before that stage is completed, and progress quickly to the next stage.

Overall purple cast with a dense image
Cause: Fogging.
Remedy: Check the lighttightness of the developing tank and of the darkroom itself.

Reversal film

Light-colored streaks or irregular spots, often yellowish
Cause: Fogging.
Remedy: Check the lighttightness of the developing tank and the darkroom.

Dark spots, possibly with a reddish cast
Cause: Air bubbles sticking to the film during development.
Remedy: After agitation, tap the tank bottom sharply to dislodge air bubbles.

Film too dense and dark, with a reddish cast
Cause: Underdevelopment.
Remedy: Use fresh chemicals; mark the quantity for which a batch can be used on the bottle; check the directions for proper time, temperature and dilution.

Too blue, with smoky blacks
Cause: Reversal bath (if the film was chemically reversed) was too concentrated; or the color developer was too weak; or the first developer was contaminated.
Remedy: Carefully label bottles and always use the same bottles for the same solutions; check the directions for the correct dilutions.

Green cast, with smoky blacks
Cause: Reversal procedure was omitted or inadequate; or film was outdated or badly stored.
Remedy: Check that fresh solutions are being used; check time, temperature and agitation for the reversal procedure (if chemical), or check lamp wattage and film-to-lamp distance against the directions (if the reversal procedure is done with a lamp).

Too light, with a blue cast
Cause: Color developer possibly contaminated with first developer.
Remedy: Label bottles correctly and always use the same bottles for the same solutions.

Milky, cloudy appearance
Cause: Inadequate fixing time, incorrect fixer concentration, fixer exhausted or too cold.
Remedy: Refix in fresh solution.

Highlight areas appear pink
Cause: Insufficient wash following the color development stage.
Remedy: Follow directions on wash time.

Yellow-brown staining
Cause: Inadequate bleaching procedure.
Remedy: Rebleach and repeat fixing, washing and drying stages.

Blotchy image with yellowish-white tones
Cause: Old or incorrectly stored paper stock.
Remedy: Store paper on its side in a cool, dry, dark place and use it as soon as possible.

Light rings on the image
Cause: Interference rings ("Newton's rings") caused by a poor fit between negative and carrier glass.
Remedy: Use a specially designed glass or use a glassless negative carrier.

Color negative printing

Overall color cast
Cause: Wrong filtration.
Remedy: Add a combination of filters of the same color as the cast, or remove a combination with the complementary color.

Cyan stains
Cause: Partial contamination of developer.
Remedy: Remix developer; avoid carry-over.

Reddish, magenta or pink stain overall
Cause: Oxidized developer; improper storage; old solutions; insufficient wash time.
Remedy: Use fresh developer; store solutions correctly and check the mixing date.

Cyan or blue streaks
Cause: Developer contaminating bleach/fix.
Remedy: Thoroughly drain the print drum after the developer stage; use clean beakers.

Light patchy areas
Cause: Paper curled the wrong way when loaded into the print drum.
Remedy: Load paper with its emulsion inward.

Uneven, patchy development
Cause: Insufficient solution in print drum.
Remedy: Check drum-maker's directions.

Uneven stains at edge of paper
Cause: Contamination by residue of solutions used in processing of previous print.
Remedy: Thoroughly wash and dry drum between prints.

Printing from slides

Cibachrome A process

Color cast
Cause: Incorrect filtration.
Remedy: Subtract a filter combination of the same color, or add the complementary color.

Light image with greenish highlights, dull black shadow areas
Cause: Development time too long.
Remedy: Check processing time with directions; check the test print.

Foggy, dull print
Cause: Insufficient bleach time; or bleach too weak or exhausted.
Remedy: Check bleach time and dilution; use fresh bleach if necessary.

Dull and dark print
Cause: Contaminated bleach/fix solution.
Remedy: Remix and avoid carry-over.

Low contrast and flat yellow cast
Cause: Fixer omitted, exhausted or too weak.
Remedy: Check the dilution of the fixer; check that the fixing step was not omitted.

Black print with no image
Cause: Bleach bath omitted.
Remedy: Use beakers and bottles in the same order to avoid missing out a step.

Light image with overall blue cast
Cause: Developer solution too concentrated.
Remedy: Check the dilution against the manufacturer's instructions.

Ektachrome 14RC process

Cyan cast overall
Cause: First developer contaminated with bleach/fixer.
Remedy: Remix fresh developer; avoid carry-over; use clean chemical beakers.

Blue or reddish cast overall
Cause: Insufficient first or second wash respectively.
Remedy: Increase the appropriate wash time, temperature and/or flow of water.

Magenta cast on a dark print
Cause: Insufficient first development.
Remedy: Check directions for correct time, temperature, dilution and agitation.

Blue cast in shadow areas
Cause: Insufficient color development.
Remedy: Check directions for correct time, temperature, dilution and agitation.

Foggy, low-contrast highlight areas
Cause: Insufficient bleach/fix procedure; contaminated first developer.
Remedy: Check directions; mix fresh developing solution.

Selected data

Pinhole camera exposures
The effective f-number of a pinhole camera is given by:

camera length ÷ pinhole diameter.

Thus a pinhole of diameter 1/64 in at a distance of 6 in from the film has an f-number of 384. Suppose a light meter indicates an exposure of 1/30 at f11. Two stops down from this, at f22 (the first entry in the list of f-stops below), the exposure would be 1/8. At each successive f-stop in the list the required exposure time doubles; thus at f256 it is 16 sec, at f360 it is 32 sec. At f384 it has a slightly greater value, about 38 sec. (Great accuracy is not required for this calculation.)

f-number	22	32	45	64	90	128	180	256	360	512

Exposure for close-ups
When the lens of a camera is greatly extended to focus on very close objects, the f-numbers cease to be a reliable indication of the image brightness. However, corrected exposure times can easily be calculated using one of these formulas, or by referring to the table below them.

Formula 1

$$\text{Actual exposure} = \text{Exposure indicated} \times \left(\frac{\text{Bellows extn}}{\text{Focal length}}\right)^2$$

Formula 2

$$\text{Actual exposure} = \text{Exposure indicated} \times (M+1)^2$$
(M = magnification)

Magnification	$\frac{1}{4}$	$\frac{1}{2}$	$\frac{3}{4}$	1:1	$1\frac{1}{4}$	$1\frac{1}{2}$	$1\frac{3}{4}$	2	3
Multiply exposure by	1.5	2.2	3	4	5	6.2	7.5	9	16

Black and white negative films
New films are continually being developed and old ones improved, so no list of films can remain up to date indefinitely. However, if a film included in this or in one of the following tables ceases to be available in the near future, it is likely that a similar product will have replaced it. The main information found on the packaging of a film is the film size, speed and length (in terms of the number of exposures). Film sizes are coded by their conventional number (135 designates 35 mm film); film speed is normally marked in both ISO and DIN rating systems.

Name	ISO Speed	Sizes generally available
AGFA-GEVAERT		
Agfapan Vario-XL [1]	125–1600	135-36
Agfapan 25	25	135-36, bulk lengths, 120 roll-film
Agfapan 100	100	135-36, bulk lengths, 120 roll-film
Agfapan 400	400	135-36, bulk lengths, 120 roll-film
ILFORD		
Pan F	50	135-20/36, bulk lengths, 120 roll-film
FP4	125	135-20/36, bulk lengths, 120 roll-film
HP5	400	135-20/36, bulk lengths, 120 roll-film
XP1 [1]	400	135-20/36, bulk lengths, 120 roll-film
KODAK		
Panatomic-X	32	135-36, bulk lengths, 120 roll-film
T-Max 100	100	135-36
Plus-X Pan	125	135-20/36, bulk lengths, 120 roll-film
Tri-X Pan	400	135-20/36, bulk lengths, 120 roll-film
T-Max 400	400	135–36
Royal-X Pan	1250	120 roll-film

Color negative films
The color negative films listed here include the more popular brands that are easily available in most countries. Different manufacturers employ their own chemical processes, but all color films are based on the same principle of a tripack emulsion: three layers, each sensitive to one of the primary colors, are coated onto a single base. The developed negative contains an orange mask, to compensate for certain deficiencies in the dyes used.

Name	ISO Speed	Sizes generally available
AGFA-GEVAERT		
Agfacolor XRS100	100	135-15/27/36, bulk lengths, 120 roll-film
Agfacolor XRS200	200	110-24, 126-24, 135-15/27/36, 120 roll-film
Agfacolor XRS400	400	110-24, 126-24, 135-15/27/36, 120 roll-film
Agfacolor XRS1000	1000	135-24, 120 roll-film
ILFORD		
Ilfocolor HR100	100	110-24, 126-24, 135-12/24/36
Ilfocolor HR200	200	135-24/36
Ilfocolor HR400	400	135-24/36
FUJI		
Fujicolor Super HR100	100	110-12/24, 126-12/24, 135-24/36, 120 roll-film
Fujicolor Super HR200	200	135-24/36
Fujicolor Super HR400	400	110-12/24, 135-24/36, 120 roll-film
Fujicolor Super HR1600	1600	135-24/36
KODAK		
Kodacolor Gold 100	100	135-12/24/36, 120 roll-film
Kodacolor VR 200	200	110-12/24, 126-12/24, 135-12/24/36, 120, 620, 127 roll-film
Kodacolor VR 400	400	110-12/24, 135-12/24/36, 120 roll-film
Kodacolor VR 1000	1000	135-12/24/36
KONICA		
Konica Color SR100	100	110-12/24, 126-12/24, 135-12/24/36, 120 roll-film
Konica Color SR200	200	110-12/24, 126-12/24, 135-12/24/36
Konica Color SR400	400	110-12/24, 126-12/24, 135-12/24/36, bulk lengths, 120 roll-film
Konica Color SR1600	1600	135-24
Konica Color SR-V3200	3200	135-24

1 Process in C-41 color chemicals
2 Processing by manufacturer only
3 Balanced for exposure by tungsten light

Color reversal films

These films, when processed, produce transparencies. Prints can be made from color positives, either by first copying them onto negative film or by printing them directly onto special paper. Although the final quality of a print from a color negative is generally reckoned to be slightly higher, many professional photographers use reversal materials since publishers prefer the original transparency for photomechanical reproduction.

Name	ISO Speed	Sizes generally available
AGFA-GEVAERT		
Agfachrome CT-100	100	135-27/36
Agfachrome 50 RS	50	135-36, bulk lengths, 120 roll-film
Agfachrome 100 RS	100	135-36, 120 roll-film
Agfachrome 200 RS	200	135-36, 120 roll-film
Agfachrome 1000 RS	1000	135-36, 120 roll-film
ILFORD		
Ilfochrome 100	100	135-20/36
FUJI		
Fujichrome 50 D	50	135-36, 120 roll-film
Fujichrome 100 D	100	135-36, 120 & 220 roll-film
Fujichrome 400 D	400	135-36, 120 roll-film
Fujichrome P1600 D	1600	135-36
Fujichrome 64 Tungsten $_3$	64	120 roll-film
KODAK		
Ektachrome 64	64	110-20, 126-20, 120 roll-film
Ektachrome 100	100	135-12/24/36
Ektachrome 200	200	135-20/36, 120 roll-film
Ektachrome 400	400	135-20/36, 120 roll-film
Ektachrome P800/1600	800–1600	135-36
Ektachrome 160 Tungsten $_3$	160	135-20/36
Kodachrome 25 $_2$	25	135-20/36
Kodachrome 64 $_2$	64	110-20, 126-20, 135-20/36, 120 roll-film
Kodachrome 200 $_2$	200	135-20/36
KONICA		
Konica Chrome 100	100	135-20/36

Black and white reversal films

Although any black and white film can be processed to give a positive directly, the result may be of low quality unless a film intended for reversal is used.

Name	ISO Speed	Sizes generally available
AGFA-GEVAERT		
Dia-Direct $_2$	32	135–36

Instant-picture films

35 mm instant-picture film can be used in any 35 mm camera, but after exposure, the film must be processed in a special unit available from the manufacturers. Other instant-picture films are designed for use with a compatible instant camera, although many roll-film SLR cameras (and a few 35 mm models) can be fitted with special instant picture back for a final check on exposure and color. Non-35 mm instant films fall into two basic categories: the 600 series films comprise two layers, which are peeled apart after the development time has expired. Integral films on the other hand don't peel apart and development is self-limiting.

	ISO Speed	Image	Format
POLAROID			
Type 668 Polacolor	80	colour print	8 print pack, $3\frac{1}{4} \times 4\frac{1}{4}$ inches
Type 667 High-Speed Print	3000	B & W print	8 print pack, $3\frac{1}{4} \times 4\frac{1}{4}$ inches
Type 665 Positive/Negative	75	B & W print and negative	8 print pack, $3\frac{1}{4} \times 4\frac{1}{4}$ inches
SX-70 778 Integral	125	colour print	10 print pack, $3\frac{1}{8} \times 3\frac{1}{8}$ inches
600 779 Integral	640	colour print	10 print pack, $3\frac{1}{8} \times 3\frac{1}{8}$ inches
Image Film Integral	600	colour print	10 print pack, $3\frac{5}{8} \times 2\frac{7}{8}$ inches
Polachrome CS	40	Colour transparency	135-12/36
Polapan CT	125	B & W transparency	135-36

Technical guide

Color kits for home processing

All commonly available color negative films are now processed using Kodak's C-41 chemistry, and compatible kits are available from several manufacturers. These kits may also be used to process the two chromogenic black and white film: Ilford XP-1 and Agfa Vario XL. Color slides are processed in Kodak's E6 chemistry, and again, kits are available from Kodak themselves and other manufacturers. In a similar way, there is a universal process for printing negatives, and chemicals and paper from different manufacturers are all compatible. Printing from transparencies is a little different: there are basically two processes, and paper and chemistry cannot be interchanged.

For color negative films: (all C-41 compatible)	**Agfa AP 70** 500 ml kit for 6 rolls 135–36 3 bath, 24 mins at 30°C
	Kodak Flexicolor 500 ml kit for 12 rolls 135–36 4 bath, 25 mins at 38°C
	Paterson 2NA 1500 ml kit for 15 rolls 135–36 2 bath, 12 mins at 37.8°C
For color slide films: (all E6 compatible)	**Agfa AP 44** 500 ml kit for 4 rolls 135–36 5 bath, 34 mins at 38°C
	Kodak E6 600 ml kit for 10 rolls 135–36 7 bath, 37 mins at 38°C
	Paterson 3E6 600 ml kit for 6 rolls 135–36 3 bath, 30 mins at 38°C
For prints from negatives: (all Ektaprint compatible)	**Agfa AP 92** 1000 ml kit for 20 sheets 10 × 8″ 2 bath 11 mins at 33°C
	Kodak Ektaprint 2 1000 ml kit for 14 sheets 10 × 8″
	Paterson 2RP 2000 ml kit for 40 sheets 10 × 8″ 2 bath, 7.5 mins at 38°C
For prints from transparencies:	**Kodak Ektachrome R**-3.5000 1000 ml kit for 14 sheets 10 × 8″ 3 bath, 10 mins at 38°C
	Ilford Cibachrome A 1000 ml kit for 16 sheets 10 × 8″ 3 bath, 9 mins at 24°C

Chemical functions

The following table explains the essential functions of each of the basic chemical stages in color processing.

First developer	Converts the exposed silver halides (latent image) into black metallic silver.
Stop bath	A solution used to stop development.
Color developer	Converts exposed silver halides to black metallic silver; also produces dye "cloud" around each crystal.
Conditioner	Prepares metallic silver for bleaching.
Bleach and fix	Converts metallic silver to a halide, thus performing a function similar to that of the thiosulfate solutions used in black and white processes; reduces silver halides to water-soluble salts.
Stabilizer	Mild acid used to harden the emulsion.

Filters for color photography

A wide selection of very pale color correction filters is available, though these are essentially of importance only to professional photographers who need to match their films very accurately to specific sources of light. Such filters are not included in the following table, which contains only the filters that have a more general application. Remember that most filters cut down the amount of light reaching the film, and that some compensation in the exposure will therefore be needed. A TTL metering system will normally make the necessary compensation automatically.

Filter	Use
Wratten 80B (correction/conversion)	Adds blue to photoflood light, raising its color temperature almost to that of daylight, allowing daylight film to be used indoors with photoflood light.
Wratten 80B (correction/conversion)	Alters the color temperature of daylight so that artificial light film may be exposed outdoors by daylight or indoors with electronic flash or blue flash bulbs.
FL-D	Converts fluorescent light more closely to the color temperature of daylight. This allows photography with daylight film indoors by fluorescent light.
UV (ultraviolet) or Skylight (1A)	Prevents UV rays, which would give prints or slides a slight overall blue cast, reaching the film. This blue cast would be noticeable on skin tones taken in shady areas under a blue sky. UV filters can be left permanently on the lens for protection against dirt or scratching. Will penetrate the haze that would otherwise partially obscure a distant part of a scene.
Polarizing	Reduces glare and reflections from shiny surfaces (glass, water or polished wood—but *not* metal). The only filter that will darken a light blue sky (but not make a gray sky blue) without much affecting other colors.

Contrast filters

Any relatively strongly colored filter can be used to correct or modify the tonal balance given by a black and white film. They are particularly useful, for example, in bringing out detail in a cloudy sky (the most pronounced effect being given by a dark red filter, the mildest by a pale yellow one) or in increasing the contrast between two colors that the film would normally record as roughly the same tones, such as green and red. The table lists the exact effect of each filter.

Filter color	Tones of color rendered lighter (by comparison)	Tones of color rendered darker (by comparison)
Blue	Blue	Yellow, Orange, Red
Green	Green	Blue, Orange, Red
Yellow	Yellow, Orange, Red	Blue
Orange	Orange, Red	Blue, Green
Red	Red	Blue, Green

Filters for color or black and white films

A few of the corrective filters that have been listed in the previous tables are suitable for use with both color and black and white films. These are grouped together in this list.

Filter	Description
UV	Also known as skylight or haze filter. Used to cut down ultraviolet light, penetrate haze and clarify distant objects. UV filters are also useful for reducing excessive blueness in snow scenes. The filter is clear in appearance, and requires no exposure correction.
Polarizing	Polarizing filters are used to reduce reflections from such surfaces as glass or water; in color photography they also serve to intensify the blue of the sky.
Neutral Density	Gray filters of varying strengths are sometimes useful both in color and in black and white photography as a means of cutting down the light reaching the film without altering the color balance.

Attachments for special effects

Special effects filters tend to produce striking effects that can easily become gimmicky. It is therefore important to preserve their novelty value by using them only occasionally. Most special filters and other attachments are suitable for use with either color or black and white films.

Attachment	Use
Graduated color filter	Three types available—one color only, graduating from light to dark; one color graduating into another color; one color, which darkens overall by rotating the front of the filter.
Dual color filter	A two-colored piece of glass in a filter mount.
Neutral-density filter	A gray filter used merely to reduce the intensity of the light.
Soft-focus filter	To soften the definition of the whole picture.
Soft-spot filter	To give the whole picture—except the subject in the middle of the frame—a slightly fuzzy look.
Close-up attachment	Available in various diopter strengths (+1, +2, +3, +4) to allow a lens to focus on objects closer than it normally could.
Cross-screen or starburst filter	Used to spread rays of light emanating from a point source of light within a lens's field of view; usually available for four, six or eight points.
Split-field attachment	Effectively only half of a close-up lens; this allows distant and close-up subjects to be simultaneously in sharp focus beyond the depth of field associated with a particular lens at a given aperture.
Prism filter	Available in many types, which can multiply the main subject image three, four, five or six times; for example, three parallel similar images of the subject or one main image surrounded by three or four repeated images of the subject.
Color-burst filter	Used to diffract light, producing a spectral pattern from any visible point source of light within the scene. The filter mount can be rotated allowing the filter effect to be positioned at any angle around the light source.

Technical guide

Night-time exposure guide

The best time to photograph "night" scenes is in fact at dusk rather than when it is completely dark. Not all light meters are sufficiently sensitive to function at very low light levels; the table given here will provide a useful indication of the kind of exposure times to expect for some of the more common nighttime subjects. The figures relate to a film speed of 125 ASA; they should be adjusted according to the speed of the film you are using.

Subject	f stop/shutter speeds			
	f4	f5.6	f8	f11
Bonfire/fireworks	1/15	1/8	1/4	1/2
Well-lit store windows	1/30	1/15	1/8	1/4
Well-lit streets	1/4	1/2	1	2
Floodlit monuments	1	2	4	8
Full-moon landscape	1 min	2 min	4 min	8 min
Well-lit store interiors	1/15	1/8	1/4	1/2
Well-lit stage	1/30	1/15	1/8	1/4
Average home lighting (close to subject)	1/4	1/2	1	2

Color temperature scale

The color of a light is measured in terms of the temperature of a theoretical "black body," heated to the point at which it emits light of the same color. The scale used is the Kelvin scale, which starts at absolute zero (−273°C) and has units called kelvins, of the same size as degrees centigrade. The table shows the color temperatures of a selection of typical light sources. Color films are balanced to record colors accurately when used with a particular kind of light, usually either daylight or tungsten (ordinary electric) light.

Light source	Color temperature
Clear blue sky	10—20,000 K
Blue/cloudy sky	8—10,000 K
Cloudy sky	7000 K
Sun through clouds (midday)	6500 K
Electronic flash (average)	6—6500 K
Blue flash bulbs	6000 K
Summer sunlight (average) (10 am—3 pm)	5800 K
Morning/afternoon sunlight	4—5000 K
Sunrise/sunset	2—3000 K
Clear flash bulbs	3800 K
Photoflood bulbs	3400 K
Studio bulbs (photopearl)	3200 K
Household light bulbs (100 W or more)	2900 K
Household light bulbs (up to 60 W)	2500 K

Shutter speed guide for moving subjects

Experience will enable you to judge the shutter speed needed to "freeze" a given subject, which depends not only on the speed of the subject but also on its distance from the camera. This table, showing some fairly typical shutter speed values, will help you to estimate the correct range with reasonable accuracy to begin with.

Subject	Direction of movement		
	Direct approach	Diagonally	Across
Walking pedestrians	1/30	1/60	1/125
Slow traffic	1/60	1/125	1/250
Sailboats	1/60	1/125	1/125
Cyclists	1/60	1/125	1/125
Speedboats	1/125	1/250	1/500
Trains	1/125	1/250	1/500
Footracers, Swimmers	1/250	1/500	1/1000
Football matches	1/250	1/500	1/1000
Auto races, Motorcycle races	1/250	1/500	1/1000
Slow airplanes	1/250	1/500	1/1000

Glossary

Aberration. Inherent fault in a lens image. Aberrations include ASTIGMATISM, BARREL DISTORTION, CHROMATIC ABERRATION, COMA, PINCUSHION DISTORTION, SPHERICAL ABERRATION. COMPOUND LENSES minimize aberrations.

Accelerator. Alkali in a developer, used to speed up its action.

Actinic. (Describing light) able to affect photographic material. With ordinary film, visible light and some ultraviolet light is actinic, while infrared light is not.

Acutance. Objective measure of image sharpness.

Additive color printing. A method of filtration occasionally used in making prints from color negatives. Three successive exposures of the negative are made, with red, green and blue light respectively. See also SUBTRACTIVE COLOR PRINTING.

Additive synthesis. Method of producing full-color image by mixing blue, green and red lights. These colors are called the additive primaries.

Aerial perspective. Sense of depth in a scene caused by haze. Distant objects appear in gentler tones than those in the foreground and they tend to look bluish. The eye interprets these features as indicating distance.

Air bells. Bubbles of air clinging to the emulsion surface during processing, which prevent uniform chemical action. Removed by agitation.

Airbrush. An instrument used by photographers for retouching prints. It uses a controlled flow of compressed air to spray paint or dye.

Anamorphic lens. Special type of lens which compresses the image in one dimension by means of cylindrical or prismatic elements. The image can be restored to normal by using a similar lens for printing or projection.

Angle of view. Strictly the angle subtended by the diagonal of the film at the rear NODAL POINT of the lens. Generally taken to mean the wider angle "seen" by a given lens. The longer the focal length of a lens, the narrower its angle of view. See also COVERING POWER.

Angstrom unit. A unit of length equal to one ten-millionth of a millimeter, generally used to express the wavelength of light.

Anti-halation backing. See HALATION.

Aperture. Strictly, the opening that limits the amount of light reaching the film and hence the brightness of the image. In some cameras the aperture is of a fixed size; in others it is in the form of an opening in a barrier called the DIAPHRAGM and can be varied in size. (An *iris* diaphragm forms a continuously variable opening, while a stop plate has a number of holes of varying sizes.) Photographers, however, generally use the term "aperture" to refer to the diameter of this opening. See also F-NUMBER.

ASA. American Standards Association, which devised one of the two most commonly used systems for rating the speed of an emulsion (i.e., its sensitivity). A film rated at 400 ASA would be twice as fast as one rated at 200 ASA and four times as fast as one rated at 100 ASA. See also DIN and BSI.

Astigmatism. The inability of a lens to focus vertical and horizontal lines in the same focal plane. Corrected lenses are called "anastigmatic"

Automatic camera. Camera in which the exposure is automatically selected. A semiautomatic camera requires the user to preselect the shutter speed or the aperture.

Back projection. Projection of slides onto a translucent screen from behind, instead of onto the front of a reflective screen.

Ball-and-socket head. A type of tripod fitting that allows the camera to be secured at the required angle by fastening a single locking-screw. See also PAN-AND-TILT HEAD.

Barn doors. Hinged flaps for studio lamps, used to control the beam of light.

Barrel distortion. Lens defect characterized by the distortion of straight lines at the edges of an image so that they curve inward at the corners of the frame.

Bas relief. In photography the name given to the special effect created when a negative and positive are sandwiched together and printed slightly out of register. The resulting picture gives the impression of being carved in low relief, like a bas-relief sculpture.

Beaded screen. Type of front-projection screen. The surface of the screen is covered with minute glass beads, giving a brighter picture than a plain white screen.

Bellows. Lighttight folding bag made of pleated cloth used on some cameras to join the lens to the camera body. Found on large studio cameras.

Between-the-lens shutter. One of the two main types of shutter. Situated close to the diaphragm, it consists of thin metal blades or leaves which spring open and then close when the camera is fired, exposing the film. See also FOCAL-PLANE SHUTTER.

Bleaching. Chemical process for removing black metallic silver from the emulsion by converting it to a compound that may be dissolved.

Bloom. Thin coating of metallic fluoride on the air-glass surface of a lens. It reduces reflections at that surface.

Boom light. Studio light attached to a long arm.

Bounced flash. Soft light achieved by aiming flash at a wall or ceiling to avoid the harsh shadows that result if the light is pointed directly at the subject.

Bracketing. Technique of ensuring perfect exposure by taking several photographs of the same subject at slightly different settings.

Bromide paper. Photographic paper for printing enlargements. The basic light-sensitive ingredient in the emulsion is silver bromide.

B setting. Setting of the shutter speed dial of a camera at which the shutter remains open for as long as the release button is held down, allowing longer exposures than the preset speeds on the camera. The "B" stands for "brief" or "bulb" (for historical reasons). See also T SETTING.

BSI. British Standards Institution, which has an independent system of rating emulsion speed. similar to the ASA system. However, the BSI system is used industrially rather than by photographers.

Buffer. Alkaline salt, such as sodium carbonate, used in a developer to maintain the alkalinity of the solution in the presence of acids liberated during processing. See also ACCELERATOR.

Bulk loader. Device for handling film which has been bought in bulk as a single length and which needs to be cut and loaded into cassettes.

Burning in. Technique used in printing photographs when a small area of the print requires more exposure than the rest. After normal exposure the main area is shielded with a card or by the hands while the detail (e.g., a highlight which is too dense on the negative) receives further exposure. See also DODGING.

Cable release. Simple camera accessory used to reduce camera vibrations when the shutter is released, particularly when the camera is supported by a tripod and a relatively long exposure is being used. It consists of a short length of thin cable attached at one end to the release button of the camera; the cable is encased in a flexible rubber or metal tube and is operated by a plunger.

Callier effect. Phenomenon which accounts for the higher contrast produced by enlargers using a condenser system as compared with those using a diffuser system. This effect, first investigated by André Callier in 1909, is explained by the fact that the light, focused by the condenser onto the lens of the enlarger, is partly scattered by the negative before it reaches the lens; and because the denser parts of the negative scatter the most light, the contrast is increased. In a diffuser enlarger, on the other hand, all areas of the negative cause the same amount of scattering.

Calotype. Print made by an early photographic process using paper negatives. Iodized paper requiring lengthy exposure was used in the camera. The system was patented by Fox Talbot in 1841, but became obsolete with the introduction of the COLLODION PROCESS. Also known as a Talbotype.

Camera movements. Adjustments to the relative positions of the lens and the film whereby the geometry of the image can be controlled. A full range of movements is a particular feature of view cameras, though a few smaller cameras allow limited movements, and special lenses are available which do the same for 35 mm cameras.

Camera obscura. Literally, a "dark chamber" An optical system, familiar before the advent of photographic materials, using a pinhole or a lens to project an image onto a screen. One form of camera obscura, designed as an artists' aid, is the ancestor of the modern camera.

Canada balsam. Resin used to cement together pieces of optical glass, such as elements of a lens. When set it has a refractive index almost exactly equal to that of glass. It is obtained from the balsam fir of North America.

Glossary

Cartridge. Plastic container of film, either 126 or 110. The film is wound from one spool to a second spool inside the cartridge.

Cassette. Container for 35 mm film. After exposure the film is wound back onto the spool of the cassette before the camera is opened.

Cast. Overall shift toward a particular hue, giving color photographs an unnatural appearance.

Catchlights. Tiny highlights in the eyes of the subject of a portrait photograph, caused by the reflection of a bright light source.

CdS cell. Photosensitive cell used in one type of light meter, incorporating a cadmium sulfide resistor, which regulates an electric current. See also SELENIUM CELL.

Center-weighted meter. Type of through-the-lens light meter. The reading is most strongly influenced by the intensity of light at the center of the image.

Characteristic curve. Graph of the image density produced by a given photographic emulsion against the logarithm of the exposure. A steep curve indicates a high-contrast material.

Chromatic aberration. The inability of a lens to focus different colors on the same focal plane.

Circle of confusion. Disk of light in the image produced by a lens when a point on the subject is not perfectly brought into focus. The eye cannot distinguish between a very small circle of confusion (of diameter less than $\frac{1}{100}$ in) and a true point.

Close-up lens. Simple positive lens placed over the normal lens to magnify the image. The strength of the close-up lens is measured in DIOPTERS. Also known as SUPPLEMENTARY LENS.

Coated lens. See BLOOM.

Cold cathode enlarger. Type of enlarger using as its light-source a special fluorescent tube with a low working temperature. Particularly suitable for large-format work.

Collodion process. Wet-plate photographic process introduced in 1851 by F. Scott Archer, remaining in use until the 1880s. It superseded the DAGUERREOTYPE and CALOTYPE processes.

Color analyzer. Electronic device which assesses the correct filtration for a color print.

Color conversion filters. Camera filters required when daylight color film is used in artificial light, or when film balanced for artificial light is used in daylight.

Color correction filters. Filters used to correct slight irregularities in specific light sources (e.g., electronic flash). The name is also used to describe the cyan, magenta and yellow filters which are used to balance the color of prints made from color negatives.

Color negative film. Film giving color negatives intended for printing.

Color reversal film. Film giving color positives (i.e., slides or transparencies) directly. Prints can also be made from the positive transparencies.

Color temperature. Measure of the relative blueness or redness of a light source, expressed in kelvins. The color temperature is the temperature to which a theoretical "black body" would have to be heated to give out light of the same color.

Coma. A lens defect which results in off-axis points of light appearing in the image not as points but as disks with comet-like tails.

Compound lens. Lens consisting of more than one element, designed so that the faults of the various elements largely cancel each other out.

Condenser. Optical system consisting of one or two plano-convex lenses (flat on one side, curved outward on the other) used in an enlarger or slide projector to concentrate light from a source and focus it onto the negative or slide.

Contact print. Print which is the same size as the negative, made by sandwiching together the negative and the photographic paper when making the print.

Contre jour. Against the light. The term is used to describe photographs taken with the camera pointing into the sun or toward the light source.

Converging lens. Any lens that is thicker in the middle than at the edges. The name derives from the ability of such lenses to cause parallel light to converge onto a point of focus, giving a REAL IMAGE. Also known as a positive lens. See also DIVERGING LENS.

Converging verticals. Distorted appearance of vertical lines in the image, produced when the camera is tilted upward: tall objects such as buildings appear to be leaning backward. Can be partially corrected at the printing stage, or by the use of CAMERA MOVEMENTS.

Converter. Auxiliary lens, usually fitted between the camera body and the principal lens, giving a combined focal length that is greater than that of the principal lens alone. Most converters increase focal length by a factor of two or three.

Convertible lens. Compound lens consisting of two lens assemblies which are used separately or together. The two sections are usually of differing focal lengths, giving three possible permutations.

Correction filter. Colored filter used over the camera lens to modify the tonal balance of a black and white image; the same term is also used for COLOR CORRECTION FILTERS.

Covering power. The largest image area of acceptable quality that a given lens produces. The covering power of a lens is normally only slightly greater than the standard negative size for which it is intended, except in the case of a lens designed for use on a camera with movements (see CAMERA MOVEMENTS), when the covering power must be considerably greater.

Cropping. Enlarging only a selected portion of the negative instead of printing the entire area.

Cut film. Another name for sheet film.

Daguerreotype. Early photographic picture made on a copper plate coated with polished silver and sensitized with silver iodide. The image was developed using mercury vapor, giving a direct positive. The process was introduced by Louis Daguerre in 1839, and was the first to be commercially successful.

Daylight film. Color film balanced to give accurate color rendering in average daylight, that is to say, when the COLOR TEMPERATURE of the light source is around 6500 kelvins. Also suitable for use with electronic flash and blue flashbulbs.

Densitometer. Instrument for accurate measurement of density. Used to achieve a precise assessment of negatives, usually for scientific purposes.

Density. The light-absorbing power of a photographic image. A logarithmic scale is used in measurements: 50 percent absorption is expressed as 0.3, 100 percent is 1.0, etc. In general terms, density is simply the opaqueness of a negative or the blackness of a print.

Depth of field. Zone of acceptable sharpness extending in front of and behind the point on the subject which is exactly focused by the lens.

Depth of focus. Very narrow zone on the image side of the lens within which slight variations in the position of the film will make no appreciable difference to the focusing of the image.

Developer. Chemical agent which converts the LATENT IMAGE into a visible image.

Diaphragm. System of adjustable metal blades forming a roughly circular opening of variable diameter, used to control the APERTURE of a lens.

Diapositive. Alternative name for TRANSPARENCY.

Dichroic fog. Processing fault characterized by a stain of reddish and greenish colors—hence the name "dichroic" (literally, "two-colored"). Caused by the use of exhausted FIXER whose acidity is insufficient to halt the development entirely. A fine deposit of silver is formed which appears reddish by transmitted light and greenish by reflected light.

Differential focusing. Technique involving the use of shallow DEPTH OF FIELD to enhance the illusion of depth and solidity in a photograph.

Diffraction. Phenomenon occurring when light passes close to the edge of an opaque body or through a narrow aperture. The light is slightly deflected, setting up interference patterns which may sometimes be seen by the naked eye as fuzziness. The effect is occasionally noticeable in photography, as when, for example, a very small lens aperture is used.

DIN. Deutsche Industrie Norm, the German standards association, which devised one of the two widely used systems for rating the speed of an emulsion (see also ASA). On the DIN scale, every increase of 3 indicates that the sensitivity of the emulsion has doubled. 21 DIN is equivalent to 100 ASA.

Diopter. Unit of measurement of the strength of a lens, defined as the reciprocal of the focal length expressed in meters. Used in photography to express the strength of a SUPPLEMENTARY LENS.

Diverging lens. Any lens that is thicker at the edges than in the middle. Such lenses cause parallel rays of light to diverge, forming a VIRTUAL IMAGE on the same side of the lens as the subject. Diverging lenses are also known as negative lenses.

D-max. Technical term for the maximum density of which a given emulsion is capable.

Dodging. Technique, also known as shading, used in printing photographs when one area of the print requires less exposure than the rest. A hand or a sheet of card is used to prevent the selected area from receiving the full exposure. See also BURNING IN.

Drift-by technique. Processing technique used to allow for the cooling of a chemical bath (normally the developer) during the time it is in contact with the emulsion. Before use, the solution is warmed to a point slightly above the required temperature, so that while it is being used it cools to a temperature slightly below, but still within the margin of safety.

Drying marks. Blemishes on the emulsion resulting from uneven drying; also, residue on the film after water from the wash has evaporated.

Dry mounting. Method of mounting prints onto card backing, using a special heat-sensitive adhesive tissue.

Dye coupler. Chemical responsible for producing the appropriate colored dyes during the development of a color photograph. Dye couplers may be incorporated in the photographic emulsion, or they may be part of the developer.

Electronic flash. Type of flashgun which uses the flash of light produced by a high-voltage electrical discharge between two electrodes in a gas-filled tube. See also FLASHBULB.

Emulsion. In photography, the light-sensitive layer of a photographic material. The emulsion consists essentially of SILVER HALIDE crystals suspended in GELATIN.

Enlargement. Photographic print larger than the original image on the film. See also CONTACT PRINT.

Exposure. Total amount of light allowed to reach the light-sensitive material during the formation of the LATENT IMAGE. The exposure is dependent on the brightness of the image, the camera APERTURE, and on the length of time for which the photographic material is exposed.

Exposure meter. Instrument for measuring the intensity of light so as to determine the correct SHUTTER and APERTURE settings.

Extension tubes. Accessories used in close-up photography, consisting of metal tubes that can be fitted between the lens and the camera body, thus increasing the lens-to-film distance.

Farmer's reducer. Solution of potassium ferricyanide and sodium thiosulphate, used in photography to bleach negatives and prints.

Fast lens. Lens of wide maximum aperture, relative to its focal length. The current state of lens design and manufacture determines the standards by which a lens is considered "fast" for its focal length.

Fill-in. Additional lighting used to supplement the principal light source and brighten shadows.

Film speed. A film's degree of sensitivity to light. Usually expressed as a rating on either the ASA or the DIN scales.

Filter. Transparent sheet, usually of glass or gelatin, used to block a specific part of the light passing through it, or to change or distort the image in some way. See also COLOR CONVERSION FILTERS, COLOR CORRECTION FILTERS, CORRECTION FILTERS and POLARIZING FILTERS.

Fisheye lens. Extreme wide-angle lens, with an ANGLE OF VIEW of about 180°. Since its DEPTH OF FIELD is almost infinite, there is no need for any focusing, but it produces images that are highly distorted.

Fixed-focus lens. Lens permanently focused at a fixed point, usually at the HYPERFOCAL DISTANCE. Most cheap cameras use this system, giving sharp pictures from about 7 ft (2 meters) to infinity.

Fixer. Chemical bath needed to fix the photographic image permanently after it has been developed. The fixer stabilizes the emulsion by converting the undeveloped SILVER HALIDES into water-soluble compounds, which can then be dissolved out.

Flare. Light reflected inside the camera or between the elements of the lens, giving rise to irregular marks on the negative and degrading the quality of the image. It is to some extent overcome by using bloomed lenses (see BLOOM).

Flashbulb. Expendable bulb with a filament of metal foil which is designed to burn up very rapidly giving a brief, intense flare of light, sufficiently bright to allow a photograph to be taken. Most flashbulbs have a light blue plastic coating, which gives the flash a COLOR TEMPERATURE close to that of daylight. See also ELECTRONIC FLASH.

Floodlight. General term for artificial light source which provides a constant and continuous output of light, suitable for studio photography or similar work. Usually consists of a 125–500 W tungsten-filament lamp mounted in a reflector.

F-number. Number resulting when the focal length of a lens is divided by the diameter of the aperture. A sequence of f-numbers, marked on the ring or dial which controls the diaphragm, is used to calibrate the aperture in regular steps (known as STOPS) between its smallest and largest settings. The f-numbers generally follow a standard sequence such that the interval between one stop and the next represents a halving or doubling in the image brightness. As f-numbers represent fractions, the numbers become progressively higher as the aperture is reduced to allow in less light.

Focal length. Distance between the optical center of a lens and the point at which rays of light parallel to the optical axis are brought to a focus. In general, the greater the focal length of a lens, the smaller its ANGLE OF VIEW.

Focal plane. Plane on which a given subject is brought to a sharp focus; plane where the film is positioned.

Focal-plane shutter. One of the two main types of shutter, used almost universally in SINGLE-LENS REFLEX CAMERAS. Positioned behind the lens (though in fact slightly in front of the focal plane) the shutter consists of a system of cloth blinds or metal blades; when the camera is fired, a slit travels across the image area either vertically or horizontally. The width and speed of travel of the slit determine the duration of the exposure. See also BETWEEN-THE-LENS SHUTTER.

Forced development. Technique used to increase the effective speed of a film by extending its normal development time. Also known as "pushing" the film.

Format. Dimensions of the image recorded on film by a given type of camera. The term may also refer to the dimensions of a print.

Fresnel lens. Lens whose surface consists of a series of concentric circular "steps," each of which is shaped like part of the surface of a convex lens. Fresnel lenses are often used in the viewing screens of single-lens reflex cameras and for spotlights.

Gamma. Strictly, the gradient of the straight-line section of the CHARACTERISTIC CURVE. In effect, an expression of the contrast of a given photographic material under specified conditions of development.

Gelatin. Colloid material used as binding medium for the emulsion of photographic paper and film; also used in some types of filter.

Glazing. Process by which glossy prints can be given a shiny finish by being dried in contact with a hot drum or plate of chromium or steel.

Grain. Granular texture appearing to some degree in all processed photographic materials. In black and white photographs the grains are minute particles of black metallic silver which constitute the dark areas of a photograph. In color photographs the silver has been removed chemically, but tiny blotches of dye retain the appearance of graininess. The faster the film, the coarser the texture of the grain.

Granularity. Objective measure of graininess.

Guide number. Number indicating the effective power of a flash unit. For a given film speed, the guide number divided by the distance between the flash and the subject gives the appropriate F-NUMBER to use.

Halation. Phenomenon characterized by halolike band around the developed image of a bright light source. Caused by internal reflection of light from the support of the emulsion (i.e., the paper of the print or the base layer of a film).

Half-frame. Film format measuring 24 × 18 mm, half the size of standard format 35 mm pictures.

Halogens. A particular group of chemical elements, among which chlorine, bromine and iodine are included. These elements are important in photography because their compounds with silver (SILVER HALIDES) form the light-sensitive substances in all photographic materials.

Hardener. Chemical used to strengthen the gelatin of an emulsion against physical damage.

High-key. Containing predominantly light tones. See also LOW-KEY.

Highlights. Brightest area of the subject, or corresponding areas of an image; in the negative these are areas of greatest density.

Holography. Technique whereby information is recorded on a photographic plate as an interference pattern which, when viewed under the appropriate conditions, yields a three-dimensional image. Holography bears little relation to conventional photography except in its use of a light-sensitive film.

Glossary

Hot shoe. Accessory shoe on a camera which incorporates a live contact for firing a flashgun, thus eliminating the need for a separate contact.

Hue. The quality that distinguishes between colors of the same saturation and brightness; the quality, for example, of redness or greenness.

Hyperfocal distance. The shortest distance at which a lens can be focused to give a DEPTH OF FIELD extending to infinity. (In fact, it then extends from half the hyperfocal distance to infinity.)

Hypo. Colloquial name for sodium thiosulphate, which until recently was used universally as a fixing agent. The term was thus used as a synonym for FIXER.

Incident light. Light falling on the subject. When a subject is being photographed, readings may be taken of the incident light instead of the reflected light.

Infrared radiation. Part of the spectrum of electromagnetic radiation, having wavelengths longer than visible red light (approximately 700 to 15,000 nanometers). Infrared radiation is felt as heat, and can be recorded on special types of photographic film. See IR SETTING.

Integral tripack. Composite photographic emulsion used in virtually all color films and papers, comprising three layers, each of which is sensitized to one of the three primary colors.

Intermittency effect. Phenomenon observed when an emulsion is given a series of brief exposures. The density of the image thus produced is lower than the image density produced by a single exposure of duration equal to the total of the short exposures.

Inverse square law. Law stating that, for a point source of light, the intensity of light decreases with the square of the distance from the source; thus, when the distance is doubled, the intensity is reduced by a factor of four.

IR (infrared) setting. A mark sometimes found on the focusing ring of a camera, indicating a shift in focus needed for infrared photography. Infrared radiation is refracted less than visible light, and the infrared image is therefore brought to a focus slightly behind the visible image.

Iris diaphragm. See DIAPHRAGM.

Irradiation. Internal scattering of light inside photographic emulsions during exposure, caused by reflections from the SILVER HALIDE crystals.

Joule. Unit of energy in the SI (Système International) system of units. The joule is used in photography to indicate the output of an electronic flash.

Kelvin (K). Unit of temperature in the SI system of units. The Kelvin scale begins at absolute zero ($-273°$C) and uses degrees equal in magnitude to $1°$C. Kelvins are used in photography to express COLOR TEMPERATURE.

Laser. Acronym for Light Amplification by Stimulated Emission of Radiation. Device for producing an intense beam of coherent light that is of a single very pure color. Used in the production of holograms (see HOLOGRAPHY)

Latensification. Technique used to increase effective film speed by fogging the film, either chemically or with light, between exposure and development.

Latent image. Invisible image recorded on photographic emulsion as a result of exposure to light. The latent image is converted into a visible image by the action of a DEVELOPER.

Latitude. Tolerance of photographic material to variations in exposure.

Lens hood. Simple lens accessory, usually made of rubber or light metal, used to shield the lens from light coming from areas outside the field of view. Such light is the source of FLARE.

Lith film. Ultrahigh-contrast film used to eliminate gray tones and reduce the image to areas of pure black or pure white.

Long-focus lens. Lens of focal length greater than that of the STANDARD LENS for a given format. Long-focus lenses have a narrow field of view, and consequently make distant objects appear closer. See also TELEPHOTO LENS.

Low-key. Containing predominantly dark tones. See also HIGH-KEY.

Macro lens. Strictly, a lens capable of giving a 1:1 magnification ratio (a life-size image); the term is generally used to describe any close-focusing lens. Macro lenses can also be used at ordinary subject distances.

Macrophotography. Close-up photography in the range of magnification between life-size and about ten times life-size.

Magnification ratio. Ratio of image size to object size. The magnification ratio is sometimes useful in determining the correct exposure in close-up and macrophotography.

Mercury vapor lamp. Type of light source sometimes used in studio photography, giving a bluish light. The light is produced by passing an electric current through a tube filled with mercury vapor.

Microphotography. Technique used to copy documents and similar materials onto very small-format film, so that a large amount of information may be stored compactly. The term is sometimes also used to refer to the technique of taking photographs through a microscope, otherwise known as PHOTOMICROGRAPHY.

Microprism. Special type of focusing screen, composed of a grid of tiny prisms, often incorporated into the viewing screens of SLR cameras. The microprism gives a fragmented image when the image is out of focus.

Mired. Acronym for Micro-Reciprocal Degree. Unit on a scale of COLOR TEMPERATURE used to calibrate COLOR CORRECTION FILTERS. The mired value of a light is given by the expression: one million ÷ color temperature in kelvins.

Mirror lens. Long-focus lens of extremely compact design whose construction is based on a combination of lenses and curved mirrors. Light rays from the subject are reflected backward and forward inside the barrel of the lens before reaching the film plane. Also known as a catadioptric lens.

Montage. Composite photographic image made from several different pictures by physically assembling them or printing them successively onto a single piece of paper.

Motor drive. Battery-powered camera accessory, used to wind on the film automatically after each shot, capable of achieving a rate of several frames per second.

Negative. Image in which light tones are recorded as dark, and vice versa; in color negatives every color in the original subject is represented by its complementary color.

Negative lens. See DIVERGING LENS.

Neutral density filter. Uniformly gray filter which reduces the brightness of an image without altering its color content. Used in conjunction with lenses that have no diaphragm to control the aperture (such as MIRROR LENSES), or when the light is too bright for the speed of film used.

Newton's rings. Narrow multicolored bands that appear when two transparent surfaces are sandwiched together with imperfect contact. The pattern is caused by interference, and can be troublesome when slides or negatives are held between glass or plastic.

Nodal point. Point of intersection between the optical axis of a compound lens and one of the two principal planes of refraction: a compound lens thus has a front and a rear nodal point, from which its basic measurements (such as focal length) are made.

Normal lens. See STANDARD LENS.

Opacity. Objective measurement of the degree of opaqueness of a material: the ratio of incident light to transmitted light.

Open flash. Technique of firing flash manually after the camera shutter has been opened, instead of synchronizing the flash automatically.

Optical axis. Imaginary line through the optical center of a lens system.

Orthochromatic. Term used to describe black and white emulsions that are insensitive to red light. See also PANCHROMATIC.

Oxidation. Chemical reaction in which a substance combines with oxygen. Developer tends to deteriorate as a result of oxidation unless stored in airtight containers.

Pan-and-tilt head. Type of tripod head employing independent locking mechanisms for movement in two planes at right angles to each other. Thus the camera can be locked in one plane while remaining free to move in the other.

Panchromatic. Term used to describe black and white photographic emulsions that are sensitive to all the visible colors (although not uniformly so). Most modern films are panchromatic. See also ORTHOCHROMATIC.

Panning. Technique of swinging the camera to follow a moving subject, used to convey the impression of speed. A relatively slow shutter speed is used, so that a sharp image of the moving object is recorded against a blurred background.

Panoramic camera. Special design of camera whose lens moves slowly through an arc during exposure, covering a long stretch of film.

Parallax. Apparent displacement of an object brought about by a change in viewpoint. Parallax error is apparent in close-ups only, shown in the discrepancy between the image produced by the lens and the view seen through the viewfinder in cameras where the viewfinder and taking lens are separate.

Pentaprism. Five-sided prism used in the construction of eye-level viewfinders for SLR cameras, providing a laterally correct, upright image. (In practice many pentaprisms have more than five sides, since unnecessary parts of the prism are cut off to reduce its bulk.

pH value. Strictly, the logarithm of the concentration of hydrogen ions in grams per liter. Used as a scale of acidity or alkalinity of a substance. Water is neutral at pH 7.

Photoelectric cell. Light-sensitive cell used in the circuit of a light meter. Some types of photoelectric cell generate an electric current when stimulated by light; others react by a change in their electrical resistance.

Photoflood. Bright tungsten filament bulb used as an artificial light source in photography. The bulb is over-run and so has a short life

Photogram. Photographic image produced by arranging objects on the surface of a sheet of photographic paper or film, or so that they cast a shadow directly onto the material as it is being exposed. The image is thus produced without the use of a lens.

Photometer. Instrument for measuring the intensity of light by comparing it with a standard source.

Photomicrography. Technique of taking photographs through the lens of a microscope, used to achieve magnifications greater than those obtainable using a MACRO LENS.

Physiogram. Photographic image of the pattern traced out by a light source suspended from a pendulum. The pattern depends on the arrangement and complexity of the pendulum.

Pincushion distortion. Lens defect marked by the bending of lines at the edge of the image so that they are convex toward the center. See also BARREL DISTORTION.

Pinhole camera. Simple camera which employs a very small hole instead of a lens to form an . image. Pinhole cameras are principally used as a simple demonstration of the idea that light travels in straight lines; but they can take photographs.

Polarized light. Light whose electrical vibrations are confined to a single plane. In everyday conditions, light is usually unpolarized, having electrical (and magnetic) vibrations in every plane. Light reflected from shiny nonmetallic surfaces which makes it difficult to distinguish color and detail is frequently polarized and can be controlled with a POLARIZING FILTER.

Polarizing filter. Thin transparent filter used as a lens accessory to cut down reflections from certain shiny surfaces (notably glass and water) or to intensify the color of a blue sky. Polarizing filters are made of a material that will polarize light passing through it (see POLARIZED LIGHT) and which will also block a proportion of light that has already been polarized: rotating the filter will vary the proportion that is blocked.

Positive. Image in which the light tones correspond to the light areas of the subject, and the dark tones correspond to the dark areas; in a positive color image, the colors of the subject are also represented by the same colors in the image. See NEGATIVE.

Positive lens. See CONVERGING LENS.

Posterization. Technique of drastically simplifying the tones of an image by making several negatives from an original, with different densities, contrasts, etc., and then sandwiching them together and printing them in register.

Primary colors. In the ADDITIVE SYNTHESIS of color, blue, green and red. Lights of these colors can be mixed together to give white light or light of any other color.

Process film. Slow, fine-grained film of good resolving power, used for copying work.

Process lens. Highly corrected lens designed specially for copying work.

Pushing. Technique of extending the development of a film so as to increase its effective speed or to improve contrast.

Rangefinder. Optical device for measuring distance, often coupled to the focusing mechanism of a camera lens. A rangefinder displays two images, showing the scene from slightly different viewpoints, which must be superimposed to establish the measurement of distance.

Real image. In optics, the term used to describe an image that can be formed on a screen, as distinct from a VIRTUAL IMAGE. The rays of light actually pass through the image before entering the eye of the observer.

Reciprocity law. Principle according to which the density of the image formed when an emulsion is developed is directly proportional to the duration of the exposure and the intensity of the light. However, with extremely short or long exposures and with unusual light intensities the reciprocity law fails to apply and unpredictable results occur. See also INTERMITTENCY EFFECT.

Reducer. Chemical agent used to reduce the density of a developed image either uniformly over the whole surface (leaving the contrast unaltered) or in proportion to the existing density (thus decreasing contrast). The best known is FARMER'S REDUCER.

Reflector. In photography, the sheets of white, gray or silverized card employed to reflect light into shadow areas, usually in studio lighting arrangements.

Reflex camera. Generic name for types of camera whose viewing systems employ a mirror to reflect an image onto a screen. See TWIN-LENS REFLEX CAMERA and SINGLE-LENS REFLEX CAMERA.

Refraction. Bending of a ray of light traveling obliquely from one medium to another: the ray is refracted at the surface of the two media. The angle through which a ray will be bent can be calculated from the refractive indices of the media.

Rehalogenization. The process of converting deposits of black metallic silver back into silver halides. This process may be used to bleach prints in preparation for toning. (See TONER.)

Resin-coated (RC) paper. Photographic printing paper coated with synthetic resin to prevent the paper base absorbing liquids during processing. Resin-coated papers can be washed and dried more quickly than untreated papers.

Resolving power. Ability of an optical system to distinguish between objects that are very close together; also used in photography to describe this ability in a film or paper emulsion.

Reticulation. Fine, irregular pattern appearing on the surface of an emulsion which has been subjected to a sudden and severe change in temperature or in the relative acidity/alkalinity of the processing solutions.

Retina. Light-sensitive layer at the back of the eye.

Reversal film. Photographic film which, when processed, gives a positive image; that is, intended for producing slides rather than negatives.

Reversing ring. Camera accessory which enables the lens to be attached back to front. Used in close-up photography to achieve higher image quality and greater magnification.

Ring flash. Type of electronic flash unit which fits around the lens to produce flat, shadowless lighting; particularly useful in close-up work.

Rising front. One of the principal CAMERA MOVEMENTS. The lens is moved vertically in a plane parallel to the film. Particularly important in architectural photography, where a rising front enables the photographer to include the top of a tall building without distorting the vertical lines. See also CONVERGING VERTICALS.

Sabattier effect. Partial reversal of the tones of a photographic image resulting from a secondary exposure to light during development. Sometimes also known as SOLARIZATION or, more correctly, pseudo-solarization, it can be used to give special printing effects.

Safelight. Special darkroom lamp whose light is of a color (such as red or orange) that will not affect certain photographic materials. Not all materials can be handled under a safelight, and some require a particular type of safelight designed specifically for them.

Saturated color. Pure color free from any admixture of gray.

Selenium cell. One of the principal types of photoelectric cell used in light meters. A selenium cell produces a current when stimulated by light, proportional to the intensity of the light.

Shading. Alternative term for DODGING.

Shutter. Camera mechanism which controls the duration of the exposure. The two principal types of shutter are BETWEEN-THE-LENS SHUTTERS and FOCAL-PLANE SHUTTERS.

Silver halide. Chemical compound of silver with a HALOGEN (for example, silver iodide, silver bromide or silver choride). Silver bromide is the principal light-sensitive constituent of modern photographic emulsions, though other silver halides are also used.

Single-lens reflex (SLR) camera. One of the most popular types of camera design. Its name

Glossary

derives from its viewfinder system, which enables the user to see the image produced by the same lens that is used for taking the photograph. A hinged mirror reflects this image onto a viewing screen where the picture may be composed and focused; when the shutter is released, the mirror flips out of the light path while the film is being exposed. See also TWIN-LENS REFLEX CAMERA.

Slave unit. Photoelectric device used to trigger electronic flash units in studio work. The slave unit detects light from a primary flashgun linked directly to the camera, and fires the secondary flash unit to which it is connected.

SLR. Abbreviation of SINGLE-LENS REFLEX CAMERA.

Snoot. Conical lamp attachment used to control the beam of a studio light.

Soft focus. Slight diffusion of the image achieved by the use of a special filter or similar means, giving a softening of the definition. Soft-focus effects are generally used to give a gentle, romantic haze to a photograph.

Solarization. Strictly, the complete or partial reversal of the tones of an image as a result of extreme overexposure. The term is often used, however, to refer to the SABATTIER EFFECT, which produces results similar in appearance.

Spectrum. The multicolored band obtained when light is split up into its component WAVELENGTHS, as when a prism is used to split white light into colored rays; the term may also refer to the complete range of electromagnetic radiation, extending from the shortest to the longest wavelengths and including visible light.

Speed. The sensitivity of an emulsion as measured on one of the various scales (see ASA and DIN); or the maximum aperture of which a given lens is capable.

Spherical aberration. Lens defect resulting in an unsharp image, caused by light rays passing through the outer edges of a lens being more strongly refracted than those passing through the central parts; not all rays, therefore, are brought to exactly the same focus.

Spot meter. Special type of light meter which takes a reading from a very narrow angle of view; in some TTL METERS the reading may be taken from only a small central portion of the image in the viewfinder.

Spotting. Retouching a print or negative to remove spots and blemishes.

Standard lens. Lens of focal length approximately equal to the diagonal of the negative format for which it is intended. In the case of 35 mm cameras the standard lens usually has a focal length in the range of 50–55 mm, slightly greater than the actual diagonal of a full-frame negative (about 43 mm).

Stop. Alternative name for aperture setting or F-NUMBER.

Stop bath. Weak acidic solution used in processing as an intermediate bath between the DEVELOPER and the FIXER. The stop bath serves to halt the development completely, and at the same time to neutralize the alkaline developer, thereby preventing it lowering the acidity of the fixer when it is added.

Stopping down. Colloquial term for reducing the aperture of the lens. See also STOP.

Subminiature camera. Camera using 16 mm film to take negatives measuring 12×17 mm.

Subtractive color printing. Principal method of filtration used in making prints from color negatives. The color balance of the print is established by exposing the paper through a suitable combination of yellow, magenta or cyan filters, which selectively block the part of the light giving rise to an unwanted color CAST. See also ADDITIVE COLOR PRINTING.

Supplementary lens. Simple POSITIVE LENS used as an accessory for close-ups. The supplementary lens fits over the normal lens, producing a slightly magnified image.

Telephoto lens. Strictly, a special type of LONG-FOCUS LENS, having an optical construction which consists of two lens groups: the front group acts as a converging system, while the rear group diverges the light rays. This construction results in the lens being physically shorter than its effective focal length.

Test strip. Print showing the effects of several trial exposure times, made in order to establish the correct exposure.

TLR. Abbreviation of TWIN-LENS REFLEX CAMERA.

Tone separation. Technique similar to POSTERIZATION, used to strengthen the tonal range registered in a print by printing the highlights and the shadows separately.

Toner. Chemical used to alter the color of a black and white print. There are four principal types of toner, each requiring a different process for treating the print. Almost any color can be achieved through the use of toners.

Transparency. A photograph viewed by transmitted, rather than reflected, light. When mounted in a rigid frame, the transparency is called a slide.

T setting. Abbreviation of "time" setting—a mark on some shutter controls. The T setting is used for long exposures when the photographer wishes to leave the camera with its shutter open. The first time the shutter release is pressed, the shutter opens; it remains open until the release is pressed a second time. See also B SETTING.

TTL meter. Through-the-lens meter. Built-in exposure meter which measures the intensity of light in the image produced by the main camera lens. Principally found in more sophisticated designs of SINGLE-LENS REFLEX CAMERAS.

Twin-lens reflex (TLR) camera. Type of camera whose viewing system employs a secondary lens of focal length equal to that of the main "taking" lens: a fixed mirror reflects the image from the viewing lens up onto a ground-glass screen. Twin-lens reflex cameras suffer from PARALLAX error, particularly when focused at close distances, owing to the difference in position between the viewing lens and the taking lens. See also SINGLE-LENS REFLEX CAMERA.

Ultraviolet radiation. Electromagnetic radiation of wavelengths shorter than those of violet light, the shortest visible wavelength. They affect most photographic emulsions to some extent. See also INFRARED RADIATION.

UV filter. Filter used over the camera lens to absorb ULTRAVIOLET RADIATION, which is particularly prevalent on hazy days. A UV filter enables the photographer to penetrate the haze to some extent. UV filters, having no effect on the exposure, are sometimes kept permanently in position over the lens to protect it from damage.

View camera. Large-format studio camera whose viewing system consists of a ground-glass screen at the back of the camera on which the picture is composed and focused before the film is inserted. The front and back of the camera are attached by a flexible bellows unit, which allows a full range of CAMERA MOVEMENTS.

Viewfinder. Window or frame on a camera, showing the scene that will appear in the picture, and often incorporating a RANGEFINDER mechanism.

Vignette. Picture printed in such a way that the image fades gradually into the border area (which may be either black or white).

Virtual image. In optics, an image that cannot be obtained on a screen: a virtual image is seen in a position through which rays of light appear to have passed, but in fact have not. See also REAL IMAGE.

Wavelength. The distance between successive points of equal "phase" on a wave; the distance, for example, between successive crests or successive troughs. The wavelength of a wave is inversely proportional to its frequency. The wavelength of visible light determines its color.

Wetting agent. Chemical that has the effect of lowering the surface tension of water, often used in the final rinse (of film, in particular) to promote even drying.

Wide-angle lens. Lens of focal length shorter than that of a STANDARD LENS, and consequently having a wider ANGLE OF VIEW.

Working solution. Processing solution diluted to the strength at which it is intended to be used. Most chemicals are stored in a concentrated form, both to save space and to inhibit the deterioration of the chemical as a result of OXIDATION.

X rays. Electromagnetic radiation with WAVELENGTHS very much shorter than those of visible light. X rays are often used in the security checks at airports and can, if sufficiently powerful, fog film.

Zone focusing. Technique of presetting the aperture and focusing of the camera so that the entire zone in which the subject is likely to appear is covered by the DEPTH OF FIELD. This technique is particularly useful in areas of photography such as sports or action photography in which there is not enough time to focus the camera more accurately at the moment of taking the photograph.

Zone system. System of relating exposure readings to tonal values in picture-taking, development and printing, popularized by the photographer Ansel Adams.

Zoom lens. Lens of variable FOCAL LENGTH whose focusing remains unchanged while its focal length is being altered. Zooming is accomplished by changing the relative positions of some of the elements within the lens.

Index

Numbers in bold type refer to main entries in the book

Index

ACKNOWLEDGEMENTS

The author and publishers wish to thank the following people and organizations for their help in preparing this book:

Caroline Bayer
Tessa Marsh

Artists
Priscilla Barrett
Ray Burrows
Harry Clow
Chris Forcey
Tony Graham
Tony Hatt
Industrial Art Studio
Alun Jones
Kevin Maddison
Venner Artists

Retouching
Roy Flooks
John Harold

Photography for Artwork
Gray Studio
James Jackson

Photographic Services
Summit Arts
Gray Studio
Copeland Douglas and Dyer Ltd

Design Assistance
George Glaze

Editorial Assistance
Fred Gill
Lionel Grigson
Jonathan Hilton
Lionel Perry
Keystone Agency

Index
Michael Gordon

Cut-out figures
Ken Gillam

Headline Typesetting
Conway Group Graphics

Electron Micrographs
Kodak Research Division